SHE-WOLF

Since antiquity, the she-wolf has served as the potent symbol of Rome. For more than two thousand years, the legendary animal that rescued Romulus and Remus has been the subject of historical and political accounts, literary treatments in poetry and prose, and visual representations in every medium. In *She-Wolf: The Story of a Roman Icon*, Cristina Mazzoni examines the enduring presence of the she-wolf as a cultural icon in Western history, art, and literature, from antiquity to contemporary times. Used as the image of Roman imperial power, papal authority, and the distance between the present and the past, for example, the she-wolf also served as an allegory for greed, good politics, excessive female sexuality, and, most recently, modern multicultural Rome. Mazzoni engagingly analyzes the various guises of the she-wolf over time in the first comprehensive study in any language on this subject.

Cristina Mazzoni is Professor of Romance Languages at the University of Vermont. In addition to numerous articles in scholarly journals, she is the author of *Saint Hysteria, Maternal Impressions, The Voices of Gemma Galgani* (with Rudolph Bell), and *The Women in God's Kitchen*.

SHE-WOLF

THE STORY OF A ROMAN ICON

CRISTINA MAZZONI

University of Vermont

CAMBRIDGE
UNIVERSITY PRESS

CAMBRIDGE UNIVERSITY PRESS
Cambridge, New York, Melbourne, Madrid, Cape Town, Singapore,
São Paulo, Delhi, Dubai, Tokyo

Cambridge University Press
32 Avenue of the Americas, New York, NY 10013-2473, USA

www.cambridge.org
Information on this title: www.cambridge.org/9780521145664

First published 2010

Printed in the United States of America

A catalog record for this publication is available from the British Library.

Library of Congress Cataloging in Publication data
Mazzoni, Cristina, 1965–
She-wolf : the story of a Roman icon / Cristina Mazzoni.
p. cm.
Includes bibliographical references and index.
ISBN 978-0-521-19456-3 (hardback)
1. Roman she-wolf (Legendary character) – Art. 2. Arts. I. Title.
NX652.R47M39 2010
700′.45845632 – dc22 2009045327

ISBN 978-0-521-19456-3 Hardback
ISBN 978-0-521-14566-4 Paperback

Author's photo credit: Stephanie Seguino.

For Paul, who tames a wolf every day.

CONTENTS

CONTENTS

ILLUSTRATIONS

PREFACE

DURING THE COURSE OF A YEAR I SPENT IN THE ETERNAL CITY, THE Roman she-wolf edged her way into my daily life, subtly yet insistently demanding this book be written. Living in Rome made the encounter inevitable: No one can go to Rome and not meet the she-wolf. There was a stone she-wolf suckling twins on the façade of my children's elementary school and other she-wolves lactating on several public buildings that my family passed every day. A she-wolf, teeth and udders exposed, was stuccoed above each entrance to the neighborhood covered market where we did much of our shopping. She-wolves were engraved on the potholes and trash cans in our neighborhood and airbrushed on the sides of the delivery van to the little grocery store next door, and – more predictably – she-wolves graced the sides of monuments that we admired and the hallways of museums we visited.

The timing of our arrival in the summer of 2006 made the she-wolf's presence all the more unavoidable: She had just been chosen – not surprisingly – as the mascot for Rome's first film festival. In preparation for the weeklong October event, posters featuring the photograph of a live wolf dotted the city. Although she strikes the pose of the bronze statue in the Capitoline Museum – standing and looking intently at her viewer, ready to attack, heedless of the babies tugging at her distended udders – the focus is on the animal's face, adorned by a glittering red carnival mask shaped like a butterfly. Through this accessory, the masked she-wolf playfully and competitively hints at Venice, home to Europe's best carnival as well as the Italian capital of cinema. For several months, the butterfly-masked beast was everywhere, her mysterious countenance plastered all over Rome – a place that is and always has been hers.

At the same time, another she-wolf entered my family's life. Weeks after our move to Rome, my oldest child was diagnosed with lupus – *wolf*

xi

in Latin. Because Paul's is a skin lupus, I call it his *lupa* – she seems less malevolent than the systemic kind and her maternal instincts keep at bay her more ferocious mate. Lupus is named after the wolf, some say, because the patient's face acquires a wolfish appearance from a characteristic reddish, swollen rash, called a "butterfly mask." For months, the she-wolf on the poster grinned at me knowingly through her own butterfly mask, red and raised like my son's rash. Others believe that the rash makes the patient look as if a wolf has bitten him. The illness is furtive like a wolf and can be as destructive and unpredictable. However, Rome's she-wolf is a mother – I kept telling myself – neither an angry ruler nor a vindictive deity. She guards her cubs and nurses hard-hit boys into healthy growth. In my sweetest dreams, the red butterfly across my son's face will fly away for good, settling instead on the muzzle of a movie-hungry, Roman she-wolf far more eager to don its scarlet wings.

No single volume of publishable size can aim to include every representation of the Roman she-wolf; neither can any single scholar reasonably aspire to such a task. This book provides numerous examples from a wide range of times and places, and it has been great fun to come across each successive she-wolf in these past few years. Underlying this outwardly overambitious project, however, is a haunting, humbling awareness of how elusive the she-wolf is and how much work there remains to be done. The she-wolf is a slippery beast, quick-moving and ever-changing; the last thing I want to do is cage her, even in words. Fleeting as they are, however, the glimpses of the beast described in this book could not have been captured had I been alone; many have accompanied and aided my metaphorical wolf hunt.

First, the librarians at the University of Vermont: For many years now, Barbara Lamonda and the interlibrary-loans staff tirelessly tracked down for me the often hard-to-find books and articles necessary for my research. The Department of Romance Languages and the College of Arts and Sciences Dean's Office provided welcome financial support both at the beginning and at the end of this project. The advice of friends and colleagues was invaluable, particularly the feedback and encouragement of Rudy Bell, Joyce Boyer, Dino Cervigni, John Cirignano, Andrew Elfenbein, Gayle Nunley, Frank Oveis, Barbara Rodgers, Robert Rodgers, and especially Vincent Pelletier. At Cambridge University Press, I benefited from the comments of two generous, constructive readers and the support of a smart, efficient, and always-kind editor, Beatrice Rehl. At the final stages of the project, the editing work of Peggy Rote and her team helped improve the book's legibility. The

she-wolf speaks many languages, and I am grateful for the work of transla-
tors and my language teachers over the years – above all, in this twentieth
anniversary of my life-changing Latin class with him, to Reggie Foster.
When translations are not indicated in the bibliography, they were not
available and I provided my own.

The selection of the objects that appear in this book (i.e., she-wolves
of metal and stone, pigment and ink) and the methods employed to
understand them (strings of words are the snares I lay for the beasts)
are determined by a background in which the personal and the profes-
sional cannot be disentangled from one another. The eclectic style of
my criticism comes from training in comparative literature, with its ten-
dency to flout disciplinary boundaries and sense of entitlement to poach
from all; and from a feminist bent, with its focus on what happens to
women in the precarious process of representation. Both backgrounds
shape the readings of this book – that is, the traps I laid for the she-wolf
but also the traps the beast surely has laid for me. My birth in Rome
and frequent residencies in that city since then come first, and none
of it would have been possible without the sustaining work and help
of my mother, Stefania Mazzoni, as well as, in memoriam, my father
Giuseppe Mazzoni and grandparents Ida and Lamberto Filippi. Later
personal coincidences continued to bring me close to the Roman beast:
I went to high school in Palestrina (the ancient Praeneste), where the
mirror that first represented a she-wolf nursing human twins is believed
to come from; I was raised in Valmontone, hometown of the accomplice
of those thieves whose hands were nailed next to the bronze she-wolf
in the fifteenth century; and my husband and children are part *Hirpini* –
descendants of the Southern Italian people whose ancient name means
"wolves." Most recently, the experience of mothering a child with lupus
promoted within me an intimate sensitivity to every mention of wolves.
These, as well as considerations of time, space, and personal preference,
are some of the reasons I chose the particular she-wolves discussed in
the following pages. Many more beasts – visual and verbal, literal and
metaphorical – reside in the virtual forest of my laptop's hard drive.
When in my quest for the she-wolf I become either cocky ("Hey, I've
got her now, I finally know what the she-wolf is about!") or discouraged
("Will the she-wolf ever stand still and let me grab at least her tail?"), I go
browsing through these beasts. Their number, ironically, comforts me,
for that pack of she-wolves makes it clear that we cannot know all of the
she-wolf's signs, much less the whole of her. In her immense variety, the
she-wolf understands our uncertainties, because uncertainty makes her

who she is: As a critic, too, she tells me it is okay not to be sure. Finally, the she-wolf confirms our sense that there are always other meanings beyond the obvious ones, more interpretations to consider, and different values deserving of recognition. Few can listen to the she-wolf's stories and disagree.

INTRODUCTION: ROME
AND THE SHE-WOLF

THE WORD *TROIA* IN ITALIAN MAY DESCRIBE A FEMALE ANIMAL –
a sow – or a human sex worker: *troia* is a derogatory term for a
female prostitute. Capitalize the word, however, and it becomes, instead,
the illustrious ancient city of Troy, Rome's urban ancestor. Likewise,
the Latin word *lupa* has two meanings: It indicates, metaphorically, a
prostitute; yet *lupa* is also the she-wolf who suckled Romulus and Remus.
It is from the fusion of two separate legends embedded in each of these
two ambiguous, grammatically feminine words – *troia* and *lupa* – that
the story of Rome's birth derives: the fifth-century BCE Greek legend,
which attributed Rome's founding to the Trojan hero Aeneas around
the twelfth century BCE, and the later indigenous legend of the she-wolf,
dating from 300 BCE and according to which a native founder and his
twin brother were saved by a local beast four and a half centuries earlier.
By the first century BCE, the two legends had blended harmoniously,
making Romulus a descendant of Aeneas as a compromise and with a
few hundred years elapsing between the births of the two alleged (and,
until then, competing) founders. However crucial Aeneas's arrival on
Italian soil, though, and no matter how necessary Romulus's building
of Rome's first wall and his murder of his brother, it is the scene of the
she-wolf nursing two baby boys – and the narrative that this image tells –
that remains the most visible and most frequently represented moment
in the story of Rome's foundation. How and why this has been and
continues to be the case form the subject of this book.

It is with these puns of *Troia* the city and *troia* the whore and *lupa*
the she-wolf and *lupa* the prostitute that our story must begin. At the
end of the most famous war in Western history, the ancient city of Troy
finally burned. According to conventional dating, this took place in the
year we would today call 1184 BCE. The war started because Aphrodite,

grateful to have been chosen by Paris as the most beautiful of three goddesses, caused the loveliest of all Greek women, Helen, to fall in love with Paris himself, a Trojan. This turned out to be not much of a gift because beautiful Helen, alas, was married already – and to a Greek king no less. Paris abducted Helen from her husband Menelaus and took her to his home on the other side of the Aegean. Menelaus's countrymen went to Troy, in present-day Turkey, to get Helen back and besieged the city for ten years. The crafty Greeks eventually defeated the city of Troy through the memorable trick of the hollow wooden horse, but only after much death and destruction. Aphrodite's Trojan son Aeneas managed to escape his burning city and, after some adventures, landed on the shores of the region of Latium in the center of the Italian peninsula's western coast. With Aeneas were his father Anchises – representative of the past and sometime lover of the Greek goddess of love – and Aeneas's own son Ascanius – the hopeful image of the future. Aeneas's wife, Creusa, daughter of the Trojan king Priam and mother of Ascanius, became lost somewhere during the flight. Unable to keep up with the men in her life, she had no place in Aeneas's impending adventures and would have impeded his strategic marriage to Lavinia, the daughter of Latium's King Latinus. Ascanius was also known as Iulus: From him, the Julian dynasty – of Julius Caesar fame – would take its name. Ascanius founded the city of Alba Longa, the "Long White City," in the countryside about 12 miles southeast of the place that would later become Rome.

Eleven generations after Aeneas's flight from Troy, Rhea Silvia – the daughter of Alba Longa's former king Numitor and descended from Ascanius – gave birth to twin boys, Romulus and Remus; or rather, as the ancients would say, Remus and Romulus: The former was firstborn, and the Romans regularly referred to their adventures as the story "de Remo et Romulo" (Wiseman, *Remus* xiii). Beautiful Rhea Silvia was also known as Ilia, meaning "the Trojan girl" – a reminder that Aeneas was her ancestor. She was a Vestal virgin, tradition claims, and bound by religious vows to abstain from sexual intercourse. Her uncle Amulius had forced her into this chaste position. After traitorously deposing his brother Numitor and killing his nephews, Amulius feared the retaliation of Numitor's descendants through Rhea Silvia; her perpetual virginity would ensure Amulius's own safety. Rhea Silvia's religious vows did not stop the god of war, Mars, from raping and impregnating the princess in her sleep (in a seriously weird version of the story, Mars takes Rhea Silvia – or, alternately, her handmaid – in the form of a wooden phallus that appears in the middle of her house). Amulius, fearful of what Rhea

Silvia's sons might do to him when they grew up, ordered his servants to get rid of them by drowning them in the Tiber River. At this point, Rhea Silvia disappears from the story: She is either killed or imprisoned by Amulius and – her biological task accomplished – we never hear of her again.

At the time of the babies' birth, however, the Tiber River had grown big and treacherous. Amulius's timid servants, rather than murder the two boys, simply abandoned them on the riverbank. They did not want to jeopardize their own lives by getting too close to the risen waters; to the servants, the babies' death must have seemed inevitable. However, the infants were eventually washed up on another shore, in the Velabrum – a marshy area at the foot of the Palatine Hill, where Rome would later be founded – and were rescued by a newly delivered she-wolf. Thirst had attracted the beast to the river and her cubs were gone: dead in some accounts, simply ignored in most others. The she-wolf's sore udders, swollen with unsuckled milk, needed relief. According to the tale, it was the twins' father, Mars, who sent this providential foster mother to the babies, for the wolf was an animal sacred to the god of war. Aided by another of Mars's sacred animals – a woodpecker – the she-wolf nursed the twins in a cave later known as the Lupercal, located at the southwestern corner of the Palatine Hill, near a fig tree. This tree was the famed *Ficus Ruminalis*, which some say is named after Rumina, goddess of sucklings and lactating mothers. The she-wolf nursed Remus and Romulus until Amulius's herdsman, Faustulus (a shepherd in some versions of the story, a lowlier swineherd in others), found the babies, took them away from the beast, and brought them home to his wife. In many accounts, her name is Acca Larentia, and her own child had been stillborn, some historians say.

The twins grew up and eventually killed their great-uncle Amulius, their would-be murderer. With Amulius dead, Romulus and Remus returned the throne of their birthplace – the ancient town of Alba Longa – to its rightful ruler: their grandfather Numitor. It was now the year 753 BCE, a date calculated by a Roman scholar of Caesar's time, named Varro, seven hundred years after the fact and controversially confirmed, interestingly, by recent archaeological findings (Carandini, *Roma*). Unsatisfied with the passive role of heirs and wildly restless like the animal whose milk they once swallowed, the two brothers decided to start their own city. Romulus wanted to build it on the Palatine Hill, showing his attachment to the place where he had been found as a baby by the she-wolf. Remus, however, had chosen a different location,

probably the neighboring Aventine Hill. They decided to let a flight of birds settle the matter. Some accounts say that Remus on the Aventine saw six vultures and Romulus on the Palatine saw twelve of the royal birds. The brothers were unable to decide peacefully whether the winner should be the one who saw the most vultures or the one who saw fewer birds but saw them first (some deception was also involved in this episode). It is obvious that each brother wanted to be the winner. So, Romulus and Remus got into a fight and Remus was killed. An alternate version of the story postpones the murder by having each brother build city walls on different hills: Romulus on the Palatine, Remus on the Aventine. Remus contemptuously mocked or stepped over Romulus's walls (they were low), and the ending of the story is the same: Romulus killed his brother in what is – after Cain's murder of Abel – the most famous fratricide in Western culture.

There are several stories of Rome's birth. Only one, however, has gained enough popularity to be generally accepted as the report of what might have happened: the story of the twins Romulus and Remus, the she-wolf who rescued them, and their ancestor Aeneas who came from the other side of the sea. This is the narrative that is found in history books and city guides. It is the official story, but – make no mistake – it is not the only one. As the ancient Greek historian Plutarch acknowledged, "From whom, and for what cause, the city of Rome obtained that name, whose glory has diffused itself over the world, historians are not agreed" (*Lives* 31). Indeed, it is around the very name of Rome, as Plutarch implied, that the questions about the city's beginnings revolve.

My favorite alternate story remembers a female founder who, like Aeneas, came from Troy. Greek legends describe how a few surviving Trojans took to the sea to escape the fire that was destroying what was left of their homes. The wind brought them to the mouth of the Tiber River, where they set anchor. The women, discouraged and weary of life amidst the waves, instantly took to this land and, unbeknownst to their men, burned their own ships to put an end to the tiresome voyage. The women's leader was of the highest birth and brightest intellect: Her name was Rhome. Unlike her husband, Rhome saw the homemaking potential of that land in the bend of the river. The Trojan men were angry at first, but their wives – no less crafty than the besieging Greeks they had fled – pacified their husbands with kisses, caresses, and doubtless other more intimate acts discreetly left unrecorded. The women's blandishments achieved the intended effect; to this day, said Plutarch – who told this story in the first or second century of the current

era – Roman women remain exceedingly affectionate toward their husbands and kinsmen because they still seek forgiveness for that long-ago act of insubordination (*Lives* 31). Left with neither ships nor choice but likely abundant sexual availability on the part of their eager-to-appease partners, the Trojan men settled on what later became known as the Palatine Hill. Here, within a short time, they came to see the wisdom of their women through the happiness they found in the verdant country and among the courteous locals. With this appreciation of a rebellious lady's defiance came the honor of naming their new city after Rhome, the women's acknowledged leader and the one who turned a pit stop into a permanent home.

Rhome's story is a good one but not quite good enough. Plutarch is generally considered reliable; his writings are among our most important sources of knowledge about the ancient world. However, he too mentioned this tale almost in passing – Rhome's adventures had already been told in the account of Hellanicus of Lesbos, fifth century BCE (Raaflaub 127) – before getting to the real story, the one his readers had come to expect: the one that by the time Plutarch wrote it had already become famous throughout the Roman world. Rhome's story, therefore, rarely is told and much less remembered. That a smart and educated woman, by choosing the right location and burning a few ships, should have promoted the founding of Rome – such a potent city, such a virile empire – was and unfortunately remains unthinkable. Far more convincing, then and now, is the story of a man who tried to kill his baby nephews, a virgin princess who slept through a rape, twin newborns who survived waters wild enough to scare away grown men, and a savage beast who suckled the two babies instead of eating them.

It is not an edifying story, the one leading to Rome's birth on April 21, 753. This was a month of fertility, celebrated by the pre-Roman dwellers of Latium with feasts of lamb and sheep's-milk cheese. For Rome to be born, however, someone had to die: Rhea Silvia steps out of the picture immediately after giving birth. The she-wolf's cubs likewise are gone, making their mother's milk available to hungry, needy humans. Romulus kills Remus because Rome could have only one founder. Roman and Greek historians write of usurpation and murder, rape and deception, child abandonment, the convenient elimination of baby animals, and, in the end, fratricide. Rome's birth is a tale made of transgression upon transgression, not the least of which is the scandalous suckling of the city's future founder by a smelly, dirty, ferocious beast – a she-wolf, no less – as wild and dangerous an animal as was likely to be found in Italy, then

and now. However, the surprise of the she-wolf is of a different sort than the shock of a man usurping his own brother's kingdom, of a god raping a virgin girl, or of a young man murdering his own twin brother. The she-wolf's unsettling act is a surprise because the animal, however savage, acts with mercy when none is expected, replacing human iniquity with kindness. In a story of substitutions – the king's brother on the king's throne, the god of war in the body of a seductive human rapist, a virgin performing the maternal work of giving birth – this is the most shocking of all: a wild animal in the place of a human mother, her eight udders supplanting Rhea Silvia's two breasts in the babies' famished mouths.

"When the infants' lips close upon the she-wolf's teats," as Michael Newton (5–7) suggestively writes in his book on feral children, "a transgressive mercy removes the harmful influence of a murderous culture. The moment is a second birth: where death is expected, succor is given, and the children are miraculously born into the order of nature." The twins' family intended to destroy them but the natural love of a beast instead preserves them: "Nature's mercy admonished humanity's unnatural cruelty: only a miracle of *kindness* can restore the imbalance created by human iniquity." Some feral children – whether nursed by wild animals in mythological tales or treated as animals in more harrowing contemporary accounts of abuse – are able to escape, according to Newton, "to a nature that appears unexpectedly merciful and kind." In other words, redemption very well could rest for abused children today – as it did in the eighth century BCE – in what the Romulus and Remus story represents as a she-wolf: the unexpected kindness of nature's mercy. Regardless of their veracity, what is believed about the stories of feral children – the mercy of nature, for instance – allows a glimpse into the workings of the cultures that narrate them because, Newton contends, these stories are "like a screen on which to project their own preoccupations. Silence is the great guarantee of mystery, but it also permits a thousand fancies, the projection of a multitude of needs" (235).

Embodied in a generous, silent she-wolf and materialized in numerous verbal and visual objects – including an unforgettable bronze statue – the story of Rome's birth also has endured for centuries as a screen for the preoccupations of both single individuals and entire nations. One such preoccupation is everyone's natural curiosity about our origins and about the effects of the time and place from which we came on the time and place lying before us. In this, the Romans' embrace of the she-wolf – for all her prodigious and fantastic details – speaks to a common desire. What effects, for example, will the suckling by a fierce she-wolf

have on the character of Rome's people, given the close physical and metaphorical bonds that Western culture posits between a mother and her offspring? The contested relationship between nature and culture is implicit in this question, for the nursing she-wolf abbreviates the distance between humans and animals; visual and textual, physical and imaginative ways must be found, then, to reestablish difference in order to assert our humanity. Through animal similes and metaphors – for example, greedy and hungry people act like wolves, promiscuous women are she-wolves – we remember that *they* are not *us*, even as their proximity remains undeniable. Analogous are the workings of symbols and – in the case of the she-wolf – of political symbols especially: They orient and unify a group even as they separate its members from those not in it. Only Romans have been mothered by the beast; only they should have the right to claim the she-wolf's image as their own. Intrinsic to the she-wolf as political symbol are preoccupations about identity. It is true that human societies like to identify with a past that is suitably illustrious to explain present greatness or console current woes; the Romans did this consistently and they are not alone. However, if the she-wolf herself could represent to the same people different things at different times (e.g., the power of the Empire or the authority of the Church, Italian nationalist identity or every immigrant's right to call Italy home) and if the she-wolf could also represent different things to different people even at the same time (e.g., the mercy of nature, the looseness of women), then how can the she-wolf's ability to symbolize a group remain sufficiently stable and unambiguous to be ideologically effective?

As a sign, the "she-wolf" – word or image, legend or history – has no special allegiance to a single, unbroken meaning. Her ambiguity and variability invite us to question how we acquire knowledge, particularly knowledge of the legendary past that the she-wolf represents. Legends by definition are untrustworthy, yet it is precisely through the discourse of legend that we may learn something about the beast that saved Rome's founder. Because they elaborate the past, legends underscore the meaning rather than the facts of those memories we hold dear. Legends rely on the power of their narrative more than on the truth effects of verisimilitude; legends depend on the human ability to create necessary stories effective in understanding identity. Unlike fables, legends are narratives in which people believe, identifying with what they have to tell: Legends repeat belief and reinforce it, affirming the values of the group to whose tradition they belong. "Who'd believe the boys weren't hurt by the beast?," asked Ovid in his *Fasti*, when he narrated the she-wolf's rescue of the royal

infants (39). Ousted as a dependable way of knowing by the current dominance of scientific discourse, belief is a practice crucial to the she-wolf narrative; belief is embedded in the dual interpretation of the Latin *lupa* as both beast and whore. In their need to re-create the past, to tell their own history – even when there is no reliable evidence and legends are all that remain – the Romans are not alone. The creation of a narrative for a time that is all but lost is something all modern nations have done, for without a proper history – and especially without the availability of a sufficiently developed birth legend – no culture can sustain itself.

All nations, in a sense, have their own she-wolf. "Some say," historians of early Rome preface their accounts, "others think." Although no one can trust with certainty his or her own knowledge of remote events, we keep telling stories like the she-wolf's because there is something in them that makes sense to our memory, if not to our sense of historical veracity. With its moral and narrative complexity, the she-wolf's story speaks about the persistence of sibling rivalry and the mercy of nature, no less enduring. It affirms that wicked relatives have their place in every family's narrative: Their cruel actions may hurt but, the story reassures us, they will not prevail. The legend promises that in the end, everything may turn out right for two discarded youngsters – although much suffering, even disproportionate suffering, will be experienced in the meanwhile; that the beast within us may be placated by the cry of the needy – after all, the she-wolf did not eat the babies, she fed them instead of feeding *on* them; that natural mercy will conquer human greed, however murderous; and that out of likely death, new life – and a great life such as Rome's – might rise again. The she-wolf narrative recalls as well the importance of the complex workings of memory in the act of remembering: The instability of historical narratives may be reflected in our shaky understanding of our past and of ourselves. The she-wolf never stops reminding us that without the continuity provided by these stories – however flawed, even unbelievable – we can never hope to achieve a sense of identity: the knowledge, that is, of who we are, have been, and might become.

The first part of this book is dedicated to the bronze statue that is the she-wolf's most famous and influential representation: the *Lupa Capitolina* or *Capitoline She-Wolf*. With or without the toponym linking the bronze to Rome's Capitoline Hill, these are the names (always capitalized and italicized) that I use throughout this book to refer to the bronze statue now at the Capitoline Museum. The lowercased "she-wolf" and, occasionally, the Latin *lupa* refer to the Roman beast more generally. For sentimental, grammatical, and practical reasons, the female pronoun is

used throughout when referring to the she-wolf – whether it is the live beast or an inanimate object representing her that is being described. Like the second and third parts, the first part of the book is divided chronologically into three chapters: The first chapter of each part concentrates on antiquity, the second on the Middle Ages and the Renaissance, and the third on modern and contemporary times – from the nineteenth to the twenty-first century. With her contested geography (Where was the *Lupa* made? Where did the *Lupa* reside until the ninth century?), meaning (Does the *Lupa* actually represent *the* she-wolf legend?), and chronology (Is she ancient or medieval?), the bronze *Capitoline She-Wolf* is not only the most influential representation of the Roman animal nurse but also embodies many of the contradictions and ambiguities of the she-wolf more generally – as a historical, literary, political, and artistic figure. The uses to which this particular statue was put range from ancient prophet of political collaboration (perhaps) to medieval protector of pontifical justice, from Renaissance patron of the rebirth of antiquity to invasive symbol during this same period of the pope's temporal power. A Romantic icon of ancient grandeur, the *Lupa* guaranteed the authenticity of early tourists' experiences of Rome, through the material connection to the ancient past that her bronze shape embodied. This authenticating function endures in contemporary poetry and guidebooks, as it did – ironically – in the replicas of the *Lupa* sent by Italy to friendly nations during the fascist era. Whether as public gift or private sight, as religious icon or political symbol, the *Capitoline She-Wolf* directs her viewers to consider the ever-changing meaning of even a single artwork and, more generally, to reflect on what it is that shapes our interpretation of the objects we experience.

The second part of this book examines the she-wolf's presence in written texts, beginning with Roman antiquity and ending with a 2006 novel set in contemporary Rome. In the work of classical writers, ingestion of the she-wolf's milk established for Romans an indisputable cultural and ethnic identity (and, furthermore, one as aggressive as the wolf's). The beast's misogynous and allegorical representation in later literature, however, identified in the she-wolf's milk-producing, life-saving udders the very source of physical and spiritual danger for all susceptible men: irresistible female breasts. The linguistic ambiguity of the Latin *lupa* shapes the she-wolf's connotations in many of her written representations: The literal she-wolf is either revered for her maternal compassion or feared for her marauding ferocity; the metaphorical she-wolf has inspired devotion as the image of Rome's antiquity and grandeur but also terror

for the voracious greed and lascivious nature that she personifies. No less ambiguous is the she-wolf as a literary representation of history: Her nursing image commands compassion for the past, but, alternately, her wild-animal nature triggers a sense of distance from it. This is related, in turn, to either pride in the superiority of the here and now or apprehension, on the part of a weak present, regarding the encounter with so formidable a past. Whereas knowledge of having imbibed the she-wolf's milk can provide that sense of Italian national identity craved by nineteenth-century patriots and twentieth-century fascists, Romulus and Remus were no one's legitimate sons – and certainly not the she-wolf's. This fact turns the very notion of national identity into something so fluid that, like the she-wolf's milk, it may be assimilated by seemingly "illegitimate" children, such as foreign immigrants to Rome.

The third part of the book turns to visual representations of the she-wolf (excluding the bronze *Lupa Capitolina* examined in the first part), with a chronological division analogous to that of the two previous parts. As was the case for both her bronze statue and her written representations, the she-wolf preserves her fundamental ambiguity in the world of images. Despite the undecidable meaning of some of these visual representations (e.g., Do all she-wolves from the Italian peninsula refer to the story of Romulus and Remus?), together, these images form a pattern of meaning that allows the signification and the interpretation of each she-wolf through the understanding of the entire complex of beasts. Ancient images of the nursing she-wolf expressed a public statement concerning divine intervention at the birth of Rome; as such, the she-wolf was disseminated throughout Rome's territories as a reminder of the city's protective authority. Alternately, the nursing beast embodied a private companion in each person's journey to the underworld – hence, her frequent appearances on funerary steles and urns. Spectacularly, she exemplified the ideal female conduct: obedient to the powers above and self-sacrificially maternal. Christian iconography had no trouble appropriating the she-wolf's quintessentially pagan image as the earthly support – often represented as a physical pedestal – for its new spiritual order. As a visual connection to divine power and ancient greatness, and placed within a visibly Christian context, the nursing beast identified the importance of Rome for the spread and the authority of the Christian Church, even as she mediated the renewed appreciation of antiquity in the Renaissance. Neoclassical art as well as fascist propaganda saw in the she-wolf the ideal embodiment of patriotic sentiments even though, as a political symbol, the she-wolf – in contemporary as in ancient, medieval,

and modern times – continued to prove slippery and difficult to control. Still, the she-wolf's indeterminacy, although uncomfortable for ideologues, allowed the Roman beast to endure in contemporary art. These transformations of the narrative expressed by her form are alternately and, at times, simultaneously tragic and playful, humble and monumental, permanent and ephemeral. They ensure the she-wolf's memory even in an age – our own – repeatedly described as being marked by forgetting.

PART I

THE *CAPITOLINE SHE-WOLF*

CHAPTER 1

ANTIQUITY

A SHE-WOLF AMONG ROME'S ANIMALS

WHEN CONSIDERING THE PRESENCE OF ANIMALS IN THE HISTORY and the geography of Rome, there is little doubt that the she-wolf comes first: There is no Rome before her and there would be no Rome without her. Rome is a she-wolf and the she-wolf is – in so many ways – Rome. As Francesco Domenico Guerrazzi, writer and politician, wrote in 1863, "Rome has the nature of the she-wolf" (572). The beast is maternal: She rescues and feeds twins of a different species the way Rome, since its beginnings, has hosted visitors from other lands and settlers of diverse backgrounds; the wolf god was the protector of fugitives and exiles, and these outcasts were indeed the earliest inhabitants of Romulus's city. (Of course, one never knows whether Rome and the she-wolf will protect their vulnerable charges or gobble them up.) The she-wolf is a wild predator that attacks those weaker than herself; she prefers lambs above all else. Rome, too, has done its share of preying on the weakness of others; any history book easily confirms the city's proverbial greed: "The she-wolf of Rome devoured many sheep. Carthage, Corinth, Jericho, Jerusalem, Londinum (London), Piraeus, Seleucia, Troy – these are but a few of the cities that the Romans destroyed" (Schneider 133). The she-wolf, perhaps, was not a wild animal at all but rather a very human prostitute, her profession indicated by the Latin word for she-wolf, *lupa*. Those same four letters also mean a whore; so also Rome is the whore of Babylon for some readers of the Bible, past and present. The she-wolf of the legend is mysterious and does not let herself be known: Identifiable as she feeds the babies, she stalks away from her story, and from history, as soon as human rescue is in sight. We know neither where the she-wolf comes from nor where she ends up; likewise, who can claim

15

to know Rome? Proverbial wisdom warns against this fruitless ambition: "For Rome, a lifetime is not enough" (*Roma non basta una vita*).

The she-wolf's position is that of immobile representative of a place outside of time, the place significantly known as the Eternal City. However, the she-wolf slowly reveals and encourages us to share in her own changing incarnations in a variety of metaphors – some temporary, others more lasting. In Rome, no other animal has unleashed the power of metaphorical thinking as much as the she-wolf. Her figurative significance is so deeply entrenched that it has hardened into a bronze statue and a readily recognized emblem: The *Lupa Capitolina*, or the *Capitoline She-Wolf*, stands for the city (Fig. 1). This brazen image allows, at first sight, no other interpretation. Although the word "she-wolf" (*lupa*) was used in ancient Rome as a name for a prostitute, the she-wolf is today the animal symbol of Rome. Everyone knows this.

Still, the she-wolf is not alone in the zoo that is this city. Urban centers are not friendly to animals, and one would not expect to find many in the streets of Rome; in this, however – as in so many other things – this city is a surprise. Its symbolic and zoological aviary includes Christian doves sharing the air with imperial eagles; the much-appreciated Capitoline geese; and alas, strident pigeons and seagulls – both species very much alive, their screeches not as useful as the geese's once were. In addition to birds, there are busy bees all over town (heraldic signs of the Barberini family); dozens of white sheep in church mosaics and on marble sarcophagi (the apostles in ovine form); and, in the quarter named after Saint Eustace, one repeatedly encounters the martyred hunter saint's regal stag. There are the lion's hide worn by laboring Hercules, live cats everywhere, and exotic elephants of marble and of ivory – as well as sacrificial sows and lambs on reliefs and mosaics, devilish snakes of stone and paint, and Christian-eating tigers and leopards depicted on floors and walls. Some of these animals are of flesh and blood or bones: The Rome zoo is large, as is the Museum of Natural History with its taxidermy and skeleton exhibits. Romans are as fond of keeping pet dogs as they are systematic about feeding their iconic feral cats. Other animals are made of more durable and immobile materials – a stone and metal menagerie of sorts, an inanimate zoo in which the animals neither roar nor bray, much less bleat or howl. A few of Rome's animals – the live ones – refer primarily to themselves, but so many of Rome's beasts represent something or someone else: Through a cultural code less and less widely shared, they visually tell lengthy, often complicated narratives to an increasingly

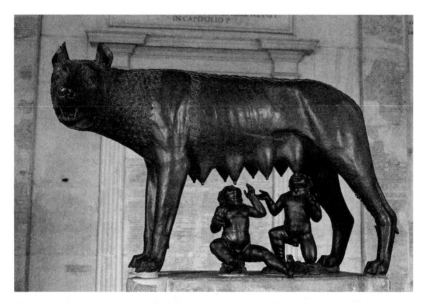

Figure 1. *Capitoline She-Wolf*, fifth–fourth century BCE. Palazzo dei Conservatori, Musei Capitolini, Rome. Photo credit: Cristina Mazzoni.

smaller audience. Some remain close to the she-wolf because of the stories they recall or the values they embody.

On the front of the Ara Pacis, the nursing she-wolf on the left panel is coupled on the right panel with another animal mother: a sow (the Ara Pacis is discussed in Chapter 7). Although today many have forgotten the crucial role this humble swine played in the birth of the city, in Roman times no words were necessary to explain the correlation. In a prophetic dream, a white nursing sow indicated to Aeneas the place where the city of Alba Longa, Rome's precursor, would be founded by his son Ascanius: The adjective *alba* in the city's name, meaning "white," is often thought to pay homage to the sow's whiteness. Unlike the she-wolf, this newly whelped animal mother did not have the good sense to stalk away and was sacrificed in thanksgiving to the goddess Juno. Competing with the she-wolf as foremost symbol of ancient and, especially, imperial Rome is not the humble sow, however (she was butchered, and perhaps one nursing female in the birth legend of this city was quite enough), but rather the magnificent eagle. Sacred to Jupiter like the wolf was sacred to Mars, the eagle shares the attributes of the king of the gods: dominion, omnipotence, justice. It is no wonder that it became the emblem of

Roman emperors and the Roman Empire – and, later, the United States of America.

On the Capitoline Hill – she-wolf territory – other birds dominate. Although geese have little in common with eagles other than feathers, beak, and wings and are nowhere nearly as maternal as plump sows or newly whelped she-wolves – that is, they have no teats to feed their offspring – the respect the Romans expressed for these humble birds is ancient. A flock of geese saved early Rome much like the she-wolf saved Romulus and Remus; as such, geese and the she-wolf, although both speechless animals, have entered a human history made of words. Less clearly linked to the she-wolf than the sow on the Ara Pacis, a bronze pair of Roman geese is on display in the Capitoline Museum (they actually look like ducks), next door to the bronze statue of the *Lupa Capitolina*. Visitors enter the *Sala delle Oche*, the Hall of the Geese, through a door connecting it to the *Sala della Lupa*, the Hall of the *She-Wolf*. The bronze pair is said to celebrate the geese whose obstreperous cackling in 390 BCE warned the besieged Romans of the Gauls' impending climb into the city fortress. The Romans, half-starved by the siege, were surely glad they had not eaten the scrawny birds that were sacred to Juno. The event was commemorated every year for generations to come: Geese were carried on purple-cushioned litters at a ceremony in the course of which dozens of Roman watchdogs were crucified on the Capitoline Hill instead – guilty of not barking at the Gauls' arrival.

Although the shared cultural code that once made the geese and the sow easily recognizable emblems of Roman history and prehistory may be losing its range of recognition and popular appeal, the she-wolf continues to represent intelligibly – in the West, at least, and certainly throughout Rome – the legend of this city's birth. The nursing beast remains in Rome a collective – although not uncontroversial – representation of shared cultural and ethnic origins, effectively blending nature and culture and, in fact, naturalizing the society she represents. Through the she-wolf's body, nature and the gods sanction Rome's existence and legitimize the city's geographic and historical claims. The she-wolf maintains her territories; she keeps haunting Rome's streets and Western art and literature because she is "good to think," as Claude Lévi-Strauss famously said in his discussion of totemism: "Natural species are chosen not because they are 'good to eat,' but because they are 'good to think'" (89). Furthermore, specific animals are selected as totems – and the she-wolf is a notable example of this – not simply because they are objects of fear, envy, or admiration. Rather, such animals are "good to

think" because in their physicality, they embody ideas and relationships that are central to a certain culture and mark in their shape the encounter between speculative thought and empirical observation. With the possible exception of the she-wolf, none of the animals of Rome that I list herein is a totem: They are not associated with the Roman people through a specific magico-religious relationship nor are or were they unanimously regarded by the Romans as their physical ancestors. Still, in their embodiment of speculation and observation, these historical and symbolic beasts are linked inextricably with Rome and its inhabitants. In the specific and certainly unique case of the she-wolf, the identification with the functions of a totem, if not complete, then is certainly profound. It has been claimed that "the she-wolf, before becoming the symbol of the *urbs*, was the totem animal for the Latial populations of prehistory" (Grandazzi 166). Specifically, the she-wolf was an apotropaic totem because the early Latial peoples were shepherds: The she-wolf idol, to whom they prayed and sacrificed, placated other wolves who might ravage these shepherds' flocks; the she-wolf's prolific nature, indicated by the fullness of her udders, amplifies the danger inherent in her fangs (Levi 36–37). Although later Romans did not regard themselves as the she-wolf's blood descendants, their ancestry in her body is steeped in the milk with which she suckled their founder. She represented for them the solidarity of a common origin (their past) and the cohesion of a shared destiny (their future).

UNDERSTANDING AND REPRESENTING THE *LUPA CAPITOLINA*

"The she-wolf of the Capitol as emblem of Rome is charged with an intensity of significance such as is associated with no other emblem, sign, or symbol of any other city, ancient or modern. Neither the owl of Athens nor the bear of Berlin is immediately and forcefully and unmistakably identified with the city for which it acts as a kind of totem" (Andreae 36). Art lovers marvel at her perfection, dutiful tourists are thrilled to see such a famous and tirelessly reproduced image, and even children dragged against their will through museums are likely to find this ferocious animal appealing. We may not know the name of the artist who sculpted the *Capitoline She-Wolf* – the iconic *Lupa Capitolina* – or exactly when and where the bronze was made; however, there is no question today that this is a monument to high art and ancient history and the ultimate image of Rome's tutelary beast. Still, the story of the *Lupa* complicates every

attempt to determine a single and unchanging meaning: The ways the statue has been used, what has been felt and thought or said and written about the she-wolf, affected and shaped the many meanings she acquired and produced through the ages. The very representations of the *Capitoline She-Wolf* – whether in the words that describe her or the images that imitate her – are inseparable from the various contexts from which they have emerged; representations are never transparent. The words used to describe the *Lupa* and the narratives woven around her have consistently, if variably, shaped her significance – as have the images she inspired and the emotions associated with her, the ways she has been classified and conceptualized, and, of course, the values that have been placed on her form. All these activities, which together comprise representation, are cultural practices that "need to be *meaningfully interpreted*" and "*depend on meaning* for their effective operation" (S. Hall 3, my emphasis). The bronze *Lupa*, then, cannot simply be looked at and deciphered once and for all. Her meanings are multiple and they have been – and continue to be – fought over in sometimes harsh ways: Power is always involved in these struggles to understand, manipulate, and appropriate. Equally important is the relationship with language (whether verbal or visual, written or oral, explicit or implied) of all the participants contributing to the exchange. For meaning, the *Lupa* never tires of reminding us, is always an interactive process and is as entangled with the complexities of language and perception as it is embroiled in questions of power.

Lewis Carroll's Humpty Dumpty knew all about the correlation between words and power in the process of representing things through language: "'When *I* use a word,' Humpty Dumpty said, in a rather scornful tone, 'it means just what I choose it to mean – neither more nor less.' 'The question is,' said Alice, 'whether you *can* make words mean so many different things.' 'The question is,' said Humpty Dumpty, 'which is to be master – that's all'" (99). Through the centuries, viewers' reactions to the *Lupa Capitolina* illustrate the effects of representation on this statue's changing meaning. In turn, the variable status of the statue's numerous viewers – their power, we could say or, to echo Humpty Dumpty, how much of a "master" each was – has determined the effec-tiveness, the durability, and the influence of their remarks. Nineteenth-and twentieth-century classical scholars, for example, confirmed the *Lupa Capitolina*'s status as a masterpiece of ancient art with words that deter-mine her meaning for today's visitors. "Rugged and uncouth though it is, this statue moved my spirit more than all the beautiful images that surround it," said the German classical historian, Theodor Mommsen,

when he saw the *Capitoline She-Wolf* during his first visit to Rome in 1844 (Carcopino 15). A few decades later, archaeologist Wolfgang Helbig said about the bronze, "With flashing eye and gnashing teeth she menaces an approaching foe. The terror-striking effect of the head was enhanced by the glittering enamel of the deeply incised pupils, a fragment of which still remains in the right eye" (1: 460). Although the eyes of the beast are fully cast, there are small cavities in place of the pupils, once likely filled with colored paste. Renowned French historian Jérôme Carcopino calls the wolf "the most venerable work of Roman archaeology" (3).

So what is it about this statue that continues to make her so compelling to those who see her and such an inspiration for writers and artists through the centuries, even to this day? The *Lupa Capitolina* wields an undeniable appeal through her form alone; yet, her formal qualities cannot be disentangled from the defining attributes that have been attached to the statue in the course of history.

The *Capitoline She-Wolf*, first of all, reminds us of the rarity of her kind. Few ancient bronzes have lasted to the present day because unlike stone, bronze (i.e., a strong alloy of tin and copper) could be fused and reused, and it often was. From statue to cannonball: This was the sad fate of numerous ancient works of art. Therefore, we hold ancient bronze statues especially dear because there are so few of them, and these few tell a story of survival against human need and human greed and against what Romain Rolland called "the power of languor given off by the Italian soil," a languor whose "maleficent charm . . . had rusted away the brass of the Roman she-wolf. Rome," Rolland concludes, "breathes forth death" (381–382). Thankfully, Rolland's rust is metaphorical and the *Capitoline She-Wolf* is still in good shape – attesting to the statue's acknowledged sacred and civic significance as well as the recognition of the wolf's artistic worth.

Fashioned with the technique called the "lost-wax method," the sculpture began with a detailed, full-size model made out of clay that was then covered with a half-inch-thick layer of wax. Some of the details were worked on the wax rather than on the clay; this is true of the *Lupa*'s ears and the crown of curls framing the border between the head and the mane. The wax was covered with a thicker layer of clay. The entire piece then was heated so that the wax melted and drained through the holes pierced through the bottom (the holes were later covered over with more clay once all the wax was gone). At this point, there was a thin hollow space between the clay model and the rough layer of clay that once covered the now "lost" wax. Molten bronze was poured through small

holes into this hollow space. After the bronze hardened, the top layer of clay was chiseled away, revealing the bronze statue. Much of the inner clay model was then removed by scraping it out through the bottom openings. With the removal of this inner clay, the bronze statue became hollow and relatively light, rendering it much easier to transport than a marble statue of the same size. Finally, finishing touches were applied by working with the hardened metal, and the resulting artwork was a unique and unrepeatable product – no other replicas could be made from the original model. With the exception of the tassel that connects the lower part of the wolf's neck to her belly, the sculpture of the *Capitoline She-Wolf* was made in one piece with a single casting of fused bronze.

In addition to her rarity as a bronze statue, the *Lupa* is notable for her antiquity. Generally regarded as the most ancient representation of the Roman she-wolf, the *Lupa Capitolina* has been long believed to be the work of unknown Etruscan artists of the fifth or fourth century BCE (the name of the celebrated Vulca of Veii is occasionally invoked). "The extraordinary realism of the tense, watchful stance – ears pricked, brow furrowed, jaws snarling, hackles rising – epitomizes at its finest and most vividly factual the unidealized, down-to-earth quality of Etruscan art" (Honour and Fleming 158). "It is certain that the aggressive vigor of the Capitoline bronze, which later became the emblem of Rome, clearly marks it as belonging to the art of the Etruscans" (Mansuelli 122). Although some claim otherwise, the *Lupa Capitolina* is one of the most ancient among the locally produced statues to be seen in Rome. Even if this bronze were indeed of medieval origin, as some say (see Chapter 2), that would still make her well over a thousand years old – and one of the rare examples of medieval sculpture in Rome. Surely, even a (relatively) paltry thousand years is enough to endow this bronze with the aura of the antique. The restoration work carried out in recent years analyzed the clay residue left within the she-wolf: There was a substantial amount, about 40 percent of the original model, and more than 2 kilograms of the residual clay could be extracted. To the restorers' delight, even some fingerprints of the artist were found – deeply moving traces of a human touch. It was determined that the clay within the bronze statue came from a place just north of Rome, a volcanic area located along the Tiber River between Rome and Orvieto – that is, Southern Etruria. The widespread belief that the *Lupa* is Etruscan was bolstered by this finding; because a significant amount of clay was needed to make a bronze statue the size of this wolf, and clay was available everywhere in Italy, there

was no reason to transport a heavy load from a distance. The clay used for models of statues in the ancient world came from the vicinity of the foundry (Lombardi 610); the metal used for the *Lupa*, conversely, was mined in Sardinia. These material findings of clay and metal excluded manufacture of the bronze in Greece or Southern Italy, as some art historians hypothesized, and determined instead that it was produced by Etruscans – or, at least, in Etruscan land and with Etruscan soil. For the majority of scholars, the most convincing date of manufacture, according to these physical findings, is between 480 and 470 BCE: "Every available evidence counsels us to place the Capitoline statue at the end of the Archaic period, within the singularly productive decades between c. 500 and 480" (Brendel 253). Some say that the ancient bronze *Lupa* was lost for several centuries and then found again at the foot of the Palatine Hill, in the area known as the Velabrum. Others, including the influential turn-of-the-century Roman archaeologist Rodolfo Lanciani, believed that the *Lupa*, along with other Roman bronzes, was never lost and discovered – rather, these bronzes were kept together and preserved from the fall of the Roman Empire onward, in or around the Lateran Palace of the popes.

Rare and ancient, the *Lupa Capitolina* is also exceptionally well made; she is a formidable beast. The imperfections of her hind legs only serve to highlight for the viewer the technical skill that went into the statue's production, such as the fine details of vein and muscle, the delightful curlicues that comprise the part of the wolf's mane that frames her face (needless to say, a wolf does not have a mane; the animal here is assimilated to the traditional, archaic representation of lions), the realistically jagged edges of her ears, and the intensity of her gaze as it contrasts with the body's general harshness. Slightly larger than life, the bronze measures 75 centimeters in height and 1 meter 14 centimeters in length. Both realistic and stylized, she is so lean that you can count her ribs and trace her veins. Visitors' fingers itch to touch the regular, S-shaped curls of her mane, reminiscent of a lion's (and, significantly for this mysterious beast, resembling the outline of numerous question marks), and to caress her sinewy legs, her feline paws, and her smooth, distended udders. She stands still, her mouth partly open to reveal her redoubtable fangs. Her small ears are jagged at the edges, like those of a real-life wolf who has weathered some battles in her life and still bears the traces of the fight. Her four sets of udders are slightly different in shape and size and placed at varying distance from one another. Her tail is not as fine as the rest of her body; added by a later sculptor and much too big for a normal wolf,

the bushy appendage renders the statue more stable by connecting the torso to the hind legs.

The expressiveness of this she-wolf's body and face remains extraordinary despite the passage of time. "Hostile and wary, the animal snarled at the stranger dangerously, as she still snarls at the curious visitor of today in the quiet *salone* that now houses her" (Brendel 252). This wolf looks ferocious: Her eyebrows, raised in bronze imitation of the lighter coloring visible in live wolves, are contracted and expressive; her ears are pricked; her gaze intent, penetrating – humanized, even, through the precision of its expression. Her facial muscles are tense, and the vein running from her nose to just under her right eye is visibly swollen. On her surface, the *Lupa Capitolina* blends a precise attention to the reality of live wolves with a certain respect for representational conventions regarding sculpted animals. This wolf is rigid and expressive, at once static and poised to pounce. Although the meanings of facial features and body language are culturally relative – that is, not all expressions signify the same emotions across time and space – still, the flexed muscles of the beast, her attentive gaze, her wrinkled brow all elicit a connection between human and animal, between artwork and viewer. The wolf's gaze makes the statue's visible emotions something with which viewers can immediately identify: She looks attentive and ready, protective and fierce. The "unusually complex expression in the face of the wolf," as artist Stanley Horner described his own aesthetic reaction to the *Lupa Capitolina*, "is more devastating than the Mona Lisa; it can smile and snarl in the same countenance, whichever I wish to project unto it." The ability to accept a variety of projections on the part of her audience is a crucial aspect of the *Lupa*'s and, more generally, the she-wolf's significance: As we read her expressions, how much of our personal narrative do we project onto her form? "Perhaps," Horner wonders, "it is the wolf, after all, who holds the human psyche; perhaps it is the babies who have turned into animals! The mystery of the sculptor's motivation and workings pervades my experience" (93).

For all her remarkable expressiveness, the *Capitoline She-Wolf* is inherently ambiguous. "Close inspection shows the *Capitoline Wolf* to be a composite beast, zoologically and stylistically" (Brendel 252–253). One does not have to know about the possibility that the she-wolf of Rome's foundation legend might have been a prostitute to realize that there is something odd about this bronze, something mysterious. The *Lupa* appears to be an unwilling mother, more ready to sprint than to nurse, seemingly unaware that there are twin babies below her – their sweet

Renaissance roundness contrasts with the *Lupa*'s archaic harsh lines. The theme of the fierce mother beast, desperate and savagely brutal when defending her offspring, is recurrent in ancient culture. Viewers would have instantly recognized the danger the wolf presented and that her swollen udders pointed not to a sweet-tempered maternity but rather to a mother's unlimited ferocity. So, although clearly a mother, this is no gentle nurse: The twins, without whom it is difficult to imagine her today, are a Renaissance addition. Clearly, the wolf has no idea of who is under her, reaching for her milk – or even that anyone is indeed below her: Her teats are too high for any normal-sized baby to comfortably reach. The wolf's distended udders, though, are bodily evidence that she is a recent mother about to turn ferocious – and kill if necessary – to protect her young. The *Lupa Capitolina*'s ambiguity, instead of distancing her from her viewers, draws us in: We are called to fill in the blanks, in a way, to figure out exactly what story she is silently expressing. Ancient iconography depicts she-wolves either looking straight ahead or with their head and neck maternally stretched toward the twins, sometimes licking them. The *Lupa Capitolina*, it is plain to see, strikes neither pose: Her head is turned, but she is looking neither at you, her observer, nor at anything below her pendulous udders. Yet, many descriptions of the *Capitoline She-Wolf* assume the beast's head is turned toward the twins, representing a maternal action that is not there. This explanation is from an 1849 guide to Rome by Sir George Head: "For here is exhibited the most extraordinary contrast in nature imaginable between the gaunt figure of the ferocious animal and the tender rounded limbs of the infants, yet reconciled by the maternal solicitude that inclines the monster's lean, pliant neck towards its adopted offspring; while the children, as if endued with supernatural strength owing to Divine origin, almost stand upon their feet in their efforts to reach the mother's teat" (Head 30). As such descriptions often do, Head's wrong-headed words follow Virgil's lines in the *Aeneid* (see Chapter 4), in which the beast turns to lick the twins that she is nursing. Anyone looking at the statue, however, must immediately realize that this is not her pose and that the *Lupa Capitolina* is not turning toward the twins – much less licking them. It is her observer that the beast wants to assess. She knows that her sucklings are elsewhere: not under her, it seems, but near enough that she will strike if you venture any closer.

The bronze she-wolf at the Capitoline Museum exudes an aura of authenticity. Reproductions of the *Lupa Capitolina* abound throughout the city of Rome, for the wild beast is regarded as the city's mother and

her bronze representation at the Capitoline – despite the questions concerning her date of manufacture – as the primeval shape from which so many other images of the she-wolf derive. In the bronze, we see the most faithful reproduction – it is thought – of the animal that saved Romulus and Remus from certain death, the animal without which Rome would never have been founded. Actually, we do not know whether the myth of the she-wolf chronologically preceded or followed its most hallowed bronze representation: Was the bronze statue crafted to provide an image for the story of the wolf nurse, or was the story of Romulus's rescue inspired by the statue of the *Lupa* – which probably implies that there were twins under the bronze wolf even in ancient times? Jérôme Carcopino insisted that the myth of the she-wolf did not yet exist when the bronze wolf was produced: The story of Romulus and Remus dates back to the second half of the fourth century BCE, whereas the bronze was cast in the course of the fifth (54). Other scholars, such as André Alföldi, in an essay published ironically in honor of Carcopino, countered that the she-wolf was the Romans' totem animal at the very dawn of the city's history: The bronze, Alföldi says, came later (2). In either case, the *Lupa Capitolina* is not a comfortable object for those in search of authenticity. It is true that the bronze, whether ancient or medieval, has survived against the odds and is physically available to us today as a material bridge to a lost world, a bygone era – the past lives on in the statue of the *She-Wolf*, which thus comes to embody it metonymically, as a part standing for a much greater whole. At the same time as she makes the past immediately available through her sheer physical presence, however, because of her physical boundaries, the *She-Wolf* points to its absence. *Pace* Walter Benjamin, who famously insisted in 1936 that "the aura of the work of art . . . withers in the age of mechanical reproduction" (521), a large part of the *Lupa*'s impact on her viewer is due precisely to her vivid aura of authenticity, undiminished and possibly even increased by her frequent reproduction: The bronze *She-Wolf* is well known even to those who have never seen it. The legendary she-wolf may be historically distant but she is physically, even immediately, present.

THE *LUPA*'S IDENTITY IN CICERO AND LIVY

Steven Saylor's 2007 *Roma* is set in the ancient city and tells Rome's story through a fictionalized account. Through a dialogue between two very different characters, the novel presents two conflicting ancient Roman attitudes toward the statue of the she-wolf that suckled Romulus and

Remus and the female mammal that the bronze represented. The practice of belief, in either interpretation, is central to the tale.

> Beneath a standing she-wolf, two naked babies squatted and turned up their faces to suckle the animal's teats.
> "Well, what do you think, young man?
> "It's remarkable. Very powerful. Very beautiful."
> "Do you suppose the founder of the city and his unfortunate brother were literally raised by a wolf?"
> "So legends tell us."
> "And do you never question legends? Some believe the she-wolf to be a metaphor, or perhaps a too-literal interpretation of a tale passed down by word of mouth. The same word, after all, can refer to a woman of the she-wolf variety – a prostitute. Is it not more likely that the Twins were raised by such a woman, rather than by a wild animal?"
> Claudius was unable to see the younger man's expression, but from the silence that ensued he could tell that Kaeso was taken aback. Claudius laughed good-naturedly. "Forgive my outspokenness. Obviously, such ideas are not spoken in the staid households of the Fabii!" (337–338)

Saylor's novel alludes to the story about the founding of Rome and about the rescue of the city's first king, drawing from the multiple interpretations of these tales. Predictably, one of the characters then goes on to imagine – alluding to the tale's ambiguity – that the she-wolf was not actually a wild canine but rather a feral woman: The rescuer, in this version, was not a forest-dwelling predator but rather another man-eater of sorts – an amateur whore or a professional prostitute. She may redeem herself through her feeding activity; she herself may be saved through her own saving of Rome's future founder by means of her necessary milk. Still, this very human she-wolf remains unpredictable, unstable, and therefore dangerous. This human she-wolf's teats may feed but her breasts enslave. Her tongue can give shape – as mammals' tongues were once believed to do – but, in other circumstances, it is an instrument of pleasure too. The problem is that one can never be sure of the she-wolf's intentions or of what she plans to do with her breasts and her tongue (these body parts are discussed in Chapter 4).

With his description of the she-wolf's statue, Saylor is generous and imaginative: Although there is no reason not to believe he is describing what is now known as the *Capitoline She-Wolf*, the *Lupa Capitolina*, no one knows anything definite about this statue's ancient whereabouts. A bronze she-wolf, *the* bronze she-wolf, is located today in the Capitoline

Museum atop the Capitoline Hill in the heart of Rome. We know that the two babies frolicking under her udders, attempting to suckle her while kneeling in adoration, were added in the late fifteenth century. But where was the statue of the beast before assuming its place of honor in the room named after her, the *Sala della Lupa*, or Hall of the *She-Wolf*? It is surprising for an artwork so famous and believed to have been made in the fourth or fifth century BCE that no one has been able to trace its whereabouts before the ninth century CE. Many art historians have tried and most have a definitive opinion on the matter, but opinions they are and no single explanation has been accepted by all.

Several references from the ancient world describe the statue of a she-wolf, although few scholars today believe that any of these descriptions actually tells us anything about the Capitoline beast. Rome's most famous orator, Cicero, wrote in or around 65 BCE about the statue of a she-wolf struck by lightning on the Capitoline Hill. In the third of the orator's four speeches against the conspirator Catiline, Cicero interprets the damage suffered by this bronze during an electrical storm as an ill omen portending Catiline's impending conspiracy and, more generally, as one of the events through which "the immortal gods seem with a voice from heaven to have proclaimed the things which are now come to pass." In Cicero's view, the bronze she-wolf – with her extensive and profound historical and political significance – could not remain immune to the imminent dangers that Catiline's treason posed to the very fabric of the Roman republic. The wolf is among the objects "beaten down," "overthrown," or "melted" when "struck with lightning," Cicero tells us: "Romulus, too, that founded this city, was smitten, whom you remember to have been gilt in the Capitol, a babe sucking and opening his mouth wide for the wolf's teats" (*Catiline and Jugurthine Wars* 201–202). Embodying Rome and its founder, emblematic of Rome's very birth, the wolf statue must suffer along with the city's affliction: This polished bronze also naturally risks destruction when Rome's political integrity is at stake.

Like animals can sometimes detect – through an increased sensitivity of their body – changes of weather and impending natural disasters, so too this bronze image of a wild beast could portend a dangerous political future that, although not part of the natural world to which wolves belong, would have affected her intimately. Almost two decades after that speech against Catiline, Cicero connects once again the statue of a nursing wolf with the prediction of the future in his *On Divination* (45 BCE) – a text describing the ways in which knowledge of future events may be acquired. Cicero counts on the obvious importance of the

she-wolf and her milk in the formation of Romulus's identity and of the city's own. In this text on divination, as in the earlier and more overtly political text against Catiline, the she-wolf is embodied in the statue of a beast that even a natural calamity such as lightning did not spare. Portents are everywhere, the text implies, and no one – not even the sturdiest of Roman artifacts, the most stable of Roman symbols – is safe from their irruption into this time-bound, natural world:

> Here was that noble nurse o' the Roman name,
> The Wolf of Mars, who from her kindly breast
> Fed the immortal children of her god
> With the life-giving dew of sweetest milk.
> E'en her the lightning spared not; down she fell.
> Bearing the royal babes in her descent,
> Leaving her footmarks on the pedestal.
>
> (*Treatises* 150)

In these lines, Cicero is referring to a gilded statue of the she-wolf standing in the Forum and so mightily struck by lightning that it was knocked down off its pedestal. This event, in Cicero's estimation, could only portend badly for a city indebted to the she-wolf for its birth, its history, its power, and its entire political and social body.

In the second part of his book on divination, Cicero returns to the portentous event and its significance – a significance in need of inter-pretation and perhaps not entirely clear: "Romulus, represented by the sculptor as sucking a she-wolf, was likewise smitten by the lightning. Hence, according to you, some danger to the city of Rome was threat-ened" (*Treatises* 219). For a long time, the bronze statue known as the *Capitoline She-Wolf* was identified with the one described by Cicero because the beast's hind paws are quite visibly ruined, as if scorched by a fire of possible electrical origin. Rome certainly did live through the difficulties portended by the lightning that struck its tutelary animal. Like the she-wolf, Rome survived – but not unscathed.

Cicero's observations notwithstanding, recent restoration work on the *Capitoline She-Wolf* has determined that the lesions visible on the wolf's hind legs are not the result of lightning or any natural agent but rather were caused by an imperfect solidification of the bronze during the manufacturing process, when the molten metal was poured into the space left hollow by the melting of the wax model (Carruba 17–19). The edges of these lesions are in fact rounded, not jagged as they would have been had the cause been a traumatic, external event such as lightning.

The *Lupa*'s imperfections are internal; her defects are intrinsic to her shape and not due to the wrath of the gods or the effects of natural calamities.

This detail about the *Lupa*'s hind legs may be irrelevant anyway: Whereas Cicero describes the bronze statue of a she-wolf as having been covered in gold, chemical analysis has established that the *Capitoline She-Wolf* we see today never received such gilding; if it had, some trace would have remained – detectable, if not to the naked eye, then by scientific inspection. To confirm the general feeling that the bronze described in ancient sources is not the same animal we can see today, it must be noted that there are no visual reproductions of the *Capitoline She-Wolf* dating back to Roman times. Ancient images of the she-wolf without exception show her striking a wholly different pose – either looking straight ahead or stretching her neck to gaze at or lick the suckling twins below her. Never, like the *Capitoline She-Wolf*, do ancient, nursing she-wolves turn to look at their viewer.

Just as uncertain as Cicero's are Livy's references to an ancient she-wolf statue. Working during the same century as the famed orator, Livy wrote about a bronze beast while telling of an event that had taken place two hundred years earlier, around 296 BCE. Livy reminded his readers that two government officials, the brothers Gneus and Quintus of the Ogulnii family, set up the financing of public objects to be displayed in the center of the city. Among other precious items were the "images of the founders of the city in their infant state under the teats of the wolf, at the Ruminal fig-tree" (703; there were at least two different trees in Rome vying for the honor of being *the* fig tree of the legend). It is not clear from Livy's text whether the Ogulnii added a set of twins to an existing statue of the she-wolf (much like twins were added in the fifteenth century after the *Lupa* was moved from the Lateran Square to the Capitoline Hill) or they set up the entire group, nurse and nurslings, as a gift to the city. Historians can become excited about which of these two situations Livy was speaking (see, e.g., Evans 80–81). In either case, according to the principal scholar of the ancient she-wolf iconography, the Belgian Cécile Dulière, the Ogulnii's choice of subject demonstrated that a she-wolf legend was already circulating by the time of their gift, although it is the statue sponsored by the Ogulnii that gave the story of the she-wolf and twins its unprecedented importance (53). In fact, classical scholar T. P. Wiseman claims that the Ogulnian monument of 296 BCE constitutes "the first clear evidence for the she-wolf's sucklings as the twin sons of Mars, and therefore presumably Romulus and Remus" (*Remus* 76).

The Ogulnii funded their gift statue with money confiscated from loan sharks (apparently as common in Rome then as they are now). The two brothers were not just any government officials, and their choice for this particular public monument – a she-wolf with a set of twins nursing from her teats – was no casual decoration. Quintus Ogulnius was the man associated with the 300 BCE *lex Ogulnia*, a law that allowed greater equality between patricians and plebeians by giving the latter their own place in the college of pontiffs and of augurs. The innovation brought about by this law might well be the reason behind Quintus Ogulnius's addition of twins under the she-wolf: The two babies could represent the patricians and the plebeians, their new equality reflected on the two boys' identical features. (Bloodied in fratricide, their fate – alas – was not to be glorious in equal measure.) Although the she-wolf was an Etruscan sacred animal – identified with a chthonian divinity that accompanied the deceased to the underworld – and despite the fact that the Ogulnii were of Etruscan stock, "their action of erecting the monument," it has been claimed, "looks somehow like an expression of sincere subscription to Roman belief" rather than an "underhand adherence to the Etruscan goddess" (Holleman 428).

In 269, Quintus Ogulnius was consul and, in commemoration of the erection of the Ogulnii brothers' gift she-wolf (as explained in the next two chapters, she-wolves have the habit of being given as awkward gifts), silver coins known as "Hercules didrachme" were issued that showed a she-wolf licking and nursing a set of twin babies. The beast's head, of course, was turned toward the twins in order to lick them; the coin did not depict the *Capitoline She-Wolf* although it is generally thought to depict the Ogulnii monument. Rome was not yet acknowledged as the great superpower it was soon to become, and both representations – the statue, a sacred monument in bronze, the most noble and durable of materials then available; and the coins, the most common and modern means of commercial exchange in the Mediterranean basin – did much to circulate the fame of Rome's history through the glory of the city's founder and the unique circumstances of his rescue as an infant by a wild animal. The image of the she-wolf nursing the twins became crucial in Rome's creation of its own history – tinged with divine approval through Mars's she-wolf – and for the spread of its conquering mythology, so clearly supported by the gods. Still, where the *Lupa Capitolina* was located at that time and what she was doing and how remain mysteries to this day.

ROMULUS AND REMUS BETWEEN RIVALRY AND COOPERATION

As a result of the rich animal symbolism of the Etruscan people, isolated representations of animals were not uncommon even in a city such as Rome, known to frown on the veneration of beasts. The bronze *Lupa Capitolina* originally most likely showed the she-wolf alone, without any babies. Without doubt, the two chubby babies we see today reaching for the she-wolf's teats are a Renaissance addition. Whereas some scholars still believe that the *Capitoline She-Wolf* originally had sucklings under her – just not those we see today – most agree that this particular wolf stood alone until the babies were added sometime in the late fifteenth century, inspired by other images of the nursing Roman beast. They were created and installed when the *Lupa's* role as mother of the Roman people, *mater Romanorum*, and no longer as the fierce guardian of the administration of papal justice was being emphasized as her primary task (see Chapter 2). From her full udders, the wolf's maternal mission could be guessed easily; the placement under this milky abundance of two hungry, needy babies, who would make good use of the nutrition and protection she provided, reinforced and redoubled the *She-Wolf's* essential role as mother of all Romans.

So well adapted are the bronze twins to the character and style of the bronze *Lupa* and other ancient bronzes that, for a long time, people assumed – surprisingly – that these very babies were original to the statue, ancient rather than Renaissance artifacts. Similarities are especially visible if we compare the twins and the bronze of a boy pulling a thorn from his foot, the famed and beloved *Spinario*. (The *Spinario* was originally part of the same group of Lateran bronzes donated by Sixtus IV to the city of Rome in 1471 and currently is located in a room near the *Lupa* in the Capitoline Museum.) The two infants under the wolf and the older boy intent on removing the thorn all have soft and elastic flesh and curling knots of hair, and the rocky knoll on which the twins rest recalls the *Spinario's* base. The twins' body shape and posture also signal antiquity and paganism: "the pose of the kneeling child suggests reverence, as before a source of grace, and the way the twins raise both their hands simultaneously implies reception and wonder, as at a miracle" (Wright 354). For a long time, it was commonly believed that the two babies were the very same added to the she-wolf by the Ogulnii brothers in the third century BCE, as Livy recounted in his *History of Rome*. It was

not until a German art historian, Johann Joachim Winckelmann, in the eighteenth century definitively described them as a modern addition that they were accepted as such (Wright 354). Although the name of Antonio del Pollaiuolo is often mentioned as the most likely sculptor of the twins, we still do not know for sure who made the statues of the babies or precisely who commissioned them (Wright 528).

Although the date of the twins' creation is better known than that of their lupine foster mother's, they – like the wolf – have intricate, multiple meanings. Their significance has been puzzling for Renaissance and classical scholars alike. Some say that the twins represent the union within one city of two distinct peoples, the Latins and the Sabines. French historian Jérôme Carcopino made this claim in his 1925 monograph on the *Lupa Capitolina* and pointed out as corroborating evidence the Sabine people's veneration of wolves (66–69). The two distinct ethnic communities became one, so the story goes, when Romulus's men – male outlaws and refugees from all over – unable to convince their neighbors to let them marry their women, attracted the Sabine people to Rome with an invitation to games and spectacles and then abducted their women in the legendary "rape of the Sabine women." Over time, however, with the ruthless expansion of Rome and the incorporation of a large number of ethnic groups within the city's folds, this emblem of Rome as being composed of just two peoples became increasingly inadequate. Other scholars advance a different but analogous hypothesis – namely, that the twins stand for and justify through myth the Roman republican institution of the two consuls, those patrician men who shared political power for a year before serving in the senate. This is the thesis of an influential classical historian, Theodor Mommsen (in Wiseman, *Remus* 106). Still others – led by a woman archaeologist this time, Cécile Dulière – see in the identical twins of Rome's origins the equality of patricians and plebeians and of the aristocracy and the working classes (Dulière 52–53).

In addition to the specific symbolism of the twins represented with the nursing she-wolf, the birth of twins in Roman antiquity caused joy at the fertility they embodied. In a world in which infant mortality was high and more than half of all children died before the age of five, twins doubled the chances that at least one offspring would survive to adulthood. Their birth also caused amazement at the analogies between twin human births and the multiple births characteristic of animals, an analogy particularly relevant in the case of an animal mother suckling human babies

and – through her activity – invoking the ties between men and beasts. Being a twin was a sign of distinction and supernatural predilection. However, emblems of fraternal harmony, like Castor and Pollux, Romulus and Remus were not: Rivalry, not cooperation, was their destiny, until the death of one and the triumph of the other. Knowing what we now know about what happened when the frolicking babies become semidivine and warlike young men, within every instance of the she-wolf with her twins lurks the sinister specter of fratricide. Rome was created out of this fratricide, despite its temporary elision in the image of the nursing she-wolf as symbol of Rome's birth. As political scientists and philosophers such as Hannah Arendt have remarked recalling the story of Romulus and Remus, brotherhood in our society has grown out of fratricide and political organization out of crime (Arendt 20). W. H. Auden stated it more poetically, also with obvious reference to the birth of Rome, when he wrote of the need for a brother's blood for raising a city's walls but also for the birth of "our dear old bag of a democracy": "without the cement of blood (it must be human, it must be innocent), no secular walls will safely stand" (637). As mythological fratricides go, Wiseman notes, Romulus's of Remus was unique: "I know of no twin story anywhere else in mythology where one of the twins is violently removed and the other goes on to a heroic career of his own" (*Remus* 16).

Sibling rivalry, alas, has a long history in Western society, a history that is often glorified in favor of the winning brother. This is not true of Cain and Abel – Abel is killed but remains God's favored one; no one likes Cain – but it is cunning Jacob who becomes God's preferential choice. Like Esau, Remus was born first (although only some legends specify this) and, like him, he is ousted by his younger brother. Second-born like Jacob, Romulus was to be father of the Roman people, like Jacob of the Jews. Sibling rivalry ran in Romulus and Remus's family: Their great-uncle Amulius usurped his own brother Numitor's throne and tried to ensure that no one would avenge him. Amulius was not expecting the intervention of the god Mars (himself the prominent member of a contentious family), and Mars's boys continue the family tradition of fraternal competition: Counting birds and building walls, they end up fighting each other to death. Therefore, what is best remembered of this foundation story and the image that has come to epitomize Rome's birth in the West is not the death of a brother but rather the rescue of twins; not the flight of birds but rather the feeding of a she-wolf; not the building of walls but rather the breaking down of barriers between humans and animals.

RESTORATION AND THE *LUPA'S* AGE

Of her beloved Rome, Irish novelist Elizabeth Bowen said in 1960 that it "holds in its keeping more than one masterpiece of illusion" (182). Like the wolf in sheep's clothing, Rome's borrowed fleece makes the city appear tamer than it is by telling stories that sometimes correspond – but just as often do not – to the narratives found below the surface, beneath the city's feral coat. Looking under a sheep's clothing is usually worth it: Although this city's wolfish pelt, too, is but a surface covering, it is one closer to what Rome is and to what Rome has been. All too often, things in the Roman past have been taken for what they were not: Rome's fleece, for all its imperfections and its trickery, dazzles the observer, who is content with the easiest explanation, the most superficial of stories. At this game of surface deception, the she-wolf is an eminent authority and to catch her at this game has been the work of many a specialist. "Tracing the many phases on which the bronze beast exerted some influence in the course of the centuries," claims art historian Bernard Andreae, "one gains an understanding of Roman history that no literary source, no epigraph, no other art work can open to one more readily and more significantly" (38).

The process of restoration is an example but also a metaphor for understanding the past beyond its illusions, for peeling away time's material and ideological incrustations. The *Capitoline She-Wolf* not so long ago underwent the restorers' cleaning process: The 1997–2000 restoration returned the original sheen to the bronze *Lupa Capitolina*, which had been covered with oils and waxes multiple times in the course of a long history – oils and waxes that were meant to boost the statue's polish but that eventually resulted in an increasingly dull coat. The process turned out to involve significantly more than aesthetic appreciation and historical accuracy; rather, the restoration of artworks has been described as "one of the most interesting cultural issues in which all aesthetic, historical, and cultural concerns are involved" (Saito 143, 146). When the artwork being restored is one that has been famous for centuries, like the *Lupa Capitolina*, attracting the interpretive curiosity of professionals and amateurs alike, the restorer's removal of surface layers becomes a metaphorical act as well as a physical one. Like those who restore an artwork toil to recover its original look, eliminating all that did not belong when the piece was first completed – that is, the sediments of time and human hands – so also scholars who study an old piece often fantasize about getting to the artwork's "original" significance or, more realistically, they

strive to rediscover its changing meanings through the centuries. Critics today often hesitate to grapple with the issue of the "original meaning," viewing the artist's intentions as largely irrecoverable and ultimately irrelevant. In the field of art restoration, there also are those who hold that "the effects of aging in works of art do not always decrease their aesthetic appeal; moreover, they can increase aesthetic value." Therefore, "it is essential that we do *not* remove the effects of aging on art objects" (Saito 150). No one, for example, is about to permanently remove the twins from under the *Lupa Capitolina*, even though they were a spectacular effect of the statue's intrusive Renaissance restoration. "In their deciding what the work of art is to be after restoration," the frolicking twins seem to remind us about restorers, "these people's interpretations are of as fundamental importance to us and to future generations as are the criticisms of art; perhaps more so" (Wilsmore 66).

Restoration and the *She-Wolf* have never had a comfortable relationship. In the late nineteenth century, Wolfgang Helbig attributed the *Lupa Capitolina*'s imperfections to "the maladroit restoration" dating from "these dark ages of art" – the medieval period: "As the sculptors of the time were incapable of producing a statue in any degree satisfactory," the ancient *Lupa* was "discovered, lying ruined and forgotten" and "entrusted to the nearest coppersmith to be patched up for its position in front of the Lateran" (Helbig 461). Helbig confirmed the *Lupa*'s ancient origins even as he attributed its flaws to the Middle Ages. Yet, what if, as restorers have recently implied, faithful to Rome's annoying habit of donning a deceptive skin, the *Capitoline She-Wolf* is even more of a tricky beast: lying about her age, passing herself off not only as generous to human babies – giving them her milk instead of gobbling them both up – but also, in this city that reveres the past (especially its own), masquerading as many centuries older than she really is?

In the controversial opinion of some well-respected scholars, the very techniques used to craft the *Lupa* – and not just the botched work of "a stupid restorer" (Helbig 459) – date the statue to the early Middle Ages, not to Etruscan or even Roman antiquity. Led by Anna Maria Carruba, the archaeologist in charge of the 1997–2000 restoration work of the Capitoline bronze, this is the scholars' most important and most publicized argument: Whereas ancient bronzes were melted in separate pieces and then soldered together, the medieval period perfected a technique that allowed each bronze statue to be fused in one piece. This technique was especially useful with bells because when crafted without soldering points, they have a distinctly clearer sound. The *Lupa*, as we have seen,

was fused in one piece – like medieval bronzes and unlike ancient Etruscan and Roman works. The technique of one single casting of bronze, incidentally, explains the animal's pose: She looks to the side and her head and neck are not stretched toward her teats and her sucklings (i.e., the typical posture in ancient depictions of animal nurses) because the technique did not allow for complicated body shapes, only a simple and essential pose.

Carruba dates the *Lupa* to the early part of the ninth century – of the Common Era, however. Archaeologist Andrea Carandini's response to this theory is characteristically self-assured and dismissive: Carruba's "conclusion is not convincing, because medieval animals look like horrible little monsters with nothing realistic about them" (*Roma* 32). One hundred fifty years before Carruba, in 1854 – the theory of a medieval *Lupa* went through a spurt of popularity in the nineteenth century – Emil Braun, although not ready to discount the *Lupa*'s antiquity, likewise wrote that "If we came upon this bronze in any other place, we should involuntarily be reminded of the works of the earlier middle ages, with which it has many points of resemblance" – after a scathing critique of this "stiff, unpliant, clumsy . . . certainly not lifeless, but thoroughly styleless image," produced by "a mere mechanical bungler" (81–82). Wolfgang Helbig, conversely, in the context of his harsh assessment of all early medieval artistic accomplishments, cannot date the beauty of the *Lupa Capitolina* to the Middle Ages because "it seems impossible to ascribe a work of so much importance to a period of such extreme artistic degradation . . . the sculptors of the time were incapable of producing a statue in any degree satisfactory" (1: 461). In their study of the reception of ancient sculpture, Francis Haskell and Nicholas Penny wrote that "when, in the second half of the nineteenth century, German scholars claimed that the *Wolf* has actually been made in the Middle Ages and, for a time, a cast of it was exhibited in the mediaeval Italian section of the Berlin Museum, there was a storm of protest" (337). An important she-wolf specialist wrote as late as 1934: "I confess that I, too, was long inclined to accept the medieval hypothesis" – as if this opinion were one to be ashamed of and to "confess" (Löwy 96). So strong is the *She-Wolf*'s connection to ancient Rome and so potent her grip on the imagination of her people that her dating back to the time of Rome's infancy was and continues to be all but impossible to give up.

In addition to the *Capitoline She-Wolf*'s posture and method of manufacture, there are other more circumstantial and historically based arguments to Carruba's controversial thesis. The other bronze statues that,

together with the *She-Wolf*, were given as a gift to the city of Rome by Pope Sixtus IV in the fifteenth century all underwent restoration at the time of the pope's donation; the *She-Wolf*, however, did not. This is probably because, Carruba claims, the statue of the *She-Wolf* was newer and thus in better shape than the unquestionably ancient bronzes that accompanied the gift *Lupa*. Furthermore, much of the touchup work on the *She-Wolf*'s surface was done with a file – an instrument almost never used on ancient statues. Romans, like Greeks and Etruscans, preferred cuttlefish bones and pumice stone, materials that left fewer traces than files and resulted in a smoother, shinier surface. Medieval artists, conversely, were fond of files and did not object to the resulting rustic appearance. Additionally, the shape and arrangement of the mane framing the *She-Wolf*'s face and its continuation along the animal's back are also typical of the early medieval period; during the centuries of the early Middle Ages, these ornamental motifs developed into typical elements of Frankish art.

Carruba published her findings in a short book that came out in late 2006, *La lupa capitolina: Un bronzo medievale* (The *Capitoline She-Wolf: A medieval bronze*). The book, more of an illustrated essay, is worth perusing if only for the beautiful photographs of the bronze from a number of perspectives not usually available to museum visitors. Carruba's book inspired the publication, in waves, of numerous newspaper articles popularizing this archaeologist's findings. However, these articles were too controversial, despite their self-assured tone, and perhaps also far too unwelcome; they never quite convinced the Roman public. Every time a wave of these articles comes out, it seems, they are briefly treated as a novelty and then promptly forgotten. "Rome's *She-Wolf* Younger Than Its City" is the title of an online November 2006 article on the beast's medieval origins. Another online article announced in May 2007, "Roman *She-Wolf* Come Down from Pedestal." Print articles are even more reproachful: In August 2007, the daily *La Stampa* declared, "The *Capitoline She-Wolf* unmasked by C14: A medieval work" (Attino). One year earlier, in *Repubblica* of November 2006, the most prestigious among the authors of such short texts – Adriano La Regina, who for years was superintendent of Roman archaeology and remains a staunch supporter of Carruba's thesis – proclaimed in the title of one such newspaper article: "Rome, the *She-Wolf*'s deception, she was born in the Middle Ages" (La Regina).

Italians, especially Romans, become very excited about this kind of cultural news. At a dinner party I attended at a historian's Roman

residence, I spent most of the cocktail hour listening to an elderly archaeologist – an etruscologist, no less – waxing eloquent about the madness of the theory of a medieval *She-Wolf*. After all, the bronze *Lupa* is one of ancient archaeology's most prized possessions in Rome. How could a Roman etruscologist possibly be expected to give her up? Aware of Romans' predictable outrage, at the end of his preface to Carruba's book, La Regina tries to soothe his readers' anxieties concerning the *She-Wolf*'s new dating, stating that "The symbolic values of the Capitoline She-wolf – I need to say this, should unconscious worries provoke some resistance against the new chronological attribution – remain untouched by the progress of knowledge. They live on, and in fact are nourished by, ideals belonging to a metahistorical dimension" (10). The *Lupa Capitolina*, that is, transcends all history: Ultimately, it should not matter to anyone whether the bronze was produced in ancient or medieval times – the *She-Wolf*'s importance is not affected. Yet, surely the very meaning of the *Lupa* will change if her birth is confirmed to date to the Middle Ages and not early antiquity. Can anyone claim that art has nothing to do with the cultural terrain out of which it came to be, that historical origin is meaningless?

Yet, even now that many suspect (not without good reasons) the *Lupa*'s medieval origins, Romans continue to think of the *She-Wolf* as ancient, as a beastly and maternal incarnation – *mater Romanorum* – of their earliest past. "In the traits of the she-wolf, the Romans sought to say something about themselves" (Andreae 38). Unyieldingly, the *Lupa* holds on to the Romans' perception of their own history: The symbolic she-wolf is tenacious, she likes wearing a coat that may be borrowed – a coat that might make her look more ancient than she is – and she has no intention of letting go of it. The grip of her myth is no looser than that of her jaws. As Carcopino stated in his 1925 monograph: "The ferocious grandeur breathed by this rough and intense bronze fascinates us far less, perhaps, than the illustriousness of its provenance and the distance of its past attract us" (3). If this historian is right and the grand appearance of the *She-Wolf* is far less important than her history, we must wonder how long the fascination and attraction exerted by the bronze can endure if these recent changes in her provenance and distance are finally and definitely confirmed.

CHAPTER 2

MIDDLE AGES AND RENAISSANCE

THE *LUPA* AS SYMBOL OF POWER AT THE LATERAN

> From the top of her column hard by the Lateran, the She-Wolf looked forth. The bronze figure still stood erect, just as it had been cast by the Etruscan founder in the first days of Rome. Ever since it had been removed from the Capitol where it used to stand – this wild soul of the city – the bronze beast had kept sentinel in this square, and guarded the ruins of Rome's greatness. One by one the centuries had crumbled away, but firm upon her pedestal the She-Wolf kept her place. With wide open eyes that embraced the horizon, and sharp ears cocked to catch the floating rumors, she ground her teeth fiercely. Two thousand years had not lulled her vigilance, and the jaws that seemed to be growling had not been shut. (Formont 11)

Maxime Formont's 1912 historical novel, *The She-Wolf: A Romance of the Borgias*, provides imaginative insight to the impression that the bronze beast must have made during her Lateran residence – the sense of her might heightened by physical and historical distance (she was positioned atop the column and reminiscent of an ancient founder), as well as by the belief in the *Lupa*'s origin on the Capitoline Hill, her endurance across the ages, and the sharp fierceness of her eyes, ears, teeth, and jaws. Although Formont's novel is set during the high Renaissance, the *Lupa* stayed before the Lateran Palace only until 1471. In this quarter on the Caelian Hill, southeast of the Capitoline Hill, the statue of the beast alone, without the twins, was for some time visible atop a column. Then the *Lupa* was moved to a stone shelf attached to a tower erected by the influential Annibaldi family, near the Basilica of Saint John the Lateran – the Cathedral of Rome and official see of its bishop, the pope. As *Lupa Laterana*, the bronze belonged to the pope, not

40

the city. It is strange that this earlier location and the she-wolf's affiliation with religious rather than civic power remain largely unknown to most Romans today; instead, the *Lupa* is readily identified with the municipal authority of a free and strictly secular city.

In his *Chronicon*, a historical account written circa 995 that describes events dating from the time of Charlemagne – specifically, the section about the *She-Wolf* refers to the years 827–829 – Benedictine monk Benedict of Soratte wrote that near the Lateran there was a place dedicated to the administration of justice, a courthouse of sorts, "named after the she-wolf who is called the mother of the Romans" (*mater Romanorum*). The same author wrote another text with a long title abbreviated to the single word "little book" (*Libellus*). In this little book, Benedict also described a Lateran courthouse known by the name of the statue next to which it was sited: *ad lupam* or "near the she-wolf" (Lanciani 285–286). Benedict insisted then on the courthouse being identified by its location – namely, its proximity to a bronze statue. This *Lupa* was memorable because she was precious and rare, considering that most pagan bronzes had been fused and their metal recycled; the statue perhaps was memorable also because the beast's apparent ferocity so visibly matched the brutality of the papal court held at her side.

The Lateran estate, where the she-wolf was located for centuries, had been a gift to Pope Sylvester from the Emperor Constantine who – having used it for his Church Council in 313 – had turned it into an important center of Christianity. Subsequent to Constantine's donation, the Lateran estate became the first papal residence and the location of several more Christian councils. Many treasures of the Christian tradition were brought to the Lateran during the early Middle Ages: the Ark of the Covenant, with Moses' tables of the Ten Commandments; the seven-branched golden candlestick of the Tabernacle; Saint John the Baptist's reed and tunic; and numerous other relics, so precious as to need protection in a private chapel inside the Lateran Palace – aptly named the "the Holy of Holies" (*Sancta Sanctorum*). As the Lateran compound was replete with sacred Christian objects within its interior, so also the piazza in front of the basilica's main entrance – in a mirror image of sorts – was rich with relics of the past. They were artifacts that stood for Rome's pagan past, unconsecrated and therefore unfit to enter the church building. Among these heathen relics were several bronzes that can be viewed today on the Capitoline Hill, protected inside the walls of the Capitoline Museum. They include the likeness of a boy pulling a thorn from his foot, the *Spinario* (or "Thorn-drawer"; see Chapter 1), much

admired and imitated throughout the Renaissance; a young man assisting at a sacrifice, the *Camillus*, of such ephebic beauty that many thought the statue portrayed a gypsy woman – it is still often described in guidebooks as "the Gypsy Woman" (*la zingara*) also because of the right arm extended as if to read someone's fortune; the head and the hand that was holding a globe that were once part of a colossal statue of Constantine; the equestrian statue of Marcus Aurelius; and, of course, the *Lupa*.

Not an art collection in the modern sense because the intention of their presentation at the Lateran was moralizing and didactic rather than aesthetic and historical, these bronzes were icons of a pre-Christian world and likely to rouse suspicion at a time when fear of pagan images was not uncommon. Therefore, while they were the property of the papacy, the Lateran bronzes were made physically inaccessible to most viewers and difficult to see. They were installed on high marble columns or, in the case of the *She-Wolf* for a time, on the side of tall towers: Passersby might not immediately understand the allegorically Christian significance of these pagan pieces and needed to be psychologically separated from their potential, insidious dangers. Conversely, the broken nature of the hand, head, and sphere – fragments, it was believed, of a fallen Roman idol – testified to Christianity's victory over pagan grandeur, and the pieces for a long time were regarded as trophies of Christian Rome over its pagan predecessor (Presicce, "I grandi bronzi" 194).

In its expedient employment as icon of papal justice, the Roman *She-Wolf* exemplified a common medieval use of ancient things and the Christian recycling of pagan symbols. Objects such as the *She-Wolf*, as medievalist Jennifer Summit explains, "represent historical change as a form of conversion that did not so much destroy or supplant the past as conserve its outward forms while assigning them new meaning." The material forms of the past were recuperated "in ways that made them significant to the present, thus turning the visible signs of pagan Rome into vital evidence for a material history of Christianity" (214). The ninth- or tenth-century diptych of Rambona, which depicts on ivory the nursing she-wolf carrying the crucified Christ on her back (see Chapter 8), was produced by Christians as a Christian object that employed and assigned a new meaning to a pagan symbol. The bronze *Lupa*, though, was already there, the product of a pagan age available for recycling through more subtle means. Her correct interpretation, in the absence of a crucified Jesus on top of her, relied on her geographical placement and the politico-religious uses to which she was put.

Indeed, the she-wolf has been put to many uses. When he built his imperial palace at Aachen, Germany, during the late eighth and early ninth centuries, Charlemagne modeled it on the Lateran Palace in Rome. According to tradition, the Lateran Palace had been Emperor Constantine's own residence before becoming the pope's. Although from a strictly architectural perspective, the two structures – in Aachen and at the Lateran – may have been quite different from one another, a few outstanding common features sufficed for medieval writers to make Charlemagne's palace a recognizable copy of what had been Constantine's Lateran Palace and was now the pope's. First, Charlemagne himself called his Aachen palace "Lateran," as a number of documents still attest. Second and most important, given our interest in the she-wolf, Charlemagne assembled in his palace a collection of treasures that he had acquired over time. These assorted objects have in common that they represent analogous treasures kept in the Lateran. Among them was a bronze "she-wolf" (more likely a female bear but understood at the time to be a wolf), probably brought to Aachen from southern Gaul. The bronze beast stood in the vestibule to the palace chapel in Aachen for the remainder of the medieval period. She represented, of course, the *Capitoline She-Wolf*, the Mother of the Romans – the original of which was standing before Rome's Lateran Palace (Boholm 260–264; Krautheimer 35). By establishing a symbolic connection between Aachen and Rome, the presence of the Roman she-wolf in the German city of Aachen conferred on the emperor some of the glory of his ancient predecessors – particularly Constantine, the quintessential Roman emperor and Charlemagne's regular point of reference. Through the physical presence of a bronze she-wolf, among other things, Charlemagne's new seat of imperial power in the northern city of Aachen became identified with the traditional location of the world emperor: Rome and, within Rome, the Lateran.

MASTER GREGORY AND OTHER MEDIEVAL ENCOUNTERS WITH THE PAGAN *LUPA*

The *Capitoline She-Wolf* is believed to have remained at the Lateran Palace throughout the medieval period and well into the beginning of the Renaissance, as attested to by documents from later centuries. More extensive and involved than brief references of Benedict of Soratte to the bronze she-wolf is another description of this Roman beast from the time of her Lateran residence. In the late twelfth or early thirteenth century, the learned Englishman called Magister Gregorius, or Master

Gregory (we know little else about him), wrote *De Mirabilibus Urbis Romae* (The marvels of the city of Rome). In this short book, of which a single manuscript is still in existence, the author recounts his travel experiences through Rome in terms that are predominantly secular and antiquarian. Unlike many who traveled to Rome at that time, Master Gregory was not a religious pilgrim; some scholars speculate that he may have been a canonist who came to Rome on legal business. As the final among Rome's marvels (because the thirty-second and thirty-third paragraphs about the *Lupa* are the last in Master Gregory's book), this traveler describes the *She-Wolf* residing near the Lateran Palace – specifically, within the basilica's portico (the statue must have been moved since the time of Benedict of Soratte). The bronze sculpture he sees is of a lone beast, without babies. It is not surprising, then, that Master Gregory regarded as a fable the she-wolf's connection with a set of twins. In Master Gregory's time, accompanying the *She-Wolf* instead of two babies was a bronze tablet that specified the animal's function: to prohibit sin from being uttered. That is, the *She-Wolf*, located near a courthouse and, indeed, identifying it as a place of judgment, symbolized the pope's jurisdiction and sovereignty over the city of Rome and the inability of sinners and criminals to keep their secrets from him. Before the *She-Wolf*, as before the pope, everyone must submit:

> In the portico in front of the Lord Pope's winter palace is the bronze image of that she-wolf, which is said to have suckled Remus and Romulus; this indeed is a fable. In fact, the She-Wolf was a certain Roman woman of great beauty from antiquity. She found Remus and Romulus abandoned in the river and raised them as her own. The reason she is called She-Wolf is because through her beauty and her enticements, she seized men with her love. This bronze she-wolf is stalking a bronze ram in front of the palace that spews water out of its mouth, which is then used for handwashing. Formerly, the wolf used to spew water out of each teat; however, she was removed from her place by breaking off the feet.
>
> In front of this is a bronze tablet, where the most important commandments of the law are inscribed. This tablet "prohibits sin" from being uttered. In this tablet, I read much but understood little; in fact, there are aphorisms where almost all the words must be supplied by the reader. (Magister Gregorius 58)

Master Gregory clearly is aware of both the literal reading about the animal rescue of the twins, Romulus and Remus, and of the ancient metaphorical interpretation of the she-wolf as a sexually promiscuous

woman. This author, however, twice emphasizes this animal woman's beauty and disregards the monetary side of her offers of love. She seems to be an amateur sex worker, in Master Gregory's view, in the business for the fun of it and because she happens to be attractive rather than for financial gain. Master Gregory situates the bronze *Lupa* in the portico of the Lateran Palace rather than on a column or on the shelf of the Annibaldi tower, where we see the statue in other accounts (the portico was on the northern side of the palace, where its main entrance had been located). The *She-Wolf* may have been brought inside the portico for safekeeping, as some scholars have advanced, using the imperfections clearly visible on the legs of the bronze as evidence of the statue's deterioration. (As we have seen, however, the imperfections were due to a defective pouring and hardening of the molten bronze, not the ravages of time or weather.)

The mysterious tablet on which Master Gregory "read much but understood little" is likely the *lex de imperio Vespasiani*, which listed the rights and powers that the people of Rome and the senate transferred to Emperor Vespasian. The tablet remained by the Lateran Palace until 1576, at which time it too was moved to the Capitoline Hill. The fact that much of this inscription is undecipherable tells of the loss of familiarity with the complexities of the Latin language in the century when Master Gregory lived. Nevertheless, the author does understand the tablet's primary purpose and the *She-Wolf*'s role during the trials in which the bronze was involved: to prevent sin from being uttered. The *She-Wolf*'s fearsome appearance, the threat she embodies, probably led to entrusting this beast with the task of ensuring that truth be told. (It is ironic, of course, that she should preclude false speech, given how many contradictory stories the beast herself has told throughout the centuries.) As one historian said about the tablet, "The text was a perfect match for the pope's two other political symbols: for here he possessed the bronze she-wolf who gave birth to Rome and the bronze tablet granting power and authority from the Senate and People to the emperor, and then the bronze statue believed to be the very emperor who had donated this power and authority to the pope himself" – that is, the Marcus Aurelius that was understood to be the effigy of Constantine. The presence of these items at the Lateran estate made of this place "a political powerhouse: a showcase of the secular power granted the popes and confirmed . . . by the most precious treasures of the Roman Empire" (Musto 52).

Both the tablet and the bronze *She-Wolf*, as described by Master Gregory, illustrate how in the medieval period (when this traveler wrote

his account) ancient artworks and monuments were regarded as at once impenetrable and yet near at hand. Rome, a city where the ancient, pagan vision of the world was no longer prevalent, effective, or even conceivable, had become Christian by the time of Master Gregory's visit. Ancient objects were experienced by those who lived among them as empty forms – as the shells of a distant past – because their referent was no longer decipherable. Yet, these same objects were perceived as "*near*, because these empty forms, which can be seen and touched, are immediately transposable, and are transposed, into the Christian framework where they are reinterpreted according to familiar codes." In fact, we can say about the bronze *She-Wolf* what has been said more generally about ancient objects during the Middle Ages: She was "directly assimilated and introduced into the circuit of Christian practices" (Choay 23–24). Just as the she-wolf on the diptych of Rambona was a pagan symbol recycled into an effective support for the Christian faith, so also the bronze *She-Wolf* was preserved through the medieval centuries not as historical marker of a different culture, evidence of the artistic glories of ages past – as she was after her move to the Capitoline – but rather because she could be reused at the papal court as an incitement to truth-telling and a fearsome sign of the pope's supremacy.

THE *SHE-WOLF* AND THE SEVERED HANDS

Roma ladrona ("Rome is a thief") – and a big thief, as the suffix *ona* reveals: This is a well-known phrase in Italy, where there is a long-standing association in people's minds between Rome and thievery, dishonesty, and corruption (the Northern separatist party, the *Lega Nord*, has popularized this phrase in recent decades). In a polemical song from 1979, titled "A voi romani" (To you Romans), Northern Italian singer-songwriter Alberto Fortis attacked the citizens of the Eternal City as a band of lazy, thieving, decadent, traitorous ruffians, culminating with the bloody invocation of their Roman animal mother: "*Mamma* she-wolf, poor thing, has cut off her own veins with her teeth, the newspaper reported in shock: She could not stand the fact that her own people had turned from great invaders into common busybodies." In the notes to a later album, Fortis explained to his fans (the few from Rome, as may be imagined, were not very happy) that his critique was aimed at Roman bureaucrats, not Roman residents in general. Whether or not Romans are more fraudulent than other Italians, the city is portrayed as a thief because a corrupt central government is there, perceived to "wolf down" taxes

with a greed that never abates. Beyond the reach of rational explanations, Romans' notorious dishonesty – or what many visitors and some imperfectly assimilated residents perceive as their essential corruption – is almost as legendary as the seven hills. The seat of a government many Italians regard as corrupt, Rome is the capital of Italian fraudulence: *Roma ladrona* – Rome, the big thief.

Thieving and illegal scheming have a long and startlingly distinguished past in Roman history and mythology; after all, everything in this city has ancient roots. So Ovid, in the *Fasti*, describes Mars's rape of Rhea Silvia that resulted in the conception of Romulus and Remus as a theft: "Mars sees her, desires what he sees, takes what he desires / divine power made his rape unfelt" (54). This is a theft to be admired, in a sense, for without it Rome would not have been founded. Like father, like son: Romulus and Remus imitated their divine parent when they stole the she-wolf's milk ("milk unmeant for them," says Ovid); some sources portray Romulus as a cattle thief; and Rome, initially populated by robbers and vagabonds, obtained its first generation of women by stealing them from the Sabine people.

The unfair distribution of the city's resources, accepted by many residents as an inevitable fact of life, has scandalized travelers to Rome for centuries; and, in a city governed by the popes until 1870, criticism of Roman economics was bound up with criticism of the Roman Catholic Church. In his 1869 satiric travelogue, *The Innocents Abroad*, Mark Twain encouraged Italy's lazy beggars to embrace the American virtues of enterprise and self-reliance – by robbing those churches the building of which, in his opinion, had led to the beggars' impoverished state. When the beggars that resulted from the construction of these churches swarmed around him, he told them: "O, sons of classic Italy, is the spirit of enterprise, of self-reliance, of noble endeavor, utterly dead within ye? Curse your indolent worthlessness, why don't you rob your church?" (258–259). Mark Twain makes no secret of his anti-Catholic position, but his scorn for churches and derision of priests led him to give the poor beggars bad advice, indeed. Perhaps more than any foreign traveler, beggars should recall stories of sacrilegious thieves and the swift movements of ecclesiastical justice. The *Lupa* is there to remind them.

For centuries, the bronze *She-Wolf* protected the pope's judicial system near the Lateran Palace and accompanied the trial and execution of its victims. Numerous judgments, along with the ruthless implementation of their verdicts, must have taken place before the bronze beast. One story of trial and execution is memorable for its dramatic narrative qualities.

In his *Diarium Urbis Romae* (Diary of the city of Rome), humanist historian and lawyer, Stefano Infessura (1435–1500), told the story – presided over by the *Lupa* at the Lateran – of what might happen to those foolish enough to rob a church:

> On April 12, 1438, Capocciola and Garofalo, two employees of Saint John the Lateran, stole many precious stones – sapphires, balases, diamonds, amethysts, and pearls – off the heads of Saint Peter and Saint Paul, which are found on the tabernacle of Saint John's. . . . And then these evildoers – that is, the canon Master Nicola of Valmontone and the employees Capocciola and Garofalo – were degraded in that same year, on the fourth day of September, on the major altar of the Ara Coeli. And then they were incarcerated up high in the square of the Campo de' Fiori, and they remained there for four days, and in that same month they were executed as follows. Capocciola and Garofalo were dragged to the square of Saint John's and Master Nicola was brought there on a donkey; all three were wearing miters. Master Nicola was hung on the elm tree of Saint John's Square. Capocciola and Garofalo had their hands chopped off, and then they were burned on that same square. Their hands were nailed next to the metal she-wolf, on that wall. And of these things I described, you can see the painted memory just as you enter the church of Saint John, on the upper right hand side. (36–38)

The Lateran *Lupa*, her role as "Mother of the Romans" notwithstanding, did nothing to protect her charges from the ruthless application of the pope's laws: She acted in defense of the pope's greed, not the greed of her children. Before the *Lupa*, justice was carried out that appears to us today as savage as the beast herself – more savage, in fact, because it was performed in cold blood and not impelled by a carnivore's compelling hunger.

The story of crime and punishment illustrated in the still extant drawing of three men's execution is reported in at least three important documents from fifteenth-century Rome: Stefano Infessura's notoriously anticlerical diary, completed around 1494 (cited previously); Paolo di Lello Petrone's pro-papal *Mesticanza* (Miscellanea), dating from the 1430s–1440s; and Paolo di Benedetto di Cola dello Mastro's more impartial *Memorial*, from the late 1430s. The latter document also describes how "the thieves' right hands were cut and nailed on that wall in the middle of which is the she-wolf" (86). Hands wither in putrefaction and quickly become unrecognizable – particularly in Rome's mild climate, especially in the summer: It was September when those hands came off. So, the

story of the unfortunate Capocciola, Garofalo, and Nicola was painted near the entrance to the basilica, on the right transept and not far from the bronze *Lupa*, in a series of cautionary frescoes. "Of these things I described," Infessura wrote, "you can see the painted memory just as you enter the church of Saint John, on the upper right hand side." On the right-hand side of the church, that is, one could see the severed and nailed right hands of the thieves. Today, alas, only a few drawings of this painted memory remain, preserved in the Lateran Archives; the frescoes were destroyed during a 1592 remodeling. Precious documents of both historical events and Lateran topography, the remaining drawings are glued together in a roll and date back to the sixteenth century. Although these drawings are not visible to the general public, printed reproductions are available even online. Those willing to make the effort may recognize the bronze *Lupa* standing on a tower shelf and looking at her viewers, with two oversized, severed right hands nailed and hanging on the tower by her side, next to her tail.

THE *LUPA*'S MOVE FROM THE LATERAN TO THE CAPITOLINE

Today, everyone thinks of the she-wolf as the beast of Rome – an animal without notable competitors in the symbolic zoo of the Eternal City. Until the early Renaissance, it was not so: The lion was the city's undisputed tutelary animal, the embodiment of Rome's secular government; the papal she-wolf was his emblematic rival. During medieval times, the marble lion on the Capitoline Hill – an ancient Roman statue of the wild animal sinking his considerable teeth into the back of a doomed horse – was the equivalent of the bronze *Lupa* at the Lateran estate and the symbol of municipal rather than papal justice: The aggressive feline presided over the administration of justice in the Senatorial Palace. Located on a terrace at the end of the grand stairway leading to the first floor, it was in front of this lion that capital punishments – determined by the municipal powers of Rome – were announced and occasionally carried out (Miglio 178). The restored marble lion biting a horse's back currently adorns the fountain at the center of the garden of Palazzo Caffarelli at the Capitoline Museum, next to the Palazzo dei Conservatori, the *Lupa*'s stately home. Although the garden has not been open to visitors in several years, the marble lion can be seen from the windows of one of the impressive new halls in the museum dedicated to the remains of the temple of Jupiter. Rome obviously reveres its classical antiquity far more than it appreciates

its medieval past. This beautiful and ancient symbolic lion, critical to understanding the history of late medieval Rome, has been demoted to an aesthetic and no longer political garden setting. His effigy is kept outdoors and exposed to the elements; ironically, the lion's exterior location in an enclosed garden makes him as visible as he is inaccessible to visitors.

So entrenched was the association of Rome with its emblematic lion that in medieval times, the city was believed to be laid out in the shape of this beast: "Rome has the shape of a lion, who dominates all other beasts"; Cola di Rienzo, fourteenth-century Roman politician and popular leader, wrote that "the very walls of the City have been built in the shape of a lion" (Miglio 178). Medieval maps and chronicles insisted on the close resemblance between the lion – king of all the animals and image of sovereignty and justice – and Rome, the Eternal One among this earth's cities, known through the centuries as *caput mundi* (head of the world). As the emblem of municipal Rome, the lion represented that shrinking segment of the city's political independence that stubbornly remained beyond the reaches of the pope's control. Robert of Anjou, king of Naples in the first part of the fourteenth century, gave a live lion as a gift to the city of Rome. Apparently pleased with the wild animal's presence among them, the city's magistrates in the latter part of that century requested live lions from the Medici family in Florence. (To this day, the lion known as Marzocco remains that city's symbol.) Kept in cages on the Capitoline Hill – whence they occasionally fled, much to the populace's terror – the lions embodied the living image of the city's political authority until the fifteenth century, when the pope's she-wolf took over the lion's territory.

After serving as first a pagan and then a Christian sacred symbol – an expedient reminder of the bond between this world and the next – the *She-Wolf* was not to remain a religious icon forever, much less stay in the pope's physical and symbolic possession. A few decades after the execution of the sacrilegious thieves of the Lateran's precious stones, Francesco della Rovere (1414–1484), remembered as Pope Sixtus IV, donated to the city of Rome on December 15, 1471, the bronze *She-Wolf* and several other bronzes that were preserved with the wolf at the Lateran. Sixtus's own thoughts on the significance of his gift are recorded in the first of numerous epigraphs produced during his pontificate. Preserved in the vestibule of the Palazzo dei Conservatori, this epigraph describes the new pope's act as a kind of restitution rather than a simple donation. The Lateran bronzes, after all, had little to do with Christianity and everything to do with Rome's pagan past. Like Sixtus's many other

epigraphs, this one is a self-celebration on the reigning pontiff's part, an exaltation of his will and creativity in the process of restoring Rome to its ancient architectural greatness: "Out of his great benevolence, Sixtus IV, Supreme Pontiff, has decided to return as a gift, to the place whence they came, the eminent bronze statues that are a reminder to the Roman people of ancient excellence and virtue" (Guerrini 456). That is, since antiquity, the Roman people were regarded as the rightful owners of all of Rome's riches; in turn, Sixtus saw himself as the restorer of this great wealth and possession. The Lateran bronzes belong to the residents of the city and the unique, ambiguous language of the inscription points both to the fact that they had never belonged to the pope and, nevertheless, to the latter's generosity in returning them.

From the seat of the pope's episcopal rule – the Lateran Palace and Basilica – the *She-Wolf* was relocated to the civic center of Rome, the Capitoline Hill. Approximately 50 meters in height, it is the smallest of Rome's original seven hills but the hub of secular politics and pagan religious practices. Currently the location of Rome's city hall, in ancient times the Capitoline Hill housed the city fortress and a massive temple to Jupiter Optimus Maximus – patron deity of Rome – dating back to the age of the kings. Also on the Capitoline Hill were located the city archives – repositories of Rome's distinguished past – and the Sibylline Books that told of the city's future and were consulted for official advice at critical times in Rome's history. The Capitoline Hill signaled the invincibility of the city because it was the only part of Rome believed never to have been occupied by enemies. From its name and function, English words such as *capitol* (i.e., the building in which the legislative body meets) and *capital* (i.e., the city that serves as the seat of government) are derived; in the United States, the seat of federal political power is located on "Capitol Hill."

According to many scholars, Rome's Capitoline Hill is also where the bronze *She-Wolf* originated, the place for which the statue had long ago been made before it was moved to the Lateran. When the *She-Wolf* was returned to the Capitoline Hill in the late fifteenth century as a gift from church to state, the bronze beast was not discreetly hidden in an inner room, as she is today. Rather, the statue was placed on the façade of the Palazzo dei Conservatori, just above the portico. (The name of this building derives from the elected city magistrates, or conservators, who administered the city along with the senators.) In this central, visible position, the she-wolf could not possibly be missed: "Could one devise a stronger symbolic expression of identity between ancient and modern

Rome?" Egmont Lee wrote about the *She-Wolf*'s physical location. For this historian, Sixtus's "concern was with the connotations of world government conveyed by these works of art, not with their aesthetic or historical value," which identifies Sixtus's donation "as part of his conscious and persistent attempt to fashion Rome into the capital of Christendom" (150). In fact, in mid-November 1471, one month before the actual donation–restitution, Sixtus IV gave the conservators a hundred gold florins to be used specifically "for the location where the bronze she-wolf, which was previously near Saint John the Lateran, is to be placed" (Presicce, "I grandi bronzi" 190). A 1533–1536 drawing by Dutch artist Maerten van Heemskerck shows the *Lupa* on a platform jutting like a balcony from the façade of the Palazzo dei Conservatori. Around 1538–1544 or perhaps as late as 1586 – in any case, after Michelangelo redesigned the piazza – the bronze *She-Wolf* was brought inside the palace and placed on a pedestal situated within the portico of a loggia. In the course of the following century, that loggia was enclosed with walls and became the room in the Palazzo dei Conservatori known as the Hall of the *She-Wolf*. Over time, the bronze wolf was occasionally moved around the museum but, today, the *Lupa Capitolina* may once again be found at the center of the room named for her.

The bronze *Lupa*'s celebrated return to the Capitoline Hill has been related to the rebirth of ancient tradition during the early Renaissance, when Rome's mythical origins and the legend of Romulus were once again valued and remembered. In this process, appreciation for ancient statuary was reborn as well: No longer the appendage of papal justice or a talisman with which to instill fear in the accused – much less the guardian of truth against sin or, worse yet, idol of a distant pagan past – the statue of the nurse of Rome began a new life as an artistic object of intrinsic aesthetic and historical value. With his gift of the bronzes, the pontiff renounced his own authority over the remains of pagan antiquity, handing them over to their rightful owners: the city of Rome and the Roman people. The gift was part of a larger intention of the pope's to restore Rome's past greatness – itself a spectacular construction – through a renewed appreciation of its public statuary. Sixtus IV, often described as the first of the great popes of the Renaissance, contributed to the cultural renewals of the Renaissance from his passion for all things ancient and his training as a humanist and a philosopher. Acts of urban renewal were also Pope Sixtus's favorite means of increasing his power over the city; his considered use of the visual arts included the commission of new works (e.g., the Sistine Chapel), the restoration of old ones (e.g., Ponte Sisto was

built on the ruins of an ancient Roman bridge), and relocating within the city other artworks by means of gifts and exchanges. The city was transformed through this man's careful appropriation of territorial and political authority, inextricably joined together. Skilled in both giving and receiving precious objects, Sixtus IV did not take gifts, much less art, lightly; to echo the proverbial, forbidden look into a gift-horse's mouth, we can be certain that he did gaze at length into every body part of the bronze *She-Wolf* before giving her away.

Made within months of his ascent to Peter's chair, the pope's gift of the Roman bronzes to the city of Rome was no casual donation; the gifts of powerful figures rarely are. There were political implications to this move, to be sure, and most of them less flattering to the pope than his self-proclaimed position as enlightened giver (Blondin 5–7). Givers and recipients are forever bound to one another through the gift in an economy that is ultimately impossible because it is self-annihilating. As philosopher Jacques Derrida stated: "For there to be a gift, it is necessary that the donee not give back." When this happens, the gift is no longer a gift but rather a means of asking for something: self-satisfaction, certainly, but also reciprocation, more practically. The recipient must not recognize the gift as such because "The simple recognition of the gift seems to destroy it." If I receive something as a gift, I am obligated to reciprocate; this puts me in the position of giver and not recipient, of donee and not donor. We give gifts and feel like generous givers; we receive gifts, and feel an obligation to reciprocate. Gifts and debts go together, engaging in the process of their exchange the very honor of both giver and recipient. "As soon as the other accepts, as soon as he or she takes, there is no more gift" (13–14). For there to be a gift, neither party should recognize the gift as such and both should forget it immediately afterwards. Neither ignorance nor oblivion, however, may be associated with the she-wolf of Rome. In harking back to a time preceding Rome's birth, the *Lupa* embodies memory itself. However ambiguous her identity and however generous her gift of milk to the abandoned twins, the she-wolf cannot alter the fundamental economy of gift-giving. When the *Lupa* becomes a gift – as the statue spectacularly did in the late fifteenth century and again through replicas in the first half of the twentieth century – the possibility of generous selflessness is repeatedly negated.

From this perspective, Pope Sixtus IV's gift of the bronze *Lupa* self-destroys: It self-destroys *qua* gift and it self-destroys *qua* icon of Lateran-based papal power. In transferring the statue from the Lateran Square to the Capitoline Hill, the pope's donation radically changed the *Lupa's*

meaning and, with it, the meaning of the Capitoline Hill where the bronze was placed. By the time the *Lupa* came to the Capitoline from the Lateran, the civic government of Rome – represented by the lion – had been losing its political independence and the resulting vacuum was increasingly occupied by pontifical rule. At the same time that the female wolf replaced the male lion as the city's animal symbol, the pope's authority also supplanted that of the old communal magistracies, and Rome effectively came under the pontiff's political control. When the bronze *She-Wolf* took over its space, the Capitoline Hill – the traditional geography of Rome's free civic politics – was being transformed. Political control over the city was transferred to the Lateran Palace, seat of the pope's domination, and the Capitoline Hill progressively became a cultural rather than political center. The *Lupa*, as the centuries-old sign of Rome's history and politics, embodied the most obvious illustration of this pervasive and enduring shift of power. The Capitoline Hill lost political clout and acquired cultural supremacy; it gave up its hold on the present to become the hallowed representative of a glorious but, in political terms, presently ineffectual past. The cultural program associated with the gift *Lupa* eliminated from the Capitoline Hill all traces of Rome's secular independence and placed the city firmly under the political jurisdiction of the pope.

With the physical transfer from the Lateran estate to the Capitoline Hill, the pope's *She-Wolf* was given a chance to fight and to conquer the city's lion, beloved emblem of the secular, independent city and embodiment of the municipal liberties of the Roman citizens. That is why, as a result of the pope's monetary gift and at his specific instructions, the *Lupa* was placed up high, at the center of the façade of the Palazzo dei Conservatori: The beast could dominate from there and win. Not coincidentally, in 1477, a few years after Sixtus's donation of the Roman bronzes, the bustling, open-air market that animated Piazza del Campidoglio – still a place actively used by citizens of all social backgrounds – was relocated to Piazza Navona. (The market later was moved to its present-day location in Campo de' Fiori in 1867.) An increasingly ceremonial place, the Capitoline Hill – geographical reminder of Rome's glory – had ceased to be an appropriate venue for the quotidian bustle of selling and buying and had acquired prestigious cultural value (Stinger 139–142). Therefore, when the ancient preserved body of a Roman girl named Aurelia was discovered in 1485, it was on the Capitoline Hill that it was displayed for all to see. In 1486, the recently unearthed head and limbs of a colossal marble statue of the Emperor Constantine in the Roman Forum were

also exhibited on the Capitoline Hill. In 1513, when Roman citizenship was conferred on the newly elected Pope Leo X's brother and nephew, Giuliano and Lorenzo de' Medici, a lavish party was thrown in their honor on the Capitoline Hill. A grand wooden theater was built for the occasion and on its attic storey, the city twinning of Rome and Florence was indicated through the painted and carved representations of their symbolic animals: the lion for Florence with the Arno River, and the she-wolf for Rome, with a personification of the Tiber River. Representations of both animals also were present on the stage – and, in case the audience missed the she-wolf's importance, the bronze *Lupa Capitolina* herself was placed on a column by the entrance to the theater. (To ensure that the symbolism was properly digested, among the food served at the ensuing banquet was a molded, French-style dish in the shape of the *Capitoline She-Wolf*; Miglio 185–186.)

In 1514, a year after the citizenship ceremony for his brother and nephew, Leo X instituted a Roman history course in the Palazzo dei Conservatori. Ten years later, in the same location, Pope Clement VII planned a library. Not much later, in 1538, the equestrian statue of Marcus Aurelius was finally moved from the Lateran Square to the Capitoline hill at the request of Pope Paul III; Sixtus IV must not have been ready to part with the largest and most spectacular of all the Lateran bronzes. The Marcus Aurelius was to become the physical and symbolic center of Michelangelo's redesigned piazza. By this time, the transformation of the Capitoline Hill was completed. As the Hill that once stood for the city's independence – embodied in the proud and royal lion – slowly came to signify instead erudition and knowledge of the past, Rome's municipal identity was eroded. With the Capitoline Hill eventually housing a museum – widely regarded as the first modern museum, the Capitoline Museum was founded here in 1734 – political control over the city had been transferred to the pope's court, where it was to remain until 1870.

Symbols are capsules of culture, they are distillations of meaning. The *Lupa Capitolina*'s arrival and installation on the Capitoline Hill carefully and effectively manipulated the symbolic capital that the bronze embodied: the political reputation and historical prestige and, less directly, the economic capital to which the ancient bronze shape referred. An analogous claim may be made of the Roman lion. This beast was also a concentrate of cultural meaning. With the *She-Wolf*'s transfer to the Capitoline, the lion was left a loser: Other than historians, no one remembers him as the symbol of Rome anymore. The conflict over important symbols and the struggle to manipulate them are characteristic of and generally

accompany economic, political, or cultural competition. The case of the lion and the she-wolf – the power of the Roman municipality and the pope's – is an articulate example of what social anthropologist Simon Harrison called "expansionary contest" over symbols: "In this, a group tries to displace a competitor's symbols of identity with its own symbols" (255; e.g., the lion with the she-wolf). Expansionary contests take place when two or more identities compete for survival; an important result of such contests is the disappearance of the identity symbols of the defeated side.

The struggle described herein occurred between the Lateran and the Capitoline – two geographic and political metonymies of pontifical and municipal power over Rome. The municipal side was defeated and its symbol – the lion – effectively displaced from its position of power. Yet, the municipal side was not simply left without a symbol; rather, the aim of any expansionary contest, "of suppressing the symbols of some rival group's identity, is never, of course, to leave the group in some sense devoid of an identity. The aim is to integrate or absorb the group by supplanting its symbols of identity with one's own" (Simon Harrison 265). This is what happened at the top of the Capitoline Hill in the decades closing the fifteenth century and opening the sixteenth. As a consequence, at the inception and then at the height of the Renaissance, the Eternal City no longer exhibited an exotic and ferocious lion as its chief animal protector. Rather, the renewed role of Rome's historical mission and the city's privileged status as *caput mundi* were now embodied in the local wild animal that nurtured this place before its very birth. No longer a lion, then, but a wolf – a pontifical wolf and an incontrovertibly female one: the *Lupa*.

THE HALL OF THE *SHE-WOLF* AT THE CAPITOLINE MUSEUM

Along with the other bronzes given as a gift to the city, the *She-Wolf* was entrusted with the symbolic mission of representing the distant past and with the belief in the possible return of such greatness – ostensibly, through its study and recognition but also through monumental efforts at reconstruction. This belief, and the cultural practices associated with it, was typical – indeed, constitutive – of the Renaissance: Sixtus IV, in addition to his considerable political acumen, displayed a passion for the antique; the bronze pieces placed on the Capitoline Hill were to be the visible signs of the very idea of Rome. However, the city that these

bronzes hailed differed in profound ways from ancient pagan Rome as it imperiously ruled itself and others. The humanists' Rome – for example, as reconstituted on the Capitoline Hill through the efforts of Sixtus IV, among others – was an erudite depository of history and art. Its power was purely intellectual and cultural and its political authority over the rest of the world was but a distant memory. Rome as it was reconstructed on the Capitoline Hill, beginning with the gift of the *She-Wolf*, is an entity that must present no political challenge to the exclusive rule of the popes; that is, it must be politically ineffectual. The Rome epitomized on the Capitoline Hill is a museum in progress, a geography of subtle cultural supremacy, a location whose significance and effects – after the arrival of the *Lupa* – were no longer measured by political efficacy alone. If the *Capitoline She-Wolf*, life-giving on her milk-filled underside and fiercely protective with her bared fangs, has been called *mater Romanorum* – it is at those teats that Romulus's descendants all suckled their first nourishment, albeit metaphorically – the bronze also may be rightfully called the "mother of all museums."

In an article on the meaning of the objects displayed in museums, Peter Jones contests the view held by both scholars and laypeople "that some objects can, do, and must 'speak for themselves.' This view is untenable: objects cannot speak for themselves, because objects cannot speak at all" (915). An understanding of the formation of each museum and how its collection was put together over time and space is essential for Jones to grasp the significance of each piece. This clearly is true of the *Capitoline She-Wolf*. The early incarnation of a museum on the Capitoline Hill, determined by Sixtus IV's gift and consisting of only a few ancient bronze statues, was an ideal site of artistic pleasure, certainly; but it was also this pope's contribution to the restoration of Rome's ancient magnificence. With his gift, Sixtus IV most effectively transformed the Capitoline Hill from an active center of political power to a cultural center devoted to the preservation of the past. The arrival on the Capitoline Hill of the pope's Lateran bronzes – that is, particularly the *She-Wolf*, far more symbolic in terms of Rome's history than her companion pieces – changed the meaning not only of the *She-Wolf* herself, as could be expected, but also more pervasively of the hill where she now resided. Formerly the heart of Rome's public life, the Capitoline Hill became the erudite residence of Rome's mythical past with the installation of the gift bronzes, the place where metal and stone witnesses of the city's former greatness (finally rebuilt thanks to Sixtus IV) were collected and exalted. "The current function of the Capitol as a museum," it has been pointed out,

"only echoes its original role as a site for the propaganda of religious and political causes" (Aikin 585). Because of the significance of this location, it is on the Capitoline Hill in the years after the 1471 donation that Constantine's stone fragments were exhibited, the equestrian statue of Marcus Aurelius was placed, a Roman history course taught, a library founded, and Rome's birthday celebrated. In 1654, the building of Palazzo Nuovo, which faces the Palazzo dei Conservatori, provided more space for the rapidly growing collection. The *Museo Capitolino* was inaugurated and officially opened to the public eighty years later, in 1734.

"Museums display artworks using nonverbal methods to communicate meanings and values to their publics" (Sutton 47). The expression of meanings and values without the explicit use of language certainly has been a key feature of the display of the *Lupa Capitolina*, especially since her arrival on the Capitoline Hill. The statue speaks without words, narrates without stories, and embodies on a bronze surface all the reminders necessary to what the she-wolf has to tell. The bronze resides today in the Hall of the *She-Wolf*, although she is occasionally moved from this room named after her. Following a historic restoration, from June to October of 2000 the *Lupa* was housed in the Palazzo Caffarelli, behind the Palazzo dei Conservatori. During that exhibit, the twins were displayed separately from the wolf to give an idea of what the statue looked like before the babies' addition during the Renaissance. The effect must have been disconcerting to all but the most purist of viewers. The *Capitoline She-Wolf*'s 2007 temporary residence in the bright, high-tech exedra dedicated to Rome's beloved Marcus Aurelius – the equestrian statue that dominates the large elliptical space – also had a bewildering effect on many viewers. Surely the lighting is considerably better than in the dark Hall of the *She-Wolf*, and the modernity of the minimalist space (made of white walls, steel, and wide panes of glass) allows visitors to concentrate on the *She-Wolf* herself without the decorative trappings of antiquity, Renaissance, and the nineteenth century that clutter the comparatively tiny Hall of the *She-Wolf*. In Marcus Aurelius's space, the *Lupa* seems to be an intruder, not a star: The *She-Wolf* is much smaller than the mounted emperor, and dwarfed by the tall ceilings and the fragments of Constantine's colossal bronze statue – not to mention the ruins of the Temple to Jupiter Optimus Maximus – the bronze beast loses her grandeur and some of her unique significance. In this space, the *Lupa* is an accessory and not a protagonist: a prop to the picture of an ancient Rome too grand, too bright, and too crowded to have been born of this small animal's udders.

Instead, it is within the Hall of the *She-Wolf*, cluttered as the room may be, that the *Lupa Capitolina* best retains the complexity and layers of her historical as well as artistic significance. In this room, the bronze has resided since the sixteenth century. Between 1521 and 1550, however, this location was not a room but rather an open loggia with a portico made of three arches, which were filled in during the mid-seventeenth century to better protect the artwork. Visitors sense the tension in this room between carved and flat images, complete objects and ruined fragments, modern words in the captions and ancient ones on the walls, and the careful arrangement of the installation and its messy stylistic and historical diversity. The room is so small and packed that it is impossible to see only one of its multiple decorations or to focus on just one object; not only the *Capitoline She-Wolf* but also the Hall of the *She-Wolf* as a whole tell a story. Likewise, the entirety of this room frames the story that the *Lupa* tells – calling attention to her own form and content, to her present, and to the multiple incarnations of her past.

Although museums are presented as seamless, natural narratives, it has been said in fact that they are "highly propagandistic": Museums are cultural texts, their collections of objects "assembled into fictional narratives that proffer certain interpretive readings. The stories museums tell are generally expressed not so much through the overt language of catalogues and wall texts as through the elaborate process of selection and juxtaposition of objects, particularly in what is not said, shown, or remembered" (Wallis 618). In other words and from a phenomenological rather than a narratological perspective, our perception of an artwork depends in part on the room in which it is located. In turn, "How you view that room influences what you expect to see when you walk further. And how you look at art in those galleries, in turn, is affected by the experience of entering the museum and, sometimes, even by what you see in the streets outside" (Carrier 63).

Thus, before visitors even enter the Hall of the *She-Wolf*, they already have encountered some of the bronzes that formerly accompanied the *Capitoline She-Wolf* in the Lateran – for example, the *Spinario* and the *Camillus* – and they already have been told the early history of Rome by the huge Renaissance frescoes in the *Sala dei Capitani* and the *Sala degli Orazi e Curiazi*. The latter includes the *Finding of the She-Wolf*, a large late sixteenth-century fresco by Cavalier D'Arpino that is dedicated to the discovery of Romulus and Remus nursed by the she-wolf. The attentive visitor then enters the Hall of the *She-Wolf* prepared, armed with the correct story: This visitor has seen other Roman bronzes, has observed a

more detailed and contextualized pictorial version of the she-wolf's res-
cue, and knows about the river and the fig tree and the fate awaiting the
little boys nursing at the animal's teats. This knowledge and this experi-
ence preceding and surrounding it determine the visitor's meeting with
the *She-Wolf*, for this museum room is not where the beast was originally
intended to stand. Indeed, few objects exhibited in museums were meant
to be seen in the context in which we view them, and this makes the
conditions in which we encounter museum objects especially important:
"The position, juxtaposition, sequence, and lighting of objects influence
response," Jones reminds us (911). Museums, that is, "necessarily decon-
textualize and then recontextualize their contents" – we may not know
where the *Lupa* was originally meant to stand, but it was certainly not
here in the Conservators' Palace – "thereby radically altering the matri-
ces through which meanings may be projected, discerned, constructed"
(916).

As visitors journey through the Capitoline Museum and enter the *She-
Wolf*'s space, contact with the Roman past quickly becomes immediate
and physical. When entering the Hall of the *She-Wolf*, their feet step on
an ancient polychromous mosaic from a Roman villa on the Quirinal
Hill, dating from between the first century BCE and the third century CE.
The mosaic has an estranging effect on visitors, not only because it may
seem a bad idea to let thousands of people walk on a precious historical
relic but also and especially because its modern placement on this floor is
remembered, in matching mosaic, in the inscription on one side: 1883.
Where does the ancient floor end, visitors wonder, and the nineteenth-
century mosaic begin? The mixture of ancient and modern continues
on the walls of the Hall of the *She-Wolf*, on which fragments of the mar-
ble tablets of the Consular and Triumphal Fasti are inserted, also dating
back to ancient Rome and known today as the "Fasti Capitolini." These
are the lists of Roman magistrates and military victors ("triumphators,"
as they were known – the first of these was Romulus himself) from the
expulsion of the kings through the time of Augustus. The inscriptions
date from 27 BCE to 14 CE and were discovered quite by chance in the
Roman Forum in 1546. They were fundamental for the Renaissance
understanding of Roman antiquity. Although the Fasti were certainly
not the first Roman inscriptions discovered by Renaissance humanists,
their unique importance was due to the facts that they were monu-
mental (however fragmentary), they confirmed the defining chronology
of Roman history, and they documented the ancient ceremony of the

triumphs – adapted and reenacted in Renaissance spectacles of power (Beard).

The remaining walls of the Hall of the *She-Wolf* are decorated with fragmentary frescoes depicting scenes from the history of Rome. Dating to the early sixteenth century (probably 1503–1513) and usually attributed to the Bolognese artist Jacopo Ripanda, only two of the four original frescoes that decorate the four walls remain. One was destroyed when a wall was made into a loggia sometime between 1521 and 1550 and the other was eliminated at the time of the insertion of the Fasti arrangement. What is left of the frescoes – like everything else in this room – is packed with historical meaning and ideological purposes. One wall depicts the scene of a triumphal procession, probably Aemilius Paullus's following his conquest of King Perseus of Macedon. A slave whispers in his ear, "Remember, you are only a man," because in the moments of their greatest glory, it is easy to imagine that triumphators risked forgetting their own mortality. On the opposite wall, the successful campaign of Manlius Vulso against the Gauls in Asia Minor is depicted; Vulso also was later celebrated in a triumph for his military conquests. On the walls are two marble reliefs honoring sixteenth-century military leaders Alessandro Farnese and Marcantonio Colonna. The former won the city of Antwerp back for the Catholics in 1585 and the latter successfully led papal troops against the Turks in the 1571 naval battle of Lepanto. The two reliefs were installed on the walls of the Hall of the *She-Wolf* in 1588 and 1591, respectively. By being honored alongside the rosters of the famous Fasti, these two Renaissance leaders' glory is equated to that of the military victors of antiquity. When it was chosen to house the Fasti in 1586, the Hall of the *She-Wolf* was already resonant with a sense of Roman triumph: against internal adversities (the she-wolf rescues the twins from their evil great-uncle) and foreign enemies (as illustrated in the frescoes). This background insistence on conquest and triumph helped, in turn, to confirm the *Lupa*'s civic meaning in this museum room as the symbolic origin of ancient Roman glory and to establish the statue's connection to military conquest.

Visitors' experience of the bronze *Lupa* in the Capitoline Museum, specifically in the Hall of the *She-Wolf*, involves both a strong sense of the here and now – the place, however small, is overwhelming in terms of its congeries of styles and histories and the interplay within it of wholes and fragments – and an awareness of what has been, of the magnitude of what the *She-Wolf* has meant to others in the past, and of what

the bronze continues to mean in the present. Surrounded by icons that underline her multilayered identity – ancient Roman mosaics and inscriptions; Renaissance frescoes and statues; an elaborately gilded, painted, and carved coffered ceiling from 1865; and a twenty-first-century descriptive plaque made of plastic – the *Lupa Capitolina*'s history visibly encompasses Rome's own identity in this museum home. The bronze spans Rome's urban geography as well: It is difficult to be a visitor in this city and make it all the way to the central Capitoline Museum without first encountering traces of the she-wolf, particularly reproductions of this very statue, somewhere before. Even just outside the museum, on the Piazza del Campidoglio, a copy of the *Capitoline She-Wolf* stands proudly on an ancient column. I have overheard improvised, amateurish guides describe this replica as the authentic statue, their clients not having the time perhaps to enter the museum and see the original. This outdoors she-wolf is not the original bronze *Lupa*, of course; still, placed atop an ancient column, the replica is reminiscent of the original *She-Wolf*'s past in the Lateran Square, when her distant, idol-like outline high up on a pillar pointed to a pagan past fearfully distanced from the impressionable crowds. This other Capitoline she-wolf also reminds her viewers that Rome's past, whether in the form of objects or stories, does not disappear but is ever being recycled in often-visible layers. The she-wolf on the column exists at the same time as the *She-Wolf* in the Hall of the *She-Wolf*; the floor of an ancient villa becomes the floor of a modern museum; and the mother of all Romans preserves this role even as she performs the function of fountain, judge, guardian, and political pawn. In the company of these she-wolves, the illusion of original meanings and stable signifiers becomes impossible to sustain.

CHAPTER 3

MODERN AND CONTEMPORARY TIMES

VIEWING THE *LUPA* WITH NINETEENTH-CENTURY VISITORS

T RAVELERS TO ROME OFTEN WROTE OF THE BRONZE *LUPA*: THEY WROTE to show off their knowledge or to admit their ignorance; they wrote in fear or in admiration; they were by turns irritated by the she-wolf's ubiquity or stunned by the beast's persistence. More or less consciously, they identified in the statue the multiple layers that give her – and Rome – their stratified essence, their palimpsest appearance. In these texts, even as the statue's meanings accrue with each passing year and as the *She-Wolf* comes to embody an increasingly longer past and to acquire an increasingly venerable history, she also participates in the aesthetics of loss characteristic of the contemplation of ruins. The *Capitoline She-Wolf* is certainly a well-preserved work of art, and we would be hard-pressed to call it a ruin. Yet, throughout her existence, the bronze beast has been closely associated with the condition of ruins. Most visibly, visitors have repeatedly sought to observe the harm purportedly inflicted on the statue's hind legs by the lightning described in Cicero's writings: These "wounds" authenticated the *Lupa* as ancient because she is damaged and eloquent in her ancient injury.

In 1789, Hester Lynch Piozzi, British diarist and author, informed her readers that "In this repository of wonders, this glorious *Campidoglio*" she was shown "the very wolf which bears the very mark of the lightning mentioned by Cicero" (Piozzi 385). The *very* wolf, the *very* mark: The beast's authenticity went unquestioned, ironically, as a result of her incompleteness. Five years earlier, British writer Mary Berry made another connection between the statue's electrical accident and the premeditated death of Julius Caesar. In her travel journal, Berry wrote

63

of "the famous bronze Wolf suckling Romulus and Remus, said to have been struck with lightning when Julius Caesar was killed" (103). In 1841, American novelist Catharine Sedgwick noted the same coincidence of natural and political disasters and wrote that "Among the curiosities of the Capitol (we always look in faith, dear C.; it is a great help at Rome) is the bronze wolf, with her foster-sons, mentioned by Cicero, and said to have been struck in the prophetic storm on the night before Caesar's death" (1: 205). This association between the lightning that crippled the bronze *She-Wolf* and the historic assassination on the Ides of March had been established a century earlier, in 1740, although "The fact that there was no exact authority for this to be found anywhere in ancient literature (let alone in the works of Cicero, whose name was always invoked) worried only a few of those who were told the story which was repeated by all guides and travellers to Rome" (Haskell and Penny 336). In the absence of evidence for such memorable claims, Sedgwick found that some faith, indeed, is necessary – this is Rome, after all – if one is to look on the bronze *She-Wolf* as an object endowed with a historical significance about which we may actually presume to know something. (When Voltaire's *Death of Caesar* was performed in Rome in September 1798, the *Lupa Capitolina* was brought to the Teatro di Apollo to lend verisimilitude to the scene – so closely were the animal's ruined legs related in the intellectual imagination to the assassination of the Roman leader.)

In his much-consulted *Walks in Rome* (1871), English travel writer Augustus J. C. Hare described the *Lupa Capitolina* as "though much restored, one of the most interesting relics in the city." Hare sided with those who doubt that this is "the wolf described by Cicero," explaining that "a fracture in the existing figure, attributed to lightning, has been unconvincingly adduced in proof of identity with it" (95). Hare then produced two quotations: three Latin lines from Virgil's *Aeneid* (describing the Roman wolf nursing and licking the twins; not the bronze statue, obviously, but an evocative excerpt nevertheless) and, after Virgil's lines, an entire stanza from Lord Byron's *Childe Harold's Pilgrimage* – a lengthy poem in four cantos, published between 1812 and 1818. (The medieval term *childe* indicates a young man training for knighthood and alludes to the initiation motif present throughout the work: Harold was widely interpreted by contemporary readers as Byron's own alter ego.) *Walks in Rome* is far from being the only travel guide from the late nineteenth century to rely on Byron's address to the bronze beast or on the rest of his poem. As Andrew Elfenbein remarked, "Early Victorian guidebooks

included substantial quotations from Byron's poems, especially *Childe Harold*, to guide tourists to develop themselves by copying Byron" (32). The same stanza quoted in Hare's *Walks in Rome* appears in several other guidebooks – for instance, in the influential *A Handbook for Travellers in Central Italy* published by John Murray (Blewitt 489). Byron's lines – those about the *She-Wolf* and many others about the sights of Europe – guided English-speaking travelers through more than just aesthetic appreciation: "*Childe Harold* teaches nineteenth-century readers that the European tour is a mode of individual soul-making" (Elfenbein 32). A visit to the *Lupa* was seen to cultivate one's artistic sensibilities even as it instructed travelers on the modes of spiritual development.

THE ENGLISH AND THE AMERICAN BYRON ADDRESS THE *LUPA*

This close association between Lord Byron's *Childe Harold* and English-language guidebooks to Rome, centered on the *Lupa Capitolina*, was so well established by the late nineteenth century as to become the target of literary humor. In his 1876 novel, *The One Fair Woman*, American writer Joaquin Miller (dubbed "the American Byron" and "the Byron of the West") has his American female protagonist, a spoiled and lively young woman, declaim Byron's apostrophe to the *Lupa* to her romantic Italian companion in the course of a visit to the Capitoline Museum. "'And O, thou thunder-stricken nurse of Rome!' cried Mollie, as she caught sight of the big brass wolf standing up astride of the two twins, and pointing out her sharp nose, and looking as stiff and stupid as a wooden hobby-horse. 'O, thou thunder-stricken nurse of Rome!'" (135).

Mollie's enraptured gaze, expressed with the exalted words of high Romanticism, contrasts with the narrator's jaded observation of the Roman beast: With her material, subject, and purpose transformed (i.e., from bronze to wood, wolf to horse, artwork to toy), the *Lupa* is paralyzed into physical and intellectual deficiency – "the big brass wolf," echoing the far more threatening "big bad wolf," is "stiff" and "stupid." Miller's excerpt quoted previously includes only the first two instances of Mollie's naïve compulsion to quote from *Childe Harold's Pilgrimage*. Although her own poetic memory is scant – it seems that she cannot go beyond the first line of Byron's apostrophe – Mollie presses her companion (a Byronic character himself: a moody artist who feels misunderstood by his society) for a similar poetic appreciation: "Why don't you quote Byron, Mr. Murietta? Why don't you quote Byron? Don't you know

that everybody spouts Byron that comes to Italy? That's why they put so much of Byron in the guide-book." Seemingly unaware that a native Roman might have a different appreciation of the *Capitoline She-Wolf* from her own – one mediated by texts other than Byron's, for example – Mollie generalizes Byron's usefulness while visiting Italy: "When I go into any place or any city, and I want to stand there and say something nice and sentimental, why I just turn to my red-back book, and there it is all ready, all ready, all cooked up. Byron, Byron, Byron!" The *She-Wolf*, among the English poet's guidebook reproductions, holds a privileged place: Mollie cannot restrain herself from repeatedly quoting that first *She-Wolf* line, cutting herself off at different points according to what she notices while observing the beast. She both verifies Byron's realistic depiction of the statue's defects and disagrees with the etiology of the wound.

> Then pretty Molly . . . began in a loud and solemn voice:
> "And O, thou thunder-stricken nurse of" –
> Oh, just see! Just look there! How one of her hind legs has been split and torn! Bet that's where the dogs caught her, eh?
> "And O, thou thunder-stricken" –
> Poor little twins! How hungry they look!
>
> (135–136)

Sympathy for the twins' fate is a constant among the less historically minded readings of the she-wolf (another instance is found in Wordsworth's poem, discussed in Chapter 6), but concern for the babies' condition does not stop Mollie from enjoying herself as she gazes at the bronze. While the young Californian goes off to flirt with one of the museum guards, her companion Murietta, ever Byronic, "still lingered about 'the thunder-stricken nurse of Rome,' for to him it was full of history and meaning" (137). As Murietta hangs back in the Hall of the *She-Wolf*, Mollie's mother comes into the room: "And lifting up her eyes saw the storied wolf and her twins. She then held her head, threw up her hands, clasped them together, and, perfectly certain that she was doing something very original, said, 'And O, *thou* thunder-stricken nurse of Rome!'" It was "the much-noted histrionic, theatrical tenor of Byron's public persona," a critic notes, "that made Byron so well suited to the purposes and attitudes of nineteenth-century tourism" (Buzard 116). So, after Mrs. Wopsus, a string of other visitors to the museum with different intonations and intent also declaim the very same line from Byron's apostrophe. By italicizing the relevant word, the text informs us that an elderly

man with the voice of a preacher emphasizes the numinous word *thunder*; a young man just out of school puts his accent on the dramatic participle *stricken*; a tall and bony woman stresses the maternal noun *nurse*; and a Neapolitan missionary who tries to steal one of the twins focuses instead on the toponym *Rome* (137–140). Miller's readers are thus several times removed from the Capitoline bronze: They are reading the novelist's representation of each tourist's representation of Byron's representation of the Etruscan artist's representation of the legendary representation of the she-wolf who saved Rome's founder (except that perhaps the artist was not Etruscan and the she-wolf that this artist shaped may not be the same one that suckled Romulus and Remus).

Ironic distance characterizes Miller's *Lupa*: Readers can laugh at the pompousness or fraudulence of the *She-Wolf*'s visitors, to whom Byron offered "a means of imagining and dramatizing their saving difference from the crowd of other tourists around them" through "accredited anti-touristic gestures that were performable *within* tourism" and that allowed them to claim "an aristocracy of inner feeling" and "an ideology of originality and difference" (Buzard 121–122). It would be difficult, indeed – on the basis of Miller's novel – to appreciate the bronze *Lupa* as anything other than a screen for these tourists' projection of their own distinction, much less as an artistic, historical, or political treasure. Lord Byron's original, elegiac lines about the *She-Wolf*, conversely – although they eventually become the subject of Miller's satiric barbs – hold very little sense of humor or even irony. As an example of ekphrasis – that rhetorical figure defined as "the verbal representation of visual representation" (Heffernan 3) – Byron's apostrophe to the *She-Wolf* both connects readers to the artwork it represents and reminds them that what they are viewing is twice removed from the object in question – the she-wolf, that is. However, even as it represents a static, fixed object – unlike flesh-and-blood wolves, bronze cannot move – Byron's ekphrasis restores to the immobile *Lupa* some of the narrative power of the foundation legend she depicts and the material history she has experienced.

George Gordon, Lord Byron (1788–1824), lived in Italy between 1817 and 1823, primarily in Venice and Pisa. In the fourth canto of his *Childe Harold's Pilgrimage*, the protagonist travels to Rome (where Byron had journeyed in 1817) and imagines it as a nurturing, parental place in which he, a self-styled orphan, may find a home: "Oh Rome! my country! city of the soul! / The orphans of the heart must turn to thee" is another of his famous and somewhat exaggerated apostrophes (233). Childe Harold's physical journey to Rome is Byron's own intellectual

and spiritual pilgrimage to his cultural and literary sources, a maternal space most spectacularly embodied in the bronze of the mother wolf. The Roman beast is invoked in stanzas eighty-eight and eighty-nine as the personified although unhearing "you" to the poet's "I," as the addressee of his impassioned lament, and as the other who, in her difference, emphasizes the observing and recording action of the poet himself:

> And thou, the thunder-stricken nurse of Rome!
> She-wolf! whose brazen-imaged dugs impart
> The milk of conquest yet within the dome
> Where, as a monument of antique art,
> Thou standest: – Mother of the mighty heart,
> Which the great founder suck'd from thy wild teat,
> Scorched by the Roman Jove's ethereal dart,
> And thy limbs black'd with lightning – dost thou yet
>
> Guard thine immortal cubs, nor thy fond charge forget?
> Thou dost; – but all thy foster-babes are dead –
> The men of iron; and the world hath rear'd
> Cities from out their sepulchres . . .
>
> (238–239)

The first stanza is the one often reproduced, whether partially or in its entirety, in guidebooks to Rome. The poetic contemplation of the *Lupa* residing in the Capitoline Museum encapsulates so many of the attributes of the Roman she-wolf in both her narrative and visual forms. In his ekphrasis, Byron described at once the victorious temperament of ancient Roman conquerors and their necessary demise – imaged in the ruination of the statue (i.e., "thunder-stricken," "scorched," and "black'd") but especially in the death of the *She-Wolf*'s charges, her "foster babes": Their iron, the metaphorical metal with which they were made (a less noble reflection of their mother's bronze), failed to protect them. The narrative movement of history, derived from the description of the inert statue, is perforce present in these lines: It has been so long now since their fall that cities have even been founded on the tombs of these Roman wolves. Byron's meditation on what remains of ancient Rome is full of desolation: "Rome and her Ruin past Redemption's skill," he alliteratively regrets (267). The *She-Wolf*, although "mother of the mighty heart," is "thunder-stricken" and "Scorched by the Roman Jove's ethereal dart," her "limbs black'd with lightning": Like other visitors to the Roman beast, Byron recognizes the *Capitoline She-Wolf* as the same one

described by Cicero because of the leg wounds allegedly caused by that portentous lightning of ancient times. Although silent and unmoving, the *Lupa* reveals through the poet the changes through which her form has gone.

The *Lupa* is for Byron the "nurse of Rome," not just of Romulus. In her nursing act, the poet metonymically and presciently illustrates the vaster role of the *She-Wolf*'s udders, her "brazen-imaged dugs": She has enough milk to feed all Romans. Far from being made of dead metal, these dome-shaped dugs are filled with a potent liquid, the "milk of conquest" – the bodily fluid that once made Rome into what it was, at the height of its power: the greatest conqueror in Western civilization. The "milk of conquest" is a liquid in motion, its relentless fluid spread supplementing the statue's bronze immobility much like Byron's narrative ekphrasis complements the static nature of the *Lupa* (the root of the word *ekphrasis* is "speaking out" or "telling in full"; Heffernan 6). Through ekphrasis, a silent object is given a voice and an immobile artwork is endowed with the movement of the story it tells. Because this particular ekphrasis is also an apostrophe, Byron personifies his otherwise inert (because inhuman) addressee. Both living nurse and inanimate statue, the *She-Wolf* stands on the dome-like Capitoline hill – the very shape of her udders – "as a monument of antique art." The *She-Wolf* is a mother but a choosy mother: Byron's lines give little sense of a mother's unconditional love. She is "mother of the mighty heart," for only in a brave temperament does she recognize her progeny. It is difficult not to think that Byron saw his own heart as one of the mighty organs mothered by the she-wolf that is Rome, given his repeated identification with the ruins of Italy. His ekphrasis of the *Capitoline She-Wolf* – a supplement of time and history to an otherwise silent and apparently eternal object – is Byron's self-reflective response precisely to the threats of time and the ravages of history. The dissemination of this particular ekphrasis through nineteenth- and early twentieth-century guidebooks to the Eternal City surely testifies to Byron's poetic success. As Byron describes the artwork and narrates the story, his ekphrasis is also clear evidence of the effectiveness of the *Lupa* in provoking among her viewers a sense of connection with the distant past, perceived as both irrecoverably glorious and unjustifiably violent; an awareness of the relative shortcomings of recent and contemporary history, which killed the *She-Wolf*'s foster-children; and skeptical pessimism concerning the immediate future. What good could come of cities born of tombs?

GIFT SHE-WOLVES IN THE TWENTIETH CENTURY

As well as being the object of famous and ordinary travelers' gaze, the *Lupa Capitolina* herself has traveled. The journeying of this bronze statue is not limited to the short-but-momentous fifteenth-century trip from the Lateran Square to the Capitoline Hill. Ancient coin effigies of the she-wolf had spread all over the Roman Empire, of course, but larger and more permanent images of the nursing beast also have been found throughout her people's territories: Statues of the she-wolf with her sucklings were erected everywhere that Rome's dominions extended, and ancient inscriptions also attest to the former presence of such statues in central parts of Roman-occupied territories – including Dacia, present-day Romania. The complicated relationship of Romania with Rome is illustrated in Trajan's Column, a pictorial retelling of that emperor's conquest of Dacia. The Dacian soldiers' valor and their leader's heroism underline Rome's own force in conquering a people who called themselves "wolves" or "those who resemble wolves": Only another people descended of wolves – a people, that is, engendered by Mars and fed by a she-wolf – was able to conquer them (Eliade 15). As Dacians were present in Rome, carved on Trajan's Column, so Romans appeared in Dacia in the shape of the Roman nurse and her young naked charges: Ancient and medieval depictions of the she-wolf have been discovered in several Romanian archaeological sites, including on funerary reliefs and tombstones. These findings confirm the theory that the myth of the she-wolf enjoyed great social impact during the Romanization of imperial territories, particularly Dacia.

Therefore, when Italian fascist leader Benito Mussolini made much of Roman imperial symbolism (he also wanted an empire beyond the sea) in the 1920s and 1930s, he sent replicas of the bronze *Capitoline She-Wolf* to potentially sympathetic countries. These gifts naturally had sticky strings attached and, like all gifts, they self-destroyed: The giver took far more than he gave. Several Romanian squares still display bronze copies of the *Capitoline She-Wolf*. As gifts from the Duce to the Bucharest government, the statues suggested a bond between Italy and Romania that was supposed to flourish into a "Latin Pact" between the two countries, the citizens of which spoke a Latin-derived Romance language. The project of a Latin Pact was never officially put into effect, although the wolf-sealed bond between Italy and Romania preceded Mussolini's fascist regime: In 1906, the city of Rome had given the city of Bucharest a bronze copy of the *Capitoline She-Wolf* as a gift. In the fascist 1920s,

three more copies of the statue joined that first one in other Romanian cities: Napoca, Tirgu Mores, and Timisoara. The Timisoara she-wolf was taken down in 1948; twenty years later, Nicolae Ceausescu recovered it and returned it to the original location. He was attempting to reopen relations with the West, and the bronze gift wolf was a useful visual pawn in this diplomatic effort (Muscardini 2–5).

Like its use by the communist Romanian leader, fascist she-wolf symbolism was two-sided, at the very least. On the one hand, the image of the *Lupa* presented the she-wolf as ferocious defender of her territory, a fearsome guard who pays scant attention to the babies below because there were no babies to begin with: It is the Roman people as a whole, not just a pair of infants, whom she is intent on protecting. On the other hand, the *Capitoline She-Wolf* is a loving animal mother who transgresses species boundaries to lick and feed two abandoned human twins. The latter she-wolf is a more complex maternal being and a less obviously political representation of Rome. Ironically, however, this virtuous "human" side of the she-wolf – the beast's ability to overcome difference in the name of love – is not transmitted to Romulus and Remus: Fratricide and the events following it demonstrate that – at least, according to the texts of historians and poets – the twins lacked that merciful gift expressed by the wild beast who saved them. As the emblem of a possible pact between Italy and Romania, the set of twins suckling the same animal embodies fraternity but also the wolfish spirit of the two nations; it is therefore a complex and potentially self-destructive icon. The she-wolf saves both babies and feeds both countries, but their rivalry eventually leads to violence, devastation, and destruction – or the overpowering, as Trajan's Column depicts – of one by the other.

The replica of the *Lupa Capitolina* that arrived from fascist Italy in the American city of Rome, Georgia, was less overtly political than the wolves sent to Romania but not uncontroversial. The local rayon and acetate yarn mill of Rome, Georgia, built in 1928–1929, was created from a collaboration between American and Italian capital. The cultural distance between the mill operatives and the Italian managers, as historian Michelle Brattain explains, was emphasized when the Italian partners of the Georgia plant shipped to the United States, along with the machinery, a replica of their corporation's trademark: a bronze statue of the *Capitoline She-Wolf*. The Italian corporate executives assumed the she-wolf would be placed in front of the mill, but the local managers put her in storage instead, with the intention of eventually returning her to the Italians. They did not expect the community to react positively to the image of

"an ugly she-wolf with her pendulous teats, and ... the babies with all their anatomy exposed for everyone to see" (Brattain 59–60). To send her back would have been very expensive because the wolf with her twins would have to be transported as a work of art, not part of the machinery, as she was when she was shipped to Georgia. Taxes on the shipment would be high and, although the local managers threatened to throw the gift in the nearby Oostanaula River, in the end, they kept the statue.

A compromise was reached when the American and Italian managers decided to place the *She-Wolf* replica on a marble base and to cleverly add a bronze plaque that declared the beast a gift from Italian premier Benito Mussolini himself – "as an omen of prosperity and glory" from "Eternal Rome ... to the new Rome." The bronze wolf was not an imposition from foreign investors, then, but rather a gift from a foreign head of state. The she-wolf once again became a true gift, an impossible-because-self-destructive gift. The 1929 unveiling of the statue was the occasion for a town-wide celebration, with a ceremony attended by the governor and congressmen. Thousands crowded the city auditorium, but whereas some citizens were impressed and proud of the connection between their humble mill town and the Eternal City by the same name, others were horrified by "the anatomical detail of wolf's teats and the frontal nudity of the infant twins"; the bronze was regarded as obscene, shameful, and disgraceful, "a threat to the moral standards of the community" (Brattain 59–60). For several years afterward, on the occasion of elections and public events, someone had the good taste of placing diapers on the two naked babies; other more playful citizens surreptitiously painted the she-wolf's udders red, thereby calling increased attention to their anatomical exactitude. However, after one twin was stolen as a prank in 1933, it was replaced the following year with another sent from Italy: a sign that the statue had been officially accepted.

Seven years later, when Italy entered World War II as Hitler's ally and America's enemy, the city of Rome, Georgia, received numerous threats that the statue of the she-wolf would be dynamited – an action that would have endangered the surrounding buildings as well. Therefore, the bronze was prudently stored away in the basement of the county courthouse, and her disappearance from public view came to signify American Rome's "protest against ancient Rome's entry in the war against the democracies." Two years later, stronger measures were considered, and the bronze wolf of Rome, Georgia, ran the risk of ending up like numerous ancient bronzes before her: melted down and refashioned into weapons – in this modern case, bullets with which to better fight Italy. "Melt it down and

shoot it back," a car salesman told the local newspaper, although some objected to using a peacetime gift given in goodwill for such a bellicose purpose (Brattain 86). The voice of the she-wolf's protectors must have been strong enough to overcome the beast's enemies: Today, the bronze replica of the *Capitoline She-Wolf* can be seen in front of the entrance to the Municipal Building of Rome, Georgia. In 1952, after a twelve-year absence, the statue was restored and replaced in this central location thanks to the efforts of local art lovers and history buffs. The fifteen-hundred-pound bronze beast stands motionless on a marble base, still endowed with the mendacious bronze plaque that erroneously proclaims the replica to be a gift from Italy's Duce: "To the New Rome (*Romae Novae*) from the Eternal Rome (*Roma Aeterna*)." (The full text, available in its original Latin on the Web site for the city of Rome, Georgia, reads: "Eternal Rome sent this image of the *Capitoline She-Wolf* to the new Rome as an omen of prosperity and glory, under the consulship of Benito Mussolini, in the year 1929"; "She-Wolf").

We typically think of gifts as objects freely given as a sign of affection to family and friends on special occasions. As well as affection, gifts may signify gratitude or charity, sharing or celebration. When explored from the perspective of gift theory, however, the significance of gift objects becomes more complicated. Chapter 2 summarizes Derrida's philosophical elaboration of the effects of gifts. Even more than philosophers, it is social scientists that have long been fascinated by the theory of gifts. One sociologist assesses the social usefulness of gifts by listing the following functions: "conveying identity, controlling and subordinating, conveying unfriendliness, reducing status anxiety, enforcing distributive justice, providing suspense or insulation, defining group boundaries, and atoning for unseen social deviations" (Camerer 181). The Roman she-wolf, in her various peregrinations as gift object – whether we are talking about the authentic bronze *Lupa Capitolina* or a replica of this ancient form – has fulfilled at one point or another all of these functions. In the *Capitoline She-Wolf* as papal gift to the hill that names it, the Roman people could crystallize an identity and define their social, cultural, and historical boundaries. The fifteenth-century gift of the bronze by the pontiff was presented in the accompanying epigraph as an instance of distributive justice and atonement for the pope's past appropriations of things not his. This same gift, however, ultimately controlled Rome's municipal authority by subordinating it to the pope's – not without some sense of suspense about how this power shift would be resolved. The bronze replica of the statue sent to the American rayon factory was interpreted

by some to convey friendliness to the people of Rome, Georgia (as well as to the Romanians and other recipients of similar gifts), but it is with more suspicion than gratitude that many saw the statue's arrival. The pride taken in possessing such a replica may have reduced the status anxiety of the far-flung provinces that accepted the she-wolf, in both ancient and modern times – but it also highlighted their irrevocable separation from the center of the Roman Empire, where the original she-wolf resided.

The *Capitoline She-Wolf* is an object too steeped in myth and history to be seen (much less understood) without reference to her political and social uses, her literary accounts and artistic imitations – not to mention the popular stories that accompany her and the inexpensive and careless reproductions that make her ubiquitous in Rome. As political symbol, the *She-Wolf* is a complicated, multilayered, and often duplicitous gift. Like other such symbols, the *She-Wolf* possesses the four characteristics identified by political scientist Simon Harrison. First, political symbols are property: "An individual or group having property rights in a political symbol or symbols is defined thereby to be an entity possessing symbolic capital, or, in other words, a political actor." As a political symbol, the *Lupa Capitolina* has changed hands and, therefore, switched her allegiance as cultural capital numerous times. Most notably, the nursing beast has defined the divine origins of the Roman state in antiquity and the pope's justice in the Middle Ages; she has corroborated the authenticity of Rome's cultural tradition in the Renaissance; and she has indicated Rome's allegiance to Italy, not the pope, since the Unification in the late nineteenth century. The *She-Wolf's* role as gift often has accompanied and helped determine these shifts. "Second," Harrison continues, "the symbols are status markers, ascribed with qualities broadly describable as sacredness or prestige value." The Roman she-wolf indeed began as a religious figure, envoy of the gods, and savior of a founder and future god himself – Romulus. The beast's continued prestige – both historical and political, as well as cultural and artistic – was rarely called into question. "Third," Harrison states, "their possession is a sort of legitimacy and may confer specific rights and prerogatives such as the ownership of a territory or the entitlement to a political office." This function is especially clear when we learn of the move of the bronze *She-Wolf* from the Lateran Square to the Capitoline Hill and the power such a move contributed to the pope's political authority over the city. "And fourth," Harrison concludes, "for the individual, the symbols are a focus of emotional

attachment, identification and loyalty, invested with their owners' sense of self" (270).

Before and after the paramilitary, fascist formation of youth groups called the *Figli della lupa* (Sons and daughters of the she-wolf; see Chapter 6), Romans identified the she-wolf – consistently imagined in the shape of the bronze *Lupa Capitolina* – as their tutelary animal and the most eloquent and unifying symbol of their city: We must keep in mind the Italian *mammismo*, or quasireligious devotion to the mother, to fully comprehend the added weight conferred on the she-wolf icon by her maternal dimension. Because of Mussolini's extensive appropriation of the she-wolf as symbol for his regime, however, Romans are now careful before assuming this beast as a political emblem. The Web site "Figli della lupa" (Sons and daughters of the she-wolf), for example, is sponsored by a frankly profascist group. Recently and playfully, it is the fans of the A. S. Roma soccer team (although not overtly political, it is a group usually thought of as working-class and leftist) that refer to themselves as *lupacchiotti* (wolf cubs) and occasionally as *figli della lupa*: The A. S. Roma's emblem centers on an image of the bronze *Capitoline She-Wolf*. *Figli della lupa* is also the title of a popular musical that played in Rome's upscale Teatro Sistina in 2001, subtitled "A Musical Fable." Fascist appropriations notwithstanding, the humorous side of a she-wolf nursing human babies has not been lost to contemporary Romans. The *Lupa Capitolina*'s current high-brow environment – that is, a museum hall – may not seem to encourage such a reading, but the she-wolf's ubiquitous availability outside of those serious walls makes this animal figure belong, once more, to the Romans whose mother she is still sensed to be.

FRATERNAL RELATIONS IN KOMUNYAKAA'S "REMUS AND ROMULUS"

Although we may not touch the bronze *She-Wolf* in the Capitoline Museum, there are numerous other images of the beast in Rome, far less precious and more easily accessible. In Rome, the she-wolf and the hungry, competitive twin brothers she saved are everywhere: in places public and private, on plaques visible and hidden, with messages both ostentatious and subtle. No wonder, then, that among the she-wolf's many haunts, we should find her on the logo of Rome's Office for Animal Rights: a stylized brown she-wolf with two pointy, distended

udders, on which a cat and a bird, both colored yellow, suckle effortlessly. The standing pose of the larger animal copies that of the more famous *Lupa Capitolina*, with the cat and bird taking the place of Mars's and Rhea Silvia's baby boys. In the Roman tradition, the she-wolf is mother to all living beings; she feeds smaller animals like she once fed two babies rather than feeding *on* them – as those familiar with the habits of wolves might reasonably expect. As a result of the she-wolf's milk, life proliferates. She supplies survival and fertility to predators of her own kind as well as, more surprisingly, to her own potential prey. Under her teats, peaceful fraternity reigns, however temporarily. It is this peaceful fraternity and the maternal protection sustaining it that the Office for Animal Rights invokes through the appropriation of the *Lupa*'s shape on its logo. On this logo, as in other texts and images inspired by the *Capitoline She-Wolf*, the relationship between Romulus and Remus – particularly the killing of the latter by the former – is usually elided. Without such elision, the choice of this particular nurse and sucklings would not make much sense, for example, as the logo of the Office for Animal Rights – fratricide is not the best calling card for a group intending to protect life at risk.

In his poem, "Remus & Romulus" (2001), contemporary African American poet Yusef Komunyakaa also eschews the brutal developments of the relationship between the two brothers as he reflects, through a modern ekphrasis, on the bronze statue. With his words, Komunyakaa effectively captures the sacred, enduring qualities of the maternal–filial relationship visually expressed in the bronze twins and their she-wolf nurse:

> They're at the eight teats
> Of the Capitoline she-wolf
> Their naked adoration
> Suspended in a leap
> Of faith.
>
> (47)

The bronze animal nurse is too tall for the nurslings, and the two indeed seem to "leap" – like Byron before him, Komunyakaa attributes movement to the statue's immobility – to reach her precisely enumerated "eight teats." One baby sits and the other kneels, both raised on a pedestal without which they would surely go hungry; the beast shows no intention of lying down to facilitate their meal. Their heads tossed

back so that their eager lips may reach the wolf's teats, the two naked boys strike a pose of worship, of "naked adoration." The faith this poet reads in their shape is both the simple – we might say physiological – faith that all helpless children must place in their mother, a being who is all powerful with respect to their fate; and the more mysterious, religious faith in the benevolence of a normally dangerous presence.

The symbol of Rome is a she-wolf nursing a set of twins. Neither beast nor babies alone would be recognizable as the city's emblem, so intertwined are the fates of these two compositional elements – no matter how unlikely it is, from an iconographic perspective, that the fierce, standing *Lupa* we see today at the Capitoline Museum was originally accompanied by twin boys. The *She-Wolf*'s steady gaze is fixed instead on her viewer: "Mother of the Romans" – not mother to her sucklings alone but also to all those who make their home in Rome, protecting every one, cats and birds, the Animal Rights logo implies, included. What will prevail in the end: The good example of generous mercy that the she-wolf provides through her selfless rescuing act? Or the bloodthirsty nature of every wolf, inescapably passed on through milk sucked, swallowed, and metabolized into one's own flesh? Through enigmatic words, Komunyakaa verbalizes the change this unchanging statue recounts: the growth of the babies into responsible adults, into young men who work and flourish but who are also capable of deceit, guilt, and blame:

> . . . If we lie
> To ourselves long enough,
> Practice works underneath
> The pattern of this heft
> Till flesh finds a way to rise
> To a level of blame.

The historical, cultural, divine "heft" of the wolfish flesh covers the twins, protecting them but also directing their growth: The she-wolf's body has a "pattern" and under this pattern the twins "practice works" – works that cannot help but be guided by the wolf's "heft." The twins grow, their "flesh finds a way to rise," and as adults they no longer depend for everything they do on the "heft" of their nurse. They have now risen "to a level of blame": They have acquired adult responsibility for their own actions. Yet, baby Remus and baby Romulus are not just future men. Much more than their own destiny is inscribed on their face and in their body, as well as within the eyes of their animal foster mother.

Ekphrasis reveals that nothing about this beast's meaning is confined to the physical form that the bronze once took when it was still fluid:

> ... The boys
> Face each other, & we can see
> Brutus's plot in the wolf's
> Vulnerability, in her tarnished
> Stare. Now she's only primal food
> & sex, their first coup d'état.

The future legible on the bronze group is not just the twins' own but also Rome's: "Brutus's plot" (metonymy of the assassination of Julius Caesar that hails the birth of Rome's empire) is emblematic of public history and the effects of Rome on the world as a whole. What Komunyakaa calls "the wolf's vulnerability" is the precariousness of Rome itself, which the ancient animal silently communicates through "her tarnished stare." But, however vulnerable the she-wolf may be, however far the twins may still have to go before rising "to a level of blame," they are no longer innocent and perhaps never were – just as the she-wolf, as well as being a provident mother (she provides "primal food") is also "sex." Komunyakaa does not forget the dual nature of the beast: generous and predatory, maternal nurturer and seductive temptress; still, his poem glosses over her sexuality almost as seamlessly as it elides Romulus's future fratricide. The twins' first act of feeding, of reaching for the "primal food" from the wolf's teats – their struggle to stay alive, we might say – is "their first coup d'état." For them, to live is to live politically; their very survival – as personal as a baby's gulp of mother's milk – is, in fact, the most public and historic of acts.

The liberal, charitable she-wolf chosen by the Office for Animal Rights may feed the cat and the bird as much as she wants. She may imagine, in her maternal blindness, their eventual fraternity – some lasting bond between those who shared her teats in their common hour of need. Like the wolf in Komunyakaa's poem, she is "only primal food" and the tiny animals below her must be, like Komunyakaa's Remus and Romulus, "suspended in a leap of faith." However, the two little critters suckling the wolf today, like Romulus and Remus twenty-eight centuries ago, will become adults and outgrow the she-wolf's milk – so generously given although unrealistically tolerant of differences in species and breed. Once the cat and the bird grow up and forgo milk as their primary sustenance, they will look elsewhere for a more solid, less primal food. What might happen to the bird – when the cat turns around and finds it more appetizing and filling than she-wolf milk – is anyone's guess.

THE *LUPA CAPITOLINA* IN CONTEMPORARY GUIDEBOOKS

The *Capitoline She-Wolf* can work as a metaphorical guide to Rome's history and culture, telling us – among other things and through such vehicles as historical documents and literary ekphrasis – about the workings of medieval justice and the role of symbols in Renaissance power struggles; the selective appropriations of history on the part of romantic but also fascist discourse, whether literary or political; and the persistence of Roman myth even in contemporary poetry and its usefulness in reflecting on such themes as the relationship between public and private. As well as being a guide of sorts, the *She-Wolf* regularly appears in guidebooks to the Eternal City. In fact, today there is hardly a guidebook to Rome that does not include at least one mention of the bronze beast. The *Lupa Capitolina* (some guidebooks do not hesitate to call the statue by its Italian and Latin name) is an eminent tourist attraction in Rome, as well as an important site in and through which tourists come to experience the city. This bronze is repeatedly identified as a privileged and authentic metonymy of Rome by a variety of markers encountered by contemporary tourists both before and at the same time as they encounter the statue that best represents the she-wolf: previous historical knowledge (most tourists in Rome have heard of the she-wolf's story before making the trip), the spoken words of tour guides, printed descriptions on plaques within the Hall of the *She-Wolf*, and the *She-Wolf* entry in guidebooks. It is to these latter texts that it is worth turning for a final look at modern representations of the *Lupa Capitolina* because guidebooks shape tourists' observations and interpretations, and they are how most travelers to Rome become familiar with the bronze *She-Wolf*'s meaning.

As an early Christian pilgrimage destination, Rome was among the first cities to provide guidebooks for its visitors. Medieval pilgrims had *Itineraries* and *Mirabilia*, which were replaced in the Renaissance by a variety of more historically accurate accounts. With the growth of tourism and the expansion of the Grand Tour in the eighteenth century, handbooks to the city became an increasingly popular genre. In their present form, guidebooks derive from the nineteenth-century publication of Baedeker's and John Murray's handbooks, both of which first appeared when tourism began to extend beyond the Grand Tour of the leisured classes in 1830s Europe. The *Blue Guides* of today – the one for Rome still in print was first published in 1971 and was authored by Alta

Macadam – are direct heirs to the Baedeker and John Murray tradition. The publication of numerous other more popular and less intellectual guidebooks – many of them quite visual and composed of information capsules rather than extensive didactic details – has flourished since the 1970s (Parsons 255–289). Admittedly, few of the guidebooks provide in-depth commentary or art-historical expertise. It is certainly easy – perhaps even fashionable – to scorn the practice of tourism and, as a corollary, to regard those texts that target tourists as their audience as undeserving of serious critical attention. Modern guidebooks, in general (for there certainly are exceptions), are not the best way to become conversant with Rome's history and culture. Still, in their own telegraphic way, when contemporary guidebooks direct their readers to view and appreciate the bronze *She-Wolf* at the Capitoline Museum, they frequently engage many of the culturally complex questions raised by the Roman beast.

The most basic fact about the *Capitoline She-Wolf* – namely, that the bronze embodies a memory worth preserving – is confirmed by the statue's unfailing presence in contemporary guidebooks. The *She-Wolf* can be counted on as symbol of Rome and as one of the "must-sees" in the Eternal City; in guidebooks that include photographs, the one of the *Lupa Capitolina* holds a conspicuous place. This ubiquity turns guidebooks into the most widely disseminated archives for the figure of the Roman beast, even when the animal is not entirely there: Memory, after all, can be faulty and guidebooks unreliable. Our list of instances of the she-wolf's presence in guidebooks must begin significantly with an absence. After first being placed there in 1872, shortly after Rome became part of united Italy, no live wolves have been in their cage at the foot of Capitoline Hill since the 1970s. (The caged she-wolf is discussed in the conclusion to this book.) Yet, the 2006, eighteenth edition of *Frommer's Rome*, a top-selling guidebook, erroneously remembers the wolf's incarceration as if it were still in place: "On the way up the graceful steps leading to the Campidoglio, take a look in the shrubs to the left of the stairway. Deep in the bushes is a large cage. In it are wolves perpetuating the memory of the she-wolf who suckled the infants Romulus and Remus" (Porter and Prince 48). The memory invoked by this guidebook is defective or perhaps overactive: It remembers that which is no longer there. "Take a look," this guidebook commands. Tourists may look all they want "in the shrubs to the left of the stairway"; still, they will see no she-wolves, caged or free. A little farther up the stairs and on the right rather than the left is the Palazzo dei Conservatori,

within which the Hall of the *She-Wolf* with its masterpiece is located. This rather than any absent caged beast is the symbol of Rome: an image of presence, not absence, and of fullness, not emptiness. Physically hollow, as the lost-wax method dictates, yet metaphorically full, the *Lupa Capitolina* draws viewers in through her ambiguity, challenging them to fill in the missing pieces and to unpack a sexual, historical, artistic, and ultimately symbolic identity of which the *She-Wolf* herself is unsure.

The symbolic energy of the *Capitoline She-Wolf* is constantly remarked on by many guidebooks to Rome; this intensity of meaning is intrinsic to the statue's canonical, sacralized status among Rome's must-see monuments. Like artifacts such as the Colosseum and the frescoes in the Sistine Chapel, the she-wolf possesses an especially commanding aura of authenticity among Rome's numerous tourist attractions. As a tourist sight, the bronze *She-Wolf* has been sacralized through a process that named her (the *Lupa Capitolina* is the only authentic she-wolf), framed and elevated her (the *Lupa* has been put on display and made an object of visitation, protected and enhanced), and enshrined her (the *Lupa*'s frame, the Capitoline Museum, is itself marked and sacralized); she has been subsequently reproduced, first mechanically and then socially (MacCannell 44–45). The case of the bronze *She-Wolf*, I contend, contradicts Walter Benjamin's thesis in his influential essay, "The Work of Art in the Age of Mechanical Reproduction," that its reproduction destroys the aura of the work of art. MacCannell, on the contrary, notes that Benjamin "should have reversed his terms. The work becomes 'authentic' only after the first copy of it is produced. The reproductions *are* the aura" (48). In the process of tourist-attraction sacralization, the stage of mechanical reproduction of the artwork "is most responsible for setting the tourist in motion on his journey to find the true object. And he is not disappointed. Alongside of the copies of it, it has to be The Real Thing" (45).

This "Real Thing," this true object that is the *Lupa Capitolina*, is avidly sought out by tourists in Rome. Guidebooks keep their promise and lead them there. The popular, proudly low-brow *Rome for Dummies* refers to "the famous *Lupa Capitolina*, the fifth century B.C. bronze that is the symbol of Rome, representing a wolf suckling Romulus and Remus" (De Rosa and Murphy 142). *The Rough Guide to Rome* expands on this definition by adding religious to civic symbolism and the distinction of having "a room of one's own": "the sacred symbol of Rome, the Etruscan bronze she-wolf nursing Romulus and Remus, the mythic founders of the city, gets a room to itself" (Dunford 49). The *Lonely Planet* guide,

known for its irreverent, iconoclastic style, is more self-conscious about the way popularity affects the ranking of artworks, dwelling on fame and the ability to please crowds rather than on intrinsic artistic value: "Of the sculptures, the Etruscan *Lupa Capitolina* (Capitoline Wolf) is the most famous," the *Lonely Planet* asserts, shortly thereafter listing the statue as one of Rome's "crowd-pleasers" (Garwood and Hole 67). The notion of a hierarchy of tourist sights, a top-ten list (in fact, there is a guidebook unabashedly titled *Top 10 Rome*; Bramblett and Kennedy), a canon of the authentic objects tourists must seek out, informs the *Lonely Planet* and most contemporary guidebooks. What makes the *Capitoline She-Wolf* a "crowd-pleaser" in this sense is not her aesthetic value but rather her especially commanding aura.

This aura of authenticity and relevance, on which the *Lupa*'s ability to please crowds relies, proceeds in turn from the legend the statue tells as well as from her formal appeal. The she-wolf's is a mythico-historical narrative of abandonment and rescue, and the statue at the Capitoline visually recounts its happy ending. The fact that this is the ending of one story and the beginning of another contributes to its appeal. Despite the much-reviled, formulaic nature of guidebooks – linked to superficial, consumerist tourism – they most emphatically do not all read the same. Their own ekphrasis of the statue must necessarily engage past interpretations: Surely, such ekphrasis as we find in guidebooks is highly derivative. In this unabashed borrowing, this bricolage that they perform, guidebooks nevertheless highlight a characteristic of all she-wolf readings: They depend on previous ones; without predecessors, they mean nothing. Occasionally, for example, the double-entendre implicit in the word *lupa* is mentioned. This is true of *Fodor's Rome*, in which the section titled "Romulus goes to town" describing the twins' abandonment and suckling by the beast, explains parenthetically that "(Ancient gossip says the wolf was actually a woman nicknamed Lupa for her multiple infidelities to her shepherd husband)" (Fisher 71). The guidebook's own pun, "Romulus goes to town," is justified through the double-entendres of mythic history. It is true that this guidebook avoids any reference to prostitution and *lupanars* (this antiquated term for brothels derives precisely from the homonymy of she-wolf, *lupa*, and prostitute) and confines itself to the relatively more acceptable practice of adultery – further distancing it, typographically, through parentheses. *Fodor's Rome* is nevertheless more generous than other examples of its genre in engaging the essential ambiguity of the she-wolf's story. Our belief, the sentence in parentheses allows, does not need to be stretched so far as to accept the kindness

of a real wild animal. Adultery on the part of a married woman, however, is credible. This story also draws us into a secret and suspends the reader's disbelief by placing itself within a more mysterious interpretive tradition.

Another deception – this time art-historical rather than sexual – involves the possibility that the she-wolf's bronze statue was made in the Middle Ages, not in antiquity. The *Time Out Rome* guide tackles both deceptions in an inset titled "Crying Wolf," which is separated from the rest of the text by its blue background and the image of the she-wolf atop a statue on the Piazza del Campidoglio (which is deceptive: this is a copy, not the real thing, although the average tourist or reader may not realize it and the guidebook does not explain). "For centuries, the nature of the she-wolf has been called into question: *lupa* was a Latin word for prostitute." Although "this has never dampened Romans' devotion to their symbol . . . the authenticity of this statue has recently been called into question." *Time Out Rome* courageously refers to the she-wolf's most recent restoration and to the restorers' claim that the statue is medieval rather than ancient. "If the claims are substantiated it would make Rome's 'ancient' *lupa* at least a millennium more modern than previously believed" (85). I say "courageously" because it goes against the rules of guidebooks to introduce uncertainty or the potentially multiple meanings of any given site. Guidebooks are supposed to be transparent and precise; the she-wolf, however, resists such clarity and exactness, even in the guidebooks' formulas. (Already in 1890, a Baedeker guide suggested that the *Capitoline She-Wolf* was "more probably of an early medieval origin"; 214.) A "fuzzy" knowledge of the past is not what tourists normally seek in guidebooks, for this type of text feeds a tourist's mild intellectual hunger by imparting "nuggets" of truth meant to satisfy superficial curiosity. Nevertheless, the occasional concession to uncertainty may help to draw in those readers tired of such assurances, those who desire to be more than tourists – much like the ancient speculation that the legendary she-wolf was, in fact, a human prostitute helped the more skeptical among Romans to accept a metaphorical *lupa*'s intervention in their founder's early adventures.

Indeed, it is a feature of the *Capitoline She-Wolf* that she gracefully accepts different and sometimes opposite interpretations – whether historical or stylistic, focused on the she-wolf's identity or on the description of the bronze shape. The most beloved of all Rome's guidebooks, Georgina Masson's 1965 *Companion Guide to Rome*, is enamored of the Roman beast: "which to the writer is the greatest treasure of them all."

Pace MacCannell's and Benjamin's theories of artistic reproduction, it is just as well that Masson's guidebook does not include images because in this author's words, "No photograph or drawing ever seems to do it justice; one has to see it for oneself to appreciate the mastery with which the Etruscan sculptor, believed to be the famous Vulca of Veii, portrayed this animal in which fear, intelligence and ferocity are so fascinatingly mixed." (*Rick Steves' Rome 2007*, by contrast, reproduces no fewer than four pictures of the *Lupa*: one close-up of the face and three identical full-body shots sprinkled throughout the volume.) Fear and ferocity, the emotions of prey and of predator, are fused in Masson's description into a single expression: the *She-Wolf*'s own. This author then goes on to provide the bronze's traditionally Etruscan dating and mentions the Renaissance origin of the twins – twins that are "banal by comparison" to their ancient foster mother (19).

In a 1972 guide not unlike Masson's for its avoidance of images and its personal spin on the tourist sights that it describes – although not as erudite as the *Companion Guide to Rome* – Kate Simon also must engage the ambiguity of the *Lupa* and does so by playing with the words of the Capitoline bronze: "The *Sala della Lupa* is gathered around The Ancestors, the bronze wolf of Rome with dugs like those of the many-breasted Diana-Isis-Astarte, an exceedingly old (fifth or sixth century BC) girl to be nursing twins born in the Renaissance or later" (73–74). Through a uniquely colloquial and opinionated style rarely found in more recent guidebooks (although *Rick Steves' Rome* occasionally adopts it, as discussed herein), Simon distances her book from the impersonal genre of guidebooks, even as she briefly informs her readers of the statue's identity and that the twins date from a much more recent time than the animal feeding them. In personifying the beast by calling her a "girl" – an "old girl," no less – this author is both patronizing and refreshingly humorous. "Old girl" is hardly an attribute women like to hear applied to themselves and – along with the grotesque image of an old woman nursing babies – it recalls the specter of misogyny. However, the reader must remember that it is a she-wolf, not a woman, that the text is talking about: This female is closer to a goddess (i.e., Diana-Isis-Astarte) than to a human mother.

Far more objective than either Simon's or Masson's book is Alta Macadam's still popular *Blue Guide Rome*, a book that provides a bridge between learned nineteenth-century guidebooks and the mass-market guidebooks of today. The comprehensive *Blue Guide Rome*, which has

gone through several editions since its first appearance in 1971, describes the *Capitoline She-Wolf* as "for centuries the most famous piece of sculpture in the entire city" (it is not clear whether our own twenty-first century is included in this timespan), "shown baring her teeth as she turns towards us in fear" (42). Macadam's beast, like Masson's, is both a cause of fear and its subject: She is fearful as well as fearsome, as Macadam's observation reveals. The bronze receives this level of aesthetic attention as well from the anonymous *Knopf Guides: Rome*, which waxes more eloquent about the *Lupa* than any other among the popular, mass-market guidebooks. (Is it because it is a translation from the French?) After dating "the animal totem of Rome" to the fifth century, the book invites tourists to notice how the *She-Wolf's* "naturalism combines with keen abstract sensitivity: the dilated nostrils, the wide-open eyes and the three furrows on the forehead convey a strong sense of realism, whereas the rest of the body is highly stylized" (133). The Michelin *Green Guide*, also French and anonymous, likewise notes the stylistic contrasts of the bronze: "The anatomical accuracy is treated in a remarkably stylised manner" (112). For these two guidebooks, the contrasts are stylistic rather than sexual or chronological but no less successfully blended.

In most cases of aesthetic appreciation of the bronze group at the Capitoline, both fear and ferocity belong to the she-wolf. *Rick Steves' Rome*, however, engages the emotions of the *Lupa Capitolina* from a different, surprising, and humorous perspective. The authors of this popular guidebook first dispassionately describe the wolf's nursing action, the Etruscan origin of the beast, and the twins' Renaissance addition. Then their tone changes drastically: "Look into the eyes of the wolf. An animal looks back, with ragged ears, sharp teeth, and staring eyes. This wild animal, teamed with the wildest creatures of all – hungry babies – makes a powerful symbol for the tenacious city/empire of Rome" (Steves and Openshaw 163). The authors' comment comes off as doubly comic, not only because it reverses the common expectation that the twins ought to fear the wolf – the text claims that it is the other way around and that babies are wilder than wolves: Infants, not the beast, symbolize Rome's determination. It also breaks the neutral perspective traditionally demanded of guidebooks: A clearly objective viewpoint is supposed to confirm the reliability of the information that guidebooks convey; however, no such objectivity is forthcoming in this passage.

By tentatively identifying the *Capitoline She-Wolf* with the one struck by lightning in 65 BCE – much like nineteenth-century guidebooks had

regularly done – the *Blue Guide* invites appreciation of the beast as a monument to past history and as one of Rome's hallowed ruins. This statue was long considered sacred for the religious associations of its principal subject: sent by a god, nurse to a future god, and a predator long connected with the underworld. Yet, a religious worldview is not necessary to regard any ruin and this particular ruin as inherently venerable: Ruins survived what humans cannot and thus have in their own way transcended time. Already by the fifteenth century, the bronze wolf was venerable enough to be given as a gift by the pope to the city of Rome, as several guidebooks inform their readers (e.g., *Time Out Rome*, *Top 10 Rome*, and *Lonely Planet*). The *She-Wolf*'s very existence through the ages, whether or not she was actually struck by lightning two thousand years ago, makes her image worthy of admiration – hence, her presence as an illustrious sight in every guidebook about Rome.

The *She-Wolf* must be remembered because of all that she herself remembers and all that she prompts her visitors to remember – not least, through the widely available words of guidebooks: a compact story of Rome's birth ("the animal totem of Rome . . . illustrates one of the city's best known legends"; Knopf 133); the enduring effect of this bronze and its art, and the *Lupa*'s authenticity as she guarantees the authenticity of the tourist's experience ("The original bronze She-Wolf suckles the twins Romulus and Remus"; Steves and Openshaw 163); the ambiguous status of every female body ("The she-wolf stands guard, at once a protectress and a nurturer, as the twins Romulus and Remus feed on her milk"; Bramblett and Kennedy 26); the deceptions of sex and of history ("Ancient gossip says the wolf was actually a woman nicknamed Lupa for her multiple infidelities to her shepherd husband"; Fisher 71); the manifold uses to which monuments may be put ("a she-wolf suckling the twins . . . even today is emblazoned across the chest of Francesco Totti and the A. S. Roma team"; *Time Out Rome* 85); our fear of predators and their hold on our lives ("The famous She-Wolf of Rome, shown baring her teeth as she turn towards us in fear"; Masson 19); that ancient objects may be ruined but, in becoming ruins, they also become immortal ("For centuries the most famous piece of sculpture in the entire city"; Macadam 42); that symbols, however ancient and arbitrary, continue to effect their influence on the present ("This wild animal, teamed with the wildest creatures of all – hungry babies – makes a powerful symbol for the tenacious city/empire of Rome"; Steves and Openshaw 163); that our memory may point to an absence – such as the live wolves of the

Capitoline ("Deep in the bushes is a large cage. In it are wolves perpetuating the memory of the she-wolf who suckled the infants Romulus and Remus"; Porter and Prince 48) – yet nothing absolves us from the obligation to remember.

The *She-Wolf*'s ubiquity in guidebooks and her significance for Rome's visitors may be further understood through Dean MacCannell's theory, aptly summarized by Rudy Koshar, that "tourists search for experiences, objects, and places that enable them to recover structures from which they are alienated in daily life" (325). *Alienation*, of course, is a big word with theological, psychological, and economic connotations. The *she-wolf* as a word is just as "big," though, and can participate in all of these connotations – the she-wolf ever was a meddlesome beast. The structures from which tourists are alienated in daily life and that they are enabled to recover through, for example, engagement with the bronze *She-Wolf* through the intermediary of guidebooks may be catalogued using a number of cultural themes and patterns. The original union of human beings with nature, announced through a she-wolf nursing two babies, has long been felt – in the West, at least – as irrevocably lost. Equally lost to the modern world yet visible in the numinous image of the *She-Wolf* bronze group is the cultural certainty of every human being's fundamental union with the divine – it is a god that saves the children, a god present both within the children (he is their father) and in their nurse (he is the one who has sent her). Belief is another such structure: belief in a story of divine providence, telling us that everything will turn out all right in the worst situations – in the encounter with a wild beast, no less – despite linguistic, historical, or visual deception. Who does not enjoy a happy ending and who has not felt, at one time or another, estranged from its likelihood? Art is rarely as compellingly and as immediately comprehensible as it is in the bronze *She-Wolf* – not only through her representation of the bodily experience of mothering and of being mothered but also through the visual recognition of a fearsome predator and the reassuring effect of the latter's artistic domestication: Tourists often fancy themselves as art lovers and the *She-Wolf* nurtures this desire. Perhaps most desirable of all these structures for American tourists is the identification with a national symbol, however ruined, that is twenty-eight centuries old. Such easily recognizable ancient monuments are difficult to find and more difficult yet to identify with especially for residents of the New World. Their presence in our life, however fleeting, however limited to a brief tour of Rome, remains memorable, even indelible. For

the she-wolf embodies some strong and enduring structures: Structures from which postmodern tourists, particularly those from relatively young countries, are likely to feel alienated, estranged, cut off – at least, some of the time; structures that the ancient beast, conversely, revels in and invites her viewers to share.

PART II

WRITING ABOUT
THE SHE-WOLF

CHAPTER 4

ANTIQUITY

THE NURSING SHE-WOLF AND THE GODDESS OF SUCKLING

IN THE INFANCY NARRATIVE OF ROMULUS AND REMUS, THE WOLF DOES not prey on any of the protagonists. The true predator, in this legend, is the war god Mars, who raped a virgin in her sleep, impregnated her, and then took off. To be fair to this otherwise deadbeat father, he sends a couple of animal associates – the she-wolf and the woodpecker – to watch over his two sons. It is bloody business to rape a virgin, and bloodier still must have been Rhea Silvia's delivery of the twins. Blood flows at the twins' conception: A virgin, whether raped or willing, usually bleeds at the moment of deflowering. Blood flows at the twins' birth: Human birth is always bloody. Blood flows again, more unpredictably this time, when the city is founded: Romulus, it is known, slayed his own brother Remus and remained Rome's sole founder. Blood signifies violence (sometimes) and pain (usually) but also the historical necessity of Rome's birth through the hurt of the woman who facilitated the event and the death of our hero's antagonist – who also happens to be, alas, his only brother. Blood, however, is not the only bodily fluid that visibly flows in this story of early Rome: Without the milk of the she-wolf – milk meant for wolf cubs but eagerly sucked down by two ravenous human babies – Rome's founder surely would have succumbed.

More than purely physiological products of the human body, blood and milk are fluids with age-old figurative meanings in Western culture. Blood is the juice of life and milk must properly flow for life's early sustenance. In ancient through early modern times, the two liquids were more closely connected than they are for us today: For centuries, milk was believed to be the processed blood of new mothers – blood

that ascended from the female reproductive organs to the breasts, transformed and purified in the process. According to ancient wisdom as disseminated by sixth- to seventh-century bishop Isidore of Seville, historian Thomas Laqueur explains, "New mothers, who nursed and thus needed to convert extra blood into milk, did not have a surplus and thus did not menstruate. 'After birth,' says the seemingly omniscient Isidore, passing on one millennium of scholarship to the next, 'whatever blood has not yet been spent in the nourishing of the womb flows by natural passage to the breasts and whitening [hence *lac*, from the Greek *leucos* (white), Isidore says] by their virtue, receives the quality of milk'" (36). The distillery that was the human body produced all its juices as we know them, and the most fundamental of these was blood. From menstrual blood came milk; from blood, therefore, came life.

Although it has been occasionally coopted as a metaphor for manly activities (e.g., Quintilian refers to the milky richness of Livy's writings to indicate their suitability in the education of would-be orators; Hays 113), milk is an exquisitely female product. The quintessentially masculine god of war who fathers Romulus and Remus in the blood of rape is also the one who indirectly provides them with the milk they need. The twins start their life amid a cluster of dangers: evil relatives, murderous servants, the turbulent waters of the Tiber River, and wild animals along the riverbank. Still, they are protected by benevolent and – in the version most often remembered – ultimately paternal higher powers. The mother figures in the story, however crucial to the narrative, are either forgotten (after she gives birth, Rhea Silvia disappears from the tale) or described as the passive instruments of fatherhood (the she-wolf is Mars's unthinking, purely instinctive tool). These vital, feminine vehicles of paternity take the triple form of plant, animal, and human. The plant is the fig tree with its milky sap – it is under a fig tree that the twins are nursed – and the fig tree appears in many depictions of the scene at the Lupercal, the she-wolf's cave on the Palatine Hill. The animal, of course, is the she-wolf with her milk-filled udders. The human medium is the herdsman Faustulus's wife, Acca Larentia – she too was presumably endowed with milky breasts – who raises the two babies as her own.

The twins come from wetlands, a site saturated with fluids: Conceived in blood and birthed in more blood, they were abandoned in the Tiber River, the waters of which – at the time when their great-uncle's servants went to drown them – had so risen as to frighten those meant to deposit the twins within it. Amulius's servants must have assumed that

if they left them on the riverbank, the helpless infants would stand no chance of surviving. Instead, the watery Tiber helped the children, as did a sap-filled fig tree on the riverbank. Thus, the river is frequently and gratefully personified as a brawny older man, a river god leaning on a water-gushing barrel. The Ruminal fig tree was venerated for centuries as "the reputed oldest sacred tree in Rome." An early twentieth-century historian in a lecture titled "The Sacred Trees of Rome" wrote that this tree "had kindly detained the floating cradle wherein lay Romulus and Remus" and "its shady foliage already gave shelter to a she-wolf, which, thenceforward, conveniently performed the duty of suckling the motherless twins. Hence Ruminalis, from 'rumes,' the breast, says the etymologist." It was after the she-wolf's udders that the tree is named (Baddeley 106–107). The Tiber's waters and the fig tree's roots, inanimate yet made sentient by their role in Rome's early history, were later accompanied by another life-giving fluid: the white sap of the sacred fig tree and, eventually and most crucially, the equally white but far more nutritious milk of the mother wolf.

Readers may well assume that the name "Rome" derives from Romulus's own, but the Ruminal fig tree reminds us that a female presence still hovers over the naming of this area in subtle ways. It is believed that the city's name does not come from that of a Trojan woman, Rhome. (In the alternate legend summarized in the introduction, she is the leader of refugees who determines the Trojan settlement in Latium by burning their ships.) Rather, Rome's name belongs to that of an Alba Longa male, Romulus. Nevertheless, Roma is a name with a feminine ending and a name of possibly female origins; Romulus's name is often described as etymologically related to that of Rumina. She was a fertility goddess, the goddess of lactating mothers and suckling offspring, animal and human alike: She protected lactating sheep and wolves as well as breastfeeding women. She is called Rumina or Romina or Rumilia because according to Varro (the same first-century BCE Roman scholar who established the date of Rome's founding as 753 BCE), *ruma* or *rumis* was an old Latin synonym for the word *mamma* (breast or udder). Following are Varro's words:

> The fig tree standing beside the chapel of the goddess Rumina was planted by shepherds ... for there is the practice to make libations of milk rather than of wine or to sacrifice suckling pigs. For men used to use the word *rumis* or *ruma* where we now say *mamma*, signifying a teat: hence even now suckling lambs are called *subrumi*

from the teat they suck, just as we call suckling pigs *lactantes* from *lac*, the milk that comes from the teat. (117)

Many have repeated after Varro that the name of Rome comes from the word *rumi*, whereas from the later term *mamma* (derived, in turn, most likely from "baby talk": *ma-ma* is one of the first sounds that infants produce) was devised Linnaeus's eighteenth-century nomenclature for *mammalia* (mammals). As the etymology of the word *mammals* links together humans and animals through the breasts and udders it brings to mind, so also the imagined etymology of *Rome* connects not only wild beasts and founders but also humanity and divinity through the she-wolf's udders and the name of the goddess of breastfeeding.

Goddess Rumina's sacred plant was the fig tree, its opaque white sap reminiscent of lactation. Milk was routinely offered up to Rumina in religious rituals, its use indicating the simplicity and, hence (it is thought), the great antiquity of this goddess's cult. Unlike wine, which takes work, time, and wit to make, milk is a wholly natural, unprocessed substance. It is so simple that under the right circumstances, every female mammal can instantly produce it – unaided, uninstructed: Rumina "presided over the female breasts, and [her] oblations were of milk only" (Folkard 335). No wine for goddess Rumina, ancient sources specify; wine is linked with blood, as a popular Italian saying still announces: "wine makes blood" (*il vino fa sangue*) or, because it affects circulation, drinking wine is good for your overall physical health. Wine also is associated with the masculine body, whereas milk is feminine because only female mammals can produce it – although all young humans must partake of it. To extend the contrast between milk and wine, we read from Roland Barthes's essay, "Wine and Milk": milk is the anti-wine because "wine is mutilating, surgical, it transmutes and delivers; milk is cosmetic, it joins, covers, restores. Moreover, its purity, associated with the innocence of the child, is a token of strength, of a strength which is not revulsive, not congestive, but calm, white, lucid, the equal of reality" (60). This opposition between milk and wine – defined by Barthes as the tension between innocence and knowledge, mutilation and wholeness – goes back a long way. In his *Roman Questions*, the Greek historian Plutarch adds to the reasons for associating milk and never wine with the goddess Rumina:

What is the reason that, when the women do sacrifice to Rumina, they pour forth milk plentifully on the sacrifices, but offer no wine?

94

Solution. Is it because the Latins call a breast *ruma*, and that tree (as they say) is called *ruminalis* under which the she-wolf drew forth her breast to Romulus? And as we call those women that bring up children with milk from the breast breast-women, so did Rumina – who was a wet nurse, a dry nurse, and a rearer of children – not permit wine, as being hurtful to the infants. (236)

Milk is the anti-wine, as Barthes also claimed, and the two cannot come together. Much closer to milk than wine is the sap of the fig tree. In addition to being a useful additive in the making of cheese because its milky sap can replace animal rennet as a coagulant, the fig tree was believed in antiquity to hold magical properties. It physically and figuratively connected earth with the underworld through its roots, for example, and with the heavens through its branches. The worship of trees was a prominent cult in early religions, and the *Ficus Ruminalis* may have been venerated even before its association with Romulus: "Later legend, which preferred to find an historical or mythical explanation of cults, looked upon it as sacred because it was the scene of the suckling of Romulus and Remus by the wolf" (Bailey 8). In Genesis, Adam and Eve cover their genitals with fig leaves after they sin and are ashamed, leading some to wonder whether, in fact, Eden's infamous Tree of Knowledge was a fig tree; for centuries, fig leaves have covered the sexual organs of statues and paintings. The association of figs and sexuality persists in modern Italian with *fica* (the fruit of the fig tree with a feminine ending) being the most common, vulgar word for the female genitals (*fig* is also a synonym for "vulva" in both Latin and ancient Greek).

Possibly planted by ancient shepherds at the site of this goddess's shrine, the *Ficus Ruminalis* (Rumina's fig tree) was located at the foot of the Palatine Hill, in the Velabrum. It is there under Rumina's fig tree that the she-wolf found and suckled Romulus and Remus, and it is near the Velabrum that Romulus and Remus decided to found their city. In Plutarch's *Lives*, we read:

Near this place was a wild fig-tree, which they called Ruminalis, either on account of Romulus, as is generally supposed, or because the cattle there ruminated, or chewed the cud, during the noontide, in the shade; or rather because of the suckling of the children there; for the ancient Latins called the breast *ruma*, and the goddess who presides over the nursery Rumilia, whose rites they celebrate without wine, and only with libations of milk. The infants, as the story goes, lying there, were

suckled by a she-wolf, and fed and taken care of by a woodpecker. These animals are sacred to Mars. (32)

Giving milk under the milk-goddess tree: A more propitious place could not be found to save young human lives and to create a new capital city. The fame of the twins' legend, though, regrettably obscured that of the suckling, breastfeeding goddess who protected them when they were weakest: The fig tree became associated with Romulus in the popular imagination and not as much with Rumina anymore. The breast of the goddess's name, *rumis*, in this same imagination became the udder of the she-wolf: flesh-and-milk vehicle for Romulus's survival and, therefore, for Rome's birth. The name of the tree was remembered only as the udder of the she-wolf, not as the designation of the far more powerful goddess of milk and birth (Pais 54–57). Thus, the tree of Rumina became the tree of Romulus, and Rome, from hers, became his. The remembrance of Rumina's name was slowly erased from the people's understanding of this tree. Diva Rumina's cult dwindled and eventually all but disappeared – and, with it, the ancient memory of this goddess's beneficial role in the birth of Rome.

The final act of Rome's foundation was a bloody, fratricidal killing: Only one could be the founder of the Eternal City. The story until then had been one of collaboration, of milk and water – not only blood and gore: She-wolf and woodpecker, prostitute and herdsman, river and fig tree, fertility goddess and the god of war all worked together, their particular fluids flowing as necessary, to ensure the survival of the babies and their growth into healthy adulthood. Multiple influences, then, comprise the identity of Romulus: zoological and botanical, human and divine. He has Aeneas's Trojan and half-divine blood through his mother Rhea Silvia, spilled in rape and childbirth but also handed down to her two sons through conception and pregnancy. Rhea Silvia plays a minor but indispensable part in the legend of Rome, and she disappears as soon as her birthing task is done. She is a crucial link, however, because without her body, the necessary connections between Romulus and Aeneas and between Greece and Rome would vanish. Romulus and Remus also hold some of their father Mars's divinity within them: Their personality reveals the genetic link from the start, as Ovid writes in the *Fasti*, for "They suck the teats / Fearlessly, and feed on milk unmeant for them" (39). Romulus's fierceness, however, along with his wildness and his fearlessness, come not only from the god of war but also from the milk that nourished him as a baby: the milk of a wild beast, the processed blood

of a ferocious predator, through which his descendants will be known through history and literature, to use Henryk Sienkiewicz's wording in *Quo Vadis*, as "that wolf brood on the banks of the Tiber" (130).

MOTHER'S MILK AND POET'S MILK IN PROPERTIUS'S *ELEGIES*

The lasting effects of the she-wolf's milk ensure this wild animal's enduring presence throughout Rome's history: The city's inhabitants are forever marked by Romulus's "primal food" so that the she-wolf's essential characteristics – first imbibed by the founder with his greedy gulps of lupine milk – continued to be passed on from one generation to the next. Komunyakaa's twenty-first-century choice of the Roman she-wolf as object of poetry, his recognition of the significance for the future of Rome and the Western world inherent in the *Lupa*'s "tarnished stare" and "vulnerability," comes toward the end of a long literary, historical, and artistic genealogy that assumes the she-wolf as symbol of Rome and the circulation of her milk as formative of the Romans' character. An ancient one among these poets, Propertius, ambivalently represented the she-wolf as both an icon to be imitated and a predator to be avoided.

Little is known about Propertius except that he came from Assisi, in the Umbria region of central Italy (the same hometown as Saint Francis; Umbria was once rich in wolves), and worked in Rome in the first century BCE. In the fourth and final book of his *Elegies*, published in 15 BCE, Propertius wrote about the foundation of Rome and recognized the she-wolf's direct role in this historic event. Toward the beginning of the book, he compares his own poetic task to the maternal work of the she-wolf, particularly her act of feeding the twins with her milk:

> Best of nurses to our state, thou she-wolf of Mars, what walls have grown up from thy milk! The walls! These are the themes which I would set myself to treat in devout verse. Alas, the utterance of my mouth is so meager! Nevertheless, whatever stream shall flow out of the slender wells of my heart shall all do service to my country. (140)

Book Four, Propertius's final work, marks a change in the content and tone of the *Elegies*: There is a clear thematic, patriotic expansion from the poet's earlier personal themes, more narrowly focused on love. Whereas in the rest of the *Elegies*, the topic is the speaker's stormy, passionate affair with a woman named Cynthia, in Book Four the poet turns to the story of Rome's origins. His poetry is now etiological and no longer personal;

it is the elegy of the city of Roma rather than its palindrome, *Amor*. This is a more important type of poetry and it demands a stronger poetic voice. With this change to an unfamiliar subject, the poet declares that he needs help. Pleading ineptitude is a common strategy on the part of poets who want to capture the reader's sympathy. "Please forgive me if I am not quite up to the task," poets often say, and we readers are supposed to empathize and be impressed at how much better their poetry is than we were led to expect from their apologetic tone. Significantly, however, the first being that Propertius invokes in his apostrophe is not a Muse but rather a beast: the she-wolf, the very source of Rome's greatness. "Best of nurses to our state, thou she-wolf of Mars, what walls have grown up from thy milk!" The excellence with which the she-wolf performed her role of nurse – materialized in the generous flow of her abundant milk – produced the greatest of nations. What this line proclaims, then, is that the beast's milk is the maker of walls; the beast's milk is the builder of the city.

In his efforts to tell of the birth of his state, the poet compares himself to the she-wolf and his own work to hers. He wants to write of the walls sprung from the she-wolf's milk because that is the same patriotic task he has set for himself. The walls are a synecdoche, a part for the whole: These walls, metaphorically made of milk, metonymically stand for and represent the entire city. (Through the she-wolf's presence, these walls also remind readers of the first Roman wall built by Romulus and trespassed by Remus who, as a result, was killed.) The poet's voice is not loud enough to do Rome justice: "Alas, the utterance of my mouth is so meager!" The poet figures his own voice as a physical production of his body, much like milk is the physiological product of the she-wolf's body. Both voice and milk come from the chest, both move from inside the body to the outside world, both connect one's self with another's, and both are quite literally "expressed" in order to carry out one's job – nurse in one case, poet in the other. Whereas the she-wolf's milk was effective in building up the fierce spirit of a founder and a warrior within a helpless babe, the poet fears his own voice will not succeed in a comparably arduous task. So Propertius explicitly warns the reader, seeking sympathy: "Nevertheless, whatever stream shall flow out of the slender wells of my heart shall all do service to my country." The poet's chest, unendowed with the swollen udders that mark the she-wolf as a nursing mother, is unable to produce, to *express* words as effective in depicting the Roman state as the she-wolf's own chest production, the maternal milk she *expressed*, was successful in feeding the Roman founder.

However, for Propertius as for his fellow Romans, the word *she-wolf* evokes a beast that is not always desirable. Wolves are fierce and fearless, dangerous to human beings and their living possessions. Their females transmit their own fierceness and fearlessness to their young, not only genetically but also through the milk they provide. The wolf milk that Propertius seeks to imitate in the lines from Book Four of his *Elegies* quoted herein was described previously in the same book as a dangerous fluid. Just before evoking the she-wolf's milk as object of poetic imitation, Propertius denies that the she-wolf's role as foster mother to Romulus still affects the character of Romans: "The nursling of Rome has nothing from his first fathers but the name: shall he not believe that the she-wolf is foster mother to his race?" (139). In Book Two of the *Elegies*, however, Propertius criticized Romulus for his cruelty in dealing with the Sabine women, whom he and his men famously abducted with a sly trick when they needed to populate a new city filled with single men. Romulus invited the Sabine people to a festival in his new city and, at a prearranged signal, his companions carried off all the eligible young women who were among the foreign guests. Because of this act, for Propertius, Romulus is "him who can boast no mother but was bred up by the cruel teat of an inhuman she-wolf" (152). To the harshness of his nurse's teats Propertius attributed the savagery, beginning with the rape of the Sabine women, that smeared Romulus's reign. "Thou, Romulus, fostered on cruel wolf's milk, art a ringleader in this reproach; it was thy precept to ravish the Sabine virgins and fear not; it is by thy authority that Love now dares anything at Rome" (43).

The she-wolf's milk, however triumphant in building the city of Rome, also effected a lastingly nefarious influence: The Sabine women were among the first to taste its bitter flavor. When Propertius was writing centuries later, the consequences of that first savage food could still be felt: "Love now dares anything at Rome." Wolf milk is as ambiguous as the being that produced it: Ambiguity is constant in the she-wolf tradition. The same milk that built up Rome's walls – that is, the very milk to which Rome owes its greatness – made the Romans who they are for ancient writers: a fierce people, not unlike wolves, not above rape and bloodshed. This is also what the historian Justin (Marcus Junianus Justinus) stated in his *Epitome of the* Philippic History *of Pompeius Trogus*, written in the third century CE: "The Romans' founders ... were suckled by the teats of a wolf, so the whole race had the disposition of wolves, being insatiable of blood and tyranny, and eager and hungry

after riches" (38.6). Rome's contemptible kings – shepherds or soothsayers, exiles or servants – derived their dishonorable disposition from the she-wolf's feeding role in the constitution of their original king.

That the she-wolf's milk forever colored the Romans' blood was a theme that historians and writers employed in the centuries to come. In her 1826 futuristic fantasy, *The Last Man* – the last ten pages of which are set in Rome – Mary Shelley wrote that her rugged and manly narrator is "as uncouth a savage as the wolf-bred founder of old Rome" who "owned but one law, it was that of the strongest" (14). For Shelley, Romulus exemplifies wildness and savagery, qualities that he imbibed along with the milk of his wolf nurse, the essence of the one who bred and fed him. As historian of science Londa Schiebinger states, myths and legends "portrayed suckling as a point of close connection between humans and beasts, suggesting the interchangeability of human and animal breasts in this respect." As stories such as Romulus and Remus's testify, "Children were thought to imbibe certain characteristics of the animal that nursed them" (394–395). Not just children, in our case, but an entire people and a city too. Historian Orestes Augustus Brownson wrote in 1859, "The whole history of pagan Rome gives countenance to the old fable that her founder was suckled by a she-wolf, for her wolfish ways were always her most prominent qualities" (295). After quoting the required lines from Byron about the bronze, an 1854 guide to the Eternal City stated: "How true an emblem of Rome is this ancient bronze! Imbibing the wolfish instinct for blood and rapine, instead of the milk of human kindness, she became a huge beast of prey, the terror and scourge of the world, until her own bloated carcass was in its turn trampled on and devoured by the revengeful hordes her aggressions had provoked" (N. Hall 192). Rome's brutish arts reflect the Romans' brutish nature: "It was in one of her few moments of happy inspiration that Rome chose the she-wolf for her emblem, and acknowledged for her foster mother the most savage and untractable of the brute creation"; for this nineteenth-century architect, it is "with no slight feeling of disgust that one turns [from the Greek arts to] the vulgar ambition of the wolf-suckled Romans" (Fergusson 471). The entire history of Rome and the city's ultimate fate are both present already – distilled, as it were – in the she-wolf's milk. In 1878, British historian Goldwin Smith pointed out that "The Greatness of the Romans" (the title of his article) continues to be attributed to "their foster-mother's milk" because "That unfortunate She-wolf with her Twins has now been long discarded by criticism as a historical figure; but she still obtrudes herself as a symbolical

legend into the first chapter of Roman history, and continues to affect the historian's imagination and to give him a wrong bias at the outset" (Smith 109–110).

Through the milk of the she-wolf, our kinship as humans with other mammals is exposed in all its contradictions: Milk is what connects us to brutes; thus, it is a lowly, bestial, or (at least) less-than-human aspect of our humanity. Yet, milk is sufficiently life-giving and potent to convey to those who absorb it the characteristics of the one who produced it: fierceness and courage, in the case of the she-wolf, as well as ferocity. Through its verbal construction of this kinship, poetry may express both the most compelling of our appetites – hunger and reproduction, for instance: appetites that tend to place limits on our use of reason, as Roman history reveals only too well – and our instinctive altruism in preserving the weak and protecting the needy. Whatever the flavor of the she-wolf's milk and however powerful the loving mercy that this beast showed the babies in nursing them, the twins nevertheless swallowed the animal essence that it contained along with the nutrition the milk provided. As a result, along with Mars's divine blood, Romulus's descendants inherited the she-wolf's beastly milk. There is but one law in this Roman "wolf-eat-wolf" world, a world in which *homo homini lupus*, as the Roman playwright Plautus proverbially said, "man is a wolf to every other man" (502). It is the law of the strongest, a quasi-Darwinian survival of the fittest. It is the law of the wolves, and the she-wolves, and all those bred with the blood and milk of the she-wolf and her savage patron deity.

THE LANGUAGE OF HISTORIANS
AND THE MOTHER'S TONGUE

Her udders distended and made smooth by the milk they contain, her veins throbbing with savage blood, the bronze *Capitoline She-Wolf* looks intently at her viewer. The animal neither turns to the twins nor looks straight ahead, as she-wolves do when they are portrayed with babies suckling them. Her posture tells us that despite the obvious presence of milk in the eight full udders, this wolf is not at the present moment a nurse. Bodies, especially bodies as they are represented in art, speak a language that invites translation and encourages understanding. What does the she-wolf's body say to those who look at it? Did this body always speak the same language, did it always utter – silently, of course – the same words of self-explanation? Breasts are body parts that we are well used to reading and we can grasp their literal and figurative weight with

little effort: They signify, first, bodily nutrition, maternal protection, and the fulfillment of every newborn's basic need. Through their sheer presence, the she-wolf's udders speak even more unmistakably than women's breasts: Few would find these pendulous appendages arousing. Human breasts, however, connote sexual attraction along with their maternal function. As ambivalent as breasts and sharing several attributes with them is another body part that, like breasts and udders, protrudes from the rest of the body: the tongue. It is the organ of speech and the indispensable physical support of language. As vital as it is for speaking, the tongue is also important in eating and, to a more optional extent, in sex. The tongue is as embedded in history and culture as it is hidden within the oral cavity: It is an unseen organ, internal most of the time, external occasionally – and, in these cases, rarely without special significance. The tongue is usually concealed and invisible; although we cannot speak without it, the tongue does not speak its own meanings.

In more ways than one, the tongue is ambiguous: "Because 'tongue' (like the Latin '*lingua*' and the Greek '*glossa*') also means 'language,' the very invocation of the word encodes a relation between words and flesh, tenor and vehicle, matter and meaning" (Mazzio 93). The tongue is made of flesh, but the tongue is also the maker of those intangible signs we call words. The liminal position of this organ – its movements between the inside and the outside, between silence and speech – gives it a unique place in the figurative universe of the human body. "As the one organ that can move in and out of the body, its symbolic position in a range of discourses lies on the threshold between the framed and the unframed, between the space of the self and the space of the other" (Mazzio 97). The she-wolf's tongue, although barely visible on the bronze *Lupa* at the Capitoline Museum, is an important focus for the history and poetry dedicated to the first Roman nurse. In addition to her defining udders, Rome's poets and historians dwell on the she-wolf's tongue as the organ that allows the beast to openly express the force and effects of her maternity.

The earliest written account of Rome's origins and, therefore, the first mention of the she-wolf and her tongue are believed to be the work of a historian and senator, Quintus Fabius Pictor. He lived in Rome but wrote in Greek – the language of culture and prestige – and his words date back to the time of Rome's second Punic War against Hannibal (i.e., two hundred years BCE). Pictor's objective in writing his chronicles (it is always useful to know a historian's objective) was to inform the Greek-speaking civilized world about the new Roman superpower. Pictor draws

from and organizes earlier stories of how the city of Rome came to be, dwelling – as his Greek-speaking readers would have expected – on Rome's original association with ancient and divine genealogies: the Trojan Aeneas, heroic son of the Greek goddess of love, Aphrodite; and, later, the mighty god of war, Mars, father of Romulus and Remus, who sent the she-wolf to the abandoned babies. Pictor's written words have been lost and his account is available only indirectly through the retelling of two later Greek historians: Dionysius of Halicarnassus, whose works were published in the first century BCE, and Plutarch, who wrote in the second century CE. Dionysius's version of Pictor's story in *Roman Antiquities* is a straightforward narrative rich with figurative significance. These are Dionysius's words in a late eighteenth-century translation:

> The cradle... overturned, and threw out the children, who lay crying, and wallowing in the mud. Upon this, a she-wolf, that had just whelped, appeared; and, her teats being distended with milk, gave them her paps to suck, and with her tongue, licked off the mud, with which they were besmeared. (182)

The mud in which the twins wallow is Rome's fertile soil, the site of a future Eternal City; the mud is also a dark mask concealing – "besmearing" – the babies' noble lineage. The she-wolf, Mars's sacred beast, is a new mother: She "had just whelped." Her maternity is revealed by her "teats being distended with milk" but also in the act of licking. In turn, she reveals who the royal babies are by removing the mud even as, in so doing, she performs her uniquely maternal duties. For animals, because most beasts have no arms to hug, to lick one's young is a gesture of affection. Licking is also a way of giving identity to one's young: She-bears – most famously but not alone among mammals – were supposed to form their still-shapeless cubs with the repeated movements of their tongue, licking the crude forms until they attained perfection.

Although few people today can explain its origin, to "lick something into shape" is still used in idiomatic English. It describes the improvement of something imperfect, its active transformation from failure to success, from shapelessness into a proper condition. The origin of the expression comes from the lore of the animal realm. In ancient times, cubs (bear cubs were most frequently used as an example) were believed to be born as unformed lumps of flesh, which then needed to be "licked into shape" by their mother after birth. Only then would the cubs assume their species-specific appearance. This belief in the shape-giving ability of a mother's tongue was practiced well into the Renaissance. In Alexander Pope's

words, "So watchful Bruin forms, with plastic care, / Each growing lump, and brings it to a bear" (82). The belief, borrowed from Pliny the Elder's *Natural History* – "The mother then licks them gradually into proper shape," he says of bears (306) – in turn was derived from Aristotle's *History of Animals*: "After parturition she warms her young and gets them into shape by licking them," the Greek philosopher wrote of the female fox (193). It is even possible, some scholars have advanced, that the legend of Rome's origins substitutes a female wolf for the older, more widespread cult of the mother bear because by the time the she-wolf's story was being disseminated, bears were no longer prevalent in central Italy. However, wolves – the European mammals closest to bears in size and habits – were still quite common and commonly feared. What is generally acknowledged as the oldest example in Italy of a she-wolf licking a baby – that is, a funerary stone preserved in Bologna and known as the Stele of Felsina (named after Bologna's ancient name) – portrays what appears today much more like a bear or a lioness than a she-wolf, feeding the deceased her milk of eternal life. Like this nurse, the Roman she-wolf, in giving them suck, also gives the twins life and an indissoluble fraternal bond. By licking them, she reveals them to be and makes them into the royal heirs that they are: half-divine kings born of a princess descended of Aeneas, Rhea Silvia, and of a god – Mars, the wolf's master.

Better known than Pictor's is the Roman historian Livy's later account of the twins' encounter with the she-wolf in the first volume of his *History of Rome*. Livy lived between the first century BCE and the first century CE. Factual accuracy was less a priority for him than the elegance of his prose and emphasis on the moral development of the Roman people. By his own avowal, Livy had "no intention either to affirm or refute" the truth of Rome's prehistory because these traditions are "suitable rather to the fictions of poetry than to the genuine records of history" (15). Despite his misgivings concerning the factual accuracy of his own account, however, Livy was an astute writer, as well as an elegant one, and he understood that divine intervention at the moment of its foundation gave Rome increased dignity and unqualified honor. For this reason, Livy patriotically affirmed that:

> if any people might be allowed to consecrate their origin, and to ascribe it to the gods as its authors, such is the renown of the Roman people in war, that when they represent Mars, in particular, as their own parent

and that of their founder, the nations of the world may submit to this
as patiently as they submit to their sovereignty. (15)

This author is implying that the story is so wild that it cannot be
true: It is a story better suited to the poet's rather than the historian's
craft. However, if such sacred, divine intervention in fact could be true,
Livy says, then Rome, of all places, is the one most likely to hold such
improbable events within its past. Later in the text, Livy provided his
own version of the she-wolf's legend, which he prudently prefaced with
the phrase, "The tradition is. . . . " The cradle with the exposed twins
floats up to the shores of the Tiber, Livy wrote:

> where now stands the ficus Ruminalis (they say that it was called
> Romularis). The country thereabout was then a vast wilderness. The
> tradition is, that when the water, subsiding, had left the floating trough,
> in which the children had been exposed, on dry ground, a thirsty she-
> wolf, coming from the neighboring mountains, directed her course
> to the cries of the infants, and that she held down her dugs to them
> with so much gentleness, that the keeper of the king's flock found her
> licking the boys with her tongue. (20)

Livy did not specify, like Pictor, that the she-wolf had just given birth
and her udders sorely needed relief. Neither did Livy emphasize the
beast's connection with Mars and her stalking off to a sacred forest, like
Plutarch and Dionysius. Rather, the animal described by Livy is driven to
the river by a common and not specifically maternal physiological need:
She is as thirsty as the twins are hungry – a providential coincidence,
no doubt. As the beast is going down to the Tiber River to drink, her
maternal instincts get the best of her. She licks the foundlings in Livy's
account as she did in Pictor's, but this time there is no concealing mud
to be removed by the work of her tongue. Licking is performed with the
gentleness of shaping and bonding rather than the duty of revealing, for
the babies' identity could not have been any clearer.

LICKING LINES INTO SHAPE LIKE
A SHE-WOLF HER CUBS

When reminding their readers of the she-wolf's rescue, ancient histori-
ans described how the beast licked the babies: She licked them to clean
them, to reveal them, and – above all – to make them who they are. Like

historians but more explicitly and more self-consciously, poets rely on the use of their tongue: their mother tongue, the tongue of their ancestors, and the tongue that rolls words in the mouth to test their sound, feel, and effect before committing them to writing. The word *language* comes from the Latin *lingua* (tongue), which is why tricky sentences are "tongue twisters," excessive emotion leaves us "tongue-tied," and hard-to-recall words linger on the "tip of our tongue." In the past, the word *lingua* also was regarded by some imaginative scholars as originating from the word *ligare* (to bind). According to Bishop Isidore of Seville, "Varro thinks that the tongue, *lingua*, was named from binding food, *ligare*; others because it binds words" (Mazzio 98). In the she-wolf accounts, the tongue binds the maternal to the filial body; also, most shockingly perhaps, the tongue binds the body of the animal nurse to the human bodies that rely on it – bodies that depend on the beast's full udders and, just as shockingly, on the beast's vigorous tongue. This binding activity of the tongue and of language was especially fascinating to those Roman poets who were the near-contemporaries of some of the historians discussed herein: The she-wolf's animal tongue shapes and, in shaping, learns and tells. These ancient poets dwell, therefore, on the meanings of the she-wolf's tongue for both Rome and their own linguistic craft. By dwelling on the she-wolf's act of licking, these poets privilege a primitive bodily function – a function associated with femininity rather than masculinity – as the vehicle of poetic and historical truth. As anthropologist Kathy Neustadt noted, "Licking as a function of the lower senses is metonymically and culturally related to 'feminine' activity" (189).

Virgil is remembered most often as the author of the *Aeneid*, the epic poem of Rome's origins (dating to the first century BCE). The painstaking care Virgil used to craft his lines is among the most significant anecdotes regarding this poet, about whose life little is known. Classical scholar C. E. S. Headlam aptly mused that although Virgil could pour out without difficulty hundreds of lines, he only held on to a fraction of them, and these he "polished as a she-wolf licks her cubs into shape" (23). This notion of Virgil revising his verse the way a mother wolf shapes her cubs is not Professor Headlam's original invention. That Virgil saw himself as a maternal she-wolf could be read, we are told, in the now-lost biography of the poet authored by the historian Suetonius. According to a later biography of Virgil, based on Suetonius's lost one and titled *Vita Donatiana*, Virgil produced verses the way a she-bear produces cubs: shapeless and formless. Only later did he shape and form them into publishable lines: "We are told that every day he used to dictate a very

large number of verses which he had worked out in the morning, and during the whole day he would work them over and reduce them to a very small number, aptly saying that he gave birth to a shapeless poem like a mother bear giving birth to a cub, and that at long last he licked it into shape" (Eden 26). This licking-as-shaping image is repeated in a variety of critical sources that describe Virgil's craft with the unusual analogy between literary and zoological process – between the instinctual work of an animal mother and the painstakingly self-conscious work of a human (and male) poet.

The figure of the she-wolf, busy in her formative task of licking, belongs to the background of the entire *Aeneid* as a metaphor for the poet's own practice. More specifically in this epic, the she-wolf episode is described in Book Eight, which recounts the infancy of Rome's founder. Aeneas lived several generations before his twin descendants; Romulus had not yet been born when the events of the *Aeneid* take place. Virgil therefore resorts to a literary device: He uses *ekphrasis* – that is, the poetic description of a work of visual art (Byron's and Komunyakaa's ekphrases of the bronze *Lupa Capitolina* are discussed in Chapter 3). Virgil's ekphrasis concerns a mythological rather than a material work of visual art: the shield crafted for Aeneas by the blacksmith god, Vulcan. Special-ordered for her heroic son by Aeneas's mother Venus – the Roman name for the Greek goddess Aphrodite and also Vulcan's wife – the surface of the shield was decorated with scenes of the future history of Rome, from the she-wolf's rescue of the city's founder to Virgil's own time. Aeneas's shield is the most symbolic object in the entire *Aeneid*, and it epitomizes an ideological moment of great import. In the lines depicting this shield, Virgil chose which of Rome's legendary and historical moments most deserve to be predicted at the time of Aeneas and, thus, to be remembered in centuries to come. For the poet Virgil, these chosen legends, these selections from history, lie in the past; for the characters in his epic, Aeneas first, they are all yet to come. They feature the military success of Rome and represent it "from the particular angle of the preservation of the city and/or its local or international supremacy in moments of acute danger" (S. J. Harrison 71).

The story of the she-wolf naturally comes first. The setting of Virgil's retelling is "Mars's green cavern," the Lupercal, a lively image of freshness and fertility in its unexpected greenness – the picture Virgil described is engraved on metal, not painted. Coincidentally, it is thought that the actual site of the Lupercal cave – or, more precisely, the shrine that Emperor Augustus declared the sacred site of the she-wolf's rescue – was

first identified in 2005 and excavated in late 2007. Today, it is a sub-
terranean cave, 7 meters below the current ground level; partly natural
and partly artificial, it was made precious during the Augustan age with
colored-marble mosaics and other decorations. Characteristically mater-
nal for its protective, enclosing qualities, the she-wolf's cave is reminiscent
of a mother's body but also, more generally, of the *fecunditas* and *ubertas*
(fertility and richness) that were key concepts in Augustus's political pro-
gram (the second term is derived from *uber*, meaning women's breasts
and female udders). Both martial and maternal, the she-wolf stands for
the astonishing revolution that turned the most fearsome and predatory
of cities into a common home for humankind (Picard 263):

> There, too, he made a mother-wolf, reclining
> in Mars's green cavern; and at play beside her,
> twin boys were hanging at her dugs; fearless,
> they sucked their mother. She, at this, bent back
> her tapered neck to lick them each in turn
> and shape their bodies with her tongue.
> (Virgil 219)

In his account of Rome's birth on the shield of Aeneas, Virgil focused on
place – namely, the Lupercal at the foot of the Palatine Hill, where the
twins were nursed and near which, some years later, Rome was founded.
The poem insists on the active presence of the god of war, Mars, in
both geography (the cave is his and is clearly denominated: "in Mars's
green cavern") and genealogy: The twins belong to Mars no less than
the cave does for they are, like their father, "fearless." Similar to the cave,
the twins are traces of the god of war's past and current presence. The
twins nurse hungrily while the wolf mother feeds them; she is described
as *fetam* (pregnant or, more likely, having just given birth). At the same
time that she gives them suck, the wolf makes the babies into who they
are with her busy tongue: She leaned back to "shape their bodies with
her tongue." Although the babies are never named, their identity could
not be any clearer. Inspired by her divine martial protector, the wild
beast knows to form shapeless baby boys as human bodies rather than as
wolf cubs. In rescuing the babies, in feeding and shaping a boy named
Romulus in a place that will soon accommodate the city's first walls, the
she-wolf rescued and shaped Rome itself.

There is nevertheless certain danger in this gift of milk and in the
twins' reliance on the beast's protection. Virgil's identification with an
animal mother's licking activity as his own is likewise risky. If Virgil is

like a she-bear or a she-wolf, the text he licks into shape is like Romulus. Through such parallels, a critic noted, "what Virgil himself is doing is licking into shape not only a story but Roman history itself, making it into an artifact via which he can aestheticize, again, the violence of the struggle to found an empire" (Bartsch 330). History is messy and bloody, whereas the she-wolf's licking softens it, shapes it, and makes its beastly nature more sympathetic and human-like.

Incidentally, in nineteenth-century guidebooks, Virgil's she-wolf lines in the *Aeneid* were inexplicably understood to be a description of the visibly different bronze *Capitoline She-Wolf*. For example: "Virgil also seems to have had this group in his eye when he so graphically pictured the twin brothers as fearlessly sporting round the udder of their fierce foster-mother while she, with reverted neck, caressed them alternately and moulded their bodies with her tongue" (N. Hall 191). This statement is clearly misguided: Unlike the *Lupa Capitolina*, Virgil's she-wolf is crouching, not standing, and she is licking the babies, not staring at her viewer.

Influenced by Virgil and writing a few decades after him, the poet Ovid also told the tale of the she-wolf and twins. His version is found in Book Two of the *Fasti*, Ovid's last work, which consists of six books dedicated to explaining Rome's numerous festivals and is an invaluable source for understanding Roman religious practices. Like Virgil's *Aeneid*, Ovid's *Fasti* insists on the visible effects of Mars's paternity: Anyone looking at the twins' fearlessness and their eagerness to seize that which was not theirs (the "milk unmeant for them" is Ovid's description of their first nourishment) can see in the babies a clear mirror of the god of war's own temerity:

> There was a tree: traces remain, and what is now called
> The Ruminal fig was Romulus's fig.
> A whelped she-wolf (marvel!) came to the abandoned twins.
> Who'd believe the boys weren't hurt by the beast?
> Far from harming, she even helps them: a she-wolf suckles
> Those whom kindred hands were braced to kill.
> She stopped; her tail caresses the delicate babes,
> And she shapes the two bodies with her tongue.
> You could tell they were sons of Mars. They suck the teats
> Fearlessly, and feed on milk unmeant for them.
> The wolf names the place and the place the Luperci;
> The nurse was well rewarded for her milk.

(39)

By Ovid's time, the tree had already become Romulus's own, and the goddess Rumina is unmentioned in this text. Unlike Virgil, who set the scene within a maternal Lupercal cave (a cave hallowed by Augustus, with whom Virgil certainly had a better relationship than Ovid), the author of the *Fasti* placed the nursing wolf under the Ruminal fig tree and added a caressing tail to this picture of maternal care. In this context, the tail is a nurturing, tongue-like appendage − a sign of affection rather than aggression or fear. Ovid chose the same Latin word as Virgil when he described what the she-wolf does to the twins with her tongue. The verb *fingere* is the one both poets used, a verb that does not literally mean "to lick" − which would be a rather predictable word choice, for what else can one do with one's tongue? − but rather "to form, to shape," often even "to invent." Indeed, the verb Ovid and Virgil selected to tell of the she-wolf's licking, *fingere*, is the root of the English word *fiction*. What is known about Virgil is not said of Ovid − namely, that he regarded the polishing of his own verses as an activity analogous to that of a mother animal licking her cubs into shape. Yet, Ovid's she-wolf also forms the twins the way a writer shapes his poetry: with a tongue that is both flesh and speech, a tongue that invents a body even as it finds the words to tell of the past. The she-wolf's tail gives affection, her teats give milk, and her tongue gives shape. The shape of the babies is the shape of the story − its "fiction," its narrative, the words that will make it eternal. For indeed it is the she-wolf, Ovid stated, who "names the place," a place that will, in turn, name the Luperci. (The Luperci are the young men who, as Ovid detailed in his *Fasti*, ran around the Palatine Hill during the Lupercalia festival dressed in goatskins, using leather thongs to whip the women they encountered to assure their fertility; it is a popular belief that the celebration for the patron saint of lovers, Valentine's Day, in mid-February like the Lupercalia, was the Church-sanctioned successor to these pagan fertility rites.)

The poet Propertius compared his poetic undertaking to the she-wolf's rescue: Both his and the beast's better-endowed chest perform the act of expressing and producing: verses for the former, milk for the latter. Bodily expressions both, the poet's verses and the she-wolf's milk facilitate and make possible the greatness that is Rome. The poets Ovid and Virgil likewise equated the movements of the she-wolf's tongue with those of their pen, of their words; they too must "lick meaning into shape" like a she-wolf her cubs. Poetry mirrors the acts of feminine biology but its rhymes could only be masculine; only a few lines of Latin poetry by an ancient woman, Sulpicia, possibly exist (their authenticity has been

questioned). Although of necessarily masculine origin, Virgil's and Ovid's verses nevertheless replicated the uniquely feminine processes of lactation and of licking into shape. The latter act only seems less gender-specific than nursing; it is not. Although male and female animals both have tongues, only mothers can shape their offspring; that is, females alone may *fingere* their young.

The definition of *fingere* is to feign, to make fictions, to invent, to form, to relate, to fable. Among the assorted meanings of this loaded Latin verb, which belong to the realm of history and which are the province of literature? Livy said at the beginning of his *History of Rome* that the stories of early Rome belong more to the realm of poetry than to that of history. The association between poetry and untruth through the verb *fingere* is an old one. As one critic stated, "Plato did not succeed in burying poetry but the unsavory association of artistic inspiration with untruth which he had imputed to it lasted throughout the age of symbolism. It was reflected in the Latin word for the creation or composition of poetry, *fingere*, the origin of our word 'feign'" (Raybould 116).

Regardless of the ambiguity of the expressions used to speak of poetry, it is difficult to see how the verb *fingere* – although it defines the fictional production of poets and the supposedly truthful telling of historians – could also describe the she-wolf physically licking the twins. This is the work of a mother completing the coming into being of those she birthed; it is a bodily act that extends her physical connection with her offspring beyond pregnancy and in addition to breastfeeding. Surely, what she does is not about poetry; then again, to compose poetry is to "make," from the Greek *poein*: A *poema* is a "thing made." Latin poets regularly use the verb *fingere* as a synonym for writing poetry: *Fingere* is what poets do.

Fingere, however, is also what she-wolves do and what mothers, in general, cannot help but do: to make and to bring into the world "things made" – poems, that is. *Fingere* means to create or to imitate creatively: The work of mothers and the work of poets, from this perspective, are the same. Both mothers and poets produce an individual where none existed before; yet, what they do has already been done countless times. For when they write, poets and historians imitate their predecessors and re-create the past by shaping it with their words. When they lick, she-wolves imitate the action of all mothers who came before them, reproducing the looks of the animals that they must help their offspring to become – with their tongue. Writers and mothers, men and wolves, work in place and in time, following tradition and renewing it with the labor of their tongue. They move their tongue around a young one's body and they

move their tongue around new words. The practice of she-wolves and of poets binds all that came before them with all that is to come. In the history and literature of ancient Roman times, the she-wolf embodies a telling example of making, contriving, and imitating: In saving and creating Rome's future founder, her nursing and licking envision the birth of the Eternal City as well as the verbal telling of this creation. The she-wolf saves and preserves the future of Rome much like poets and historians preserve the city's past. All of this, the poets self-consciously remind us, is the work of *fingere*: the work of making and the work of all who speak and nurture.

THE SHE-WOLF BETWEEN WILDNESS AND PROSTITUTION

The historians' and poets' excerpts discussed thus far take literally (although some of them not for long) the notion of the she-wolf as the savior of two abandoned twins. This foster mother's identity, however, is contested and not necessarily animal. There may be a woman hiding behind the furry surface of the ferocious beast. First, she could be Rhea Silvia herself, Romulus and Remus's biological Vestal mother; the name that tradition attributes to this woman is significant and related to her maternal role and animal identity. Afraid to pronounce the predator's name for fear of attracting the animal's ire, the adjective *sylvan* (of the forest) indirectly calls the forest-dwelling wolf through Rhea Silvia's related – although far less dangerous – name. Romulus's connection with the forest is deep-seated: "He was born of Rhea Silvia and belongs to the Sylvian family line; as an infant he is mothered by the forest's mythic figure, the she-wolf; and as a child he grows up in the forests" (R. Harrison 48). Nevertheless, Rhea Silvia is singularly overlooked in the story of Rome's founding, even though it is through her blood alone that Romulus may be said to descend from Aeneas. This glaring neglect of the founder's biological mother provides further evidence of how the two legends – one Greek and the other Roman, one starring Aeneas the foreigner, the other Romulus the local boy – ultimately were not connected after all.

Whereas Rhea Silvia was a virgin – at least, until Mars met her – the nurse known as the she-wolf appears to have been another sort of woman. The she-wolf, it is said by Roman tour guides – who speak as if sharing a secret known to just a select few – was not a she-wolf at all. The she-wolf, they tell you conspiratorially, was a whore. This risqué historical

notion, talked about by Romans since at least the third century BCE, is generally kept from schoolchildren. Many Italians, therefore, although taught about the she-wolf throughout their school years, reach adulthood without having learned that the furry beast may have been a lusty whore. As if finally privy to a salacious secret about a being they always knew as something else, they relish learning the rumor as much as tour guides delight in telling it: The Roman nurse they were taught as a child to be grateful to and revere was actually a prostitute. The she-wolf was a whore; imagine that.

That the word *lupa* in Latin means *prostitute*, that Romulus's foster mother may have been a whore, is not exactly the latest gossip. Brothels in Rome were generally called *lupanars* and a *lupa*, as a name for a sex professional, was particularly nasty. In the ancient world as in our own, there was more than one way to practice the profession, some more acceptable and less dishonorable than others. The way *lupae* practiced their skills ranked low in the hierarchy of the business: It was regarded as particularly indecent to seek and satisfy clients, for a small price, in the streets and in cemeteries – as *lupae* were known to do (Flemming 48–49). At the same time, their name linked the professional she-wolves with the god of war, Mars, whose sacred animal was a wolf, and with the soldiers who performed the bellicose god's work on earth. Symbolically, the *lupa*, the female of the *lupus*, was the wolf's opposite: Whereas the wolf figured military virtue – the sacred soldier's body – the she-wolf embodied the prostituted body. The fact that the she-wolf became Rome's emblem shows how central prostitution was in the life of ancient Rome: Prostitutes shaped the feminine urban space of Rome as well as the city's masculine space of war (Dupont 42). Or, in literary critic Peter Stallybrass's puzzled rhetorical question about the she-wolf's role in the birth of Rome and the problematic relation between gender and the formation of the state: "Did the Roman state, then, emerge from what was most antithetical to it: from a femininity inscribed as bestiality and prostitution, from all that stood over against what the state came to define as civic virtue?" (210).

Selling the use of one's body for another's sexual enjoyment is a uniquely human activity, yet antiquity described it with an animal name because of basic parallels between women and she-wolves. These similarities were perceived by both late antique pagans and early medieval Christians: a shared obscenity and the same smell – not to mention a proclivity for licking, as the Latin commentator Servius (a pagan) noted in the fourth through fifth century – and a common avidity with respect

to men, as Isidore of Seville, a sixth- through seventh-century Christian archbishop, concluded (Petronius 264–265; Isidore 223). The she-wolf is a rapacious beast, but it is not only her maternal instinct that makes her so: She is a predator and a man-eater not only to feed her young. The she-wolf has been likened to a prostitute and for this reason the lowest of prostitutes in ancient Rome (i.e., those who beckoned to men in the streets and in cemeteries) were called she-wolves (*lupae*): Prostitutes and she-wolves smelled alike, prowled in similar ways, and shared a common indecency.

The identification of the nursing she-wolf with a professional sex worker is ancient, first appearing in the work of the poet Quintus Ennius (239–169 BCE). In the age of Augustus, he was regarded as the father of Roman literature. The woman that Ennius evokes through the name and shape of the she-wolf is not Rhea Silvia but rather Acca Larentia, wife of the royal herdsman, Faustulus – the man who finds the babies being suckled by the she-wolf in the Lupercal cave and takes them home. In this scenario, the she-wolf stands for Acca Larentia: In caring for Romulus and Remus, she replaces both the furry she-wolf, the babies' first nurse, and the virginal Rhea Silvia, their biological but ineffectual mother (Staples 63–66; Cole 536).

That the she-wolf should be made a woman and named Acca Larentia was the inevitable conclusion of an increasingly skeptical people: Romans were having a difficult time accepting the she-wolf story as a literal explanation of their origin. The new understanding was derived from a metaphorical use of the word *lupa*, which was no longer only the wild canine commonly feared by shepherds and their flocks but also – more intriguingly and realistically – a prostitute. Although the story of the animal she-wolf was not a believable one to the average Roman, the complete elimination of the beast was even more unthinkable. Homonymy and the opportunely ambiguous meaning of the word *lupa* supplied poets and historians with a convenient and spicy compromise. Thus, two centuries after Ennius, Livy explicitly informed his readers of the she-wolf-as-prostitute connection, following the description of the twins' rescue cited previously. Although he admitted that this understanding of the she-wolf's identity is founded on popular opinion rather than irrefutable evidence, the Roman historian presented it as most probable. Livy wrote that the twins, removed by the king's swineherd Faustulus from the she-wolf's gentle care, "were carried by him to his homestead to be nursed by his wife Laurentia. Some are of opinion that

she was called Lupa among the shepherds, from her being a common prostitute, and that this gave rise to the surprising story" (20–21).

About a century later, Plutarch reported a similar version of the facts. In telling the fable, the Greek historian also referred to the multiplicity of voices that comprise the tradition and to the unfortunate ambiguity of the Latin language. Plutarch wrote in Greek, which he clearly understood to be a superior tongue: "Some say, the ambiguity of the nurse's name gave occasion to the fable; for the Latins call not only she-wolves but prostitutes *lupae*; and such was Acca Larentia, the wife of Faustulus, the foster-father of the children" (*Plutarch's Lives* 32). The "some" to whom Plutarch referred at the beginning of this passage include his predecessors, the Roman historian Livy and his Greek colleague Dionysius of Halicarnassus. In Dionysius's *The Roman Antiquities*, we read an analogous version also based on hearsay and a chorus of opinions and views:

> But others, who hold that every thing, which has the appearance of a fable, ought to be banished from history, maintain that the exposition of the children, by the officers, contrary to their orders, is void of all probability, and laugh at the tameness of the wolf, that suckled them, as an incident, fraught with theatrical absurdity: Instead of which, they give this account of the matter . . . that the nurse, who suckled them, was not a she-wolf, but (as may well be supposed) a woman, who was wife to Faustulus, by name Laurentia, who, having, formerly, prostituted her beauty, was, by the inhabitants of the Palatine hill, surnamed *Lupa*; which was an ancient Greek appellation, given to women, who prostituted themselves for gain, who are, now, called, by a more decent name, . . . *Friends*: And that some, who were ignorant of this, invented the fable of the she-wolf; that wild beast being called, in the Latin language, *Lupa*. (195–196)

Rather than question the workings of Latin, Dionysius alluded to the debts of this language to his own Greek tongue; for even the word *lupa*, he wrote, ultimately comes from the Greek. The Latin language has not evolved as well as its Greek counterpart, Dionysius seems to imply, when he added that "some who were ignorant of this invented the myth of the she-wolf, this animal being called in the Latin tongue *lupa*." The legend of the she-wolf, according to Dionysius, is not due to the Romans' gullibility but rather to their extensive although imperfect use of metaphorical language. This poetic inclination is derived – the

Greek Dionysius was quick to point out – from the Greeks, for the Romans' cultural and linguistic debt to their Mediterranean neighbors is a constant in ancient history and literature.

The name "Acca" is related to the Sanskrit word for "mother." Acca Larentia was regarded in Rome as an "earth mother" of sorts, nourishing and life-giving; however, it is not known whether this divinized Acca Larentia is the same person as Faustulus's wife. She is also a chthonian deity – a goddess, that is, who belongs to the underworld: It is to the abode of the dead that Acca Larentia takes her children at the end of their life. This life-giving divinity is the goddess of the underworld because, paradoxically, when a mother gives birth, she also condemns her offspring to sure death. In the ancient world, chthonian divinities often assumed the shape of a wolf, and the festival known as the Larentalia was a celebration of the cult of the dead. Acca Larentia was revered not only because she performed a great service to the Roman people by raising their first king but also because of her monetary bequest to the city of Rome. A public prostitute, Acca Larentia left her enormous wealth, which she earned by selling sexual favors, to the Roman people. This is the other side of her story or perhaps another story entirely: Nurse and benefactress, Acca Larentia is generous with her mothering skills – embodied in her nourishing milk – and equally with her financial assets. (The theme of the big-hearted whore has had a long life in Italian culture, as anyone familiar with Fellini's films knows.) Ancient Romans knew about the double meaning of the *lupa* they honored but did not make too much of the rescuer's profession. They were grateful to her for saving their founder and for the money she left to them.

MIDDLE AGES AND RENAISSANCE

MISOGYNY AND THE SHE-WOLF FROM TERTULLIAN TO MASUCCIO

U NLIKE THEIR PAGAN PREDECESSORS DISCUSSED IN CHAPTER 4, EARLY Christian writers were not as tolerant of sexual promiscuity, no matter how generous – with milk or money – were the women who practiced it. In his tract titled *To the Nations*, Tertullian (ca. 155–230), the first great writer of Latin Christianity, rather predictably thundered against the "abominable cases" of shameless veneration of unworthy divinities – Acca Larentia, first and foremost. She is honored, Tertullian inveighed, even though "she was a hired prostitute, whether as the nurse of Romulus, and therefore called *Lupa*, because she was a prostitute, or as the mistress of Hercules, now deceased, that is to say, now deified" (486). Tertullian described this woman's two major identities: He saw Larentina (i.e., Acca Larentia, her name having several variations) in either the *lupa* who rescued and nursed Romulus (no great honor; Tertullian had little respect for Rome's founder, in his view a trickster, fratricide, and rapist) or in the wealthy prostitute who had received great riches through Hercules's help and at her death bequeathed her fortune to the Roman people. In gratitude, the Romans deified her. However, what could be the distinction of accessing heaven for heathens and of becoming divine if prostitutes "mount it in all directions" too? Another early Christian writer, Lactantius (third–fourth century CE) – probably from North Africa like Tertullian – likewise ironizes, in his discussion of the Romans' divinization of the she-wolf: "Now how great must that immortality be thought which is attained even by harlots!" (54). The idolized she-wolf, Lactantius reminds his readers, is not an animal but rather "the wife of Faustulus, and on account of her prostitution she was

called among the shepherds (*lupa*) wolf, that is, harlot, from which also the brothel (*lupanar*) derives its name" (53).

Women in general, for these authors, do not fare much better than their wolfish peer: In Tertullian's words, woman, any woman, is "the Devil's gateway" – probably his most notorious statement and one that earned him his reputation as the first great misogynist in the Christian tradition: More than anything else, woman is an obstacle to man's salvation. For Tertullian, a prostitute and an adulterous mistress are much the same, equally deserving of being turned by history and metaphorical language into fearsome wild animals – and certainly not into beings worthy of worship.

For centuries to come, the misogynous tradition that Tertullian especially engaged in so stridently (Lactantius was not quite so raucous on this subject) continued to represent the she-wolf's narrative – for example, in literature and art, history and politics – as a formidable parable of unbridled female sexuality. In many cases, perhaps most, only the she-wolf is mentioned and the tale of Romulus and Remus with their animal nurse is not explicitly narrated or even invoked. It does not need to be: The metaphor of woman as she-wolf always contains it, whether in the author's intentions or the reader's perception, whether in the context that allows complex signification to take place or the cultural code that makes the world intelligible at all. She-wolves may not be mentioned in the West without that first Roman she-wolf turning up somehow, somewhere. In this narrative, the siren call of the female body is a threat to man's salvation here on earth as well as in the world beyond. The metaphor of woman as dangerous sexual temptress or even aggressive predator is embedded within a wider misogynist discourse, and it was to remain prevalent in numerous literary and cultural texts of the West throughout the centuries. The socially sanctioned discourse of misogyny, as Howard Bloch noted in his seminal book on the topic, was so persistent that "the uniformity of its terms furnishes an important link between the Middle Ages and the present and renders the topic compelling because such terms still govern (consciously or not) the ways in which the question of woman is conceived – by women as well as by men" (6).

There is something timeless about misogyny and we find concepts analogous to Tertullian's (second–third century) but especially Servius's (fourth–fifth century) and Isidore's (sixth–seventh century) – whose identification of woman as she-wolf we encountered at the end of Chapter 4 – in a thirteenth-century French bestiary, for example. Richard

de Fournival's *Le Bestiaire d'amour* (The bestiary of love) expounds on the common traits of both women and wolves: The she-wolf's inability to turn her neck without turning her whole body is identified with woman's incapacity to give of herself in any way other than physically; the she-wolf's search for food immediately after giving birth to her cubs is indicative of woman's inconsistency, figured in her inability to stay with the ones she loves; and as the she-wolf punishes herself by biting her own paw if she snaps a twig under her foot while hunting, so also woman is capable of reversing her actions, of skillfully concealing her own mistakes. Richard de Fournival, writes Jeanette Beer, "is supremely interested in any lupine property that can be made applicable to the human female. Having assembled these properties together, the accumulated evidence of his zoological description leads inevitably to an acrid indictment of women" (29–30).

This zoological analogy between woman and she-wolf becomes more allegorical in one of the first stories that form the anonymous *Roman de Renart*, the Old French beast epic from the twelfth century (there are versions from other times and places) telling the adventures of a well-known medieval trickster figure, Reynard the Fox. The enduring hostility between the fox and the wolf is a major theme of the Reynard stories, and it is attributed to the fox protagonist's adultery with and rape of Hersent the She-Wolf – the notoriously lascivious wife of a powerful court baron, Ysengrin the Wolf. It is the She-Wolf who first seduces the Fox, who in a later episode rapes her in full view of her jealous but powerless Wolf husband; Reynard's adultery with She-Wolf and his trial for her rape are central incidents of the epic (Subrenat 18–19). The animal protagonists of this satire are the traditional allegories of guile and wit (the Fox), arrogance and power (the Wolf), and, of course, lust (the She-Wolf). Hersent's animal identity makes the excesses of her sexual identity a given: "Of course, by the very fact that she finds herself in a tale that relies on punning and ambiguity, on a language that does not make unequivocal statements," writes a critic, "the she-wolf must, according to the text's curious logic, be represented either as whore or adulteress . . . damage could not be done to her reputation, because she never had one to begin with" (Simpson 42).

The misogyny shaping the notion of the she-wolf as lascivious woman – in Tertullian as in Servius, in Isidore as in Fournival and the Reynard stories – is "an important link," to borrow from Bloch, which allows readers to seamlessly jump ahead from North African late antiquity through the French Middle Ages to the early Italian Renaissance, and

to the she-wolf as the very face of female lust in the work of Southern Italian writer Masuccio Salernitano (this is the pen name of Tommaso Guardati, ca. 1415–1474). In a collection of fifty short stories known as *Il Novellino* (1475), Masuccio repeatedly claimed that women are born with a defective nature: They are incapable of constancy or resolve; they are unfaithful, uncharitable, vengeful, and suspicious; they are ruled by envy as their heart's central passion; and they never let themselves be guided by reason. These are the principal defects of women that a wise friend in the twenty-first *novella* enumerates to the hapless protagonist Bertramo to dissuade him from courting Fiola, a friend's wife. His final argument makes of woman a wild and lustful beast – a she-wolf, in fact:

> And as a proof that these words of mine are true, let us call to mind how often in these our times we may have seen some particular woman, loved and courted by many different gentlemen of worth, and lovers gifted with every virtue, who at the same time will, taking the libidinous she-wolf for her model, turn her back upon them all, and give herself to the embraces of some base villain filled full of every wickedness. (2: 15)

The wise friend's general statement is proven true by the tale of a certain wolfish woman in the twenty-fourth *novella*. The story is so ignominious, Masuccio informed his readers, that he refrained from providing the names of characters or places – thereby conveying both the referential illusion of the story's reality and the sense that the story is about everyone and could have happened in any city: She-wolves, Masuccio implied, are everywhere. In love with a beautiful married lady who has led him on for years without giving herself to him, the young protagonist hides in her house with the intention of raping her. He is shocked instead to see her having sex with a Moor: Anxiety about sexual purity compounds in this passage with the fear of racial contamination. The youth comes out of his hiding place with accusing words, and the lady begs him to kill her to spare her the dishonor of being labeled an adulteress – and with a Moor no less. The would-be lover (and, let us not forget, rapist – but he is portrayed as a sympathetic character) instead inveighs against female promiscuity and the she-wolf that is its most spectacular image:

> Oh wicked and most wanton she-wolf, shame and eternal infamy of the residue of womankind! Through what frenzy, through what passion, through what lustful desire have you suffered yourself to be overcome

and subjected to a black hound, a brute beast, or, as it is more meet to
say, a monstrous spawn of the earth, like this snarling cur to whom you
have given, as a repast, your own corrupt and infected flesh? (2: 57)

The she-wolf's wickedness and lust have infected not just this woman's
sexual partner – brutish and even monstrous for this text: a Moor –
but also every female in Masuccio's book: Women's inevitable trans-
gression, although highly predictable if we are to take such discourse
seriously, cannot be predicted by innocent men. Women derive shame
and infamy from their inner beast's inability to resist the basest of female
instincts; the lupine nature is their true self. Whether named or nameless,
whether Rhea Silvia, Acca Larentia, or anonymous hooker, the she-wolf
of Rome's founding continues to embody the nature of a whore, a literal
or metaphorical dweller of what are still known today as *lupanars*. This
allegorical wolf woman persists in infecting men's virtue and pervading
written texts about exactly what women are and about what it is, in the
end, that women want.

Like misogynist writings in general, Richard de Fournival's *Bestiaire*
and Masuccio Salernitano's *Il Novellino* are repetitive and derivative in
their accusations against women and, particularly in their case, women's
animalization. Such thematic and stylistic monotony is not unique to
these texts; rather, it is due to the fact that, to a large extent, misogyny
lacks an internal history for two main reasons. Thematically, it describes
"woman" (while staying away from individual "women") as a univer-
sal, essential, and immutable category, impervious to historical change;
and stylistically, Bloch observes, misogyny is "a citational mode whose
rhetorical thrust displaces its own source away from anything that might
be construed as personal or confessional. No one admits to antifemi-
nism" that is, preferring instead "to cite the sacred authorities" (47). The
authorities, in the case of the she-wolf, are Roman historians and poets
of such fame that they need not be named, their canonical texts having
disseminated legends and gossip – when the discourse of misogyny made
it expedient to do so – turned into undeniable facts, into a holy scripture
of sorts (despite some of the ancient writers' own caveats concerning the
reliability of their accounts and despite their relative acceptance rather
than demonization of the rescuer's sexual profession). The frenzied, lust-
ful passion of she-wolves is the concrete, animal expression of woman's
more intangible wickedness and wantonness: In the allegorical tradition
of misogyny, the identification of woman and she-wolf is thorough.

DANTE'S BEAST AND THE ALLEGORY OF GREED

The discourse of misogyny displays a special affinity with allegory – that rhetorical figure that makes an individual character the representative of a type and with which the figure of the she-wolf entertains an especially close relationship. The word play implicit in the Latin *lupa* hints at the multiple and usually pejorative readings to which this animal name may give rise and, therefore, to its allegorical potential. The relationship between literal and allegorical meanings, however, is both conventional and slippery: Interpretation according to appropriate cultural codes is necessary for an adequate understanding of each allegorical sign. As well as inherently lustful and deceptive, wolves – and she-wolves especially – are hungry and greedy. Throughout his collection of stories, Masuccio regularly invoked the metaphors and similes of wolves, described as ravenous, rapacious, ravening, hungry, famishing, and eternally greedy for prey. Giovanni Villani, in his fourteenth-century *Cronica* (Chronicle) – a monumental universal history in twelve books – likewise inveighed against the greed that has taken over his fellow Florentines, and it is against an allegorical she-wolf that he addressed his angry diatribe: "Oh cursed and greedy she-wolf, full of the vice of avarice governing our blind and crazy citizens!" (92). Humanized as the embodiment of social evil, the she-wolf's excesses for Villani are not so much sexual as economic; hers is a political rather than a strictly personal sin.

Thus, when Dante Alighieri (1265–1321) penned the most famous medieval allegory of the she-wolf at the beginning of his *Divine Comedy*, the beast had already undergone numerous incarnations and acquired several layers of meaning – her dangers are to the sexual body as well as to the body politic. By the 1300s, when Dante was writing, it was known to all that the she-wolf embodied the related vices of lust and of greed. Also familiar was the she-wolf's historical connection with the foundation of Rome and, to a lesser extent recognizable to those living outside of Rome, her close bond with pontifical justice through her bronze presence near the Lateran Palace. Although it is only speculation, at least one scholar claimed that Dante's literary she-wolf was inspired by the statue of the *Lupa* located on the Annibaldi tower at the Lateran, which the poet must have seen during his 1301–1302 political mission to the Eternal City (Duhn 12).

In the first canto of the *Inferno*, Dante encounters three wild beasts: a leopard, then a lion, and finally a she-wolf (a biblical allusion because these same three beasts appear in Jeremiah 5:6). The aggressive trio,

one of several tripartite reminders of the Holy Trinity in the *Commedia* (although this one reverses any salvific dimension associated with the number three), comes to the pilgrim–poet when he is still alone – but not for long. At this point in his journey, Dante is about to meet the soul of Virgil, the Latin author of the *Aeneid* and master of epic poetry, who is to be his guide to the underworld. The three predators attack Dante just as he is preparing to begin his journey – which the beasts, needless to say, intend to sabotage in every way they can.

Many allegorical interpretations of this trinity of beasts have been assigned over the centuries. They might stand for the three subdivisions of Hell: fraud the leopard, violence the lion, and incontinence the she-wolf (although some commentators interchange the meanings). Alternately, they might embody the sins of envy (leopard), pride (lion), and concupiscence (she-wolf): More than the sins themselves, to be precise, the beasts incarnate the human disposition toward such sins that affects each of us (Freccero 270). Or they might be political beasts, representatives of three governments: The leopard is Florence; the lion is France; and the she-wolf, of course, is Rome – and, at a time of increasing ecclesiastical authority in and around Rome, the Roman Catholic Church. One critic claims that the correct English translation of Dante's *lupa* should be simply "wolf," not "she-wolf"; that is, that the feminine version of this animal's name did not indicate a specific gender but rather was the more common ending used in Dante's time. In his view, "no acceptable reason justifies in both these passages the presence of a female rather than a male of the species, and there is no need to impose upon the English word 'wolf,' which is neither male nor female and does very well as a translation of 'lupa,' the strait jacket of a 'she' making it indeed female" (Giustiniani 113, 117). Needless to say, I could not disagree more: That Dante's wolf is a female, a she-wolf and a *lupa*, is crucial to the reader's understanding of this complicated animal figure.

The figural meanings of the beast might be several, but the literal poem, lucid and direct, is one. Henry Wadsworth Longfellow's 1867 translation of Dante is the first complete American edition of the *Divine Comedy*. This is how it tells the poet's encounter with the she-wolf:

> And a she-wolf, that with all hungerings
> Seemed to be laden in her meagreness,
> And many folk has caused to live forlorn!
> She brought upon me so much heaviness,
> With the affright that from her aspect came,

> That I the hope relinquished of the height.
> And as he is who willingly acquires,
> And the time comes that causes him to lose,
> Who weeps in all his thoughts and is despondent,
> E'en such made me that beast withouten peace,
> Which, coming on against me by degrees
> Thrust me back thither where the sun is silent.
>
> (1: 3, Canto I, 49–60)

On meeting the she-wolf, Dante experiences the animal's voracious appetite: "with all hungerings" the beast "seemed to be laden in her meagreness." His own fear at the beast's sight is obvious as are the reasons: The she-wolf that so terrifies the pilgrim–poet at the beginning of his divine, comic journey is the gaunt and famished image of insatiable hunger and ravenous greed. Dante must have known what this felt like – most of us, I wager, do: to want to hold on to something instead of giving it away, regardless of how much more someone else might need it; to desire ownership of what does not or should not belong to us; and to feel empty when we have obtained what we wanted because satiation and fulfillment are not to be had with material things alone and certainly not with things not ours. Dante's she-wolf is the allegorical embodiment of this metaphorical illness of the she-wolf, the *male della lupa* to which we return in Chapter 6: insatiable greed beyond the appeal of food and material things.

The she-wolf and the experiences she stands for thrust Dante back into the absolute and frightful darkness he was desperately trying to escape ("thither where the sun is silent"). Only the arrival of a teacher and guide, the wise Virgil, will restore some hope to the Florentine poet: Having penned the *Aeneid*, Virgil was familiar with the workings of ancient greed and knowledgeable about the habits of the she-wolf. The ancient poet's connection with the she-wolf is the only positive attribute of the beast in Dante's *Commedia* – and, significantly, it remains unspoken. In Virgil's text, the she-wolf embodies a beginning, and not just any beginning: the birth of Rome and – for Virgil who was writing under and for Augustus – the origin of the empire (Dante dreamed of a good empire too). So also for Dante, the she-wolf appears in Canto I, his own beginning. However, he is far more aware of the she-wolf's dangers, not identifying with the editorial work of her tongue the way Virgil did: Whereas in Virgil the she-wolf feeds his story's protagonist, in Dante, she wants to feed *on* him. Dante's she-wolf may echo Virgil's, but her feeding purpose reverses the intent and effect of her ancient predecessor. So, of

Virgil, Dante implores help not in speaking accurately of the she-wolf but rather in fighting the most frightening among the three beasts: in repelling the sin of keeping more than one should, of owning when one ought to be sharing, of never having quite enough. Oblivious to death because he is dead already, Virgil does not notice the she-wolf; neither does he fear her presence because he has survived death through his poetry. It is to him that Dante must turn for help: "Behold the beast, for which I have turned back; / Do thou protect me from her, famous Sage, / For she doth make my veins and pulses tremble" (1: 5, Canto I, 88–90). The she-wolf is real, as is her effect on the wayfaring poet. His very veins and arteries move in response to her terrifying presence. Does Dante suffer because evil, incarnate in the she-wolf, stands before him and blocks his way? Does he grieve because he is powerless in facing the beast that embodies a dangerous transgression? Or is Dante's agony, perchance, due to his own participation in the she-wolf's sin?

Certainly, the she-wolf Dante evoked is not only some distant, heraldic motif (the avarice of the Roman Church, to wit) but rather a scary, live, wild beast: significantly, this section of the poem is the only part set in this world rather than the next. The wolf's liveliness prevents any simplistic allegorical interpretation: "The animals move before the reader with far too much life, concreteness, and spontaneity to be easily confined. . . . Both aesthetically and in the perspective of the pilgrimage tradition, the three beasts can be regarded in the literal sense as real, their physical presence in turn supporting varying symbolic values" (Demaray 239). The beast is so real that the poet's very body has trouble resisting her sin, his blood circulation affected with fear of her and what she represents. What the animal stands for in general certainly terrifies him, for the she-wolf is fearsome to all; more personally, he seems especially affected by what she has meant for him in particular. Dante and the she-wolf, it seems, recognize one another, and he sees that nothing good can come from her company. Indeed, Dante scholars have remarked that "Dante never uses the wolf emblem as a positive image of the empire anywhere in his works, ignoring Roman myth and history as well as Virgil's veneration" (Lansing and Barolini 87).

Although we may not know with certainty whether the poet's she-wolf stands for lust as well as greed, there is definitely a whorish side to Dante's beast. One cannot forget the double meaning of the Latin word *lupa* (Dante certainly did not forget) and that this infernal she-wolf, like the prostitute who allegedly once suckled Rome's founder, is a licentious female. The *Commedia*, therefore, further describes her wants, although it

is Virgil now who speaks – thus rewriting his own previous appreciation of Rome's beast:

> And has a nature so malign and ruthless,
> That never doth she glut her greedy will,
> And after food is hungrier than before.
> Many the animals with whom she weds,
> And more they shall be still, until the Greyhound
> Comes, who shall make her perish in her pain.
>
> (1: 5, Canto I, 97–102)

In Dante's story, the mystery of the she-wolf's identity is bound up with the mystery of the Greyhound, the unnamed political leader who alone is capable of chasing the beast away (unfortunately, in seven hundred years of Dante scholarship, no one has provided a universally satisfactory answer to the question of the Greyhound's identity). Hunger and greed are the she-wolf's most obvious sins, but Dante's Virgil, who certainly had a way with words, alludes to promiscuous lust as well. The she-wolf's indiscriminate mating frenzy with many animals will be stopped only by her death – and a violent, painful death at that.

After all these centuries, Dante's poem remains so affecting because it touches on the human condition: our insecurities and joys, our personal fears and spiritual aspirations. As well, the poet's reflections – often acerbic and never indifferent – are those of a man who was significantly involved in the world of politics, whose ideas and beliefs about government shook up life as he knew it: He had to leave his city of birth and live in exile for many years until his death. What Dante said about the human soul is not always apart from what he said about the political animals that we are: In Dante's poetry, the transcendent is never far from the political. Dante's she-wolf images at once the fearsome nature of the poet's most dreaded sin and the object of his most deeply felt political criticism: the transformation of the Church of Rome from its original incarnation as spiritual mother of all Christians to an earth-bound, ambitious institution scandalously unconcerned with the health of the souls that it is supposed to help Christ save. The whorishness of the she-wolf – of the ancient *lupa* that is the object in these lines of Virgil's own invective – mirrors the meretricious nature of the Church of Rome, greedy for worldly goods. In the thirty-second canto of *Purgatory*, the Catholic Church is depicted as a prostitute ready to entertain unlawful intercourse with those kings and princes from whom she can derive political advantage.

No longer the rescuer of twin infants, as in ancient texts, nor the generous nurse sent by the boys' father – although, again, Dante likely had medieval Rome in mind when he imagined this greedy female beast – the she-wolf in the *Divine Comedy* devours rather than feeds, takes away instead of giving suckle. Of the three beasts he encounters as he enters the Inferno, it is the she-wolf that most frightens the poet away from the hope of ascending to heaven. She shows up again in Purgatory, where the poet inveighs against her because she reaps the largest number of human victims. Hers are the gaping jaws of eternal death. Avarice, greed, and lust – all signs of unrelenting, transgressive desire – are fatal, as is their animal incarnation. The she-wolf eats and, in eating, destroys. Her leanness, in Dante's *Comedy*, displays her excessive appetite more than any obese belly might: She eats and eats but she cannot be sated and is hungry still. Her body can never fill out into roundness; neither can her stomach be extended to fullness. Afflicted with the she-wolf's disease, *il male della lupa* – a diagnosis of insatiable hunger – or with its allegorical equivalent of a more general insatiability, the beast has little chance of finding contentment in eating or her body reflecting the actual size of her meals. It is this deceptive contrast that makes the she-wolf especially dangerous: the contradiction of one whose food does not satisfy, whose desires, although repeatedly filled, multiply instead of decrease. Readers through the centuries have continued to find Dante's adventures compelling because they speak of our own struggles: We turn to food and to the pleasure of savoring and swallowing; we turn to consumption and the flavors of acquiring and adding to our already full lives; however, it is never enough and rarely does this kind of eating, of consuming, lead to the contentment it promises – or to the leanness of the she-wolf. Although the she-wolf may pack our lives, fill our houses, and fatten our bodies, her final intent – Dante knew – is to starve our spirit.

PETRARCH'S SHE-WOLF AS THE METONYM OF LOSS

For Dante, the she-wolf was an animal to be avoided at all costs; in his life, direct confrontation spelled certain death. His she-wolf was not Virgil's: The echo of the great beginning the beast hailed for the ancient poet is all but lost in her frenzied desires. For some of Dante's near contemporaries, however, the same animal was the icon of a past in need of solicitous and reverent recovery. The meaning idealistically projected

onto the she-wolf by humanist writers was more akin to Virgil's, for whom the beast was the nurse of Rome, than to Dante's, whose she-wolf portended no greatness and embodied instead a deep-seated and well-justified fear. The most illustrious among these positive re-readers of the wolf was Petrarch, widely regarded as the father of humanistic studies for his groundbreaking work in the revival of classical texts, at the hinge between the Middle Ages and the Renaissance. Born a Tuscan, like Dante, scholar and poet Francesco Petrarca (1304–1374) – or Petrarch, as he is known in the English-speaking world – came to Rome for the second time in 1341 to be crowned poet laureate; he was the first man to be so honored since antiquity. This coronation with a wreath of laurel leaves made him, legally and ideally, an honorary citizen of ancient as well as contemporary Rome.

Petrarch alluded to the she-wolf, quickly yet significantly, in a letter to Giovanni Colonna, a text often regarded as marking the start of Renaissance humanism. With Colonna, Petrarch had shared many walks around Rome. Petrarch's Latin letter to him, written between 1337 and 1341, is a record of the poet's walks through Rome with his Roman friend and of the places that were for him central to Roman history – those places that constituted in his mind physical reminders of Rome's mythical events. It is true that those places, of which the she-wolf is one – she is a beast turned into a thing, a tale transformed into a location – are fragments; they are fixed and fearsome portents of death. However, what those places are fragments of is also a story – the infancy narrative of Western culture, in fact. Petrarch's retelling is the unraveling of a metonymy, involving the intervention of memory and, through the work of memory, the perception of the possibility of immortality.

> We used to wander together in that great city which, though it appeared empty because of its vast size, had a huge population. And we would wander not only in the city itself but around it, and at each step there was present something which would excite our tongue and mind: here was the palace of Evander, there the shrine of Carmentis, here the cave of Cacus, there the famous she-wolf and the fig tree of Rumina with the more apt surname of Romulus. . . . (Petrarca 291)

The poet and his companion move around Rome's immobile landscape, located both within and outside a city only seemingly empty; through the poet's words, the she-wolf and her companions come alive – they are given speech through the recall of their story. In his list of sights,

Petrarch proceeded chronologically, as if following the order of Rome's history, not topographically: It would be impossible to retrace his wanderings without previous knowledge of where the Roman objects are located. (Evander, who had founded Pallantium on the future site of Rome, helped Aeneas fight against the local Rutuli; Carmentis was a prophetic goddess and Evander's mother; and Cacus, son of Vulcan, was a fire-breathing monster who lived in a cave on the Aventine Hill and was eventually killed by Hercules.) The immensity of Rome's population, for Petrarch, seemed to include previous as well as current inhabitants – the she-wolf among them (Edwards 9–10). Petrarch's Rome was a largely empty space (no more than twenty thousand people lived within the walls), consisting of geographical immobility and historical permanence: The objects that encourage meditation and speech – the she-wolf among them – are still traveling in time as well as space while the two friends keep moving. "To wander," for Petrarch, "is a pure adventure in pursuit of the ghostly traces of time, a moving about which allows a worldview to emerge," wrote Giuseppe Mazzotta (19).

Petrarch's worldview emerges through his list of classical Roman objects, which establishes a relationship between the speaker and the ruins facing him; this fractured bond is expressed with the pained tones of nostalgia. Petrarch's sense of longing for the past and his almost unacceptable awareness of its irrecoverable loss are materialized in metonymies rather than allegories: Contiguous to a past to which she allows limited access, Petrarch's she-wolf is not recycled (e.g., as a fountain or the guardian of pontifical justice); much less is she allegorized as greed or lust. Rather, the she-wolf is the object of metonymic reflection, a time-travel machine of sorts. As ruins, the she-wolf and other objects encountered by the walking friends are "semiotically different from what they were before they became ruins"; they are "something with a new significance and signification, with a future that is to be compared with its past. Time writes the future of a ruin" (Hetzler 53–54). Time's implacable flow has transformed ruins such as the she-wolf into a metonymic connection between a past too distant to otherwise contemplate and a present too near to be accurately absorbed.

The she-wolf that he so admired during his walks around Rome followed Petrarch to his grave and beyond – not only metaphorically and not only as the symbol of that antiquity the poet so revered. A physical she-wolf watches over the poet's most important memorial. The national monument honoring Petrarch in his hometown, the Tuscan city of Arezzo, was erected in 1928. Massive (14 meters long, 8 meters

deep, and 12 meters tall), busy (at least twenty figures are sculpted in the stone, with numerous allegories), and made of bright white marble from nearby Carrara, the monument to Petrarch is the masterpiece of sculptor Alessandro Lazzerini. It is located in Arezzo's major park, the Prato, and shows the poet standing tall and looking ahead toward the future amid a plethora of symbolic and allegorical figures portrayed in an eclectic mixture of romantic, neoclassical, and realistic styles. Of these, the closest to the poet's body is the statue of a she-wolf nursing twin baby boys. Arezzo's monument to its native and most notable man of letters took a long time to finish; initially intended for inauguration in 1904, it was finally completed during the fascist era, when symbols such as the she-wolf – icon of imperial rule and Rome's central position in world history and politics – were beloved of Mussolini's regime. However, the connections between Petrarch and the world of history and politics embodied by the she-wolf are, *pace* this self-assured monument, much more complex than fascist ideology would have us believe.

DU BELLAY'S PARABLE OF THE SHE-WOLF'S DEATH

In his classic *The Civilisation of the Renaissance in Italy*, Jacob Burckhardt notes that "the ruins within and outside Rome awakened not only archaeological zeal and patriotic enthusiasm, but an elegiac or sentimental melancholy" (185). This feeling, a sort of piety already visible in Petrarch's relationship with the archaeological remains of classical times, was to be elaborately developed by later humanists who visited or lived in the Eternal City. Aesthetic satisfaction was repeatedly experienced in the midst of the fragmented statues, monuments, and inscriptions scattered around the city: A certain poignant beauty was found in Rome's broken things. It was precisely the ruins' lack of intactness that humanists found compelling, for such brokenness and incompleteness evoked a sense of wholeness all the more persuasive because it was absent. This aesthetics of ruins pertained not only to the contemplation of physical objects but extended also, in some texts, to meditations on broken notions belonging to the historical and mythological imagination (e.g., the figure of the she-wolf). As ruins suggest the partial devastation of artistic objects at the hands of time, stimulating their viewers to complete the partial picture left behind, so also the early modern destruction of mythico-historical beliefs and the Renaissance quest for ancient texts attracted an antiquarian and literary gaze equally eager to fill in the missing parts of the incomplete narrative before it.

Renaissance poet Joachim du Bellay (1522–1560) is among the most prominent early modern practitioners of the literature of ruins. He came to Rome from his native France in June 1553 on a diplomatic mission with the Bishop of Paris, Cardinal Jean du Bellay (he was a second-degree cousin whom Joachim treated as an uncle). Du Bellay senior was a fanatical collector of antiquities and had been sent to Rome to protect France's interests at the Holy See. Du Bellay junior joined his uncle because he needed money and thought the job would suit him. He quickly changed his mind – poets rarely enjoy keeping books and arranging loans – but stayed at his post until August 1557. Eager to advance his career through this trip to the spiritual and temporal capital of Christianity and the dream place of every Renaissance humanist, du Bellay nevertheless was disappointed. He found Rome to be a place of corruption, debauchery, and hypocrisy. More profoundly, the city constantly confronted the poet with evidence of the ruins of time, the instability of all things earthly, and the futility of every human effort. Du Bellay expressed his disenchantment and distress at finding decay where he expected glory and decadence in the place of grandeur in the collection known as the *Antiquitez de Rome* (1558).

The thirty-two sonnets that comprise the *Antiquitez* proper are followed by a set of fifteen more sonnets called *Un songe* (A dream). These verses muse on the fall of Rome through a series of apocalyptic images, in which extraordinary greatness is followed by sudden destruction. In the sixth of the fifteen dream sonnets, du Bellay elaborated on the icon of the she-wolf with her twins, inventing an allegorical parable for her death. In the popular legend that made her famous, after all, the she-wolf stalks away when the royal herdsman finds Romulus and Remus and again rescues them by bringing them into his home – where another sort of she-wolf, his wife Acca Larentia, awaits them. This she-wolf, incidentally – the human and whorish she-wolf – makes an important appearance in another of du Bellay's poems. The eponymous speaker of "La courtisanne repentie" (The repentant courtesan) bids farewell to her colleagues, "the Roman flock that follow the great she-wolf," and, later, the now elderly courtesan's "complaint sets up an association between her autobiography and a city founded in blood by a pair who drew life from an adulteress and milk from a she-wolf/whore" (Prescott 404). However, it is another she-wolf, one with an entirely different figural meaning, that animates *Un songe* and fills in part of the story that traditional legend leaves untold. The animal she-wolf's departure from the scene of Rome's founding is one that legend recalls and others have since interpreted as

a quick exit on the part of the beast: The she-wolf returns to the forest where she belongs, called back into her sylvan world perhaps by the bellicose divinity that had originally sent her to the river. In the sixth sonnet of *Un songe*, du Bellay reads instead in the she-wolf's departure a violent death at the hands of angry, jealous humans and a moving parable of Rome's fall.

The English poet Edmund Spenser (1552–1599) encountered du Bellay's *Un songe* when he was still a schoolboy and published his translation in 1569, eleven years after du Bellay's first edition. Spenser's blank-verse translation is presented here, with its characteristic sixteenth-century spelling:

> I saw a Wolfe vnder a rockie caue
> Noursing two whelpes; I saw her litle ones
> In wanton dalliance the teate to craue,
> While she her neck wreath'd from them for the nones:
> I saw her raunge abroad to seeke her food,
> And roming through the field with greedie rage
> T'embrew her teeth and clawes with lukewarm blood
> Of the small heards, her thirst for to asswage.
> I saw a thousand huntsmen, which descended
> Downe from the mountaines bordring Lombardie,
> That with an hundred speares her flank wide rended.
> I saw her on the plaine outstretched lie,
> Throwing out thousand throbs in her owne soyle:
> Soone on a tree vphang'd I saw her spoyle.
>
> (Spenser 313)

Du Bellay called this poem a "vision" for reasons of both form and content: He repeated at the beginning of each stanza the phrase "I saw," emphasizing the sense of sight – literal vision – as well as the speaker's subjectivity, his personal and metaphorical vision. The poem, of course, tells of a fictional tale, an imaginary vision of the past. The poem's tale is not an invented fable, however; it is not simply a literary completion of what legendary discourse omits, of what happens to the she-wolf – that is, after she stalks away. Rather, the emphasis on vision in this poem and in the entire collection to which it belongs reminds readers of the need to interpret what is before them: As a rhetorical figure, allegory frequently depends on metaphors of vision. Du Bellay's short parable is telling two stories at once – one literal, another allegorical – so that the poem's thrust reaches beyond the demise of a legendary wild beast. For the she-wolf, typically understood as the symbol of Rome, is

Rome's allegory in du Bellay's poem: Her death tells the story of Rome's fall.

The first image of the she-wolf presented in this poem is a tender one: The animal mother protects her two cubs within a rocky cave and feeds them even as they play. The text does not identify the species of the sucklings – namely, whether the animal's whelps are human or animal. The reader assumes that they are the infants Romulus and Remus because the poem is about Rome and the she-wolf's two nurslings could hardly be anyone else. The she-wolf stretches her neck to lick her whelps in a position reminiscent of other she-wolves – Virgil's, most notably. The nurslings' iconography, unlike the wolf's, matches the bronze statue: They play while they suck. (In one of his Latin elegies, du Bellay described the *Lupa Capitolina* itself: "Here the twins play, grasping at the obliging teats of the she-wolf, their nurse"; *The Regrets* 302.) To feed her own, the she-wolf preys on flocks of sheep: She bloodies her teeth and paws with renewed fury. Du Bellay repeatedly employed the French noun *fureur* to describe the actions of ancient Rome. Its presence in this verse confirms the beast's allegorical identification with the Eternal City: Fury brings Rome to greatness but also to destruction and, eventually, self-destruction (du Bellay openly stated this in the thirty-first sonnet of the *Antiquitez*). The she-wolf's fury, in this case, springs from her maternal instincts: It is for the little ones awaiting their nurse in her den that she must furiously seek out her prey. In this reading, the twins "in wanton dalliance" are the Roman people, maternally protected by the wild beast who acts like their mother. The sheep are the unfortunate neighbors that Rome must conquer in order to feed those whose survival depends on her hunting skills.

The she-wolf's bloodshed does not go unpunished in du Bellay's poem, and avenging men come down from the mountains. Lombardy is a long way from Rome and Latium. Today, the name "Lombardy" describes the region of which Milan is the capital province, in the far north of the Italian peninsula. Indeed, it is from the north that the invading tribes come, eventually bringing about Rome's fall. The word "Lombard" derives from the name of the Longobards (i.e., the long-bearded ones), a Germanic tribe from southern Sweden that came to Italy in the sixth century. By naming the people hailing from the Lombard region, however, it is not just the Longobards that the poem evokes. The reference to the Lombard countryside is a metonymy that includes all the so-called barbarians, who came south and took over Italy between the fourth and the sixth century: the Visigoths, led by the fearsome Alaric; the Vandals, guided by their

king Geiseric; and the Ostrogoths, with their king Totila. Visigoths, Vandals, and Ostrogoths comprise du Bellay's "thousand men" from the northern mountains, who slaughter the feeding she-wolf with a hundred spears: She must have been quite a beast to have required so many. The she-wolf dies neither quickly nor easily; rather, she sobs and wallows, stretched out on a plain covered with her blood. In the end, after she is finally vanquished, the animal's carcass must hang on a tree for all to see, dead symbol of an extinguished, furious civilization – tender to her own, admittedly, but savage for their sake. The end of the she-wolf is the destiny of all empires, the parable implies. Indeed, more than four hundred years after du Bellay's vision, Mussolini's carcass also was hung for all to see after his execution. The death of a tyrant is never enough: A spectacle of the tyrant's death and slaughtered body is also required.

There is no need for du Bellay's parable to present an explicit moral lesson: The she-wolf's blood – the blood of her victims as well as her own – quite suffices and speaks loudly even in its necessary silence. Rome the city and Rome the myth – so difficult to reconcile for Renaissance humanists such as du Bellay – finally blend in the blood of death, the corpse of the she-wolf, a ruin slain and exposed, yet immortal in every sense that matters. Like the ruins of which she is a poetic transposition, the she-wolf is a metonymic figure, a part that stands for an irrecoverable whole; like ruins, she is the compellingly partial sign of a collapsed past. Through metonymy, however, the she-wolf is also an allegory: It is the story of Rome that her own story tells.

Along with Joachim du Bellay, numerous Frenchmen came to Rome in the centuries after Petrarch, primarily because – not unlike today – travel to Italy was fashionable for those who could afford it. Rome, in particular, embodied the hopes of humanist intellectuals since Petrarch: the renewal in this contemporary age of ancient culture, with its grandeur, wisdom, knowledge, and aesthetic achievement; "Renaissance" literally means "rebirth." To learn from the old and look at the future with eyes informed by the past: This is one of the lessons the she-wolf has to teach and a lesson that many claim to have learned from her. Joachim du Bellay had to struggle with Rome's ruined landscape even as he tried to come to terms with the city's former glory. The she-wolf provided him with a way of thinking about Rome: as maternal yet fierce – indeed, fierce because maternal – and heading, even at the moment of its greatest grandeur, toward violent destruction. Knowing that destruction is to come – knowledge of which anyone looking carefully at ruins must be constantly reminded – makes the recollection of even the apex of Rome's

glory, even the sharpest of the she-wolf's fangs, cause for Burckhardt's "elegiac or sentimental melancholy."

MILK, WATER, AND A SHE-WOLF FOUNTAIN

Tertullian's she-wolf is a historical prostitute of ancient Rome who embodies much that is wrong with the pagan religion and with the female gender. Fournival's bestiary and the anonymous Reynard stories ascribe to human females the worst traits of female wolves, with an attribution that underlines the conventional nature of the woman-as-she-wolf metaphor. Masuccio's she-wolves are neither professional prostitutes nor zoological specimens, although their connection with both excessive, mercenary sexuality and brutish animality makes them who they are. For Dante, although the she-wolf's gender is very much a part of her identity – like Tertullian's, Fournival's, Reynard's, and Masuccio's she-wolves, she is lascivious – sexuality does not begin to exhaust the beast's allegorical significance; in fact, it only scratches the surface. In the *Commedia*, the she-wolf is the terrifying image of greed; this, among her traits, is the one that Dante fears most. What all of these literary beasts have in common is the fact that they require interpretation: As allegories, they point to meanings beyond the literal and, in this rhetorical process, signal the existence of an entirely different level of understanding the world through the parables they tell or to which they allude.

She-wolves can hardly escape figurative interpretations – not in the West, at least, and especially not in Rome. Whether they appear verbally, visually, or – which is often the case – as verbal representations of visual representations (i.e., ekphrasis) or, conversely, as visual representations of verbal representations (as in every illustration of the story of the Roman wolf), she-wolves constantly point to meanings beyond those that are immediately discernible. The ambiguous Roman she-wolf is the principal source of such semantic variety – her duality as mother and whore, animal and human, natural and supernatural inflecting every appearance and reading of the beast. In addition to the visual and literary arts and beyond political and historical discourse, this ambivalent animal makes her presence felt in Rome in less dignified and more ordinary locations. One such place is found near the Via della Lupa, the street of the she-wolf. Located in downtown Rome in the heart of the area known since ancient times as the Field of Mars (*Campo Marzio* in modern Italian), the she-wolf's street is nestled at the center of her divine protector's territory. A few years ago, an anonymous A. S. Roma soccer team fan humorously

applied a plastic sticker with the team's logo – an image of the *Capitoline She-Wolf* suckling the twins – on the stone plaque with the street's name. That enduring piece of plastic is the she-wolf's only trace on this street: Someone walking it today would be hard-pressed to find the significance of the name because no she-wolf, live or stone, roams or adorns the Via della Lupa. During the Renaissance, however, a fountain with the head of a she-wolf decorated the palace of the Capilupi family, located in the adjacent Via dei Prefetti. This illustrious family's name means "heads of wolves" and their front door still has the family's emblem with the wolf. The she-wolf's fountain (*Fontana della Lupa*), which now lies unseen in one of the city's warehouses, was accompanied by an inscribed marble slab that is today walled within the entrance of the building found at Number 17 of Via dei Prefetti. In this Latin inscription, the fresh, pure water of the fountain is compared to the milk that the legendary she-wolf fed to Romulus and Remus when they were needy infants:

> The she-wolf, not fierce, gave her sweet milk to the infant twins. In the same way, o neighbor, the meek wolf gives you water that flows constantly, sweeter than milk itself, purer than amber and colder than snow. Therefore, let the eager child, the young and the old, draw freely from here, with a well-scrubbed container, and bring some water home. It is forbidden to horses and donkeys to drink from this little fountain, and neither the dog nor the goat, with their filthy faces, may drink here. 1578

Through carefully chosen words, the inscription above the fountain of the she-wolf selects what is meekest about the beast – her fierceness, by contrast, is denied outright: The beast is "not fierce" (*non saeva*). The fountain transforms the liquid she provides from milk (thicker than blood, as we have seen) into transparent, harmless water: "sweeter than milk itself, purer than amber and colder than snow." With this fountain, however, and through the inscription proclaimed above the jet of water, the beast is a traitor to her own kind: Only humans may drink here, no animals are allowed – neither horses and donkeys nor the smaller dogs and goats. This prohibition replicates on the fountain's water what the she-wolf once did with her milk, when she fed Romulus and Remus rather than her own cubs. (Only in some versions of the story are the animal's biological offspring said to have been dead before the she-wolf even meets the humans she will nurse in their place; everywhere else, it is assumed that the milk meant for the wolf cubs is seized instead by these two determined, bellicose babies.) Another character appears

on the inscription, one that is absent from ancient myth: the male wolf (*lupus*), meek like his mate (*mitis*), a participant in the nurse's distribution of her vital fluid, a guarantor of her purity and that of her milk.

Today, numerous drinking fountains present throughout Rome's streets and piazzas feature the head of a she-wolf for a spout. The statue of the *She-Wolf* at the Lateran, according to Master Gregory, also had once been a fountain, her bronze teats dispensing fresh water as generously as the flesh teats of the live wolf once disgorged milk. (However, there is no physical evidence that the bronze teats of the *Lupa Capitolina* ever had holes for water to flow through, leading some to conjecture that Master Gregory may have been writing about a different statue.) In *Campo Marzio*, human beings young and old could partake of the liquids the she-wolf generously provided in two ways: metaphorically, through the reminder on the inscription of the wolf milk in the legend of rescue and suckling; and literally, as the fresh water materially available at this fountain. The marble slab itself, and the fountain for which it stands, cannot escape the workings of allegory. In this case – and in contrast with Dante's image of the beast – the she-wolf, tamed and purified by the presence of her mate, represents fulfillment through quenching: a material role the *Lupa Capitolina* may or may not have had. However, like the bronze *Lupa*, the marble slab of the she-wolf fountain is a ruin. Not physically – the inscription, like the bronze *Lupa*, is in good shape – but rather in terms of meaning. In the absence of its defining component – that is, the fountain itself – this inscribed stone functions, in fact, as a ruin of sorts: partial, fragmentary, a painfully metonymic suggestion, as the she-wolf once was for Petrarch, of the whole it must have once been. What remains visible and knowable of this formerly utilitarian fountain is its least useful part: its restrictive words, a text that tells of a mythical animal nurse reemployed when the fountain was made and used as a guardian of separation and distinction (i.e., humans from beasts) rather than as the embodiment of the legendary she-wolf's liberal generosity.

MODERN AND CONTEMPORARY TIMES

THE SHE-WOLF AND THE MEANING OF HISTORY IN WORDSWORTH AND MACAULAY

LITERALLY SPEAKING, THERE IS NO HISTORY OF THE SHE-WOLF. Ancient writers, historians included, did not usually pretend to believe in a flesh-and-blood beast stumbling across a set of whimpering baby boys and offering them suckle. Almost from the beginning, figurative interpretations were devised to account for the story of Romulus's serendipitous rescue from certain death by the intervention of a wild animal. "I have no intention either to affirm or refute," wrote Livy; "Some say," echoes Plutarch. Although the she-wolf has no history that today we would promptly recognize as such, this same animal has repeatedly compelled writers to examine the meanings of the discourse we call history. Livy, Dionysius, and Plutarch prefaced the she-wolf's tale with reminders of the unreliability of their sources. Propertius hoped to tell of Rome's origins by imitating the she-wolf's task. Through the memory of the she-wolf, Petrarch could nostalgically relate to the grandeur of Roman antiquity. For du Bellay, the she-wolf's death allegorized the historic fall of Rome itself, the fate of an entire nation epitomized by that of a single beast. The rhetorical figure of allegory, as well as the language of misogyny, entertains a close relationship with the discourse of history. This relationship may be adversarial, with history proving allegory obsolete, or it may be complementary: Allegorical figures, in this sense, continue to help us interpret the meaning of history.

The multiple connections between the literary representation of the Roman she-wolf and a reflection on the status of history endured and developed throughout the nineteenth and twentieth centuries, and into

the twenty-first, taking different directions in a variety of discourses and literary genres. English Romantic poetry is one such genre, with Byron's ekphrasis of the *Lupa Capitolina* (see Chapter 3) its most notable example. The bronze evokes for the poet the grandeur of an imperfect past, knowable also through the material traces it leaves: The "nurse of Rome" is prominently "thunder-stricken" and "black'd with lightning." A she-wolf–shaped, material trace of history that, not unlike Byron's, pretends to teach readers about its own past, as well as the effects and uses of historical discourse, is found in a sonnet by William Wordsworth (1770–1850). The great Romantic poet of the natural environment was intrigued by the question of history as it related to the self and to nature, and he was fascinated by the work and discoveries of antiquarians (Wordsworth finally visited Rome in 1837, when he was sixty-seven years old). For Wordsworth, the relics of the past were the occasion for reflection and meditation; he had little patience for those who saw those objects as trophies rather than focusing on what their remains represented or on the stories they told. However, Wordsworth also was wary of the rash conclusions that antiquarians often drew from the silent pieces of stone they found. In the excitement of discovering ancient artifacts, he too had given in to hasty misinterpretations of the past and was well aware of the seductions of this practice: Long thinking and a careful study of history were required to make the stones speak something resembling the truth of the past.

In his 1827 sonnet, "Roman Antiquities Discovered, at Bishopstone, Herefordshire," Wordsworth celebrated the archaeological excavations carried out at an English village. This imaginative poem does not shy away from engaging with the ambiguity of the antiquarians' actions, for the lessons history teaches through the relics it leaves behind are neither easy to retrieve nor simple to learn. The complete sonnet is found in the collection titled *Yarrow Revisited*:

> While poring Antiquarians search the ground
> Upturned with curious pains, the Bard, a Seer,
> Takes fire: – The men that have been reappear;
> Romans for travel girt, for business gowned,
> And some recline on couches, myrtle-crowned,
> In festal glee: why not? For fresh and clear,
> As if its hues were of the passing year,
> Dawns this time-buried pavement. From that mound
> Hoards may come forth of Trajans, Maximins,

> Shrunk into coins with all their warlike toil:
> Or a fierce impress issues with its foil
> Of tenderness – the Wolf, whose suckling Twins
> The unlettered Ploughboy pities when he wins
> The casual treasure from the furrowed soil.
>
> (119)

At the beginning of the sonnet, there are two types of men who look at the past, both allegories of the acquisition of historical knowledge. They exemplify the two major ways that we can learn about history through its remnants: the "poring Antiquarians" are an analytic lot who "search the ground," the negative effects of their activity visible in the "curious pains" with which the soil is "upturned"; and the traditional poet – "the Bard, a Seer" – who, more passionately, "takes fire" at the sight of history's remains. The Bard's vision is naturally more vivid than that of the Antiquarians and, although in a dodgy way (the parenthetical "why not?" is somewhat defensive), the Bard claims the accuracy of his fantasy: Through this poet's passion and imagination, the men of the past, "the men that have been," literally "reappear."

There is also a third way to look at the past, personified in Wordsworth's poem not by men but rather by a boy – an "unlettered" boy, no less. Wordsworth frequently uses the child as subject – in this case, emphasizing his preliterate state: Unlike antiquarians and bards, he is "unlettered"; in fact, he does not even speak. This Ploughboy provides the emotional focus of the poem and a sympathetic protagonist for the poem's resolution (Scalia 219). Confused by what he has unwittingly unearthed with his plough, the boy seems as ignorant of the twins' identity as of the she-wolf's role – although the poem carefully highlights both the wild nature of the beast (through the "fierce impress" of Rome's emperors on the coins) and her "tenderness." The latter feeling is more easily readable by the unlettered boy than by the well-schooled men: Little knowledge of the past is needed to appreciate the mercy of a beast who suckles rather than devours two babies. In some cases, scholarship can obstruct understanding, and knowledge of Romulus's and Rome's ruthlessness to come may impede comprehension of the natural mercy shown by the wolf. The boy regards his find as a treasure, however casual, and draws from it the best moral lesson that history can possibly teach: pity for the pain of others, compassion for their plight. The Ploughboy's "unlettered" ignorance does not prevent him from learning as much as if not more than the cultured Antiquarians and the imaginative Bard. History speaks to all and not only, not even especially, to the cultural elites: The heart

and the imagination – not just bookish knowledge – are nevertheless required to listen to history's voice.

Ignorance is not bliss but rather empathy. It is not that careful study or a vivid imagination do not provide any useful knowledge of the past. Sometimes history's most important lessons, however, reach beyond what knowledge and the imagination – through archaeology and poetry – are able to provide. Sometimes it is the heart that teaches and the knowledge of the scholar, like the imagination of the artist, can be an impediment. For despite Romulus's future greatness and the she-wolf's divine protector, there is much to be pitied in their story. The Ploughboy's misunderstanding – how could anyone conversant with the early history of Rome take pity on its deified, fratricidal, thieving, and rapist founder – is a deeper understanding based on his sympathy for the outcast twins abandoned and left for dead, so desperate that even the presence of a wild beast provided a welcome rescue.

Through the coin discovered by an ignorant field worker, the poem sums up the history of Rome: its legendary founding by a once-abandoned boy rescued by a she-wolf; the height of Rome's empire, with the Emperor Trajan and Roman travelers, Roman businessmen, and Roman revelers; its fall into ruins, as the very coin that elicits the Ploughboy's pity physically illustrates, buried as it is in an English field. The Ploughboy may have been ignorant and even wrong in his unplanned and unexpected assessment of the identity of the she-wolf and the twins; however, for Wordsworth, the importance of moral learning far surpassed a knowledge consisting of historically accurate facts. Of the three allegories of looking at history presented in this poem – Antiquarians, Bard, and Ploughboy – it is the latter, the poem implies, that is the most accurate and useful, however "unlettered."

The Ploughboy's moral acquisition through a contact with history not mediated by written accounts exemplifies what has been described as the Romantic paradigm of history, which "presumed that artistic creations yielded historical and moral knowledge whereas the brute acquisition and classification of historical data yielded only an amoral cognizance of facts": Re-creation through literary and artistic means, that is, was considered necessary to understand the meaning of past events (Schoch 29). Although inspired more plainly than Wordsworth's sonnet by the sequence of historical facts rather than their hidden moral lessons, Macaulay's *The Lays of Ancient Rome* also employs the literary and artistic re-creation of history to better understand the meaning of past events. Thomas Babington Macaulay (1800–1859) published his *Lays* in 1842;

a haunting and immensely popular long poem in four parts, this is his best-known work of poetry. Macaulay was a devotee of Greek and Latin literature. He derived his materials for the *Lays* from the writings of Livy and Dionysius of Halicarnassus, and he retold the tales of early Rome as an oral storyteller would: His rhymes are insistent and his rhythm mesmerizing. However, the poetry of the *Lays*, Macaulay claimed in his preface, is not his own; the poetry of early Rome is intrinsic to its stories: "The early history of Rome is indeed far more poetical than anything else in Latin literature" (4). Macaulay theorized that the stories of early Rome first appeared in the form of ballads, lost as such but transformed into the historical form that – unlike its poetic version – has managed to come down to us. His objective with the *Lays* is "to reverse that process, to transform some portions of early Roman history back into the poetry out of which they were made" (23).

The fourth and last of the *Lays*, "The Prophecy of Capys," begins by telling the early life of Romulus. Although none of the *Lays* would exist without knowledge of the earliest Roman stories, Macaulay announced in the first sentence of his preface that the dissemination of such stories is no assurance of their truth: "That what is called the history of the Kings and early Consuls of Rome is to a great extent fabulous, few scholars have . . . ventured to deny. . . . Under these circumstances, a wise man will look with great suspicion on the legend which has come down to us" (3). Still, "the most important parts of the narrative have some foundation in truth," although we must "distrust almost all the details" (4). The protagonists of the first eleven stanzas of "The Prophecy of Capys" are Romulus and Remus, and the subject of the lines quoted here is the first part of their life, when the "bloody king" who is their great-uncle Amulius exposes them near the Tiber River and they risk death at the hands of nature – in the double form of "raging flood" and "raging beast":

> IV
> They were doomed by a bloody king,
> They were doomed by a lying priest,
> They were cast on the raging flood,
> They were tracked by the raging beast;
> Raging beast and raging flood
> Alike have spared the prey;
> And to-day the dead are living,
> The lost are found to-day.
>
> (115)

This fourth stanza mentions blood only once but evokes its threatening sound two more times through the repetition of the rhyming word *flood*. The latter noun is also a reference to another fluid of historic importance for the she-wolf's tale: the water of the Tiber River. Doomed by both a king and a priest, by earthly and supernatural powers, the twins could have been lost and died; instead, they are found and alive. Natural elements that are usually devastating (i.e., "the raging flood" and "the raging beast") turn out, for these babies, to secrete instead life-giving fluids – water and milk. The next stanza elaborates on the saving actions of these natural forces:

> V
> The troubled river knew them,
> And smoothed his yellow foam,
> And gently rocked the cradle
> That bore the fate of Rome.
> The ravening she-wolf knew them,
> And licked them o'er and o'er,
> And gave them of her own fierce milk,
> Rich with raw flesh and gore.
> Twenty winters, twenty springs,
> Since then have rolled away;
> And to-day the dead are living:
> The lost are found to-day.
> (Macaulay 115–116)

A normally destructive force (i.e., a "raging flood," a "troubled river," whose ominously "yellow foam" – the notorious color of Rome's river – needs to be "smoothed"), the Tiber River is also a liquid entity that mysteriously spared the twins and even, almost maternally, "rocked" their "cradle." The role of the flood is poetically coupled with that of the mother beast: Both are "raging" and both "spared" two babies here figured as "prey" to both. From potential death, surprisingly, comes life; out of loss, as well, springs the contrary act of finding. In the fifth stanza, the water of the flood, phonetically but also conceptually related to blood, becomes the water of the Tiber River. This other water not only "spared" the babies, like the she-wolf, but also like the she-wolf, again, "knew them" – recognized in their small bodies "the fate of Rome" metonymically present in their cradle. Although "ravening," the she-wolf, because she too "knew them," does not eat them. That she might have done so is suggested by the fact that she licks them – what self-restraint must have been exercised by the beast – and feeds them rather than *on*

them with a milk itself "rich with raw flesh and gore" of other prey.
Out of this prey's death comes Rome's life.

Toward the end of the eleventh and through the thirty-first stanza, the
prophecy proper begins and develops. The ancient blind seer, Capys,
first greets Romulus at the court of Amulius (where Romulus and
Remus, now adults, intend to set things right) with words that rec-
ognize the she-wolf's role in his life: "Hail! foster child of the wondrous
nurse!" (Macaulay 118) is the first line that Capys pronounces. The seer's
acknowledgment of Romulus's difference three stanzas later refers twice
more to his relationship with the wolf. Marked by difference through
divine nature and animal nurture, he should embrace his exceptional fate
and leave the pleasures of a normal existence to those not like him –
namely:

> To them who of man's seed are born,
> Whom woman's milk hath fed.
> Thou wast not made for lucre,
> For pleasure, nor for rest;
> Thou, that art sprung from the War-god's loins,
> And hast tugged at the she-wolf's breast.
>
> (118)

Deprived of human nature and human nurture and made and saved
instead by a god and a beast, Romulus is twice marked by difference
from his kind. With this difference, he in turn will imprint the "glorious
city" that he is about to build, the seer continues, for in Rome "Shall
live the spirit of thy nurse, / The spirit of thy sire" (119). After noting
the obedient nature of such animals as the ox, ass, spaniel, and sheep,
Capys uses the entire seventeenth stanza to contrast the different nature
of the she-wolf:

> But thy nurse will hear no master,
> Thy nurse will bear no load;
> And woe to them that shear her,
> And woe to them that goad!
> When all the pack, loud baying,
> Her bloody lair surrounds
> She dies in silence, biting hard,
> Amidst the dying hounds.
>
> (119)

Because of its representation of the she-wolf's violent death as an alle-
gorical account of Rome's fall, this depiction of Romulus's nurse is

reminiscent of Joachim du Bellay's sixteenth-century sonnet. However, before the fall, Macaulay's she-wolf, as Rome's allegory, will establish herself as fiercely independent, unlike other animals, and dangerous even in her death – that is, taking down the hounds who kill her.

Macaulay's last reference to the she-wolf occurs in the twentieth stanza in which, after describing the bellicose disposition of his father Mars, Capys explains to Romulus how his destiny is determined by his physical heritage: the divinity of his father and, more directly, the nature of the animal mother who first fed him:

> And such is the War-god,
> The author of thy line,
> And such as she who suckled thee,
> Even such be thou and thine.
>
> (120)

Before concluding with the description of some of early Rome's victorious exploits until the third century BCE in the remaining stanzas, Capys describes the origin of Romulus's and the Romans' temperament as that which led to Rome's success. "Such is the War-god" is a description of Mars's character, whose genetic connection with Romulus is clear but only implied. "Such *as* she who suckled thee," conversely, more explicitly attributes to the she-wolf responsibility for the identity of Romulus and his descendants. The she-wolf's milk is made of violence, it is distilled of the flesh and gore of this predator's victims; and it is a taste for blood, a predilection for violent predation, that is passed on to Romulus along with the protein, fats, and carbohydrates that physically sustain the growth of his organism. It is significant that at the end of the 1899 edition of Macaulay's *The Lays of Ancient Rome*, readers find an engraving taking up half a page and underscoring the central position of Romulus's animal nurse: "The Bronze Wolf of the Capitol" (125).

ROME AS A SHE-WOLF FOR NIEVO, CARDUCCI, AND D'ANNUNZIO

For English poets such as Wordsworth and Macaulay, the she-wolf's historical distance was intensified by her geographical separation: Not only was she ancient and even beyond antiquity itself, the she-wolf was also Roman, her earliest stories told in a different language entirely. Italian writers, conversely, especially Roman writers, had a more ambivalent relationship with a beast they encountered far more frequently and whose

historical distance was mediated by geographical proximity. During the same century that Wordsworth and Macaulay were writing – a century that saw the creation of the Italian state and the first political unity of the boot-shaped peninsula since ancient Roman times – the Roman she-wolf acquired close-to-home political as well as historical significance for many Italians. However wolfish, the city of Rome, in fact, did not enjoy political freedom for much of its history since the fall of the empire. Peoples from the north repeatedly sacked Rome in the fifth and sixth centuries, as Joachim du Bellay lamented in his Renaissance *Un songe*. Continued wars in and around Rome during the following centuries turned the region of the celebrated seven hills into an unhealthy marsh. A legend circulated that at one point in the Middle Ages, no one lived in Rome. In reality, the small population was concentrated in the area around the Tiber River and the central Field of Mars. The emperors ruled from afar and senators governed Rome. It was from senatorial families that the popes were chosen so that, over time, the Church absorbed political clout, urban possessions, and administration of the city. The move of the bronze *She-Wolf* from the Lateran Square to the Capitoline Hill was a symbolic turning point in this shift of powers. With a few short-lived exceptions (i.e., the first and second Roman Republics, inspired by the ideals of the French Revolution, each lasting only a few months), the popes retained enduring political control of Rome until 1870. In 1861, when much of Italy was united under King Victor Emmanuel II with Turin and then Florence as its capital, Italians still turned to Rome as their desired capital, as the one city that would provide a symbolic link to their independent past. It took another nine years, however, before Rome became part of the Italian kingdom.

Ippolito Nievo (1831–1861) was a man who fought with words and body for the unification of Italy. He died shipwrecked at the age of twenty-nine while returning north from Sicily carrying important polit-ical documents. Nievo expressed in his novel, *Confessioni di un italiano* (Confessions of an Italian, posthumously published in 1867), his relation-ship with Rome as a patriot and an Italian, as a man who had devoted his short life to a country the unity of which was still, at the time of his death, more an ideal than a reality. Nievo had much to say about Rome's place in his countrymen's efforts:

> Rome is the Gordian knot of our destinies. Rome is the grandiose and
> multiform symbol of our race. Rome is the ark of our salvation, which
> with its light swiftly clears up the crooked and confused imagination

of the Italians. Do you want to know whether such a political order, whether that mix of civilization and progress can hold, and bring good results to our nation?... Rome is the answer: Rome is the stone of comparison that will distinguish the brass from the gold. Rome is the she-wolf that feeds us with her teats; and those who never drank of that milk cannot understand. (218)

A Gordian knot is an intractable problem, one that only a bold, cutting stroke is capable of solving: Ippolito Nievo probably means that military intervention is this stroke because in his view, the forcible removal of the popes from the government of Rome was the only solution to the crisis of Italy's true capital. Nievo did not live to see this symbolic city – the only city capable of clearing nationalist confusion and uniting a still divided people – become a part of united Italy, much less its capital. As the milk of the she-wolf once saved the little boy who was to found Rome, so also the milk of Rome, the she-wolf's city and a she-wolf city itself, will unite Italians into a national and political reality and make them fellow inhabitants of a country that until then had existed only in people's desire and imagination. As in ancient times, it is once again the she-wolf's milk that is expected to provide a unifying sense of tradition and heritage, a national character, to the inhabitants of Italy. Ippolito Nievo had been dead nine years on September 20, 1870, when the Savoy royal troops made a breach on the city walls near the Porta Pia and entered Rome, annexing it to the Italian state. In 1871, Rome was made the official capital of newly unified Italy.

The she-wolf was then and would remain to this day the most immediately recognizable symbol of Italy's capital, and in a Catholic city colored with yellow-and-white pontifical flags – a city teeming with churches and crosses and holy icons of all shapes and sizes – the she-wolf was perceived as an ancient Roman symbol, civic and free from religious connotations. This picture of a purely secular she-wolf did not correspond to historical reality, of course: For centuries, in the early through the later Middle Ages and into the beginning of the Renaissance, the bronze *She-Wolf* had been the symbol of papal justice when she stood outside the Basilica of Saint John the Lateran. Pope Sixtus IV's gift of the bronze statue to the city of Rome, with her placement on the Capitoline Hill, had the effect of incorporating that traditional center of civic rule within the papal sphere of control and emptying it of its political significance by endowing it with the cultural and historical value embodied by the bronze beast. Over time, however, the *She-Wolf* on the Capitoline

Hill forgot her own past at the Lateran Square and came to signify the past of pagan Rome, no longer the papal city.

The meaning of the she-wolf should be far too complex to be used for effective political advantage. Conversely, this meaning may have been so often politically exploited precisely because it is complex, its apparent solidity enveloping an underlying malleable core that could be appropriated by different political groups. Whereas, today, the controversies surrounding the she-wolf turn around the time and place of the *Lupa Capitolina*'s manufacture (i.e., Is the statue Etruscan or medieval?), in past centuries the significance of the she-wolf's symbolism – of both the bronze and the legendary beast – was contested and at the same time employed with varying degrees of anxiety by both proponents and detractors of the Roman nurse's greatness. For many, the she-wolf was the unquestioned representative of pre-Christian glory; for others, the beast's past associations with the pontiff and her allegorical incarnation of greed – not to mention her legendary sexual promiscuity – irremediably tainted her. Dante's covetous, wanton she-wolf – Italy's most memorable allegorical canid – exemplifies this enduring stain on the beast's pelt.

In his ode to the northern Italian city of Ferrara ("Alla città di Ferrara nel 25 aprile del 1895"), Nobel Prize–winning poet Giosuè Carducci (1835–1907) inveighed against the she-wolf, a symbolic animal he definitively identified with the Vatican as the seat of papal rule. "The Vatican she-wolf" is the beast that, Carducci claimed, brutally attacked "with her rabid claw" the white eagle that symbolized the Este family, which for centuries ruled Ferrara before the popes took over the city in 1598. (In 1832, the papal government was ousted by the Austrians, who ruled Ferrara until it became part of the Italian kingdom in 1859.) The eagle's wing, the poem decries, was torn off by this wolf. Carducci was not one to mince words: "Scenting its prey, the Vatican she-wolf lunges from the Tiber to the Po, her eager mouth reeking with dreadful stench" (82). The city's magnificence is sung by Carducci through images drawn from the poetry of Torquato Tasso; the latter's Renaissance lines figured as the song of a nightingale that featured blonde, blue-eyed virgins. Ferrara's splendors must regrettably flee before the she-wolf, a beast that "fiercely bares her white teeth and advances, howling." Carducci curses the "old and cruel Vatican she-wolf," wishing her damned "always and everywhere." In repeatedly cursing the beast, he consciously joins that other hater of she-wolves, Dante, whose own accursed beast in the *Divine Comedy* Carducci mentioned in his lines. For Carducci, it is the Vatican she-wolf herself (i.e., the Catholic Church of the Counter Reformation)

who caused Tasso's madness and his lengthy hospitalization. Carducci's invective against the Roman beast ends with an invocation to Giuseppe Garibaldi, regarded by the poet as the only man who could rescue Italy from the claws of the Vatican she-wolf.

Fascination with Rome's glorious past as embodied by the she-wolf has regularly generated discontent with a present unable to live up to such greatness – however problematic. Lord Byron's "thunder-stricken nurse of Rome" is an example: All of her "foster-babes are dead." Whereas Byron's accusation is leveled at the she-wolf's descendants and not at the beast herself, this was not the case with Carducci or with that other lover of past Roman glories: the prolific Italian poet, novelist, and playwright, Gabriele D'Annunzio (1863–1938). A few years after Carducci's she-wolf invective, D'Annunzio lamented the shortcomings of the present age by evoking images of the birth of Rome. In his poem, *Canti della morte e della gloria* (Songs of death and glory; 1903), D'Annunzio described the deplorable distance – psychological and spiritual far more than temporal – that separates present Rome from the city's past:

> O Truth, encircled by oak trees, sing of the sadness of the Latin people, of the Sun dying behind the Aventine Hill, and of the night embracing the holy Arx.... The tired She-Wolf's milk is depleted within her saggy breasts, and the Ruminal Fig tree is bare of its petty thieves. Acca Larentia makes money as a whore. The wingless goose lives on the Capitoline....
>
> (87)

In a comparison with its own ancient grandeur, Rome falls short: The sun has set on the city's glory and the formerly aggressive, nurturing she-wolf is now tired, her milk all used up; the legendary fig tree that had previously harbored Romulus and Remus has lost its dwellers; and Acca Larentia, once foster mother to the city's founder (D'Annunzio later relates that it is to *Larenzia mammosa*, i.e., Larentia endowed with heavy, milk-filled breasts, that Faustulus had given the twins), has turned into a greedy sex worker. D'Annunzio's symbolic metaphors express Rome's loss and mourn it with the bitter tone of one who wishes things had turned out differently.

D'Annunzio knew Rome well and experienced keenly the city's association with the she-wolf. Born in 1881 in Pescara, on the eastern seaboard, the ambitious young man moved to the Italian capital, where he lived for ten years. In addition to composing poetry and fiction, he worked as a journalist, writing a society column about the Roman "jet set": theater openings, the variety of fur coats in fashion that year, what to

do in Rome on a hot summer day. These pieces were later collected in a volume with the allusive, self-deprecating title, *Roma senza lupa* (Rome without the she-wolf). It was a city devoid of all greatness and historical identity that D'Annunzio described in his society column, a city whose connection with its ancient glory was all but forgotten even by its more aristocratic residents. The good she-wolf from this city is absent: As the glorious emblem of Rome's past grandeur, the beast can be present only through the metaphorical allusion that is D'Annunzio's title, an allusion that ironically emphasizes the beast's absence even as it bemoans it.

ANGRY AND HUNGRY BEASTS IN PASCARELLA, TRILUSSA, AND BELLI

Mother figure and whoring temptress, savage predator and tender nurse, symbol of the glory of Rome and allegory of its corrupt Church: However maternal the she-wolf's ultimate significance and no matter how graceful her transitions between one role and another, the beast has long been trapped within a series of binary meanings. She represents goodness and evil, salvation and sin, the natural world where she once thrived and the urban culture that made her immortal. Neither does the she-wolf want to be reminded of her seedy past. Few today read of the horrors her bronze icon encouraged and protected or of the lives she allowed to be sacrificed in the name of material wealth and to protect the pope's greed from the competing interests of thieves. The Lateran frescoes depicting the fifteenth-century *She-Wolf* next to two severed and decomposing hands were destroyed – their memory relegated to dusty archives and specialized tomes, available exclusively to the few who somehow already know about it. The she-wolf's predatory nature is always lurking behind her generous udders, and we should not marvel at these distended icons of nourishment without observing as well the she-wolf's bared fangs and those tense muscles ready to pounce. This is how Dante remembered the beast, and readers of his *Commedia* are ominously reminded of the she-wolf's threats. Dante's she-wolf, however, has no twins below her and neither did the *She-Wolf* at the pope's tribunal. The beast's maternal attributes must be elided for the full force of her rapacious nature to become visible, for her approach to be sensed as dangerous. Yet, the idea that ferociousness may proceed from maternal instinct is essential to the force of the bronze *Capitoline She-Wolf*; it is, indeed, an inescapable message of that statue. Whereas the *She-Wolf* at the pope's Lateran tribunal was a protectress of sorts – protectress of truth, protectress as well of the

Church's financial interests – Dante's she-wolf does not protect anyone. She is a female, certainly, but she is pure evil and there is no redeeming value to her aggressive stance toward the poet.

Dante was a Florentine: Italian, yes, but geographically distant from the she-wolf and historically threatened by her greed. The relationship of modern Roman writers with the she-wolf, although far from easy, has been more intimate – as suggested by the cycle of historical poems, *Storia Nostra* (Our history), by Cesare Pascarella (1858–1940). Begun in 1905 and left unfinished at the poet's death, this is a collection of 267 sonnets in Roman dialect that relate the history of Rome from its foundation to the nineteenth century. The she-wolf is present in the ninth, tenth, and eleventh sonnets of the first part, which describe Romulus and the birth of the city. The ninth sonnet tells of the twins' abandonment in the river; how their basket somehow became stuck on the shore; and how a she-wolf, according to the last line of this poem, "gave them milk and saved them from death." The tenth sonnet relates an imaginary history of the bronze statue, produced as a result of the twins' gratitude:

And you see, they were so grateful to that she-wolf that, as soon as both of them were able to, they had a monument erected to her, where the two of them are portrayed in the same exact position as when the she-wolf suckled them. And Romulus said it: I, he said, want that this she-wolf who has raised us should be placed in the Capitoline Museum; and since she was our first beginning, let her portrait be printed on the coats of arms at City Hall. (178)

Pascarella used the anecdote of the *Lupa Capitolina*'s monumental statue – eliding its history at the Lateran Square and placing it in the Capitoline Museum from the start, with twins original to the ancient bronze – as civic emblem and unequivocal sign of his fellow Romans' innate gratitude: "Here in Rome the plant of that vice, of being ungrateful, never bloomed," he wrote in the eleventh sonnet. Soon afterward, however, the poet commented on the flip side of this character trait: Romans are grateful to those who are good to them, sure; but if they are good to someone and that person in return does not treat them as friends, they cannot bear it. The proof of this may be read in Remus's end. Pascarella imagined Romulus repeating to his twin brother: "Stop, Remus! Stop it! Quit it! And that one, instead – we must really say without a brain – kept fooling around even more." So Romulus tolerates it for a while but, in the end, he did what "would have been better for everyone if it did not happen" (179–180).

With the wit characteristic of Roman dialect poetry, Pascarella told the story of early Rome. It is an opinionated version of history, rich with appeals to the feelings of working-class Romans; still, it stays fairly close to the legendary and historical tales of Rome as they have been handed down by tradition. More creative than Pascarella's is the relationship with the she-wolf figured in the dialect poetry of another Roman, Trilussa (pen name of Carlo Alberto Salustri, 1871–1950), possibly the most popular today among poets in the Roman dialect. The she-wolf appears often in Trilussa's lines, and she is always a political and polemical rather than a more objectively historical beast (personified animals, by the way, are frequent protagonists of Trilussa's poetry). For example, when she addressed the Bear, symbol of Russia, in the 1917 poem "La Lupa e l'Orso" (The She-Wolf and the Bear), Trilussa's feisty She-Wolf tells the Bear that she would rather go back to being a wet nurse than accept peace without glory (105). This was toward the end of World War I and questions of victory and peace were pressing. In Trilussa's 1912 poem, "Tendenze" (Trends), an old bourgeois male wolf justifies himself to the proletarian lamb he is about to devour by means of a historical and political connection: He is a relative of the female wolf that once breastfed the monarchy (289) – he is no friend to the masses. The she-wolf plays a bigger part in "Er comizzio" (The political speech, ca. 1901). The poem begins with a speechmaking lion inciting his fellow animals to the class-consciousness that must precede any revolt against the oppressing humans. Several listeners interrupt the king of the animals: first a Monkey, then a Donkey, and third but not last (many other animals follow her), a She-Wolf:

> The She-Wolf said: – And I, who gave my milk to the first King of Rome? It's because of me that, for better or for worse, there is a monarchy: But, instead, look at how Man has tricked me?! He shut me in a cage and spread the saying that I eat like a wolf! What respect! He should have showed some consideration for the nurse of the first King who made Rome! And instead. . . . (358)

Contrary to Pascarella's iconic Roman gratitude, Trilussa's She-Wolf reminds her audience of an opposite quality in human beings, Romans included: forgetfulness of history and history's lessons; lack of gratitude for the sacrifice of those who brought us to where we are. Romans, she complained, no longer remember, much less honor, their debt to their founder's first nurse. The Bear who follows the She-Wolf in responding to the Lion evokes a more poignant and contemporary comparison by

likening the She-Wolf's fate to that of the veterans responsible for the unification of Italy and who, despite their wounds and their medals, must today scrape by as organ grinders. Rome and Italy, more generally, fail to revere those in whose debt they are – whether animals or humans. To gratitude, they prefer domestication through imprisonment, with cages made of metal for wolves and of abject poverty for men.

The She-Wolf in "Er comizzio" complains about her cage as well as the proverbial hunger with which ingrate men have saddled her. Whereas English speakers rely on the vegetarian appetite of horses to indicate metaphorically the power of physical hunger, Italians turn instead to wolves: "I have the hunger of wolves" (*Ho una fame da lupi*) they say. English speakers, however, also may describe ravenous eaters in the act of "wolfing down" their food. The she-wolf's illness, *il male della lupa* in Italian, is not the skin lupus I warily named in the preface to this book but rather the habit of devouring food without finding satiety. The she-wolf's illness is an insatiable hunger sometimes identified with what we might today call chronic gastritis. This illness appears in Lorenzo Lippi's burlesque romance, *Il Malmantile Racquistato* (The reconquered castle of Malmantile), for example, published posthumously in 1688 and prized by historians of language as a collection of idioms, proverbs, and folk customs. In one of the notes considered to be an integral part of Lippi's mock epic, and essential to the understanding of the poem outside of Tuscany, Paolo Minucci wrote: "*To be wolfish.* It is said that the wolf is always hungry. Therefore, the common people describe as the illness of the she-wolf the experience of those people who would constantly eat – because they process food very quickly and derive little nutrition from it; it is the same illness that doctors call canine hunger. It is from this illness, called of the she-wolf, that we describe as being wolfish somebody who is always hungry" (199).

In a later note, Minucci reiterated: "*The illness of the she-wolf.* By this we mean an illness which makes the patient experience a continuous hunger" (253). The hunger caused by this disease is as relentless as the beast after which it is named. A hundred years before Minucci, Giambattista Della Porta, in his play *L'Olimpia* (1589), illustrated the same illness in analogous terms: "The doctors of my hometown say there is an illness called 'she-wolf,' which causes such a hungry hunger that the more one eats, the hungrier one gets. I believe I was born with this illness, not just in my guts, but in the very marrow of my bones; and not one of the syrups, medications, or treatments available can get rid of it" (9).

The expression, "the illness of the she-wolf," was common in many Italian dialects and appears, for example, in dictionaries and studies of Tuscan, Ligurian, Emilian, Milanese, and Neapolitan vernaculars, as well as in a number of folklore studies (Sanga 31). Particularly relevant for our geographical framework is the use of this expression by Roman-dialect poet Giuseppe Gioacchino Belli (1791–1863). Significantly but not surprisingly, given his Roman roots and residence and the intrinsic Roman character of his poetry, Belli associated the she-wolf's illness and the she-wolf's hunger to the needs and desires of the maternal body. The bronze *Lupa Capitolina* also may look selfishly ravenous (which corresponds to Dante's interpretation of the legendary beast), but her swollen udders relate this personal hunger to her need to feed her young: It is not only – not even primarily – for herself that she must eat. Belli's 1832 poem, "La maggnona" (The big eater), refers to a female subject, as the feminine ending of the title noun makes clear. The husband of the eponymous eater – he is the speaker of the poem – complains because of the money he must spend to feed his famished wife whenever they go out to eat: "You say that she is young, her flesh is firm: she has to fill her belly for her baby girl! But she would even eat the crusts of Saint Lazarus: she has the she-wolf's illness" (234). This husband understands the arguments made in favor of his wife's physical needs – she has the normal hunger of the young and, being pregnant, she also must proverbially "eat for two." Yet, this speaker, like most of Belli's protagonists, is also a common man of limited financial resources. His wife's wolfish hunger is a drain on his economy. As the great bard of the Roman dialect, Belli famously wrote that he wanted his sonnets to be a poetic monument to plebeian Romans – to their daily problems, including the unsolved problem of hunger. The pregnant eater is an extreme case, but not all of Belli's protagonists can count on three square meals a day (Springer 99). It is only fitting that on the 1913 monument dedicated to Belli in Trastevere, in one of central Rome's busiest squares, immediately under the feet of the statue depicting the poet there is a prominent relief of the she-wolf nursing the twins. The allegorical personification of the Tiber River is found next to the generous but famished beast, and the monument is a fountain – like Master Gregory's description of the Lateran *She-Wolf* and the *Fontana della Lupa* in downtown Rome – as useful in quenching the thirst of passersby as the wolf's milk was needed to sustain the hunger of Romulus and Remus.

The hungry she-wolf is a ravenous beast whose connotations of maternal nurturing, of feeding others rather than devouring them are

sometimes elided in the cultural representations that construct and hand down her image and her story. A complicated beast, the she-wolf is every time an icon of excess. The particular form of the excess she connotes, however, shifts according to the historical or cultural context of each representation: The *lupa*'s ancient profession as well as the visibility of her sexual attributes bespeak the she-wolf's sexual excess and the insatiability of the pleasure-inclined women who resemble the beast; the wolf's leanness indicates the excess of her hunger, of her need, and thus another more literal insatiability; and her eight swollen udders signal a maternal excess, fiercely protective and suggesting both sexual activity as the necessary cause of maternity and the perpetual hunger that is its result.

SEXY AND POLITICAL SHE-WOLVES IN VERGA, MUSSOLINI, AND THE BOMBS OF 1993

Archaeologists have examined the metal and stone she-wolves of the past as material traces cryptically conveying what once was. In these same she-wolves, art historians have cautiously discerned figurative meanings and relationships between different artists and periods. Historians have traditionally regarded texts about the she-wolf as more reliable for our study of the past than the physical objects favored by archaeologists and art historians. Despite this required confidence in verbal artifacts, it is the task of literary critics to uncover and emphasize the inescapable ambiguity and contradictions of the written word, thereby reminding us of how guarded we must remain, how circumspect and vigilant, when reading the texts left behind by the passage of time. Words, like things, are not always what they seem, much less what they purport to be. The she-wolf provides ample evidence of the unreliability of language as a useful instrument in understanding the past. A single word defines the beast of Rome: The she-wolf's name is *lupa* in Latin as well as in contemporary Italian; after all, as classicists like to quip, Italian is just bad Latin. This name cannot go unnoticed or unmarked by her gender: A wolf may be male or female but a she-wolf's gender is unmistakable. When we describe animals and specify the wolf's femaleness, it is because her distended udders leave little doubt about her sexual identity. Normally, male and female mammals are distinguished by the presence in the male of a penis and testicles; in the overwhelming majority of situations when we must identify the gender of a mammal, it is the *absence* of male sexual organs that qualifies femaleness to the untrained eye. However, with the she-wolf, this is just

not so. Signaled by an engorged fullness, the she-wolf's femaleness is an attention-getting *presence* rather than an absence of phallic or testicular protuberances. Her sexuality is no less evident in language than it is in bodily shape: In Roman times, a *lupa* was a prostitute as well as a wild female beast. Her active sexuality defined her beyond her physical attributes. Her gender has always been an inescapably cultural as well as biological construction.

The written discernment of woman as she-wolf, inaugurated in the texts of ancient Rome, was to endure through the centuries. In Roman history and poetry (see Chapter 4), this ambiguous identification was tinged with political gratitude toward the she-wolf – whoever or whatever she may have been – and it was infused with a keen awareness of the uncertainties inherent in the discourse of legend. Misogynist Christian texts (e.g., Tertullian's and Fournival's), conversely, display no such gratitude or any humble hesitation in building on the debasing, allegorical animalization of human females. The literary and, more generally, cultural heritage of the human she-wolf – of the hungry, sexually overactive, and ultimately unsatisfiable woman – was therefore to have a long life in the West. The she-wolf identity was a metaphor and a type not reserved for professional sex workers but often extended to define women in general. We encountered Masuccio Salernitano's explicitly misogynistic portrait of woman as she-wolf. A few centuries later, the infamous Marquis de Sade wrote in his 1795 *Philosophy in the Bedroom* – rather self-servingly, we should say – that "Woman's destiny is to be wanton, like the bitch, the she-wolf; she must belong to all who claim her. Clearly, it is to outrage the fate Nature imposes upon women to fetter them by the absurd ties of a solitary marriage" (219). The speaker, the young but seasoned libertine Madame de Saint-Ange, is instructing the fifteen-year-old virgin Eugénie about sex and conducting, along with two men, Eugénie's initiation into a variety of sexual acts. Along with the reader, Eugénie must learn that woman is naturally promiscuous like the canids she most resembles – bitches and she-wolves – and therefore cannot be confined to the sex available within marriage; monogamy does not suit her. In the name of social and political freedom and for the sake of emancipation from the constraints of parental and family dictates, Madame de Saint-Ange contends, young women must heed the call of nature, claim their animal-like sexual essence, and reject the misery-inducing shackles of marriage and sexual fidelity. Every woman must find the she-wolf within.

At least one Sicilian woman did. Four hundred years after Masuccio Salernitano and many centuries after Tertullian, but writing along their same literary genealogy, Sicilian writer Giovanni Verga (1840–1922) titled one of his most famous short stories "The she-wolf," "La lupa" (1880). The lustful eponymous protagonist of this tale, a middle-aged peasant woman named Pina, is an outsider to the small Sicilian town that she inhabits with her only daughter, Maricchia. Pina comes to sexually dominate her own son-in-law, Nanni, whom she herself had chosen for the hapless Maricchia. Unable to resist his mother-in-law's aggressive seductions, Nanni feels that he has no choice but to murder her if he is to stop having sex with her and save his own soul. Pina's townspeople "called her the She-Wolf because, no matter what she had, she was never satisfied." Pina is a carnivore who walks "lone as a stray bitch, with the restless and wary appearance of a starving wolf," and her fellow villagers are afraid that "she would gobble up their sons and their husbands in the twinkling of an eye with those red lips of hers." Human and animal at once, more of a wild beast than a civilized member of society, Pina is almost a werewolf and a man-eater in whose traps the reader also is ensnared: Her lips are red, looking "as though they would eat you" – *you* the reader, not just the tale's characters (34). Verga's she-wolf is a frightening predator, against which the young male of the story can offer little resistance. Nanni's only chance of victory is destruction of the beastly woman through his superior physical force. This he must do despite the fact that Pina is also a mother, also *his* mother, although a ferocious one: Heedless of her biological daughter's needs and rights, she devours the sex and personality of her legal son, her son-in-law.

The she-wolf of neither Masuccio Salernitano nor Giovanni Verga, of course, actually incarnates the Roman beast. First and strictly speaking, there is no Roman beast because there is no historically verifiable breast-feeding animal presence in the early life of Rome's founder – hardly more than a legendary figure himself. Second, even if we remain within a legendary and narrative rather than historical context and among allegorical rather than zoological females, Masuccio's and Verga's are both human females, not female wolves; they are sensuous women, not professional prostitutes. These two literary she-wolves are nevertheless constructions of the same type of woman. In her book on allegory, Maureen Quilligan remarks that "allegory names the fundamental principle beneath the reverberation of words; yet words in allegory not only extend meaning by punning allusiveness throughout individual narratives, they echo across

texts, across generations, across time itself" (98). The reader's understanding of every she-wolf woman is predicated on the textual evocation of the she-wolf's previous texts: The words describing the protagonists of Verga's "The She-Wolf" and the twenty-first story of *Il Novellino* clearly do not refer to women or beasts moving about the world but rather to other texts – whether historical, literary, theological, political, or even visual. Both of these literary incarnations, whether from the early Renaissance or the late nineteenth century, textually recall the Roman rescuer's memory: The beast of neither Salernitano nor Verga would be quite the same without the other stories of the Roman she-wolf firmly planted in the imagination of their readers. These two she-wolves place themselves in the pack, so to speak, of previous cultural she-wolves – literary and visual. In doing so, each new she-wolf both interprets her forerunners and produces yet another predecessor for she-wolves to come.

The fact that the legendary Roman beast has no clear identity, that she indicates not one but at least three characters, only makes her more suitable for literary, artistic, and political appropriation and re-elaboration. According to legend, Romulus had as many as three mothers, all of them tainted with the she-wolf's name to varying degrees. Each mother was unusual in her own way: One was a virgin princess, the other a wild beast, and the third a prostitute or serial adulteress. Romulus's three mothers converge into one figure of maternity, forming a trinity of social respectability and religious consecration (Rhea Silvia was a holy virgin), fierce animal instinct (this was the wild she-wolf's prerogative), and boundless female desire (which was the perceived cause of prostitution and adultery). All three are mothers in unique ways; all three share something of the she-wolf – the *lupa* biologically, Rhea Silvia through her forest name (*Silvia* derives from the Latin *silva*, "forest"), and Acca Larentia through her wolfish profession or promiscuous habits. All three mothers, whose lives go back to a time when Rome was not even born, allude to the Eternal City as it would be regarded through the centuries to come: a holy city, a wanton harlot, and a fierce predator.

The triple nature of the she-wolf's name – mother, beast, and whore – continued to play its confusing tricks through the ages. During Benito Mussolini's fascist regime in the 1920s, 1930s, and early 1940s, the ambiguous she-wolf also showed up to claim her charges and mark them with her own uncertainty. She did this through language and the name of an organization for fascist youths called "I figli della lupa" (Sons and daughters of the she-wolf): With the generic word *figli* (sons and daughters), both male and female children were included. Beginning in

the 1930s, Italian children, according to age and gender, were obligato-
rily placed in parascholastic, semimilitary organizations. The groups were
meant to ensure children's loyalty to the regime from early childhood.
Members of the organizations wore uniforms, met on a weekly basis to
perform physical exercises, and marched together on special occasions.
In the paramilitary groups of fascist Italy, high-school-age boys were
called "Avanguardisti" (Men, or boys, at the vanguard) and girls of the
same age were called "Giovani Italiane" (Young Italian women, or girls);
eight- to fourteen-year-old boys were called "Balilla" (from the name of
a young Italian revolutionary); and girls of that age were called "Piccole
Italiane" (Little Italian women). Finally, most vividly and Romanly, six-
to eight-year-old boys and girls were called "Figli della lupa" and "Figlie
della lupa" (Sons of the she-wolf and Daughters of the she-wolf – or,
more generally, the "She-wolf's children," her offspring). Mussolini was
keen on establishing an Italian identity and a consequent glorious destiny
derived from Rome's imperial past, and he took every opportunity to
highlight the profound Romanness of the Italian people, their *romanità*.
The she-wolf's children he so named had their own hymn that rhetori-
cally described them as "Italy's first flowers" and as those who have given
their heart over to Italy's "great Leader." They were outfitted in minia-
ture versions of the symbolic black shirts worn by Mussolini's early thugs,
and the clasp of their suspenders was decorated with a capital "M" for
Mussolini (Falasca-Zamponi 80). Although after 1937 it was mandatory
for all young Italians to belong to the paramilitary organization deter-
mined by their age and gender, it was a great disappointment to the
organizers and to Mussolini himself that these groups never consisted of
more than fifty percent of eligible boys and girls. Not known as especially
law-abiding, many Italians did not mend their ways under fascist rule:
As Mussolini is famed for saying, "Governing Italians is not difficult; it
is useless."

In a long and influential review article on the iconography of the
ancient she-wolf dating from fascist times, British art historian Eugenia
Strong concluded: "That the Roman she-wolf has not given her milk in
vain is confirmed, finally, by the name 'Sons and daughters of the she-
wolf' assumed, with legitimate pride, by today's new *proles italica*" (101).
Strong's sympathy for fascism and Mussolini himself was well known,
but perhaps the fact that she was not a native speaker of Italian made
her oblivious to the connotations of the she-wolf's name. The term
"Sons and daughters of the she-wolf" should sound at best ironic to a
classicist and to any reader familiar with ancient history and its linguistic

ambiguities. In Latin, a *lupa* is both a she-wolf and a prostitute: *Lupanars* were Roman brothels and the she-wolf who rescued Mars's twins may have been a local hooker who practiced in the great outdoors. Because the insults *figlio di puttana* and *figlio di mignotta*, both meaning "son of a whore" (both are also available in the feminine: *figlia di puttana* or *di mignotta*, "daughter of a whore") are among the most common in today's Roman slang and have been for decades at least, the dangers of Mussolini's hasty recovery of ancient names in the service of a new ideology became humorously obvious. Mussolini thought he was naming Italian children the rightful descendants of Rome's first foster mother, brothers and sisters to Mars's beloved son and the city's feisty founder. Yet, with the same words, "Figli della lupa," Sons and daughters of the she-wolf, Mussolini also unwittingly questioned every Italian mother's sexual conduct and, consequently, the fascist boys' and girls' own legitimacy. In a genealogical line such as the she-wolf's, which includes Tertullian's misogynous accusations and a subsequent series of literary man-eaters, what was intended as an honorific title turned into an inadvertent insult.

The association of she-wolves with fascism was to be spectacularly expressed in a 1974 soft-porn Nazi exploitation film, *Ilsa, She-Wolf of the SS*. The movie features a namesake protagonist whose sadism is matched only by her destructive sexuality: She castrates her victims after raping them. For its title and theme, the movie relies on the rhetorical connection among women, she-wolves, and sexual insatiability; it misogynously relates women's sexual power to political power. The authoritarian woman of the title – attractive and dangerous – is drawn from "an erotic vocabulary that posits women's sexual authority in place of political authority, illustrating in exaggerated form the interchangeableness of each setting" (Slane 249). It is not that *Ilsa, She-Wolf of the SS* is an accurate reflection of widespread ideas about women and politics: The bitch rather than the she-wolf may well be the most important animal icon of female aggressiveness in contemporary American politics. Still, the connection this movie relies on for its title – namely, the bond between women's aggressiveness and their animal nature (often but not always involving their sexual insatiability and/or a misguided and excessive maternal attachment) – plays a broad cultural role and frequently has been attached to political ambition.

Fourteenth-century English Queen Isabella is still remembered in history and in the abundant fiction she inspired by her nickname, "She-Wolf of France." Isabella was beautiful (she shared the she-wolf's sexual charm), a prolific mother (like every good she-wolf), and, allegedly, a

murderer (because all she-wolves are predators). Another "She-Wolf of France" was fifteenth-century Queen Margaret of Anjou, the aggressive, alluring wife of English King Henry VI, named "She-Wolf of France" by Shakespeare himself in *Henry VI*: "She-wolf of France, but worse than wolves of France, / Whose tongue more poisons than the adder's tooth" (183). Margaret was a more subtle she-wolf than her namesake in the animal world because she captured her prey with poison rather than fangs. The most infamous of all French queens, Marie Antoinette, also became known as a depraved, bloodthirsty she-wolf; more specifically, "the Austrian she-wolf." She slaked her thirst, French Republicans claimed, on the blood of her French subjects – lambs to her wolfish appetites (Lever 295). Not coincidentally, these queens were foreign-born: their country of origin – whether France or Austria – was prominently associated with the name "she-wolf" as a further sign of their otherness and treachery.

This allegorical tradition of reading the she-wolf's nature into the political aspirations of ambitious women is much closer to our contemporary Western world than we might like to believe. As David Hult explains, "medieval allegory has something to teach us about our most common, yet typically unacknowledged, interpretive mechanisms, especially those that lead us to transpose individual characters into representatives of a class or a type" (217). A quick and simple Internet search, for example, reveals numerous Web sites in which former presidential candidate Hillary Rodham Clinton is represented allegorically and called by the name of the she-wolf. She is Hillary, she-wolf of the Democratic left, a snarling, power-hungry she-wolf, a she-wolf who would eat her own young to get ahead (Kennedy; Hitt). It is interesting that former vice presidential candidate Sarah Palin, despite her profound political differences from Clinton, has been allegorized and called a she-wolf – but it is significant that the apparently more traditional Palin, mother of five, is a she-wolf in sheep's clothing and a she-wolf who notoriously likes to shoot her own kind (Edsall) – an allusion to Palin's hunting skills and support of aerial wolf-gunning.

Of course, the she-wolf's political connotations precede Mussolini's fascist manipulation of her name, not to mention its recent American exploitation in misogynistic journalism. Indeed, beyond the various medieval and later she-wolves, the *lupa*'s actions – like those of her more important nursling – are always already political (to this end, one can recall Komunyakaa's lines, "Now she's only primal food / & sex, their first coup d'état") and she remains a thoroughly political being in texts such as Dante's fourteenth-century *Commedia* and Carducci's

nineteenth-century ode to the city of Ferrara. Fascism made considered use of the she-wolf's shape and name for its political maneuvers and justifications. Her sexuality elided, for the fascists, the she-wolf was a figure benevolent toward her own charges and a patriotic emblem to be embraced by all true Romans. The she-wolf's malevolent political role, however – fleshed out in the invectives of Dante and Carducci – was not forgotten despite fascist rhetoric. In Rome, it came back with a vengeance on the night of July 27–28, 1993, when a car bomb exploded in front of the seventh-century San Giorgio al Velabro – a church located in and partly named after the area where the she-wolf rescued the twins, the Velabrum. The bomb all but destroyed the twelfth-century portico, inflicting serious damage to the façade, door, and other parts of the building and wounding several people. The 100 kilos of explosives turned the front of the church into a heap of ruins. It took five years of intense restoration work for San Giorgio to return to the spare medieval beauty given it by Antonio Muñoz's 1920s restoration. Some sections, furthermore, have been intentionally left unrestored as reminders of the violent attack.

In Italy, 1992 and 1993 were bloody years of car bombs. In Rome, on the same night as the explosion at San Giorgio al Velabro, another car bomb blew up near the Basilica of Saint John the Lateran – not entirely coincidentally, the Lateran is another of the she-wolf's traditional haunts and once the site of the pope's tribunal. Although the bombers may not have been aware of the she-wolf's medieval history at the Lateran, it is no coincidence that both the she-wolf and the bombs were placed in historically strategic sections of Rome. (Bombs also exploded on that same July 27 in Florence near the Uffizi Gallery and in Milan, each claiming five human fatalities.) Some commentators attributed the explosions to the mafia, others to terrorist organizations. One theory claims that the Basilica of San Giorgio al Velabro was targeted because of its connection to the Sacred Military Constantinian Order of Saint George, a Catholic Order of Knights to which many men with important institutional appointments belong. However, the Web site of San Giorgio al Velabro (Canons Regulars of the Order of the Holy Cross: The Basilica of San Giorgio in Velabro), as well as large homemade posters posted in the basilica (I saw them during a 2007 visit to San Giorgio), emphasize the church's location as the place where the she-wolf found and rescued the abandoned twins and dwell on the historical significance of the Velabrum because it marks the beginning of the city of Rome. By bombing this church, the Web site and posters declare, the attackers meant to

strike "the entire city, its history, its culture." The attack was directed at Rome not only as the seat of the Italian government but also at the Velabrum, in particular, as the place where Italy was symbolically born through the merciful suckling of abandoned babies by a wild animal mother. In the physical destruction of one of its oldest churches, located in the very place where Rome was born, the bomb was directed representatively at the she-wolf: She is responsible for the saving of Romulus, the birth of Rome, and the creation of the Italian state.

HOW TO SUCKLE THE SHE-WOLF WITHOUT GETTING BITTEN

Ingesting and absorbing the she-wolf's milk produces a Roman cultural identity. This notion informs the original Arabic title of the short novel, *Clash of Civilizations over an Elevator on Piazza Vittorio* (2006), by Algerian Italian writer Amara Lakhous (1970–). Set in the most multiethnic section of Rome – the Esquiline quarter dominated by the grand Piazza Vittorio mentioned in the title – an early version of the novel was published in Algeria in 2003 with the title, How to be suckled by the she-wolf without being bitten. Piazza Vittorio is as emblematic of the new Rome as the she-wolf is of the ancient city. The immigrants who are the novel's protagonists seek integration in a place that feeds them but wants to bite them too; this place is as ambiguous as the she-wolf, in fact, and its intentions are never as clear as the ancient beast's generosity. Even the significance of the she-wolf's bite may change according to the texts in which it is mentioned: In Lakhous's novel, the she-wolf's bite is an accident on the road to integration, to be carefully avoided. In contrast, in novelist Henry James's older description of fellow American expatriate Margaret Fuller's successful integration into Roman society, the she-wolf's bite is a desirable and reciprocal confrontation: "She had bitten deeply into Rome, or, rather, *been*, like so many others, by the wolf of the Capitol, incurably bitten" (*William Wetmore Story* 1: 129).

Although the 2006 Italian book, translated into English in 2008, is largely rewritten and its title is completely different from the she-wolf–centered Algerian title, the text contains several references to the Roman nurse and is pervaded by the questions of cultural belonging that the she-wolf's milk represents and asks. The sections of the novel spoken in the first person by the assimilated immigrant protagonist, Amedeo-Ahmed, for example, are called *ululati* (literally, "howls"). (The English translation unfortunately calls them "wails," a word that humanizes the

she-wolf's characteristically animal sound: In Italian, *ululare* is something only wolves do.) Amedeo's lupine howls have multiple meanings: They connect Amedeo to his adoptive she-wolf mother Rome as well as with the sad howls of solitude of his fellow immigrants. The howls also mark him with resigned irony: Unlike the other characters, he knows truth cannot be known and has given up on verbal attempts at truth-telling. Most of the characters in the book, for example, are not even aware that Amedeo is a North African immigrant because he has learned so well the she-wolf's language and can pronounce her howls without an accent. Moreover, Amedeo's howls mimic the calls of the Roman nurse even as they recall the *zagharid*, or the howling cries of joy and pain of Arab women. Bypassing both of his languages – Roman and Arabic – Amedeo's howls allow him to remain bonded to both of his cultures through the imitation of two mother tongues and the acquisition of two female cries.

The novel features the voices of a number of characters, each expressing a different perspective on the murder of a neo-Nazi inside the elevator of the building in which the characters either live or work. The northern Italian professor of history, for whom there is no difference between immigrants and southerners, reminds readers that the she-wolf is a symbol of Rome. He does not trust the she-wolf's children "because they're wild animals. Cunning is their greatest talent for taking advantage of the sweat of others" (Lakhous 76). Amedeo's own view of the she-wolf's milk is naturally more complex: If you succeed in drinking it unhurt, then you will become a true Roman, regardless of your ethnic background. In this novel, identity is as fluid as the she-wolf's milk and as changing as the she-wolf's own meanings through the ages. Amedeo knows Rome so well and is able to give those who ask such accurate directions that a taxi driver tells him: "Amedeo, you were suckled by the she-wolf!," which prompts him to ask himself: "Am I a bastard like the twins Romulus and Remus or an adopted son? The basic question is: how to be suckled by the she-wolf without being bitten" (101; throughout these quotations, I use the word "she-wolf" as the literal translation of the Italian *lupa* in place of the nongendered English "wolf" that the translator chose.) However, not all of the novel's characters manage to be fed by Rome's animal nurse. Amedeo, a friend to all and beloved by the novel's other characters – that he is a good person is the only thing on which everyone in the book agrees – sympathizes with the many immigrants who get drunk on beer and wine in the gardens of Piazza Vittorio and who keep howling sadly "because the she-wolf's bite is painful." Amedeo himself nevertheless

howls "with joy, immense joy. I suckle on the she-wolf like the two orphans Romulus and Remus. I adore the she-wolf, I can't do without her milk" (118). On the penultimate page of the book, Amedeo concludes that he is not in the she-wolf's hungry mouth; instead, he announces, "Here I am, in the she-wolf's arms, so that I may suckle until I'm sated. Auuuuu. . . . " (130).

As well as through explicit references to her name, her milk, her nurturing capacities, and the dangers she poses to her enemies, the she-wolf's story is recalled throughout Lakhous's novel in indirect and likely involuntary allusions: violence, sex, and an emphasis on language. At the center of the narrative is a murder: An outwardly harmless elderly woman knifes the racist thug, known as the Gladiator, who had kidnapped and tortured her little dog to death. Personal and political themes are difficult to unravel in this story as in the she-wolf's: The Gladiator (Could a nickname be more Roman?) is killed out of personal vengeance, but his violent racism turns his own actions and the actions against him into political statements. Throughout the novel, names have layered meanings and are allegories of as many types of immigrants: Ahmed is known almost exclusively as the Italian Amedeo, whereas his Bangladeshi friend, whose Italian papers mistake the word order of his names, chooses the Italian "Roberto" for his son to promote a more successful integration. The she-wolf's name also has been ambiguous. Analogies with the she-wolf's story are especially poignant in the character of Maria Cristina, an undocumented immigrant from Peru who makes a living caring for an elderly Italian woman. Through her compulsive sexuality, manifested in fleeting encounters with her countrymen on her days off, Maria Cristina seeks to escape the solitude to which her job and clandestine status condemn her. That she is also regularly raped by the Gladiator and that her numerous pregnancies must all end in abortion add to the complexity of what may otherwise appear as simple promiscuity: The representation of the she-wolf should warn readers that literary promiscuity is rarely simple. Also like the proverbial she-wolf, Maria Cristina is uncontrollably hungry, and her existential need is reflected in an appetite that makes her obese – not lean like Dante's allegorical beast.

In the milk of the she-wolf, the narrator seeks and eventually finds a cultural identity, one that he chooses rather than being born into: Of Rome, he is an adopted son, like Romulus and Remus. The twins' status, especially their relationship with the she-wolf, upsets any possible hierarchy between native and alien, Roman and foreign: Romulus and Remus are Rome's illegitimate sons – as Amedeo's historical

considerations remind the reader – and therefore are no more essentially Roman than the city's other inhabitants. It is not human blood that Romans share, says the she-wolf; after all, who knows whose blood flows in the twins' veins? Rather, it is she-wolf milk that unites the people of Rome and, unlike blood, milk may be chosen: It is never too late to start drinking it and participating in the community that is Rome. According to *Clash of Civilizations over an Elevator on Piazza Vittorio*, it is the practice of suckling the she-wolf's milk, a practice that underlines every Roman resident's lack of fixed genealogical origins, that shapes one's cultural identity – not one's blood, into which one can only be born. Amedeo's Italian wife explains that Amedeo "called the Zingarelli dictionary his baby bottle" (104). Once more, as in antiquity, the stories of the she-wolf involve the mother tongue and the mother's milk; however, there is no one mother in this novel, much less one tongue or a single way of feeding. If this she-wolf milk must be an allegory, then what she represents is language itself – and one does not have to be born into it: Anyone can learn it.

PART III

THE SHE-WOLF IN ART

CHAPTER 7

ANTIQUITY

MAMMARY MEANINGS IN THE SHE-WOLF'S VISUAL REPRESENTATION

WITH A SPARE COMPOSITIONAL STRUCTURE OF THREE NAKED figures – one adult animal and two juvenile humans – the statue of the *Lupa Capitolina* recounts a foundation legend far more intricate than her own shape. Hers is the story that Romans have been telling for centuries about their own past, so that it is enough to see a wolf give suck to a set of twins to know exactly who she is, what she has done, and what will happen a few years hence. In a compact frame, the bronze image at the Capitoline Museum expresses ancient legends of divine intervention in human history. This is the story that the *Lupa* has long been believed to be telling; the statue, after all, may have had nothing to do with the twins when the bronze was first cast. Then there are the stories of the bronze *She-Wolf* herself, tales of varying reception and changing usage, including accounts of both worldly and supernatural power struggles – ancient as well as medieval, early modern, and contemporary. Of course, the complexity of the bronze *Lupa* can best be understood in the context of other visual as well as verbal she-wolves and by being mindful of the interpretations attached to all these beasts.

The wolf's much-sung teats and tongue dramatize attitudes of and toward mothers, of and toward poets. The deceptions in which the she-wolf has been involved through the ages warn against casting quick judgments and expressing unreflective assessments – not an effective way to learn in Rome or elsewhere. The she-wolf's presence on monuments, both verbal and visual, reminds us of her story as well as the ways it can be used, the array of meanings that can be produced or extracted from a single tale. The wolf is a predator and this ferocious aspect of the Roman

beast has never been forgotten, despite the prominent and generous maternity embodied in the distended udders she offers the twins. In both the early Renaissance and the more recent fascist periods, the she-wolf's role as gift urges us to consider who is receiving what in gift giving and the effects of gifts on places and politics. The she-wolf is a ruin and her ruined state is a metonymy of Rome's own ruin. The she-wolf's milk united ancient Romans under the god of war who metaphorically birthed their city and sent her as his emissary; her bronze effigy brought together medieval Romans who feared the pagan idolatry that she recalled and the papal justice that she announced; and her identification with Rome unified would-be Italians through the nineteenth century, when they invoked her as their political mother. The she-wolf's maternal embrace more recently included foreign immigrants to Rome: Like Romulus and Remus, they may learn to speak her tongue and suck at her teats – if they learn how not to be bitten in the process.

Little wonder, then, that images of the she-wolf should abound every-where in Rome – in museums and on monuments but also in streets and piazzas and on souvenir stands. Of course, the *Lupa Capitolina* appears in all of the A. S. Roma soccer team paraphernalia available for sale through-out the city: The bronze is at the center of the team's emblem. Although three-dimensional reproductions, whether plastic, metal, or stone, are inevitably of poor quality, lacking the detail and craftsmanship of the original bronze, the cartoons of Rome's most famous beast can be very funny. In the 1980s and 1990s, tourists could buy for a few thousand lira a tee-shirt depicting the drawing of two scrawny-looking babies under the *Lupa Capitolina*: One suckled blessedly at a teat, while the other – already a picky eater – spit out wolf milk with an angry and disgusted expression. The children's identity as Romulus and Remus was obvious but, identical twins that they were, it was impossible to tell them apart. Was the spitting child Romulus, showing from the start his ambitious unwillingness to settle and be content with what life dished out to him? Or was the spitter Remus, displaying already that inability to adapt to adverse circumstances that would result in his death?

In addition to the disgruntled nursling, the cartoon focuses on the she-wolf's udders; images of the literal or metaphorical she-wolf usually do. The beast's eight udders are closely related to the city: first, in terms of their function (because their milk fed Rome's founder) but also more metaphorically in terms of their form. Some historians believe that Rome was named after the old word for breast and udder, *ruma*, not so much via the linguistic mediation of the suckling goddess Rumina and her fig tree

(see Chapter 4) but rather, more explicitly, because of the breast-like shape of the city's seven hills: "An old word such as *ruma* (or *rumen*), by which the Latin language designated the teat of an animal . . . would allude to the *mamelons* of the hills on the Roman site, which we also discover in the name of the fig tree Ruminal, in whose shade, according to legend, the she-wolf suckled the twins" (Grandazzi 170). Through these seven hills, the very city dons a feminine, breast-inspired shape: Rome is a city of curves, averse to right angles and perpendicular avenues. Navigating one's way in it without a map is a challenge beyond most tourists.

Dwellers of a curvaceous city – shaped like and named after the she-wolf's most characteristic body parts – Romans have made significant efforts to forge for themselves a less curvilinear, more masculine history, one made of straight genealogical lines. They proclaim that they take their name from Romulus, descendant of the Trojan hero Aeneas, not from Rhome, Trojan refugee wife. They remember Romulus – half human, half divine, and one hundred percent male – and not Rumina, female goddess of sucklings and breastfeeding mothers. Blood, not milk, is their favored bonding tool: The violent shedding of a red bodily fluid rather than the generous and life-giving sharing of a white one has dominated Roman history and culture. Even the she-wolf's milk, expressed at first as a vehicle for nurture, morphed over time into the source of a cultural identity consisting in aggression and rapine. Still, nothing has managed to entirely flatten, much less erase, the rounded feminine shape of the she-wolf's udders. With the city's hills and domes, as well as the nursing she-wolves visible all over town, there are many reminders of engorged udders in Rome. One might even be tempted to call this lupine and mammary ubiquity a "return of the repressed": the unforeseen comeback of Rhome, the founder, and of Rumina, the goddess; the reemergence of the bond of milk covering over the divisions of blood; the resurfacing of curved connections – embodied in distended breasts and udders willing to feed adopted and illegitimate children alike – over the straight, patrilineal succession that would mendaciously claim that Rome belongs only to Romans.

I am not alone in regarding the story of the she-wolf as a central self-representation in Western culture. Archaeologist Claudio Parisi Presicce, director of the Capitoline Museum, states in plain, unequivocal terms that "No ancient legend has reached the fame of the she-wolf nursing the twins. For modern man, the miraculous episode of the finding of Romulus and Remus on the part of a she-wolf, though not central to the total narration of Rome's foundation, has become, through a sort

of synecdoche, the initial moment of the city's history, the hypostasis of its origins" (Presicce, *La lupa capitolina* 17). The fact of Rome's birth, Presicce implies, is more deeply, more pervasively remembered through the image of a she-wolf nursing twin baby boys than through that of a man pulling a plough, building a wall, or killing his brother – all actions historically and geographically closer to the actual foundation. Consequently, T. P. Wiseman reminds us, "With the possible exception of the Trojan Horse, there is no scene in the whole iconography of classical myth more recognizable than that of the she-wolf and twins" (*Remus* xiii). The Roman she-wolf of mythology and iconography, alive in the memory of the West, might have been an instinctively maternal beast ruled by natural drives rather than moral choices – like all members of her species. Or, she may have been a dissipated prostitute seeking redemption through the care of children not her own. She may have been a good mother, willing to nurse newborns beyond the ones to whom she herself gave birth; or a man-eating, insatiable predator who handed down her vices to those she fed. As the legendary figure of the Roman she-wolf has given rise to a variety of verbal accounts and interpretations, so also the beast's visual representations have received and produced multiple meanings. Consider the example of the most famous of such representations: The she-wolf's bronze likeness, known today as the *Lupa Capitolina*, once stood, alternately, as evidence of Rome's divinely inspired foundation, of the equality between patricians and plebeians, of the impenetrability of the pope's justice system at the Lateran, and of the grandeur of Rome's past and the promise of its future glory on the Capitoline Hill. Her statue may be ancient or medieval; the bronze may have been manufactured by Etruscans, Romans, Greeks, or possibly Germans. Although scholars eventually may agree on one detail or another of the she-wolf's significance, the beast's full meaning is and will likely remain inscrutable. One would do well to suspect at this point in our interpretive journey that there well may be no single, complete, and ultimate meaning waiting to be discovered.

INTERPRETING THE NURSING BEAST ON THE MIRROR OF BOLSENA

Texts and images about the she-wolf are often ambiguous, their meaning unstable and uncertain. Whereas such ambiguous uncertainty may help to draw readers and viewers into the representation at hand – encouraging them to actively participate in what they read or see and

in the construction of meaning (from the image of the nursing beast one must reconstruct the legend of Rome's birth) – it also has a way of preventing straightforward or lastingly believable interpretations. Visual representations of the she-wolf also raise questions particular to their medium. The written texts associated with some images entertain complicated relationships to the interpretation of those very images, as discussed in the case of the descriptions – literary or tourist-related – of the *Lupa Capitolina*. Although the texts linked to an artwork may attempt more or less successfully to clarify some of its aspects (e.g., the object of its representation or the reasons for its creation), these texts themselves usually require interpretation, which is certainly true of Master Gregory's and Byron's descriptions of the bronze beast. When there are no texts linked with a particular visual she-wolf, her very identity as she-wolf – and not, for example, lioness or she-bear – or the fact that the twins she suckles are Romulus and Remus are statements open to interpretation. What, in turn, informs and in the end determines the interpretation of arcane images? This is a question raised by the ornate Mirror of Bolsena, also known as the Mirror of Praeneste or Praenestine Mirror (Fig. 2). Engraved with figures of beasts and humans, babies and adults, males and females, and a decorative natural landscape, this object is thought by some scholars to constitute the oldest depiction of the she-wolf nursing Romulus and Remus. Others, however, believe the mirror has nothing to say about the foundation of Rome.

In Etruscan and Roman antiquity, mirrors were made entirely of metal. Initially crafted of bronze or copper and then, in later and more luxurious times, of silver and even gold, ancient mirrors had a long, thin handle and a slightly convex round or oval disk. The disk was so highly polished that it was reflective, and the handle and back displayed engravings with sometimes-intricate designs. (Looking glasses were not unknown in ancient times, yet only during the Renaissance did glass definitively supplant metal in the making of mirrors.) Because of their durability, numerous Etruscan and Roman mirrors have survived to the present day and archaeological museums throughout Italy exhibit a variety of them. Still, one ought to be careful with mirrors – even when they are made of bronze, like this one, and cannot shatter and bring about the proverbial seven years of bad luck. All mirrors, particularly metal mirrors, distort the image they reflect. As for the wolf-inflected cautionary tale about mirror images: When Aesop's trusting flock looked at the wolf donning borrowed clothes, they saw the harmless reflection of another sheep. Sheep are proverbially too obtuse to realize that mirrors dupe us by appealing

to our vanity and to the equally illusory trap of self-knowledge. The identity of the she-wolf herself and the chronology of the city's bronze *Lupa* are not the only instances of unreliable appearances in the history of the Roman beast. More evidence of the ambiguity inherent in images, especially in mirror images, may be observed on the back of the Mirror of Bolsena.

Named after the Etruscan city north of Rome where many believe it was found, the so-called Mirror of Bolsena is a fourth-century BCE artifact (330–340 is regarded as the most likely date of manufacture) with a mysterious history. For a long time, it was widely thought to be a fake – from shortly after its purchase by a jeweler and influential antiquarian, Alessandro Castellani, in 1877 until its 1982 reappraisal. Although the mirror is now regarded as authentic, to date from the late fourth century BCE, and to come from the city of Praeneste (modern-day Palestrina) east of Rome rather than Bolsena to the north, the visual content portrayed on its back continues to baffle historians and archaeologists alike. Some identify it as the Mirror of Bolsena, others as the Mirror of Praeneste; these alternate names tell a story of scholarly conflicts and contradictory interpretations.

Engraved on the other side of what was once the reflective surface of the mirror are twins accompanied by four animal figures and four human adults. Of the latter, two are naked, icons perhaps of a more savage world, and two are clothed, representing civilized society. The twins lie just at the center of the busy composition; they are hefty, oversized, and muscular babies vigorously suckling a she-wolf. Another large mammal, possibly a male wolf – the mate of the animal nurse – or perhaps a dog or a lion, crouches at the bottom of the composition. Two birds perch on the dead tree pictured above the twins and above the reclining nude (except for a hat) male figure hovering over them. To the right of the naked man is a hooded female figure with a sad expression on her face: perhaps Rhea Silvia, the twins' biological mother, or Acca Larentia, Faustulus's promiscuous and generous wife. No one knows for sure. The twins are protected by two animal couples: the birds in the air, pictured in the top half of the scene, and the earth-bound mammals depicted on the bottom.

Several archaeologists and other scholars, led by Andrea Carandini – the renowned specialist of Rome's earliest years – regard this image as the first depiction available of Romulus and Remus with their nursing she-wolf ("Sullo specchio con Lupa, Romolo e Remo"); the *Capitoline She-Wolf* may be older, and Carandini is a champion of her antiquity and an ardent opponent of her medieval dating, but the bronze has no ancient

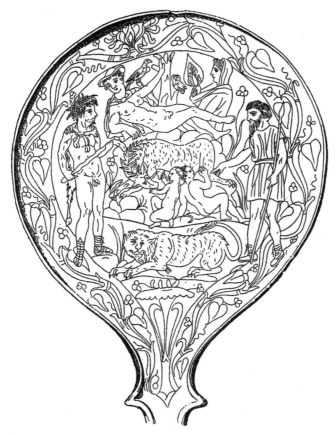

Figure 2. Mirror of Bolsena (Praenestine Mirror, Mirror of Praeneste), fourth century BCE. Antiquario Comunale, Rome. *Ausführliches Lexicon der Griechischen un Römischen Mythologie*, ed. W. H. Roscher (Leipzig, Germany: Teubner, 1886–1890). Digital image credit: Vincent Pelletier.

twins below her. The rustic god Faunus is to the twins' left and, to the right, King Latinus points to Romulus, the chosen boy destined to found Rome. Above the twins, the reclining male figure is possibly Mars, their father, or another unidentified Palatine deity. Carandini recognizes one of the birds as a woodpecker, sacred to Mars and legendary helper to the god of war's she-wolf. However, with its curved beak, the bird looks nothing like a woodpecker: It must be a raptor or a corvid, either Jupiter's eagle or Apollo's raven, as claimed in the article "Reading Carandini," by T. P. Wiseman – a British historian and Carandini's most illustrious antagonist in this as in other matters pertaining to the birth of Rome.

The reclining figure, according to Wiseman, is definitively identifiable as Mercury, the father of the Lares twins (they were the protectors of the household) and someone completely alien to the Romulus and Remus story. If these twins are the Lares, however, what is the she-wolf doing in the picture? If they are Romulus and Remus, what is the role of Mercury? Wiseman argues that we know the Romulus story in too much detail to imagine that Mercury has a previously unsuspected role in it. Conversely, so little is known about the Lares that it is possible they were believed to have been miraculously suckled by a she-wolf, with this mirror being the only evidence available today of the animal nurse's presence in the Lares' infancy. To buttress his explanation, Wiseman notes that when the mirror was made, circa 340 BCE, the story of Romulus and Remus did not yet exist and the narrative relating their adventures may have been modeled on the older story of the Lares twins.

Mirrors distort physical reality as much as they reflect it: Their images are turned left to right, two-dimensional, and often wider or thinner than what they visually echo. The back of the Mirror of Bolsena (or Praeneste) tells a story of distortion and interpretation and, more allegorically, invites us to reflect on the difficulties in reading the details of our distant past. In all probability, the reclining beast is a she-wolf, but whom is she feeding? The sucklings are twin boys, certainly, but what are their names, where are they from, when did they live, and what does their future hold? The questions raised by the Mirror of Bolsena exemplify the difficulties inherent in the archaeological task: to make sense of found objects and thus to impel them to speak. Material things form the connection that this discipline entertains with the distant past it investigates and with which it seeks to establish a relationship. What ideological differences shape the different reconstructions, by an archaeologist and a historian from different lands, of the image carved on the back of a bronze mirror? As the conflicts about the Mirror of Bolsena suggest, archaeology's retrieval of lost truths through digging and physical labor turns it for some into the lesser partner of history, the humble craft to the historian's high art. For how can stones or scraps of metal – much less artworks – tell a single tale? Looking at identical graffiti on the back of the same ancient mirror, archaeologist Andrea Carandini found something different from Wiseman: a clarification and confirmation of the early history of Rome he discovered in his many years of digging. "I am an archaeologist," Carandini wrote, "i.e. a historian who makes use first of all of the things made by man." Carandini sees himself as someone who "starts from objects" – that is, "from constructions and

things" (*Roma* 7). Carandini is Roman and his ancestors, everyone says, were obsessed with history as it fit into a comprehensive and comprehensible pattern. So, this archaeologist reads the origins of the city of his birth on the stone walls he dug up on the Palatine Hill – stone walls that tell us that what has long been regarded as the myth of the birth of Rome in the eighth century may actually be based on historical fact. As if that were not enough, Carandini comfortingly reads the same story on the scratched metal back of a mirror, identified as a precious, eloquent relic of early Roman theology. Not everyone agrees and, indeed, Carandini continues to jeopardize his scholarly reputation – even as his popular appeal endures – by his dogged insistence on the stones' ability to tell a story, to reveal a comprehensible, narratively structured past. His position at times opposes the more reputable task of empirical historians, who base their suppositions first on written texts and only second on the more ambiguous objects found in archaeological digs.

Carandini's fellow academic Wiseman, a historian – on what he sees as the uncertain meaning of the same carved lines on a bronze surface – reads the unknowability of that very story and its deceptive resemblance to a variety of other narratives. For Wiseman, Carandini's explanations are a "superb . . . exercise in cultural politics" based on historical arguments that are "a strange mixture of the admirable and the perverse" ("Reading Carandini" 182). In their alternate interpretations of a single object, each scholar invokes – or, better yet, produces – a different context made of signs that require interpretation: The methods of archaeology are as much of a scholarly construct as those of history, the story of the Lares twins as much of a cultural product as that of Romulus and Remus. Mysterious, controversial objects such as the Mirror of Bolsena caution that even context may not be all that legible, nor all that helpful, in understanding the meaning of an object. This is because context is also the product of interpretation.

The Wiseman and Carandini readings of the contested mirror make their reader privy to the process by which expert interpreters of ancient things (i.e., a respected classical historian and a renowned classical archaeologist) make sense of what they see: not only how the shape of a beak identifies the divinity protecting the image; how a hat, a bodily posture, or the health of a tree explains the otherwise baffling identity of a character – but also how open to interpretation that beak, hat, and tree actually are. Two similarly expert readers perceive different shapes, different emphases, and different relationships among the elements of the same image. "The object," to borrow from art historian Anne Higonnet,

"forces us to see how meanings function at one moment in relation to each other. It forces us to see how meanings act as functions of each other, with no independent significance." Higonnet then claims that each signifying element of an object "refers to past meanings which themselves are just the most recent links in an endless regression of citations" (Higonnet 400). This notion has certainly shaped my understanding of the she-wolf: The beasts of Virgil, Masuccio, Verga, and Lakhous, to take four among the literary she-wolves encountered thus far, produce their own meaning within and as a result of this "endless regression" of she-wolf representations; without the context of previous beasts, these four wolves would make little sense. Placing the Mirror of Bolsena within this signifying network is both especially problematic (because we do not know what other representations of the she-wolf might have preceded the one on the mirror) and particularly enlightening: How do we make sense of images when context is not available – and when this absence is not due to semiotic theory telling us that context is constructed and should not be trusted but rather because an objective context is quite simply, quite literally, *not there*? At the physical and allegorical center of the Mirror of Bolsena – and at the center of the network of meanings explored in this book – is the figure of the she-wolf. The question of whether the nursing beast on the mirror is, indeed, a she-wolf invites us to doubt the usefulness of attributing a single meaning, a definitive interpretation, to signs that have proven elusive – such as the she-wolf herself. Allegory and the she-wolf have a close relationship; the workings of allegory frequently shape the she-wolf's ability to signify. Allegory also enters into our understanding of the Mirror of Bolsena; however, in the interpretive controversy about this Etruscan image, the she-wolf functions as the allegory not of women as animals or of the she-wolf as Rome but rather of signification itself. In the space in which the historian's and the archaeologist's readings meet and clash, the central she-wolf stands for the means through which signs mean something to someone, reminding us of the challenges and the rewards of that intrinsically unstable and dynamic process that is the production of meaning.

THE SHE-WOLF AS PROTECTOR OF THE LIVING AND THE DEAD

Although the *Lupa Capitolina*, whether ancient or medieval, is by far the best-known and most influential portrayal of the Roman she-wolf, the bronze sculpture is one of numerous she-wolves in ancient art –

all of them less famous than the bronze and most of them less intact. Some of these beasts (e.g., the she-wolf on the Mirror of Bolsena) are as controversial as the *She-Wolf* in the Capitoline Museum – although a smaller circle of viewers is aware of the debate: Unlike the medieval dating of the *Lupa*, the uncertainty of the she-wolf's identity on the contested Etruscan mirror has never made the front page of Italian newspapers. Other ancient she-wolves communicate their message in ways that scholars seemingly agree on better. These beasts appear, for example, on coins and medals, altars and pedestals, funerary stones and cinerary urns, and an assortment of marble sculptures and reliefs. Along with other visual and verbal renditions of the Roman she-wolf, ancient ones participate in what Higonnet calls "an endless regression of citations," for their own animal shape holds no wholly independent significance. From this perspective, all she-wolves are copies of copies – there is no "original" or "real" she-wolf that they can aim to reproduce. Rather, when taken together, representations of the she-wolf comprise a shifting pattern of meaning, the energy and transformations of which guarantee – to return to Higonnet's argument – that this pattern of meaning "can neither last nor reproduce itself exactly, but rather constantly mutates into unprecedented forms and functions" (Higonnet 400). Previous chapters discuss some of the ways in which this pattern of meaning has worked for the bronze *Capitoline She-Wolf* and for the she-wolves of literary, historical, and political writings. This and the following two chapters illustrate the she-wolf's constant mutations in the visual field in diverse historical periods and geographical locations. Through an "endless regression of citations," the she-wolf's texts, whether written or visual, reuse and recycle but also reinvent and reassemble an animal icon that, arguably, has no independent or original life of its own: As a legendary rather than historical figure, the she-wolf can never leave her status as representation. Likewise, the work of understanding, producing, and reproducing the she-wolf's meaning in our own interpretation benefits from an awareness of her repeated formal and functional transformations across time and space.

The oldest evidence of a baby suckled by a wild beast is found on a funerary stele from Felsina (modern-day Bologna), a fifth-century BCE sandstone relief picturing a single human figure taking nourishment from an animal that – although it definitely appears more like a lioness than a she-wolf – is regularly included in the genealogy of the Roman beast. Like the Capitoline bronze, this animal nurse also looks at the viewer and not at the sucklings. "The choice of imagery is baffling,"

one art historian noted about the stele, because whereas this may not even be a she-wolf, the similarities with Rome's legend are striking: "There can be no thought of the Roman founding legend in this frontier town of the Etruscan north; but a parallel saga may have been current there" (Brendel 375). Alternately, which would make the stele only indirectly related to the action of the Roman nurse, the human figure depicted on the sandstone relief is suckling after death (i.e., this is a funeral stone, and the lean limbs and bodily proportions of the suckling indeed suggest a miniature adult rather than a baby), with milk indicating the redemption and rebirth of this person's journey to the afterlife (Carcopino 81). The Felsina stele is Etruscan, and Etruscan art "is characterized by the appearance of breasts in unexpected contexts. . . . There was a taste for showing animals with swollen teats, even in the case of males, and for animal nurses" (Bonfante 179). For the Etruscans, furthermore, the wolf was associated with the underworld and its divinities. The people of Rome, conversely, projected a wider spectrum of meanings onto this animal, meanings that varied with the passing of time and the intentions of the producers of the images.

On early Roman coins, the theme of the she-wolf feeding the city's legendary founder and his twin signified and circulated the notion of Rome's grandiose destiny: Republican and imperial Roman coins, in addition to expressing Rome's economic supremacy, were an important means of ideological dissemination and therefore a major political as well as economic instrument. The earliest of these coins, commonly believed to have been minted in 269 BCE, are the Hercules and Ogulnii silver didrachms. Through the image of the she-wolf, the coins are connected to the Ogulnii monument and to the Roman nurse described by Livy (see Chapter 1). The Ogulnii didrachms are regarded as the earliest depictions of the she-wolf nursing the twins, particularly by those who do not recognize the story of Romulus and Remus on the Mirror of Bolsena. The effects of these coins on their viewers and handlers were complex. As historian Jane Evans stated in her study of Roman propaganda, "The motif of the wolf and twins, which has a long history in public and private monuments and artifacts, is seen upon its first appearance to represent Roman interest and pride in its origins and even to symbolize the city and people. The later coins continue the same use of the motif" (63).

The notion that the founder's nursing by a wolf pointed to the city's pride in its origins and belief in its own future glory was augmented beginning in the second century, when the scene of the nursing she-wolf included the image of the armed goddess personifying the city:

the Dea Roma, a female figure representing victory on both coins and engraved gems. These images appear in the late Republican period, a time when Rome's boundaries were growing as a result of individual and family power struggles. The power of the Dea Roma, the family ties of Romulus and Remus, and the eventual individual destiny of Romulus: All of this is expressed on the coins and engraved gems. During the late Republican period, coins also often paired the she-wolf with an eagle. This is a significant association because Dionysius of Halicarnassus wrote that an eagle, along with another earlier she-wolf, had been sent to Aeneas to indicate the illustrious future of Lavinium, the city Aeneas founded on his arrival on the Italian shore. The she-wolf and eagle are omens of the greatness of Lavinium and, therefore, of Rome as well: Rome is Lavinium's descendant much like Romulus is Aeneas's. The she-wolf is an animal belonging to both Lavinium and Rome, to both Aeneas and Romulus – she is a doubly significant and protective beast, uniting Rome's two founders and thus exceptionally useful to the discourse of propaganda. According to Evans, this type of coin extends the scope of Rome's historical and geographical presence, suggesting "that Italy is a national extension of Rome because Aeneas is the common ancestor of the Roman and Italian peoples" (65).

Coins and gems are not the only vehicles for Roman propaganda through the she-wolf, of course. Ideological programs often were depicted on sculpted emperors' cuirasses – that is, the body armors that protect the chest and back. The most renowned wolf on a cuirass is the one on the marble statue of Augustus found in Livia's villa at Prima Porta (15 CE). However, the canid at the feet of the central, victorious figure (Romulus, Tiberius, or Mars? – this man's identity remains uncertain) is not nursing, leading some to question whether it is, in fact, an image of the beast who fed Rome's founder or instead an unidentified wolf or even a dog. It is later in the first century that either Domitian or his brother Titus first employed the motif of the she-wolf nursing Romulus and Remus as decoration for his cuirass. Later, the same motif also was repeated on Hadrian's cuirasses: The most widespread iconography of this emperor shows him wearing a full parade-dress military costume. On a popular style of carved illustrations of Hadrian's cuirass, the nursing she-wolf forms a pedestal for a female figure interpreted as either the *palladium* (i.e., the sacred image of Pallas-Athena brought from Troy to Italy by Aeneas) or Athena herself. Either female figure emphasizes the emperor's Roman and sacred attributes as well as Rome's victory and eternity. Furthermore, this being a Greek goddess, the union of the two

female figures – Athena and the she-wolf, animal and divine, Roman and Greek – effectively pictures the relationship between Rome and its Greek-speaking eastern provinces (Hadrian has indeed been called the most philhellene of all Roman emperors). For as the she-wolf supports Athena on the emperor's cuirass, so also Rome will protect the Greek-speaking east it has conquered: Able to rely on the she-wolf, the cuirass announces, the inhabitants of these provinces are also now Roman (Gergel 406).

By the time of Hadrian, the she-wolf no longer evoked primarily the story of Rome's origins, located in the distant past, as much as it signified Rome's present power and the divine mission in which the emperor was invested. It is also around Hadrian's time that the she-wolf nursing the twins becomes a characteristic attribute of the allegorical personification of the Tiber as the river god Tiberinus. At this time, the she-wolf's posture also changes significantly: Her head is no longer turned all the way toward the suckling twins, licking or about to lick them, but rather looks back only three quarters of the way. Whereas the crouching and subservient she-wolf of early depictions pointed to the beast's miraculous taming by a god and the she-wolf turned toward the twins recalled through the beast's stance the emperor's own protection of his Roman people, this latest posture with the head proudly raised makes the she-wolf a sign of the Roman empire's predestination to greatness (Presicce, *La lupa capitolina* 30).

Within a simple composition – a wild animal nursing two human babies – the image of the Roman she-wolf tells an entire and fairly complex story. It looks backward to the arrival of Aeneas, the usurpation of Amulius, the rape by Mars of Rhea Silvia, the attempted murder of the babies, and their rescue by an animal nurse. It looks forward to the arrival of Faustulus, the growth of the half-divine twins, their righting of Amulius's wrongs, the furrow and the wall, Remus's murder, and the foundation of the city. Nothing more than a she-wolf and two babies are needed to tell all of this and more. Many representations, however, are more complex. For example, the marble altar from Ostia (the ancient port of Rome), now located at the museum of Palazzo Massimo alle Terme in Rome, includes human, divine, and animal figures (Fig. 3). Later used as a pedestal for statues, the altar was dedicated to Mars and dates from the late first or early second century CE. For the first time, the altar of Ostia represents Jupiter's eagle in the place of Mars's woodpecker (Dulière 123). Through the detailed presence of cave and tree, Tiber

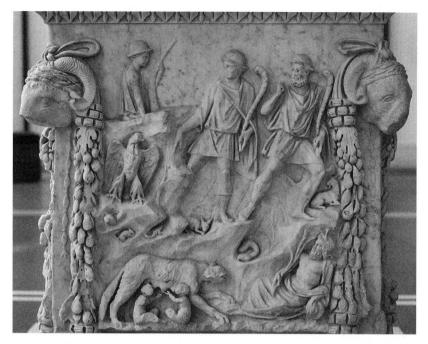

Figure 3. Altar of Ostia, first–second century CE. Palazzo Massimo alle Terme, Rome. Photo credit: Cristina Mazzoni.

River, and coast-dwelling shepherds in this rural landscape, the scene is geographically specific – as is often the case in ancient depictions of this episode. Rome is founded locally, by locals, and not – as was often the case in Greek foundation legends – through the founder's arrival in a *terra incognita* (Presicce, *La lupa capitolina* 19). The presence of the shepherds in this setting – where greatness is concealed in the most humble and poorest of babies – has led some scholars to recognize in the composition of the nursing she-wolf scene a forerunner of the *crèche* – that is, the finding of the newborn Jesus by the shepherds (Pais 51).

On the altar of Ostia, the she-wolf is simply turned toward her sucklings. Other depictions of the animal nurse with the twins portray her in the act of licking them – shaping their bodies (see Chapter 4) and revealing their royal identity. Rome's Museo delle Terme, located in front of the Termini train station and across the street from Palazzo Massimo, houses a first-century urn for the remains – as the inscription says – of a Roman freedman, Tiberius Claudius Chryseros, and two women who

were probably his wife and daughter, Julia Theonoes and Claudia Dorcas (Fig. 4). The nursing she-wolf carved below the inscription is licking the suckling babies. According to the caption provided by the museum, the animal exemplifies Augustan religious iconography and embodies vital strength and fertility. As in the stele of Felsina, a nursing mother beast accompanies the deceased to the next life, whether in the role of divinity of the underworld, as on the Etruscan stone, or as a sign of life's renewal. Funerary urns from ancient Rome regularly depict the licking she-wolf as a sign of the bond between nature and culture, flesh and spirit, and this world and the next. However, so pervasive was iconography such as the she-wolf's that even on these personal objects, Paul Zanker remarks, "It became impossible to find a means of individual expression. Sculptors and patrons had to try to formulate personal sentiments, if this was the goal at all, using the language of imperial politics . . . the she-wolf with the infants Romulus and Remus, the embodiment of Roman pride and self-assurance, is transferred to funerary altars as a symbol of selflessness and love within the family" (278).

As well as with the glorious destiny of Rome, the nursing she-wolf is repeatedly associated in ancient art – both Etruscan and Roman – with the process of death and the passage from this life to the next. In addition to the traditional cultural associations between life and death in Western culture, the story of the she-wolf in particular repeatedly recalls both processes: the birth of a founder (Romulus) and the death of his father figure (Amulius); the death of a brother (Remus) and the birth of a city (Rome); and the death of cubs and the life of babies (through those texts that posit the she-wolf's offspring as dead). The life potential of infancy and death's destructive powers are meanings tightly bound together in the she-wolf icon: We see vigorous baby boys nursing at the she-wolf's teats but the viewer already knows that only one of them will survive young adulthood; the other is doomed.

These are only some of the possible interpretations of each particular she-wolf image: The symbolism of the Roman beast is ever mutable, her shifts well expressed in Joaquin Miller's novel (see Chapter 3), *The One Fair Woman*, by the series of visitors to the bronze *She-Wolf*, who all quote the same famous line of Byron's about the beast – each, however, emphasizing a different word and therefore a different side of the same object. Different aspects of the she-wolf's pattern of meanings also have been emphasized in her iconographical uses. Her presence on Roman coins and imperial cuirasses is monumental, intended to warn and remind (this is the meaning of *moneo*, from which the word "monument" derives):

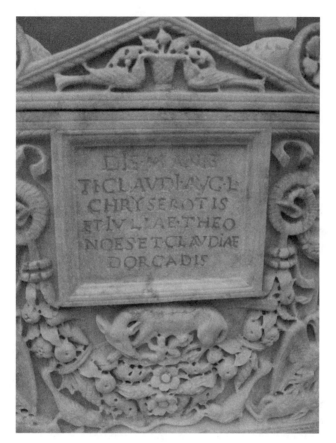

Figure 4. Funerary urn of Tiberius Claudius Chryseros, Julia Theonoes, and Claudia Dorcas, first century CE. Museo delle Terme, Rome. Photo credit: Cristina Mazzoni.

Viewers should not forget who is in charge in Roman territories and why. On altars, this monumental value is preserved, to an extent, although the context makes it less bombastic: Animals are sacrificed on these blocks of stone and their death, despite the she-wolf's own immortality, remains a hovering presence. The milk of life flowing in places of death reappears on funerary stones, urns, and sarcophagi. The she-wolf embodies Rome's power and, more poignantly, the city's eternity. Can she be said to stand for the eternal life of the individual whose corpse or ashes are guarded by her stone image? This is a common interpretation of the she-wolf motif on objects related to death, but not everyone agrees: "The personal application," wrote one archaeologist, "seems to me unlikely and if there is any special meaning in the symbol, it is probably shorthand for 'I am

a Roman' . . . or, possibly: 'This tomb is under the protection of Roman power'" (Nock and Beazley 140).

Once again, although not as spectacularly as with the *Lupa Capitolina* or even the Mirror of Bolsena, the meaning of the she-wolf slips away from interpretive certainty, finding instead a place within a shifting pattern of meanings. Whereas it may be true that for some viewers, and even perhaps for the sculptors or the owners of these gravestones, the meaning of the she-wolf image did not extend beyond Roman cultural belonging and Roman protection, certainly the complexity of this venerable icon allowed it to indicate different things to different people. Coins, engraved gems, sculpted cuirasses, altars, tombstones, and urns are objects, after all, and *qua* objects, both invite and exceed verbal description, unable to contain a single understanding based on univocal language. As art historian Lisa Tickner explains, "The object is at the same time *not* an object – in the sense that it is always more, socially, discursively, and in terms of its affect, than a bounded artifact – and obdurately *an object* in the sense that it is not fully transparent to language and understanding" (Tickner 406). Language cannot stop and fix the physical objects that contain the she-wolf other than within a limited, opaque, multifarious, and ever-shifting pattern of meaning. Yet, it is also through language that these she-wolf objects may become for us today more than bounded artifacts and enter a field of signification that recognizes in them the markers and makers of multiple identities: Rome's and the Romans', of course – the former's glorious destiny and the latter's preeminent position among peoples; the artist's and the owner's – the blank space of their standard anonymity filled in by the intentions we attribute to them; and the viewers' own as well, whose interpretation of each Roman beast is both shaped and revealed – as it was for Miller's visitors to the *Lupa Capitolina* – by all that they bring with them as they gaze at the she-wolf. A reading of Miller's viewers should encourage us to be aware of our present as we engage critically with the objects of the past; to accept difference but not be afraid to identify with it; and while we seek to understand, to hold on to generosity, intelligence, and a healthy dose of skepticism.

THE DOMESTICATION OF FEMALES ON THE ARA PACIS

In a city often described as the embodiment of memory, monuments are everywhere. There are monuments ancient and modern, monuments

originally intended as such, and others that have become reminders of a collective memory over time. Among Rome's monuments, some are more visible than others, and two among the most visible and memorable of all are the Vittoriano, early twentieth-century homage to united Italy's first king (whose she-wolves are reviewed in Chapter 9), and the twice imperial Ara Pacis, Emperor Augustus's celebration of his own achievement of Roman Peace restored through Mussolini's own imperial ambitions. When walking or even driving by the banks of the Tiber River, we cannot possibly miss it: Its grandeur beckons and its new huge and bright travertine casing, with immense glass windows held together here and there by steel bits, catches the eye of even the most distracted passerby. The Ara Pacis, or Altar of the Peace, has stood in its current location since the late 1930s, although the grand casing it now dons was inaugurated as recently as 2006. The venerable Roman monument in its contemporary container dates back to 9 BCE. Consisting of a raised sacrificial altar surrounded by precinct walls, it was dedicated to the allegorical embodiment of Peace as a Roman goddess. It is also a monument to Octavian Augustus, the first Roman emperor and architect of the *Pax Romana* (Roman Peace): a peace founded on victory and prosperity but also dependent on Roman virtue and the Roman gods. Augustus's role as the second Romulus is highlighted by the presence, to the left of the entrance, of a relief illustrating the scene at the Lupercal: The she-wolf nurses Romulus and Remus while Mars and Faustulus, haughty god and lowly herdsman, look on with complacency and awe, respectively (Fig. 5).

In the centuries that followed the construction of the Ara Pacis, the nearby Tiber slowly carried the monument off, and it was not until the sixteenth century that pieces of the altar started reemerging from the muck and mud of the river. However, archaeology – with its appreciation for the residues of ages past – was just beginning to exist, and what we would now regard as precious fragments to be reverentially displayed in specially designed containers were instead sawed up into smaller sections and sent as gifts – mostly to Florence and some to France. Ironically, the vanity of immortality – that vanity that had so much to do with the construction and reconstruction of the Ara Pacis – eluded the remains of this monument to imperial self-aggrandizement for several centuries. Only at the beginning of the twentieth century did someone start thinking about reconstructing the chunks of stone the river had reluctantly returned. A few decades later, in 1937, Mussolini's imperial madness was at its apex (he had declared Italy's very own empire in East Africa in 1936) as

was his desire to restore Rome to the magnificence of the city's imperial past. In 1938, the two-thousandth anniversary of the birth of Augustus was celebrated. He and Mussolini shared a love of their own grandeur, a singular fearlessness in the face of the traps of vanity, and a love for the she-wolf. What better opportunity for the Italian dictator to reinforce the connection between the Roman Empire and his own than to give the old marble a new lease on life? Supported by Mussolini's government, archaeologist Giuseppe Moretti rebuilt the Ara Pacis in 1938, minus the fragments that had been for centuries in the hands of the French. Because he used concrete for his work, it is now impossible to insert the pieces that have been found since then – the entire structure might crumble and collapse. The altar was rebuilt where it originally had been erected, near the banks of the Tiber River – its once fearsome waters now tamed by sturdy retaining walls. (Over these walls, too, the she-wolf was to manifest her presence, as discussed in Chapter 9.)

The inside and outside of the marble precinct walls of the Ara Pacis are covered with reliefs inspired by personal and political vanity, which have made the altar both famous and controversial. The carvings commemorate a combination of mythological and historical scenes, and there are varying opinions about precisely which legendary and historical personages are reproduced in the various panels. As a result of modern reconstruction, however, the characters depicted in the she-wolf scene at the Lupercal are unmistakable. At the front of the altar, on the right side of the entrance, we can see Aeneas – ancestor of Rome's founder and the son of Aphrodite – sacrificing the white brood sow sent by the gods to show him where to build his city. Aeneas is featured on the southern wall and, on the northern wall to the viewer's left, is baby Romulus being nursed by the wild she-wolf with his twin brother, under the Ruminal fig tree – a central location in the early legends of Rome. To the right of Romulus and Remus is Faustulus, the royal herdsman who will raise the boys with his wife. On the left is the god Mars, the twins' father and image of the supernatural power from which Rome proceeds and of whose military supremacy the peaceful nature of this scene – and the peace celebrated with this altar – is the result. This peaceful carved she-wolf, with her babies and their two father figures, is indeed unmistakable but almost entirely reconstructed. From the fragment of a tree trunk, a small portion of Mars's body, and another of Faustulus's, archaeologists surmised the entire story of the Lupercal: The she-wolf and twins and most of the herdsman and of the god of war are a shallow, modern carving on the stone rectangle. All of this is flatly engraved rather than on

Figure 5. Ara Pacis, first century CE. Museo dell'Ara Pacis, Rome. Photo credit: Stephanie Seguino.

relief and an unabashed reconstruction – although one that, according to specialists, "appears reasonable" (Rehak 115).

The two front panels of Aeneas and Romulus are symmetrical in meaning as well as composition. Both portray episodes of Rome's legendary early years, thematically linked in these reliefs through the central position held by the discovery of female maternal mammals: the white sow feeding her brood found by Aeneas, the Trojan refugee, and the she-wolf feeding the royal twins discovered by Faustulus, the local herdsman. Both episodes were regarded as having attained their fulfillment with Augustus's ascent to power. From Aeneas through Romulus, the foundation of Rome was desired by the gods, developing over the course of the centuries that separated the Trojan War from the rape of Rhea Silvia, and as a result of more than only one portentous event: Aeneas's arrival on Latium's coast, as the Greek tradition dictated, and Romulus's more indigenous adventures with evil relatives and gentle beasts. The gods must have wanted Rome to be founded just as these same gods eventually expected the city to conquer the world under the direction of Augustus himself, the new Romulus.

The she-wolf suckling Romulus and Remus on the wall of the Ara Pacis is represented as a model of female behavior. Her role, like that

of the white sow on the adjacent relief, is to lie down and feed her charges without asking questions, without raising doubts. The she-wolf is idealized not only because without her intervention Rome would not have been born but also, in the context of this particular monument, because she spectacularly fulfills her female destiny. She is revered because of her maternal role and, indeed, she disappears once that mission has been accomplished. Augustus's desire to reinstate traditional family values in a city increasingly prone to moral laxity is well known; if even she-wolves could be gentled by maternity, what woman would not be? "The Ara Pacis program thus includes a consistent use of gender and combines female fertility with female morality" (Kampen 16).

Along with Aeneas and Romulus, the Ara Pacis evoked Augustus himself as the city's new founder, the one who boasted to have found a Rome made of brick and left it a city made of marble. This material metamorphosis was not only the description of a superficial program of urban ornamentation, a "new skin" for the city – a wolf's luxurious pelt donned on top of its once sheepish fleece. Rather, the change from brick to marble more ambitiously indicated a lasting and pervasive insistence by Augustus on the deep spiritual renewal and physical regeneration of the city in its entirety. Indeed, Rome became known as the Eternal City – a moniker it still enjoys today – shortly after Augustus became emperor. The Senate even considered calling Octavian "Romulus" for his role in founding Rome anew; they opted instead for Augustus, a propitious augury for Octavian's second foundation of Romulus's city.

Augustus's family, the Julian line, is seen on the Ara Pacis as descending directly from Aeneas and Romulus, from the sow and the she-wolf. Symbolized by the latter wild beast, the city's birth corresponds to the origin of the Julian family, embodied in Iulus, Aeneas's son, and probably the figure assisting him in sacrificing the white sow. Augustus was the new Aeneas, who discovered and piously sacrificed the nursing sow; and he was the new Romulus, himself discovered and nursed by a pious she-wolf sent like the sow by the gods. Holiness of place is redoubled in these two panels: Both the fig tree, background to the she-wolf scene, and the temple of the Penates, where Aeneas's sow sacrifice takes place, are holy places – just as the precinct of the Ara Pacis is also holy. This double geographical holiness affects the animals in the scene as well: They are divine envoys, both females and both mothers, who for the greater good of the state are tamed and, in the case of the brood sow, sacrificed through slaughter. (The she-wolf had the good sense to stalk away.) Although originally feral, both beasts are thus effectively absorbed

into the civilized world of Augustan Rome through their sacred signifi-
cance, for the domestication of females is a significant part of the cultural
program detailed in the carvings of the Ara Pacis. In the altar as a whole
and most obviously in the images of the she-wolf and the sow – both
defined by their nursing abilities – female figures are fertility figures as
well as the epitome of female morality and dramatic examples of norma-
tive conduct. This insistence is reinforced by the classic composition of
the reliefs on which they appear, restrained in terms of both movement
and emotion, and thus reminiscent of a distant past remembered as highly
moral (Kampen 16–18). The style points to the "good old days" when
women, like sows and she-wolves, concentrated exclusively on their role
as mother.

CONTEXT AND THE SHE-WOLF'S MEANINGS

The historical and cultural distance separating contemporary viewers
from these early images of the she-wolf makes the task of reconstructing
their varying meanings particularly daunting. In our understanding of
the objects of the past, the Mirror of Bolsena asks about the role of
interpretation at a basic, physical level: To what does the image carved
on the back of the metal disk refer? Is it a she-wolf or another wild
beast? Are the babies Romulus and Remus, or are they a different set
of twins – perhaps the Lares? Clearly, the first step in understanding this
Etruscan object should be to identify the figures portrayed in it. Is there
an objective way of doing so or do the training, interest, and background
of the interpreters inescapably shape their identification – of themselves
as well as of the figures on the mirror – and, therefore, the explanation
they provide? Carandini and Wiseman, archaeologist and historian, are
equally constrained by the dating of the object; on that, at least, they are
in agreement. However, their divergent readings of the same mirror show
how context is a construction and not a given. Context, so frequently
invoked in literary and artistic interpretation as the arbiter of meaning,
is to a certain extent produced by the interpreter – who chooses, at
the very least, what belongs to the context and what does not; what is
relevant about it and what is not. Does it matter whether the tree has
leaves? Is it worth looking at the beak of the bird? How bushy does the
tail of the beast have to be for us to call her without doubt a she-wolf?

The numerous she-wolves appearing throughout antiquity – on coins,
engraved gems, emperors' cuirasses, religious altars, funerary stones, urns,
and sarcophagi – illustrate how even within the relatively limited space

and time of ancient Rome, the she-wolf acquired and expressed a number of artistic and political understandings and uses. Each representation of the she-wolf was also an interpretation. In turn, each contemporary reading of the she-wolf's meaning, whether or not we are conscious of it, is as constrained by our own context (including our identity) as the representation of the she-wolf in antiquity was shaped by the context and identity of those imagining her – artists and buyers, viewers and critics alike. As we observe ancient she-wolf images and seek to understand the pattern of meanings to which they belong and contribute (this makes for a highly rewarding dialogue with the past through its most material remains), generous attention and critical self-reflection must accompany our quest for the context (however uncertain) in which the she-wolf appears, what the intention (however unfathomable) of those disseminating her image might have been, and what the reception of her image (however irrecoverable) might have comprised. That the narrative of the she-wolf played a role in all of this cannot be denied: It was precisely the uncertain nature of that narrative, it can be argued (e.g., its legendary status and the ambiguity of its animal protagonist), that allowed for the multiple meanings and uses of the she-wolf image. Romulus's acts of plowing his field and his fratricidal murder – although more directly exemplary of Rome's birth and certainly not lacking in drama – were never invested with or perceived to embody such a full array of meanings. Therefore, neither action inspired as rich an iconography or as complex a narrative tradition as the story of a she-wolf rescuing – against all odds – a pair of human babies and giving them her milk.

MIDDLE AGES AND RENAISSANCE

RECYCLING THE SHE-WOLF AND THE DIPTYCH
OF RAMBONA

ROME IS A PALIMPSEST, IT IS OFTEN SAID: AS THE SHAPES OF OLD
writing remain faintly visible under more recent layers of text on a
manuscript repeatedly inscribed, traces of the city's past also may be read
underneath its current appearance. Elizabeth Barrett Browning said it
well in 1854: "It's a palimpsest Rome – a watering place written over the
antique" (2: 165). The Eternal City destroys nothing, preferring to trans-
form objects instead to suit current beliefs and customs: Temples become
churches when a cross is placed at their heart, pagan monuments are
turned Christian by the addition of holy people's statues, images of gods
are allegorized into the likeness of saints, and so on. Neither the words
telling of the she-wolf nor the images that picture the Roman beast
have escaped this process of reconstruction and reinterpretation through
verbal and visual representation. Rome and the she-wolf play at writing
and rewriting their own past; Rome and the she-wolf constantly recycle
themselves – like sheets of parchment too precious to discard after just
one use. The city's layers, like the she-wolf's, are physical as well as
literary, artistic, and – more generally – cultural; they embrace objects
and texts as well as beliefs and practices.

"It is curious to note in Rome how many a modern superstition
has its root in an ancient one," noticed William Wetmore Story in
1863, "and how tenaciously customs still cling to their old localities."
One such locality for the American novelist is the Capitoline Hill, a
traditional Roman place of religious worship. When the she-wolf was
no longer appropriate as a holy object of devotion because of the pagan
veneration she embodied, another more acceptable nearby icon (i.e., a

miracle-working baroque statue of baby Jesus) took the animal's place: "On the Capitoline Hill, the bronze she-wolf was once worshipped as the wooden Bambino is now" (84–85). The sense of holiness intrinsic in certain places is crucial in Story's account because it determines Roman beliefs and practices more than the specific objects of such practices actually do. The Capitoline Hill is one such fundamentally holy place for the Roman people. When worship of the she-wolf had to be abandoned, Romans needed to replace it with an acceptable equivalent: The practice of worship was what mattered and it had to continue. Instead of the Roman wolf, its object became the wooden and bejeweled statue of a baby Jesus, believed by its devotees to have been carved by angels in the Garden of Gethsemane.

As for religious icons, surely the *Lupa Capitolina* – crafted in pagan times and picturing the envoy of a pagan god – is quite pagan (the possibility that she is, in fact, medieval and therefore Christian is still regarded as too remote to appreciably affect the *Lupa*'s meaning). Nevertheless, medieval pontifical justice materially appropriated the bronze, turning to its own advantage the beast's ideological allegiance: still fiercely protective but of the pope's interests, not the animal's original protégés'; still maternal but to a Christian population, not to the fratricidal son of Mars. Other analogous appropriations on the part of religious iconography successfully recuperated the Roman beast as a Christian image. The story of Saint Romulus exemplifies this type of adaptation at a narrative level. A fourth-century bishop and martyr from Fiesole, near Florence, the protagonist of this Christian tale was associated, through his name, with the early adventures of Rome's pagan founder. Born of a relationship between the daughter of a Roman citizen and her father's slave, Saint Romulus, according to the apocryphal story, was exposed in a forest and left to die. "But lo! A she-wolf came and suckled the babe, and it grew and throve." The emperor's huntsmen could not capture beast or babe, and only Peter the apostle succeeded, with prayers and nets, when "he cried with a loud voice, 'If thou be born of a she-wolf, avoid thee hence! But if thou be born of a woman, come hither that I may catch thee!'" It is Saint Peter who selects the previously anonymous boy's name when he has him baptized: "Let us confirm him in the name of the Holy Trinity, and call him Romulus" (Gould 132–133). Given the lupine identity of his animal nurse, no other name could be as fitting. The similarities between the two boys keep growing, but this later Romulus turns the strength he derived from the she-wolf's milk toward Christian rather than pagan or political purposes.

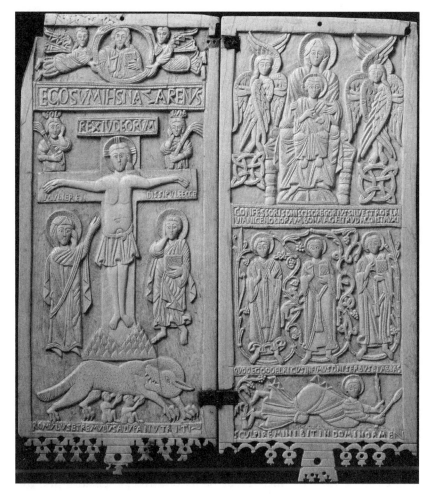

Figure 6. Diptych of Rambona, ca. 900. Biblioteca Apostolica Vaticana, Musei Vaticani, Vatican City. Photo credit: Scala / Art Resource, NY.

In addition to Christianized stories, the she-wolf was domesticated into new religious meaning through the recycling of images. Foremost among these is the ivory carving known as the diptych of Rambona, from the name of the abbey where it was found in the Marche region of Central Eastern Italy (Fig. 6). Sometimes cited in the she-wolf critical literature for the uniqueness of its iconography and, less often, for the quality of its workmanship, the diptych illustrates seamlessly the material and intellectual appropriation of pagan symbols into moving elements of Christian iconography. The diptych of Rambona was manufactured around

the year 900, probably by Roman artists, and is preserved today in the Museo Sacro of the Apostolic Library at the Vatican Museum. It shows the nursing she-wolf, complete with twins, holding up the Golgotha mountain on which Jesus is being crucified. In this striking ivory image, the universality of the Church reflects ancient Rome's older dominance. As represented in this object, Golgotha consists of twin hills, mirroring the nursing twins and reminiscent of the hills of Rome. True, Jesus is surrounded by Mary with other saints and angels, and God the Father – not Mars – towers above the cross. However, it is on the back of the Roman she-wolf, synecdoche of a domesticated pagan past, that Christ's earthly foundation and his redeeming sacrifice necessarily rest.

As if anyone could possibly wonder who the furry, fanged, nursing animal might be, the identity of the she-wolf and twins is announced by a Latin inscription below the group: "Romulus and Remus fed by the she-wolf" (*Romulus et Remus a lupa nutriti*). It is a good thing, too, writes historian Jérôme Carcopino critically, that such an inscription should be available, given the lack of realism of the babies' image: Sitting with their back toward the viewer, the twins have ridiculously thin legs under excessively chubby bodies, in Carcopino's opinion. The she-wolf herself fares no better for the French scholar: She raises her head in a violent, paradoxical movement, he noted, on paws shorter than their own claws, while her thick, plume-like tail sweeps the ground (13–14). Archaeologist Wolfgang Helbig is no kinder toward the medieval ivory, comparing it to the far superior *Lupa Capitolina*: "On the diptych of Rambona, a Lombardic work of the ninth century, the she-wolf, in the act of suckling the twins, is represented beneath a relief of the Crucifixion; and it would be hard to imagine a more glaring contrast than exists between the infantile barbarity of this representation and the typical severity of the Capitoline example" (1: 461).

Embodied in the nursing beast – What other image could stand for the city as effectively? – Rome supports Christianity physically and allegorically. This alliance lends to the relatively new religion – that is, Christianity – ancient Rome's older and more established cultural and spiritual authority. The she-wolf's head is turned back, as in many of her images. However, in this Christian carving, the beast's muzzle is neither down toward the avidly nursing twins nor, like the *Capitoline She-Wolf*, pointing toward her viewer. This she-wolf looks up: up toward Christ, up toward the Father. It is God whom she serves by feeding the twins and thus acting as a divine instrument of Rome's birth. By gesturing to God the Father and God the Son, this ivory she-wolf also points to the fact

that Rome's universal empire, earthly at first, has become the Church's equally extensive spiritual domain. The she-wolf's physical location in this carving is low: She is found at the bottom of the entire composition, whereas the more overtly Christian figures are higher. However, as well as connecting the beast to earth and nature – where, after all, the she-wolf belongs as a member of the natural world and symbol of an earthly empire – the animal's body is hailed as the pedestal holding up Christ's sacrifice. The she-wolf is low because Rome is the Church's earthly foundation, geographical as well as historical. The beast's action allies pagan antiquity and the Christian faith, worldly empire with the city of God. In this image otherwise made of strictly supernatural beings, the earthly she-wolf may signify Rome as the seat of Christianity, Rome as the secular power over which Christ triumphs, or even Rome's new Christian empire. In all three cases, the she-wolf is the Eternal City's symbol and protector. The animal's ancient role as rescuer and guardian is reinforced by a new Christian allegory as mystical supporter of Golgotha's weight.

A visual frame composed of unequivocally Christian figures decides the meaning of the she-wolf's narrative in the diptych of Rambona; context, for the understanding of this ivory beast, is indispensable. Although she is unavoidably a synecdoche of ancient Rome, it is not a tale of pagan victory over adversity (i.e., Romulus's survival despite Amulius's attempted murder) that the wolf relates in this picture: The Christian icons surrounding the beast impel her to tell a different story. This beast turns toward God, her master, even as she supports with her physical presence the burden of Golgotha, made of the weight of sin and Jesus' crucifixion. Without the crucified Jesus on her back, the Rambona she-wolf would have signified the predestined glory of a false pagan empire, not the true Church. With Christ the Bread of Life on top of her, through her milk she becomes instrumental in providing food that prefigures what will be recognized, eventually, as the Eucharistic meal.

THE ROMAN NURSE AS ALLEGORICAL PEDESTAL IN PERUGIA AND SIENA

More than once in medieval art, the she-wolf finds herself on the lower part of an artwork, functioning as a metaphorical as well as literal pedestal, and telling the allegorical story of a relationship with Rome through her physical shape and position. Several centuries after the diptych of Rambona the Roman wolf made another medieval appearance as physical and spiritual supporter of a world order that was profoundly different from

the one her legendary incarnation had occupied. This she-wolf appeared on one of the marble bas-reliefs of the *Fontana Maggiore* in Perugia, completed in 1278 and crafted by the father-and-son team of Gothic sculptors, Nicola and Giovanni Pisano (Fig. 7). On the twenty-five–sided lower basin of this monumental fountain, there are fifty architecturally framed reliefs grouped in twos. These diptychs include themes taken from the Old Testament as well as Roman legends and classical fables; for example, we see the ingrate wolf refusing to reward, as he had promised, the crane that pulled a bone out of his throat and the ferocious wolf who kills and eats a lamb drinking at the same stream "for no reason at all." Together with the twelve sculpted figures on the next tier of the fountain (representing biblical and political personages as well as personifications of places and ideas), these twenty-five diptychs form a visual encyclopedia, usefully located in the religious and civic center of the city. In the late thirteenth century, Perugia was experiencing a period of political triumph and economic prosperity and needed an increased and effective water supply – no easy feat in this hill town. Perugia's *Fontana Maggiore*, like the teats of the she-wolf, had a practical and symbolic function, dispensing a life-giving liquid and an encyclopedic compendium that was pedagogic as well as entertaining.

The image of the she-wolf suckling the twins on this fountain shows two babies looking at one another while tugging, with hand and mouth, on a human-looking set of udders. The nursing beast, semicrouching, is oblivious to them, turning her head 180 degrees away and back toward a hillside with two precariously perched trees on it. This relief, which seems to barely fit in its tightly encasing frame, is paired with another on its right that features the Vestal virgin, Rhea Silvia, in a sitting position; she looks sadly in the direction of the wolf and twins – although the column between the two reliefs would preclude her from enjoying the view of her children. Rhea Silvia holds with one hand and points with the other to a bird cage – the latter, a familiar symbol of virginity: Once the cage is open, the bird that is virginity flies away for good. The presence in Perugia of Rome's founder, his biological mother, and his animal nurse highlights this city's political ties with Rome and the comparable antiquity of the two settlements: Perugia had been Etruscan before coming under Roman rule. The griffin, animal symbol of Perugia, is connected to Rome in a diptych linking the hybrid beast with the Guelph lion that was – until 1471, at least – still the symbol of municipal Rome. The physical location of both the lion and the she-wolf seems

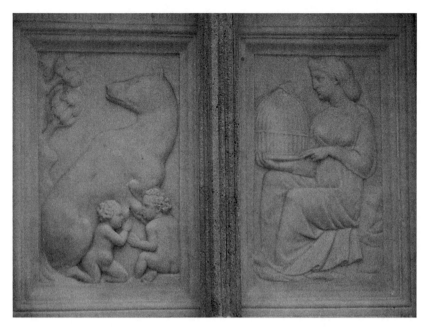

Figure 7. Nicola and Giovanni Pisano, *Fontana Maggiore*, 1278. Perugia. Photo credit: Cristina Mazzoni.

to announce that Rome supports Perugia: On the next tier of sculpted figures and borne, in a sense, by the reliefs below, Perugia's own legendary founder is present, echoing his Roman peer Romulus who holds him up, as it were, on the lower level. The *Fontana Maggiore* is a manifestation of civic pride, the city's authority illustrated through the marble shapes of this monument and in historical tradition and divine protection: The she-wolf, ancient envoy of the god of war, provides both. Her support is stylistic as well as thematic. From an art-historical perspective, the image of the nursing she-wolf illustrates the return of antiquity in late medieval artistic production, in terms of both content and form: Nicola Pisano is credited with bringing to Tuscan art "a fresh study of the antique" (P. Williamson 251). Ancient themes represented in a classical style such as this she-wolf – reminiscent of the Ara Pacis for its classicism and its attention to female figures of traditional maternity – make Perugia's *Fontana Maggiore* a valuable precursor to the Renaissance rediscovery of Greek and Roman art.

Another contrasting interpretation of the she-wolf's presence on Perugia's *Fontana Maggiore*, however, is also possible: We should be, by now,

familiar with the she-wolf's habits of ambiguity and indeterminacy. Surely, at first sight, the unmistakably Roman beast points to Perugia's greatness and antiquity, her presence at the center of town evoking the Umbrian town's notable association with the more illustrious Eternal City. However, immediately following this she-wolf on the Pisano family's monumental fountain are reliefs of the other two wolves mentioned previously – both pictures of ancient beasts not nearly as pious or protective as their female nursing peer. Those two nasty wolves also signal the appreciation of classical antiquity in the late medieval period: They tell two tales of Aesop and Phaedrus, "The Wolf and the Crane" and "The Wolf and the Lamb." These ancient wolf fables, rather than relating comforting foundation legends like the story of the she-wolf, promote caution: Beware of wolves for these animals are ungrateful, like the wolf toward the crane that had saved his life (he provides no reward for the bird who helped him), and gratuitously ferocious, like the wolf with the lamb at the stream (unable to win his argument, the wolf ate the lamb and silenced him for good). So Rome, although a trusted ally of Perugia when the *Fontana Maggiore* was built – those other two wolves also seemed innocuous to bird and lamb – is also a wolf that one had better learn to mistrust, as biblical and classical stories remind us (Boldrini 216). (Significantly, there is no reference in Perugia's fountain to the happily ending story of Francis of Assisi and the wolf, set in nearby Gubbio just a few decades earlier.) It is toward these two bad wolves, not at the suckling twins, that the she-wolf on the fountain seems to be looking. Her unusual posture nudges her viewer to follow her advice: Beware of that other kind of wolf, the she-wolf's gaze suggests, and be aware of the complicated nature of wolves of either gender.

About 100 kilometers from Perugia, there is another she-wolf that has been working diligently as an allegorical pedestal since the Middle Ages. In the course of the medieval period, the Tuscan city of Siena developed its own she-wolf iconography, and a nursing she-wolf is featured as the heraldic emblem of the town. According to some sources, Remus's genes survived Romulus's building spree: A fourteenth-century legend actively promoted by Sienese city elders and written down in the mid-fifteenth century by Tisbo Colonnese claimed that Siena was founded by the twin sons of Remus, named Senio and Aschio, who fled Rome after their father's violent death. In the fourteenth century, the she-wolf and twins were communally adopted "as a symbol and image of the city's ancient and classical past" (Nevola 141). Siena's

self-proclaimed Roman roots and its identity as a second Rome were meant to establish that it was at least as ancient as Rome – and certainly more ancient than its archenemy city, Florence. Medieval rivalry between the two Tuscan cities was notorious. In his early fourteenth-century chronicle of Florence (*Cronaca fiorentina*), for example, Dino Compagni – a contemporary of Dante Alighieri – inveighed against Siena by identifying it with the whorish she-wolf of a local prophecy and claiming that "*the she-wolf is a whore*" ("*la lupa puttaneggia*," author's emphasis). Compagni repeated this sentence twice, quoting from the authority of the prophecy and explaining it briefly: "*the she-wolf is a whore* – for 'she-wolf' means Siena, represented by a she-wolf" (110, 118). Aschio and Senio (the city is named after the latter) brought with them to Siena a carved image of the she-wolf that had saved their father; the symbol of Siena to this day is a she-wolf nursing twin boys. As travelers have frequently remarked, the she-wolf can be seen everywhere in town: on political frescoes and atop columns, on church façades and gates to the city, on public fountains and Siena's coat of arms; the she-wolf's countenance is visible even on the gargoyles at the Palazzo Pubblico. The beast reminds Sienese citizens of their illustrious (if fictional) ancient history and the survival of Remus's gene pool in the Tuscan land.

Two are among Siena's most illustrious portrayals of the she-wolf. The she-wolf commonly reproduced as the emblem of the Tuscan city is a gilded bronze statue by Giovanni Turrini (or di Turino, ca. 1427). It originally stood on an ancient Roman column made of granite, just outside Siena's Palazzo Pubblico in the Piazza del Campo, at the political and religious center of the city. This long and lean, even bony, she-wolf looks straight ahead, quite unlike the Capitoline bronze. Her ears are pricked and forward, her expression is aggressive: She seems poised to attack her enemy Florence despite the two babies below her. In the obliviousness to her most immediate maternal responsibilities, this she-wolf does resemble her Roman bronze peer. Of the twins, only one is suckling her; the other is lying down on his back, his outstretched arms reaching in vain for the beast's teats. The she-wolf as the animal representation of the city of Siena spread quickly. As a historian of Siena explained, "by 1468 the symbol was sufficiently associated with the Sienese Commune to be painted on government buildings in the contado, as part of Siena's official symbols" (Nevola 141). The she-wolves were numerous and strategically placed at important intersections and piazzas, as well as along the main roads through the city: No one could possibly miss

them. It must be remembered also that most travelers through Siena in the medieval period were headed toward Rome. Therefore, Rome was on their mind, and the she-wolf repetitively and prominently encouraged these passers-through to connect the Eternal City where they were headed with the smaller one that they were traversing. The intention behind the production and display of these she-wolves "was not only to mark redeveloped areas, but more explicitly constantly to remind travelers and citizens alike of Siena's ancient origins, and Republican civic identity as associated with the symbols of the ancient Roman Republic's foundation myth" (Nevola 142). As well as through their role as civic symbols and their thematic references to ancient Rome, these images of the she-wolf recalled Rome's grandeur through their own classicizing style, *all'antica*, and through the material antiquity of the columns that supported them.

The other influential image of the Roman she-wolf in her connection with the city of Siena is found inside the Palazzo Pubblico. This unassuming beast, far less grand than her gilded peer outside the Palazzo, is a small figure on the elaborate fresco by Ambrogio Lorenzetti in the Sala dei Nove (i.e., the Council Chamber of the nine ruling officials who governed the city). Lorenzetti's *Allegory of the Good Government* (1337–1339) portrays the blessings of a fine political system and the disastrous consequences of a bad one (Fig. 8). Three large walls in this room are decorated with outsized allegorical personifications of political and spiritual ideas, along with the smaller figures of mortal beings. On the northern wall is the largest character of all: a colossal white-bearded ruler. His identity and significance are mysterious but he is thought to personify either the specific Commune of Siena or, more generally, the Common Good. At the ruler's feet, and performing the work of a pedestal, crouches the heraldic badge of the city: a she-wolf giving suck to twins, her idyllic maternity confirming the peacefulness of the scene. The children are strikingly realistic: The baby on the left, turned three quarters toward the viewer, holds the animal's udder with one hand and with the other he plays with his little foot. A substantial part of the teat is inside his mouth, as it should be in an effective nursing session; he has that vacant stare so common in suckling infants. It is interesting that the artistic source of this infant is believed to be the Roman statue of the *Spinario* – the bronze boy pulling a thorn from his foot that accompanied the *Lupa* at the Lateran and from there to the Capitoline Hill (Polzer 98). The other twin in Lorenzetti's fresco is turned three quarters the opposite way, wholly absorbed in his feeding task: His hands grab the wolf's udder

Figure 8. Ambrogio Lorenzetti, *The Allegory of Good Government*, 1337–1339. Detail: *Government Flanked by Magnanimity and Prudence with the She-Wolf, Romulus, and Remus at Government's Feet*. Palazzo Pubblico, Siena. Photo credit: Alinari / Art Resource, NY.

while the beast rests her paw on his back, her tongue busily licking him. This giant personifying Siena is a good ruler; his allegorical opposite, located on the western wall, is a devilish male figure, horned and fanged, representing tyranny. Instead of resting on the Roman wolf, this bad ruler's feet lean on a goat – the diabolical animal *par excellence*: a symbol of lust and a visual contrast to the peaceful, affectionate, nurturing, and protective wolf that supports the good city.

The nursing she-wolf in Siena tells a different tale than her Roman equivalent and source. As an effective instrument of Sienese civic propaganda, the story of this other, more recent she-wolf developed its hold on the Tuscan city's imagination through the conscious diffusion of memorable images – a process relatively limited in time – more than as a result of long-term verbal insistence in the course of many centuries. The significance of the Sienese she-wolf, as a consequence, has proven easier to unravel than that of her Roman original – whose legendary roots along with the chronological distance of her early representations render an outline of her semiotic trajectory far more difficult to contemplate. The very antiquity of the Roman beast and her complexity and secretive, ambiguous nature made her a source of inspiration for writers, artists, and politicians – although it is impossible to say when her artistic function ends and her political effects begin. The easy identification of the she-wolf's image, the prestige of the city she immediately recalled, and the generosity of her rescuing act must be some of the reasons why other cities decided to appropriate the she-wolf as their own. Thus, instead of developing its own foundation story and especially its own symbolic image, Siena adopted and adapted Rome's. The story that this Tuscan city ended up with, however, calls increased attention to its own derivative status: Any image of the she-wolf is a visual representation of an unreliable (because legendary) verbal representation. To this epistemological uncertainty, Siena's she-wolf adds another layer of doubt by performing, both verbally and visually, an unabashed imitation of the Roman she-wolf's own uncertain tale.

THE RIVER AND THE SHE-WOLF IN BOLOGNA AND THE QUATTRO FONTANE

With its renewed appreciation of ancient art, history, and literature, the Renaissance sometimes depicted the she-wolf as a decorative motif that succinctly referred to Rome's divinely ordained foundation and greatness. Less ancient or less powerful Italian cities, such as Perugia and Siena in the

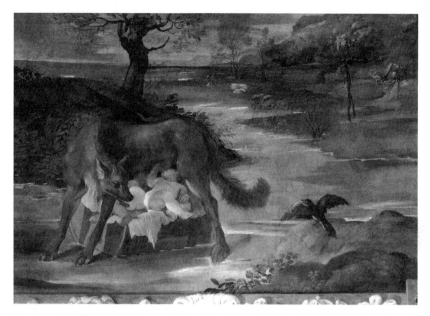

Figure 9. Annibale, Ludovico, and Agostino Carracci, *The Wolf Nursing Romulus and Remus*, 1589–1590. From *The Story of Romulus and the Founding of Rome*. Palazzo Magnani-Salem, Bologna. Photo credit: Alinari / Art Resource, NY.

medieval period, were often happy to associate their own foundation with Rome's more spectacular one through the instantly recognizable image of the nursing wolf. Other cities also vied for recognition as Rome's daughters. The fresco titled *The Wolf Nursing Romulus and Remus*, by Annibale Carracci and his brothers Ludovico and Agostino (it is not certain which brother painted what), similarly positioned scenes from Rome's past in the center of an Italian city that sought recognition of its own power and antiquity: Bologna, the ancient Etruscan town of Felsina, to the northeast of the peninsula. The she-wolf scene is the first of fourteen panels in Bologna's Palazzo Magnani dedicated to Romulus and Remus and completed circa 1590 (Fig. 9). Carlo Cesare Malvasia described the fresco in his classic 1678 biography of the Carracci brothers as follows:

> In the first scene, set on the banks of the Tiber, one sees the twin infants generated by the Vestal Rhea's incestuous love suckling at the breast of the pious mother wolf, who turns her head to lick those tender little babies, and seems to marvel and delight in discovering that the heavens have destined her to be the proud, wild nurse of the progeny of

Mars . . . the facility of the draftsmanship is matched by the aptness of the color. A couple of lights and darks, a little bit of high horizon, and a large tree, effectively foreshortened and solidly adorned with leaves, create an immense landscape. The color of the water . . . holds its own against the cloudy sky and creates a marvelous effect, for set against this muted color of the water, the tender flesh of the little babies is so vivid that it has the very flush and pulse of life. (149–150)

Rhea's "incestuous love" refers to the possibility, mentioned by Plutarch in his *Lives*, that the twins were fathered by Rhea's uncle Amulius dressed up as Mars. Malvasia shows little sympathy for the twins' biological mother – not the victim of rape, in his text, but rather a participant in incest – even as he humanizes their animal nurse: The mother wolf is "pious" although "wild" and capable of "marvel and delight." Malvasia then strangely calls the wolf's charges "the progeny of Mars": Had he not just accused Rhea of incest? Rhea is descended of Aeneas and thus distantly related to Aphrodite. If the twins are Rhea's and Amulius's, how can they also be the offspring of the god of war? The she-wolf is recognizably Mars's beast and, in the Carraccis' as in the majority of images of Romulus, she is the only signal of the god of war's presence. It is through the ingestion of her milk, the Carraccis perhaps imply, that Romulus and Remus become – in this as in other representations of their early, life-saving, and character-forming meals – "the progeny of Mars."

Malvasia's stylistic comments focus on the coloring of the painting and the chiaroscuro that emphasizes the centrality of the twins to the entire scene. Rome is made present at the center of Bologna through the subject of the frescoes, inevitably; more subtly, Rome also is evoked through the Carracci brothers' artistic technique. The classical sense of epic and greatness, for example, is expressed in the sheer size of the standing she-wolf – long-legged and generally massive: The babies are still recumbent on the tall trough that had served as a raft on their Tiber journey – without this added height, they would not be able to reach the large animal's teats (Strinati 21–23). This wolf does not especially resemble the bronze on the Capitoline Hill: The head of the Carraccis' beast, relatively small compared to the body, is actually turned toward the twins but she is not looking directly at them, much less licking them. That it is surprising she does not eat them is highlighted by the epigraph under the fresco: "Beaten not slain we are nourished" (Malvasia 155). Despite their clear differences, the Carracci brothers' wolf and the *Lupa Capitolina* are both standing and neither are doing much to facilitate their chubby charges' feeding.

Furthermore, both are so disproportionately large that the twins need a pedestal to reach her teats: The *Lupa's* twins kneel on rocky knolls; the Carraccis' are lying on the trough that carried them on the water. The Roman location of this scene in Bologna is confirmed by the Ruminal fig tree in the background and by the Tiber River, which intersects the entire picture and in whose shallow waters the wolf's four legs are physically positioned. "Playfulness smiles," wrote Malvasia, continuing his personification of the beast, "in the picture of the she-wolf" (152).

The Tiber River is reduced to not much more than a puddle in the Carraccis' fresco: The she-wolf's paws barely get wet even as she stands in it. Based on this representation, it is difficult to imagine the Tiber as a treacherous force of nature that had frightened away the servants charged with drowning Romulus and Remus. More commanding are those personifications of the Tiber River that give it the appearance of the god Tiberinus: a brawny old man with a cornucopia, leaning on a gushing barrel of water. In this form, the Tiber also is the regular companion of the she-wolf, each of them identifying the other even in the absence of the unmistakable twins. In baroque statuary, one such image of the personified Tiber accompanied by the she-wolf – one that tourists in Rome rarely miss – emerges from sculpted shrubbery at the Largo delle Quattro Fontane, the busy intersection of Via XX Settembre and Via delle Quattro Fontane in downtown Rome (Fig. 10). The four fountains that give the intersection and the street their name were produced between 1588 and 1593 by unknown artists. All four contain a reclining, semicolossal human figure in the company of an animal. The Tiber River, bearded and muscular, holds an overflowing cornucopia – which represents the fertility of the Roman plain – and is accompanied by the she-wolf who is partially concealed in the thick stone vegetation. It is among these shrubs, the viewer presumes, that she is guarding the almost invisible twins (only part of one baby can be glimpsed under the wolf). In this sculpted fountain, the animal's role is to identify by her presence the personification of Rome's principal river. She also presides over a crowded intersection that is the masterpiece of Pope Sixtus V (1585–1590) and one of Rome's best-loved vistas. From here, we can see three obelisks, one down each of three roads; at the end of the fourth road is Michelangelo's façade of the Porta Pia. The she-wolf identifies the Tiber River and Rome, but she is also politically inscribed within the urban arrangements of a pope intent on redesigning the city according to a master plan of his own. The water feeding the four fountains comes from the Acqua Felice aqueduct, named after Sixtus

V himself (Felice Peretti); the people of Rome were getting sick from drinking the water of the Tiber and a new aqueduct was necessary. The Acqua Felice brings spring water into Rome from the Pantano Borghese area outside the city, near the town of Colonna. At the Largo delle Quattro Fontane, the Tiber may be present as a personification embodying power and fertility and even divinity; however, the water he is overseeing along with the she-wolf is not really his.

METAPHOR AND SYMBOL IN RUBENS'S ROMULUS AND REMUS

Allegory is the rhetorical figure that allows the representations of the Tiber River as an old man and Rome as a she-wolf. Described by some critics as a form of sustained metaphor, allegory (like metaphor) represents one thing – for example, a river or a city – with the more easily represented image of another – for example, a brawny man or a nursing animal. Although they are defined as figures of speech and are thus generally associated with verbal rather than visual language, both allegories and metaphors are also effective instruments of visual communication, allowing viewers to better understand something new or difficult to represent by evoking its similarity with a more familiar image. The metaphor of humans as wolves, which relies on the aggressive greed of both, is commonly used as an example of this literary figure. "Man is a wolf to man," as Roman playwright Plautus famously said, with an aphorism that became a proverb. The juxtapositions of metaphor are absurd at a literal level: How could a man, at the same time that he is a human being, also be a wolf; how could a river be a man; and how could a city be a beast? Although outwardly simple, metaphor operates in complex ways: Men and wolves must have implicit common qualities for the figure of speech to make sense. Metaphor is understood as a way of clarifying the unknown by comparing it with something more familiar, but the two terms of a metaphor also explain one another; that is, metaphorical understanding circulates between both terms rather than just moving from the familiar to the unfamiliar. "If the metaphor is successful, wolves are perceived with human qualities as well," wrote one philosopher, and "in many cases of metaphor it is difficult to state which is the known term and which is the unknown term because there is an interaction between the two" (MacCormac 240). Untamable, predatory, self-serving, and lustful: Is it really wolves that are like this or is it their association with humans that makes them so? Likewise, although not

Figure 10. Fountain of the Tiber River, seventeenth century. Largo delle Quattro Fontane, Rome. Photo credit: Cristina Mazzoni.

nearly as common, a woman may be called a she-wolf because she is exceedingly greedy or cruelly fearsome. Speakers of English, even those ignorant of early Roman history, understand the title, "Hillary Rodham, She-Wolf of the Democratic Left," because she-wolves are notoriously greedy and fearsome. At the same time, however subtly and indirectly, the she-wolf is endowed with the attributes of the woman to whom she is being compared. In the Carraccis' fresco, the she-wolf smiles and Malvasia's description of this painting also humanizes the beast by calling her pious. Smiles and piety – human prerogatives – establish the humanity and, hence, the safety and desirability of the she-wolf's maternal acts.

Because parental figures signify both protection from present dangers and the value of the past for a correct understanding of the future, they make frequent appearances as informative metaphors in artistic as well as literary, political, and historical discourse. The representation of Rome's foundation abounds in significant parental figures, often presented as couples with male and female halves: the Vestal virgin Rhea Silvia and her divine lover Mars; the herdsman Faustulus and his wife Acca Larentia; Rumina, the goddess of sucklings, with her protective fig tree, the grammatically masculine *Ficus Ruminalis*; and the she-wolf, of course, accompanied by the Tiber River as a powerful river god. All of these beings – whether human, animal, or plant – act paternally or maternally toward Rome's future founder. Through the workings of both metaphorical and symbolic pictorial language, several of these figures of procreation and protection through nature and nurture appear together in the most famous painting of the twins' rescue: Peter Paul Rubens's *Romulus and Remus*, hanging in the picture gallery of the Capitoline Museum in the Palazzo dei Conservatori – upstairs from the bronze statue of the she-wolf (Fig. 11). *Romulus and Remus* was painted by the Belgian baroque artist circa 1616, sixteen years after Rubens first came to Rome at the age of twenty-three. The scene is set in the marshy Velabrum – sacred for being the place where the wolf is said to have found the abandoned twin boys.

In Rubens's *Romulus and Remus*, the foreground shows two very plump, indeed, Rubenesque babies – their full and rosy flesh a baroque convention, no doubt, but also a metaphorical indication of their future greatness and the size, as it were, of their future. One baby is sitting up and reaching toward a flying woodpecker that is bringing him three cherries: It is the woodpecker's role to assist in the babies' weaning, and in this picture he is an avatar of Mars. The other baby is suckling the teat of a large and realistically depicted she-wolf: Unlike the Carraccis', there is

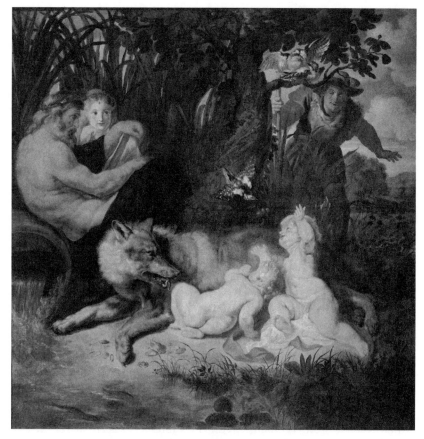

Figure 11. Peter Paul Rubens, *Romulus and Remus*, 1616. Pinacoteca Capitolina, Musei Capitolini, Rome. Photo credit: Erich Lessing / Art Resource, NY.

nothing smiling or especially pious-looking about this beast. The wolf's head is turned toward the children, gazing at them with pricked ears and a partly opened mouth. Behind this lively mother-and-children group is the immobile fig tree, the sacred *Ficus Ruminalis*; two other woodpeckers are perched on a branch. According to Roman legend, traditionally only one woodpecker was the she-wolf's helper in raising the twins, but Rubens depicts three birds – perhaps to enhance the sense of parenthood and fertility or perhaps, like the three cherries, as an allusion to the Trinity. This painting utilizes Rubens's typical X-shaped composition. Faustulus stands to the right of the tree and partially hidden by it, looking stunned at the unusual scene and experiencing perhaps what has been called the "ontological thrill" of an unexpected encounter with a wild animal:

"the sense of a sudden intensification – quickening or thickening – of Being" (Herrnstein Smith 5). To the left of the fig tree are two figures, seemingly invisible to Faustulus – after all, they are royal or divine and he is only a herdsman. One is an old and very muscular man, the allegorical personification of the Tiber River. The she-wolf and twins are on the shore and, from the barrel on which the half-reclining Tiber is resting his back, the water that feeds the river gushes out, fertile with fish.

Behind this allegorical elder, we see a sweetly smiling Rhea Silvia, the twins' biological mother, or perhaps her ghost: Rhea Silvia's incarceration or execution described in some of the written accounts would preclude her actual presence in the scene. That she is a spectral figure is confirmed by our knowledge that had Rhea Silvia been around, the babies would clearly not have needed the she-wolf's milk. Rhea Silvia also had to disappear from her sons' legend because in the words of one classicist, "a Vestal virgin who was a mother was in ritual terms an anomaly. She could not be placed conveniently in any ritual category. She was neither virgin nor wife. This is why she did not feature either in the subsequent adventures of her sons or in Roman cult" (Staples, 64). Rhea Silvia could have no room in Roman religion because its theology had no place for the sexually anomalous (i.e., any being that did not fit into conventional categories). Rubens's Counter Reformation context, conversely, must have been eager to meaningfully recuperate the figure of a virginal mother, so crucial to Catholic theology. However, in this picture too, Rhea Silvia holds a central yet uncomfortable position, as if her absence from Roman legend questioned her right to be in any subsequent representation of the she-wolf story. As the Tiber directs his serious and complacent gaze, like Faustulus, at the group consisting of the twins, the she-wolf, and the woodpeckers, Rhea Silvia instead looks away from her children, staring into the distance to the viewer's right. Like Mary, the mother of Jesus, in pictures from various historical periods, this virginal mother seems to be contemplating and accepting a less-than-rosy future: Her son may be great and even a founder – of Rome for Rhea Silvia's son and of Christianity for Mary's son; nonetheless, an early violent death and betrayal by a loved one will be a significant part of Mary's offspring's fate and of Remus as well. One could say about Rubens's Rhea Silvia what Julia Kristeva said about the faces of Giovanni Bellini's Madonnas: They are "turned away, intent on something else that draws their gaze to the side, up above, or nowhere in particular, but never centers it in the baby . . . and the painter . . . can never reach this elsewhere, this inaccessible peace colored with melancholy" (450).

In this painting, Rhea Silvia may be read as a metaphor of Mary, the mother of God: Both give birth to a doomed son and both are mothers of great founders – although the divergent fates of execution and greatness are compressed within a single son for Mary even as they are split between Rhea Silvia's two boys. Rubens's *Romulus and Remus* also makes ample use of other visual metaphors: The twins are at the center of the composition and the story; the light shining on them signifies their future greatness while the old man Tiber and the young woman Rhea Silvia sit behind the legendary scene, both literally and metaphorically. Furthermore, nature and the divine – figured in the wild animal nursing them – are on the boys' side because the wolf is feeding and not eating them. In addition to metaphors, this painting communicates by means of symbols – another way to use one image, concept, or word to describe an entirely different one. Within their cultural framework, metaphors must make sense even to listeners and viewers who have never heard of or seen them before: To be at the physical center of a painting, as the she-wolf is in Rubens's, is to be its most important subject. Whereas metaphors can be understood in fairly straightforward ways, symbols are more fleeting and mysterious, their connection to the thing they symbolize often having been lost in the passing of time. That the she-wolf is a metaphorical mother to the twins in *Romulus and Remus* is clear enough; that she is the symbol of Rome, however, can be known only through a study of history, however superficial. How could the viewer, without knowing beforehand, correctly perceive the Eternal City in the eternally hungry beast (the she-wolf's ribs are significantly visible in Rubens's picture)? Unlike metaphors, symbols do not have to entertain a discernible connection with that which they designate. Without explanations, viewers of Rubens's picture may realize their metaphorical centrality from the twins' position and the light shining on them. However, in the absence of a caption or previous knowledge, they could not guess that the old man stands for the Tiber River, that the fig tree locates the Velabrum, and that the she-wolf embodies Rome.

Metaphors and symbols are less direct than explicit descriptions. Still, by condensing and contracting meaning, they are often more compact; by preserving the elusive overtones of their referent, they can be more accurate; and by establishing new connections and images, they are also more memorable. "An eloquent symbol has a way of flattering our desire for depth without offending our sense of coherence. With a high degree of lucidity it manages to remain enigmatic. Its poetical force derives from a union of the transparent and the opaque" (Wind 349). What

would Rubens's painting look like if, instead of a she-wolf, Rome had been represented as an assemblage of buildings, the Tiber as an actual waterway, and Romulus as an adult man building the walls that were to form his city – that is, if the painting had illustrated a literal rather than a profoundly allegorical legend?

The symbol of a city is intrinsically the mark of its freedom. To represent oneself in such a way is to declare one's uniqueness, one's difference from others and relative independence from them. I am a she-wolf and certainly not a lamb, Rome proclaims; I am a she-wolf and not a lion like Venice, not a snake like Milan, not an elephant like Catania, and much less an apple like New York. The she-wolf condenses and contracts Rome's ancient past and a mother's instinctive protectiveness, even as she flatters Romans' desire for such antiquity and generosity. The she-wolf's story is lucid when summarized for history books and legend collections but her enigmas, rather than being unraveled by the passage of time, increase in size and number with each successive representation of the Roman beast. The she-wolf is transparent in her associations with the city: Everyone recognizes her as Rome's own nurse. However, any inquest into her changing meaning over the course of time reveals her to be an opaque representation of the Eternal City: reluctant to express straightforward meanings, unable to relate simple stories, and constantly tugging – like the twins at her udders – at the imagination of writers and artists, impelling them to tell her story again.

THE SHE-WOLF'S EMPTY PELT ON A RENAISSANCE MAP

Not unlike the she-wolf representing the city of Rome, the more improbably stalwart donkey and elephant are the recognizable symbols of America's two major political parties. She-wolves are rapacious and strong, at the top of the food chain, and an apt mirror of the Roman superpower. Eagles also are regal and keen-eyed and it is no wonder that the bald eagle is the symbol of the United States – the contemporary equivalent of ancient Rome, some say, for its worldly stature. Unlike eagles and she-wolves, elephants are grotesque animals, huge and ungainly and with ridiculously long noses. Donkeys are commonly perceived as stubborn and stupid. It is through the hugely popular work, published in the 1870s, of political cartoonist Thomas Nast that the donkey came to be perceived rather as humble and independent; likewise, the elephant was praised as a dignified beast, with intelligence matching its strength. Despite Italy's

long-standing fascination with everything American, few Romans today recognize the donkey and elephant as American political symbols – or even as political symbols at all. In the dense thicket of Italy's numerous political parties – in many ways, a Dantesque *selva oscura*, or dark forest, – we do not encounter zoological symbols as often as botanical emblems featuring carnations, roses, daisies, ivy leaves, and olive branches. Still, living as they do in a symbolic zoo of fish, lambs, bees, and bears – not to mention eagles and she-wolves – Romans are familiar with the figurative value of animals.

The she-wolf was the representative of Rome's founder–king and then of Rome's republic and empire in turns; later, she became the reminder of the pontiff's judicial system near the Lateran Palace. She was next transformed on the Capitoline Hill into the icon of Rome's ancient culture first and its secular government later; the Roman beast has preserved through the centuries the assorted layers of symbolic and metaphorical usage she acquired over time. This animal is wild and dangerous, as the behavior of her mate repeatedly proves in European fairy tales and legends: Ensconced at the top of the food chain, wolves are the voracious harbingers of violent death for weaker beings. The she-wolf is likewise greedy and, for her, nothing is ever enough. In idiomatic Italian, the hunger of a wolf is difficult to satisfy; no matter how much she eats, the she-wolf remains lean and full of appetites – hence, the "illness of the she-wolf." Dante's veins and wrists tremble, and so perhaps should ours, at the thought that we might participate in her heedless voracity. The she-wolf is simultaneously maternal and lewd; that is, she is an attentive nurse as well as a sexual predator. The ambiguity of her name makes her complexity inevitable. She is both a memory of the past – the sylvan predecessor of what is now a city as well as the historical incarnation of Rome's god-inspired founding – and an indication of the direction that Rome's future is taking: rapacious and generous and, at best, contradictory. As the enduring image of the city of Rome, the she-wolf over the ages has been appropriated by poets, artists, politicians, and other cultural actors as a metaphor, a fleeting figure of speech that eventually hardened into a more permanent symbol: of history and memory, sex and motherhood, violence and insatiability, freedom and subjugation.

In addition to the recognizable, canonical artistic images of the medieval, Renaissance, and baroque ages – the Pisano family's fountain, the Carraccis' fresco, and Rubens's painting discussed in this chapter – the she-wolf as political symbol of Roman identity also regularly appears

on representations not generally regarded as artworks. For example, she is the symbol of the Eternal City on the frontispiece of countless books about or published in Rome and on numerous maps, including the late sixteenth-century map of Rome housed in the permanent collection of the Museo del Corso on Rome's busy Via del Corso (Fig. 12). Published by Umbrian engraver Francesco Villamena from a watercolor by French artist and cartographer Étienne du Perac (the original appears in du Perac's monumental plan of the city of Rome, his 1574/1595 *Urbis Romae Sciographia*), the map is a depiction of ancient Rome. Of course, its representation is quite different from the maps we are used to viewing, careful as it is to illustrate miniature pictures of monuments and heedless of the constraints of scale and exactitude. We find a she-wolf on the bottom right-hand corner of this map – or, more precisely, a she-wolf's stretched out, emptied pelt. There is no doubt about the beast's gender: Her three sets of udders (rather than the more accurate four sets displayed by the *Lupa Capitolina*) hang down, pear-like, from either side of her split-open coat. As if that did not make the identity of the pelt's owner sufficiently clear, two naked and chubby baby boys are by her sides, each next to a set of teats. Rather than suckling her (the she-wolf's withered udders are hardly worth the trouble), the babies assist in holding up the hollow remains of their foster mother. Within and framed by the she-wolf's shape is a rectangle containing a lengthy Latin inscription – a flowery dedication to King Charles the Ninth that describes the map but does not mention the beast.

By the time visitors to the Museo del Corso reach du Perac's and Villamena's map, they already have been greeted by the beast's likeness at the entrance of this small collection. The Fondazione Cassa di Risparmio di Roma, the bank that sponsors the Museo del Corso, features eighteen bees and the nursing she-wolf on its rectangular emblem. Stylized versions of the official emblem, one square and the other round and each divided into two parts by a line through the middle, are what visitors see on the door handles and entrance floor of the Museo del Corso. Three busy, provident bees hovering near their hive occupy half of the square or circle. The other half holds Rome's beloved animal: the she-wolf nursing Romulus and Remus, a metaphor of compassion beyond the boundaries of race and species and an image of fecundity and prosperity. Labor and wealth, bees and the she-wolf: What better totems for a bank? "Work hard like a bee," these images proclaim, "and you shall be fertile like a she-wolf." The she-wolf on the map, however, is different from the beast on the bank's emblem; the she-wolf on the map

Figure 12. Étienne du Perac and Francesco Villamena, map of ancient Rome, 1574–1595. Museo del Corso, Rome. Photo credit: Cristina Mazzoni.

has been killed, gutted, and skinned before being nailed on an imaginary wall – that is, a corner of the large map – as the border for the young king's dedication. Two green palm fronds emerge from the sides of the beast's head; palm fronds are the symbol of martyrdom and they may designate the dead beast as the carcass of Rome – perhaps following the city's sack in 1527. From this perspective, the she-wolf on the map is reminiscent of du Bellay's slaughtered beast: That she-wolf also was hung in public after being killed by invading hordes. Du Perac's she-wolf works as a frame for the Latin words of praise to a king, even as she herself is framed twice: literally, by the painted red frame to which she is attached with ribbons tied in six places and, metaphorically, by the map of Rome that portrays and represents her. This she-wolf is so removed from her

legendary role and historic significance as to radically unsettle the symbolic work she typically performs. Would the city of Siena, Perugia, or Bologna still want to reproduce the she-wolf, and the alliance with Rome that this animal recalled for its citizens, if the city the beast stood for were – metaphorically, of course – gutted and skinned, eyes closed and dead, and udders withered almost beyond recognition? Could such a beast function as an allegorical pedestal for religion or politics in her ruined and uncertain state?

The she-wolf on the map was opened up for examination, her hollow pelt a graphic reflection of what the cartographer had done to the city: Both living and moving entities were reduced to still two-dimensional likenesses. Yet, in this faded condition, city and beast continue to express clearly their ancient and still decipherable significance. The city on the map remains an icon of the real, material city at the time of its greatest glory: Its buildings may be ruined but its grandeur is undiminished; scholars in the Renaissance made a career out of that realization. The she-wolf on the map differs in profound ways from the iconic image of the she-wolf in everyone's imagination. This beast holds an unusual posture: frontal and upright rather than standing or crouching; her udders are strangely empty; and her body, normally lean and muscular, is hollow and thus no longer able to perform as a supportive pedestal for anything – whether the crucified Christ, Perugia's founder, or the idea of Good Government. It is the twins, instead, who must hold her up. Yet, viewers are not likely to have any doubts about who she is: This is a female wolf with two male babies appearing on a map of Rome – who else could she be but the nurse of Rome? This beast is yet another palimpsest indicating, below its most recent and ruined surface, the traces of the animal's past greatness – not unlike the Roman ruins that movingly suggested to Renaissance scholars and artists the hidden presence of the city's revered history. The she-wolf's body on du Perac's map could be only that of the Roman *lupa*: Physically empty, perhaps, and only a shadow of her former self, but metaphorically and as a symbol, this she-wolf is as full as she ever was.

Using a complex and ultimately impossible visual analogy in *Civilization and Its Discontents* (1929), Sigmund Freud famously compared the city of Rome to the unconscious and its tenacious, almost physical hold on the past:

> Let us, by a flight of imagination, suppose that Rome is . . . a psychical entity with a similarly long and copious past – an entity, that is to say, in

which nothing that has once come into existence will have passed away and all the earlier phases of development continue to exist alongside the latest one. (44)

With its layered history and geography of churches built atop temples and piazzas over the outline of stadiums, with times and spaces seamlessly superimposed on one another, Rome is an architectural icon of remembrance and the impossibility of forgetting. In every one of her successive incarnations, the she-wolf preserves traces of previous forms and meanings – like Rome's topography and every human being's unconscious self. Although it was imperfect casting that caused the *Lupa Capitolina*'s leg wounds, the bronze will always be Byron's "thunder-stricken nurse of Rome." On the diptych of Rambona, the she-wolf supports Christianity even as she fulfills her maternal duties to Mars's son. Dante's beast embodies greed but there is a touch in her of the whore that she may have been. Even as a hanging, bleeding corpse, du Bellay's wolf continues to represent the protective abilities of a great empire. Likewise, the she-wolf's status as palimpsest allows her to signify beyond the limitations of her ruined physical condition on du Perac's map because nothing of what she was previously is lost. As Rome's symbol, the she-wolf – even when skinned, gutted, and hung on a map – remembers and displays her own past, layered like that of the city that might never have been born without the milk-filled flesh of a wolf.

CHAPTER 9

MODERN AND CONTEMPORARY TIMES

THE NEOCLASSICAL SHE-WOLVES OF VALADIER AND PINELLI

THE ROMAN SHE-WOLF IS A CULTURAL MONUMENT. WHETHER MADE of stone or words, metal or pigment, the picture of a wild beast nursing two human babies is an enduring one and continues to speak of the past – especially of a great Roman past – like few other objects. In the course of the nineteenth century, the she-wolf became an icon of the desire for Italian national unity: Her indigenous form united nature and culture, present and past, and two different babies under one protector. Naturally, then, images of the she-wolf appear in architectural structures of modern Rome. There are she-wolves, for example, on that most visible of its buildings, the *Vittoriano* of Piazza Venezia, the controversial monument to the first king of united Italy, Victor Emmanuel II, situated at the foot of the Capitoline Hill. An allegorical she-wolf accompanies the Tyrrhenian Sea in one of the Fountains of the Two Seas and, at the top of the monument, the bronze allegories of Liberty and Unity ride triumphal chariots on the hubs of which wheels are the heads of she-wolves. In a monument such as the *Vittoriano*, which repeatedly summons images of past incarnations of Rome – a monument that has been described as "a rhetorical device for manipulating public memory" (Atkinson and Cosgrove 31) – the she-wolf carries out her multiple political tasks. As a wild beast defending the Tyrrhenian Sea, she is the nationalist embodiment of a god-sent protection and the literal hub around which the wheels of allegorical Liberty and Unity may spin. The location of the twentieth-century structure on the side of the most ancient site of Roman religious and political power, the Capitoline Hill – indeed, the site of the *Lupa Capitolina* herself – confirms the acceptance,

220

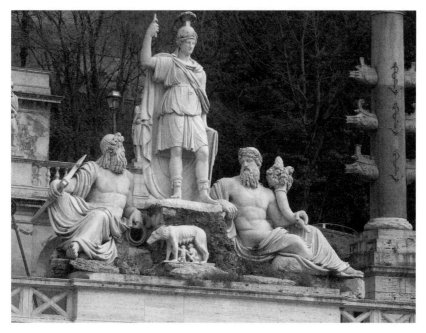

Figure 13. Giuseppe Valadier, Fountain of the Dea Roma, 1823. Piazza del Popolo, Rome. Photo credit: Cristina Mazzoni.

on the part of this monument, of the beast's pivotal role for the city's past and for its present and future.

Because of her legendary association with Roman antiquity and frequent presence in ancient art, the image of the she-wolf lends itself quite readily to monumental treatment. Pretentious depictions such as the early twentieth-century *Vittoriano*'s and the art inflected by the neoclassical style of the early nineteenth century, in turn, underline the monumentality of the beast, her figurative and historical weight. An example of this use of the wolf in central Rome is the Fountain of the Dea Roma on the Piazza del Popolo, designed by Giuseppe Valadier, architect and urban planner, and sculpted in 1823 by Giovanni Ceccarini (Fig. 13). This monumental fountain shows the warrior goddess fully armed. Modeled on Minerva, however, the goddess Roma would not be easy to recognize for who she is if it were not for the clarifying presence of the nursing wolf. In Valadier's fountain, the Dea Roma is flanked by the reclining, personified figures of the Aniene (i.e., Rome's second river) and the Tiber, and a smaller statue of the she-wolf suckling the twins stands under the goddess and at the center of the composition. Although the goddess's

feet do not actually touch the wolf, the Dea Roma is visually held up, in a way, by the animal nurse – not unlike the she-wolf in the diptych of Rambona holds up Christ and the one in Lorenzetti's fresco in Siena supports the personification of Good Government. For many years, Valadier was the director of major archaeological works; he certainly must have known that the image of Rome as a warrior goddess, identified by the presence of a nursing she-wolf, had been popular on imperial Roman coins and signaled the city's growing power. Valadier's neoclassical urge to revive the style as well as the content of ancient iconography led to the creation of a monumental fountain that remembers the myth of the she-wolf as well as its numismatic impressions. The fountain's own patriotic message is thus reinforced and intensified through the significance not only of each image – that is, Rome deified, the Tiber personified, and the she-wolf allegorized – but also through the memory of what the combination of these images together once signified.

As stately as Valadier's and dating from this same neoclassical period, although two-dimensional, Bartolomeo Pinelli's she-wolf appears in the etchings of his successful volume, *Istoria Romana* (Roman history, 1816). This is a visual account of ancient Rome based on a text by French historian Charles Rollin and made of one hundred of Pinelli's characteristic images with lengthy captions. Although he was a native Roman working primarily on Roman subjects, many of Pinelli's customers were travelers who wanted to take home as souvenirs his detailed replicas of the city – like tourists today take home photographs or postcards of the places they visit as visual reminders of their experience. Because of his customer base, in much of his work Pinelli imagined Rome as a visitor would want to see and remember it. His perspective – necessarily focused on the city's antiquities – naturally fit quite well with his neoclassical training and tastes.

The first she-wolf in *Istoria Romana* appears sideways on the shield of the goddess Roma, who is addressing the dapper artist among the ruins and requesting him to produce the very book the reader is holding. Pinelli's most important she-wolf, however – the one that tourists would want to take home through reproductions of his art – is the protagonist of the second etching in his *Istoria*: the scene at the Lupercal (Fig. 14). Faustulus has just found the twins being nursed and licked by a she-wolf and he is holding onto a boulder to keep steady: Seeing a she-wolf nursing two human babies is bound to make someone lose his balance. Shaded by the Ruminal fig tree, the herdsman appears terrified, while the reclining personification of the Tiber River, holding a cornucopia

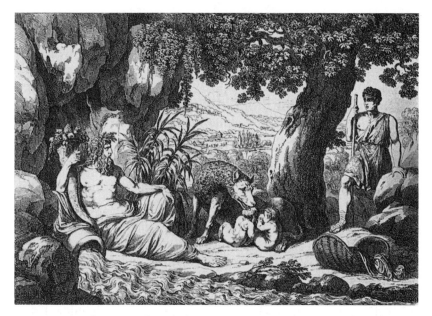

Figure 14. Bartolomeo Pinelli, *Romulus and Remus, Nursed by the She-Wolf, and Discovered by the Shepherd Faustulus, Istoria Romana,* 1816 (Rome: Scudellari, 1818–1819). Digital image credit: Vincent Pelletier.

and leaning on a gushing barrel, looks at him gravely. This she-wolf is a recognizable print version of the *Capitoline She-Wolf*, although she strikes a different pose. Unlike her bronze model, Pinelli's wolf is crouched and busily licking the twins; her mouth is partly opened, like that of the bronze, and showing her fangs; the shape of her head looks exactly like that of the *Lupa*; and for their shape and placement, the curls of her mane are a faithful reproduction of the bronze beast's, as are her ears and muzzle. The premier illustrator during a period of nascent nationalism in Italy and a fervent patriot himself, Pinelli worked through his images of an early and glorious Rome to disseminate the tradition of an Italian state – one born of the she-wolf whose story the Dea Roma herself had invited him to reproduce.

Pinelli's etchings of the ancient beast were popular and effective because "His virtuoso, obsessive draftsmanship is pre-romantic in its intensity and emotion, while amazingly modern in its freedom and classical simplification" (Olson 12). This popularity and effectiveness are also due to the fact that the she-wolf had been continuously remembered in art from antiquity through the medieval, Renaissance, baroque, and

neoclassical periods. She was a recognizable icon that had never lost the power to tell a story, the significance of which could vary according to the needs and desires of each age. Each new she-wolf depends on previous ones, and each new she-wolf provides yet another model for she-wolves to come.

It was inevitable that in their explorations of time and space, artists of the twentieth and twenty-first centuries would also meet the she-wolf. By this time, the beast may have become simply a historical memory, temporally distant from all of these artists and geographically remote from most. However, the Roman she-wolf keeps roaming the worlds of time and space and the realms of art as well as literature, history, and politics; she is always eager to meet fellow travelers. Twentieth- and twenty-first–century painters and sculptors have regularly made her acquaintance. Among them, some have felt compelled to picture her once again and, by so doing, add their own version to the long and disordered line of literary and artistic she-wolves of the West. For many artists, the she-wolf embodies the shape of a fascinatingly distant past: To imagine the she-wolf is to imagine such past anew and recapture it through her familiar form. In their material connection with history through the medium of their work, some of these artists have undertaken, in the she-wolf's shape, an archaeologically inspired task; others have laughed at and with her; others were primarily concerned with remembering her shape and understanding what it might mean. Trained by their practice, the she-wolf's artists have rightly mistrusted initial, superficial glances – the animal's pelt may have appeared suspicious or borrowed perhaps, or it was simply that the artists could not see it well enough to reproduce it. So they looked closer, dug deeper, and discovered layers of new and renewed meaning in the she-wolf palimpsests – layers that contemporary art succeeded in recovering and expressing.

It was not only artists, though, who found the she-wolf to be a source of inspiration in the twentieth and twenty-first centuries. Before turning to them and to better understand their she-wolves, a detour through fascist iconography is required.

THE TAMED SHE-WOLVES OF FASCIST ICONOGRAPHY

Historians and cultural critics often remark that Mussolini understood well the effectiveness of visual media in communicating political ideas. Fascist propaganda astutely employed ancient and familiar icons and

myths to promote a young and new political regime. The likeness of the she-wolf – a beast that was Roman and mother, ancient and wild, fearsome and protective – was an ideal medium with which to articulate the ideology and ethos of Italian fascism. This political movement presented itself as rooted in antiquity yet indomitable, as a powerful entity daunting to others but protective of its own. Fascism saw itself as a she-wolf. The variety of ways in which the she-wolf was incorporated within fascist art and architecture, as well as in its rhetoric and propaganda, reflects how dramatically diverse were the cultural productions inspired by Italian fascism. Although public responses to the repetitive reproductions of the she-wolf in fascist Rome should have been predictable – pride and fear among them – the reality was much more complex. The she-wolf is a wild and savage beast, difficult to tame even for the most ruthless of leaders. As it turned out, the she-wolf's images are no easier to control than the live beast they represent or her ambiguous, sexually charged name. Thus, fascism enjoyed telling and retelling the she-wolf story that it assumed as its own parable, yet the meaning of the tale did not always come out the way fascist discourse intended. "She-wolf" is a slippery word, in Italian as in Latin, and the myth to which the beast belongs – or rather, more accurately, the myth that belongs to the beast (her story, untamable as her wild animal nature, cannot be fully appropriated) – is not much more stable. When Mussolini called Italian children "Sons and daughters of the she-wolf" (see Chapter 6), he also questioned their legitimacy by invoking the she-wolf's sexual promiscuity, thereby questioning their mother's monogamy.

One way in which fascist rhetoric tried to domesticate the she-wolf's eloquent wildness was by introducing new elements in her old story and anchoring the beast to them in such a way as to underline current achievements and their connections to ancient glory. This procedure leaves little room for alternative and discrediting details and aims to eliminate – or, at least, minimize – the possibility of double-entendres. An example of this fascist rhetorical turn is seen in the she-wolf carved on the façade of the historic Palazzo Fiat of Via Bissolati, designed in the 1930s–1940s by famed architect Marcello Piacentini and home today of the Carige Bank (Fig. 15). The travertine relief, an anonymous piece (although Piacentini was known to work closely with the artists who decorated the structures he designed; Fochessati 67), shows the nursing she-wolf with her twins, stared at by the head of a bull – the animal symbol of Turin, the northern Italian city that is home to the Fiat automobile company. She-wolf and bull – female and male icons of ancient history

and modern industry, respectively – are accompanied on this relief by other synecdoches of Italian successes: a tractor and a wrench, an anchor and a propeller, and cogs and wheels of various shapes and sizes. All are hopeful images of Mussolini's new Italy, both agricultural and industrial, happily at home on land, at sea, and in the air. The nursing she-wolf, needless to say, stands at the symbolic center of the stone relief overseeing this dreamed-about Italy, both old and new. Her myth may be an ancient one, the carving proclaims, but how brightly it illuminates recent achievements and how impressively the she-wolf shares her own aura of greatness with other animals, as well as with the inanimate representatives of a contemporary society seeking its greatness through agriculture, technology, and seafaring. (The she-wolf, by the way, had already encountered the bull in ancient times under more adverse circumstances: As the animal symbol of those Italian allies who rebelled against Rome during the Social War of 91–87 BCE, the bull gores and tramples the Roman she-wolf in the short-lived yet numerous bellicose coins from that time period; see, e.g., Evans 85.)

Because the she-wolf is the symbol of the city of Rome and because of the visual and ideological legacy of fascism, the animal is everywhere. As historian Marla Stone pointed out, "The fascist imaginary which dominated Italian visual culture between 1922 and 1943 mobilized an endless array of *fasci*, eagles, Romulus and Remus she-wolves, Roman battle standards, soldiers, triumphal arches and columns" (207). Especially prominent and significant was the she-wolf's deployment on murals (e.g., one very visible on the terrace of a fascist building in front of the Church of Sant'Andrea della Valle), mosaics (e.g., those on the fascist architecture of Piazza Augusto Imperatore), and stone reliefs (e.g., the Palazzo Fiat). "Murals, mosaics, and bas-reliefs," Stone continues, "coincided with fascist patronage agendas in both form and content: they were all long-standing types of public art which combined Italian traditions dating from Antiquity with fascism's interest in broadening the social participation of cultural production and reception – and exploring their rhetorical possibilities" (211). Again, as in the Renaissance and in the neoclassical period, ancient form and content come together on the body of the she-wolf, intensifying her artistic, historical, and symbolic significance.

To note the she-wolf's ubiquity in fascist Rome might seem pointless: What is so special about the presence of this icon on numerous fascist buildings when the same image can be seen on contemporary trashcans and utility hole covers all over the city? The question is legitimate but the difference between fascist and contemporary deployments of the ancient

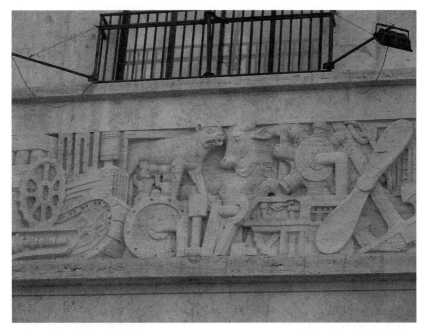

Figure 15. Travertine relief, Palazzo Fiat, 1930s–1940s. Via Bissolati, Rome. Photo credit: Cristina Mazzoni.

Roman beast also must be acknowledged. If the she-wolf's relatively subtle presence on contemporary artifacts signals their ownership by the Roman municipality (it could be said that the city likes to mark its territory), the fascist she-wolf icon was more self-consciously, more astutely, and certainly more spectacularly displayed. Without a doubt, there is a strong ideological component to the presence of the she-wolf on so many post-fascist artifacts, but it is neither as systematic in its iconographic practice nor as explicit as the fascist exploitation of the she-wolf image. The traces of the she-wolf's fascist performance that are visible on the Palazzo Fiat as well as numerous other public buildings (including elementary schools and covered markets) signal the most pervasive renewal of the meaning of the beast since antiquity. The fascist cult of ancient Rome, the new party's emphasis on its rescue of a country at risk and on the rebirth of Italian greatness, and the devotion of fascism to the power of images, together help explain the profusion of she-wolves on Rome's public buildings. In 1938, for example, the "Two Percent Law" was proposed; it legislated that "in all public works two percent of the total construction costs will go toward decoration"

227

(Stone 212). As a fascist sign and a political message, the she-wolf was invasively inserted into every aspect of everyday life: In the fascist ideal, the political, personal, and social lives of individuals had to be totally integrated; a she-wolf nursing two babies could evidently image – despite the personal, private denotation of this image – the public power of the state. For the nursing she-wolf brought together divine, animal, and human natures, and her bodily maternity had long ago acquired the greatest political significance to the people of Rome. In her body, she seamlessly sequences the past into the present even as she articulates, more subtly and controversially, the indeterminate role of gender and sex in the birth and sustenance of the state.

WOMEN AND MEN IN THE POSE OF THE SHE-WOLF

Women in the position most often assumed by the she-wolf in art (i.e., on all fours with breasts hanging down and, often, twins suckling them) are not uncommon in the Western imagination. In 1972, Federico Fellini's movie *Roma* created a stir among feminists because of its poster: a naked woman on all fours with three visible breasts (the viewer imagines that each breast belongs to a set of two), long hair, head raised, and on a pedestal like that of a statue. She is unmistakably a human version of the *Capitoline She-Wolf* despite the absence of twins. In the course of Fellini's *Roma* – a film that is the director's homage to the city where he spent his adult life – the she-wolf predictably appears more than once. Early in the movie, the bronze *Lupa* shows up on the screen during a school slide show; the young athletes in the newsreel projected during the director–protagonist's childhood are called in voice-over "the sons and daughters of the she-wolf"; and toward the end, the actress Anna Magnani, quintessential interpreter of Roman film roles, is interviewed and described ambiguously as both she-wolf and Vestal virgin. In her ability to interpret a variety of typically Roman female roles, Magnani embodies for Fellini both of Romulus and Remus's physical mothers, Rhea Silvia and the wild beast.

In twentieth-century Italian art, the most memorable female human "wolf" on all fours is a sculpture by Arturo Martini (1899–1947) titled *The Wounded She-Wolf* (Fig. 16). Martini's body of work is based on his quest for the perfection of the human form through a self-conscious exploration of artworks from earlier historical periods and other cultural

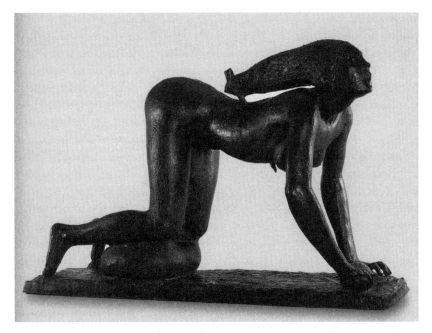

Figure 16. Arturo Martini, *The Wounded She-Wolf*, 1930–1931. Private Collection. Photo credit: Archivio Claudia Gian Ferrari.

traditions. In his art, Martini pays obvious homage to Egyptian, Etruscan, Greek, and Roman art, as well as to the art of the Middle Ages and the Renaissance – even as his work preserves its distinctively modern character. Martini's *Wounded She-Wolf*, made between 1930 and 1931, may not be traditionally maternal – she looks too slim and sexy – but she nonetheless remembers and honors the *Lupa Capitolina*. Made of bronze like her Capitoline inspiration, this is a woman on all fours, a woman overtly animalized into a she-wolf through the title of the piece and the posture of her shape. Martini's modern emphasis on the horizontality of the human body – evidenced in his wounded she-wolf and influenced by ancient statuary – was to affect, in turn, later twentieth-century sculpture: Even the she-wolf–woman's hair is horizontal, as if flowing in a strong wind rather than falling more naturally on her shoulders. "The natural shapes of men," wrote Arturo Martini in *Colloqui*, "are those of a child walking on four legs. I have an affinity for original things, first things, and for me a standing man is never lyrical, does not have the beauty of movements, the imbalances of an animal, because he needs to assume

229

an acquired stance" (Ferrari; this quotation was used in 2007 on the plaque accompanying the *Wounded She-Wolf* statue during the Arturo Martini exhibit at the Galleria Nazionale d'Arte Moderna in Rome).

Evocative as well of the shape of the Etruscan Chimera of Arezzo, Martini's she-wolf is a sensuous young woman, naked and appealing; her back is arched, her head tilted back. The woman's mouth is open in a scream of pain that bares her small teeth and lengthens her body, tensing it. An arrow has struck her, its tip emerging from her breast and its end visibly piercing her back; the point of entry is invisible because it is surrounded by the woman's long hair. The woman is shapely and sexy but also thin, gaunt even, as if famished. Like the *Lupa Capitolina*, this female wolf is on all fours, mouth partly opened to reveal her teeth; like that older she-wolf, this one is naked and lean. The significance of the arrow remains unexplained and invites metaphorical interpretation but provides no guidance as to its secondary meaning; it does explain the woman's strange position, though, the tautness of her body and the anguish on her face.

The title and posture of the statue recall the Roman beast; the woman's arched back echoes that of the Chimera; her lean, angular face remembers Egyptian portraiture; and her expression of despair mirrors that on the plaster casts of victims of the Vesuvius eruption that Martini had recently observed in Pompeii. Martini's *Wounded She-Wolf* dates from 1930–1931, when Mussolini's fascism was well established, as was the Duce's desire to control Italy's artistic production. Two major approaches characterized fascist statuary: a radically archaic style, going back to the Middle Ages, intended to express the existence of an Italian national consciousness across time; and a classical style that invoked abstract metaphysics through spatially isolated statues as well as harking back to the glory of Rome's antiquity (Fergonzi 66–68). In his work, Martini carefully avoided choosing specific ideas or celebrating certain symbols – and he was much admired by fellow artists and intellectuals because of his courageous distance from official artistic dictates. Martini sought instead, precisely in this fascist period, to tell stories. The image of the she-wolf allowed him to do just that: Everyone knows her story, and by naming his wounded woman after this most symbolic of Roman beasts, Martini evoked a specific historical narrative even as he denied the fascist glorification of the animal. The she-wolf is not a successful conqueror but rather a losing prey, in Martini's piece; she is wounded by an arrow and tells the tale of an unexplained, unknowable attack that victimized her.

Mussolini never tired of proclaiming the she-wolf to be Rome's animal, for she embodies Rome's past and indicates the city's present connections to its noble history. Being reminiscent of statues from other lands, Martini's she-wolf is not quite so certain of her cultural origins: Her face looks Egyptian and her position is not only that of the Roman she-wolf but also of the Egyptian kneader type – an example of which is on exhibit in the center of Rome at the Museo Barracco. This incorporation of Egyptian elements is not Martini's only ambiguity. The Roman she-wolf is surely a female but, in the fascist exaltation of this beast, she is most definitely not a woman: Such double meanings may not enter fascist ideology for fear that the she-wolf's sexual ambivalence would destabilize her glorification. The fascist interpretation of the beast, that is, must occlude some of her connotations by avoiding certain textual features and potential meanings – features and meanings that are actually there: the sexually active woman, in this case, who may be hiding under the wolf's deceptive pelt. Martini's wounded she-wolf, although clearly an animal in name and posture, is at the same time incontrovertibly a woman, and sexy rather than maternal. This wolf woman chooses to embrace rather than fear the complicated story she seeks to tell, with all its doubts and uncertainties. To the she-wolf's existing hesitations, Martini's wolf adds her own: the injury of the piercing arrow and the visible pain of a deadly wound, inviting viewers to reflect on the meaning of this new violence inflicted on a much-offended animal.

Inspired by the iconic *Lupa Capitolina* of Rome, artists have produced other female wolves and wolfish women on all fours. In addition to these, there are also lupine males on all fours – men, that is, who impersonate a different gender and a different species than their own. Given his attachment to the figure of the Roman nurse, it is not surprising that Benito Mussolini should have repeatedly been imagined as one of these men. In a December 1936 cartoon by Kimon Marengo (1907–1988, also known as Kem), the stylized body of the *Capitoline She-Wolf* features Mussolini's unique square-jawed face, the black shirt worn by his supporters, the characteristic fez, and numerous medals and decorations. The Duce's lips are fleshy and dark to highlight the female identity he has taken on as Roman she-wolf. The beast's eight udders are clearly visible but, instead of Romulus and Remus, miniature caricatures of Europe's infant fascist leaders are attached to four: a bare-legged and bare-bottomed Hitler; Kemal Ataturk wearing only an open jacket and top hat; General Metaxas in traditional Greek costume; and General Franco dressed like a Spanish bullfighter and being charged by a bull. The leader of the British Union

of Fascists, Sir Oswold Mosley, is stark naked and attached to the wolf's tail (this cartoon is used on the cover of D. Williamson's book, *The Age of the Dictators*). If anyone should miss the artwork to which it alludes, the cartoon is clearly captioned with an ancient-looking Roman epigraph that says "*Lupa Capitolina.*" Europe's major dictators, the cartoon implies, have all nursed at the teats of Mussolini's fascist nourishment as a physical expression of his ideas.

A more recent and less overtly political man in she-wolf clothing shows up in Luigi Ontani's 1992–1993 *Lapsus Lupus* (Fig. 17). Acquired by the Solomon R. Guggenheim Museum in 2005, *Lapsus Lupus* is a hand-tinted photograph of a *tableau vivant*, a typical form of art for Luigi Ontani: He appropriates and imitates famous artworks, himself playing the protagonist's role. The photograph (technically, a watercolor on gelatin-silver print) shows the female wolf as a male human: artist Luigi Ontani (1943–) himself, pink-skinned and naked under a thick and furry wolf-skin, positioned on all fours, and striking the pose of the *Lupa Capitolina*. The wild beast in *Lapsus Lupus* is a disguised human male but also an undeniable mother – if not an interspecies mother like the original she-wolf, then a cross-gendered and interracial one: The twins under him are clearly of mixed ethnicity. These dark-skinned little boys seem to allude to the birth of a new multicultural and multiethnic Rome. The origins of the city may be as pink as Ontani's body and as white as the she-wolf's milk, but its future is inescapably multicolored. Indeed, the she-wolf's most recent nurslings in this picture look different from how they have always been imagined. The cultural relevance of Ontani's ethnic choice is reflected in an October 2008 blog entry criticizing the proposal to create separate classes for immigrant children in Italian elementary schools, significantly titled, "I nuovi figli della lupa" The new sons and daughters of the she-wolf. The schoolchildren smiling at the camera in the picture accompanying the article are as diverse as Ontani's Romulus and Remus, although a few years older. Ontani's she-wolf, however, feeds the new immigrants without any apparent intention of biting them – as Amara Lakhous's novel (see Chapter 6) had feared: These are two helpless babies after all, their skin color hardly a threat to the Eternal City.

Ontani's she-wolf likes to cross boundaries, both sexual and ethnic. Most strikingly, this particular she-wolf is a man in she-wolf's clothing: Ontani wears a wolf's pelt on his back, the only covering for his naked body, so as to best identify with the beast he is impersonating. It has

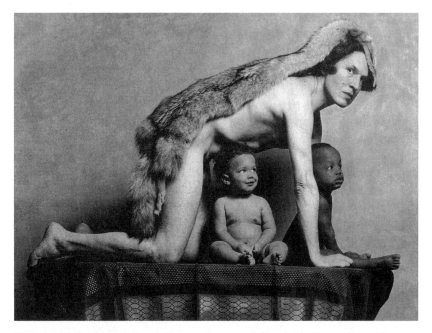

Figure 17. Luigi Ontani, *Lapsus Lupus*, 1992–1993. Solomon R. Guggenheim Museum, New York City. Gift, Angela Westwater, 2005. Digital image credit: Vincent Pelletier.

been written of Ontani's eclectic approach that "As essential as the naked body is to him as a manifestation of beauty – and the viewer is often astonished to find the painted bodies of the artists' models replaced by Ontani's own – garments appear to be equally important. Concealment and revelation are two poles of his art. In this context, the mask motif appears as the primary image of changing identity" (Weiermair 12). Like an incomplete garment, the she-wolf's pelt covers only half of the artist's naked body. In doing so, it calls attention to its own function as mask: Ontani's is a masquerade, not a disguise, because we are meant to realize what is going on and certainly not be deceived by it. Therefore, in this picture, Ontani is both himself and another – he is at once part wolf and part man. Nevertheless, his genitals remain invisible, preserving that bodily ambiguity typical of Ontani's works. The artist's identity shifts between human and animal, much like the identity of the she-wolf of old. To this uncertainty he adds a gender ambiguity absent in the Roman myth: The she-wolf may be a beast or a human, but she is most definitely female. "It was only natural for Ontani, who is always attentive to the

ways in which his skin and its sensibility expand, to find his way to transvestitism, dressing in the skin of others, or, better, in the skins of other skins" (Alinovi 51).

After putting on the skin of Goethe in the Roman Campagna and repeatedly that of Saint Sebastian being martyred in Rome, Ontani leaps to another species entirely and wears the skin of the she-wolf. Playfully narcissistic like the rest of his work, Ontani's *Lapsus Lupus* is an ironic, teasing representation of the birth of Rome. Well known for making fun of cultural icons, critics sometimes say that Ontani displays too much enjoyment in his own wit for his work to be truly subversive. In his photographs, described as "the crux of his style" because of their immediacy and tenderness, "self-aggrandizing gravitas and self-deprecatory wit complement each other" (Schwabsky 81). Through the centuries, the she-wolf has been involved in the representation of Rome's self-aggrandizement. In his she-wolf pose, Ontani's face is serious and self-important, but his masquerade as a wolf and as a nurse is self-consciously strange and funny because it is, ultimately, self-reflexive, self-critical, and self-deprecating. "In altering a work according to a different, usually contemporary and/or trivialized code," Michele Hannoush points out, "parody challenges the notion of fixed works altogether, and thus leaves itself open to the same playful or critical treatment" (113–114). Ontani's parody of the *Lupa Capitolina* seamlessly and deliberately inscribes itself in that constantly shifting pattern of meanings that, for simplicity, we call the she-wolf. Against the charges of creative poverty, lack of self-consciousness, and destruction of the artistic tradition it mocks, a parody such as Ontani's is inherently creative and necessarily self-reflective also through its comic elements. Furthermore, when seen from this perspective, parody "ensures that the tradition it revises will continue even beyond itself" (Hannoush 116).

Ontani's wolf is a *lupus*, a name significantly kept in its masculine form: The play with genders is not so easily laid to rest by a man posing as a female wolf, and Ontani does not go so far as to claim that he is a *lupa*. The Latin phrase of this photograph's title translates literally as "the fallen wolf" but clearly refers to such expressions as *lapsus linguae*, *lapsus calami*, and *lapsus memoriae* (a slip of the tongue, a slip of the pen, and a slip of memory). The problem is that these phrases take the genitive case after the word *lapsus* ("slip"), whereas Ontani's title does not, preserving the nominative in both words: *lupus* instead of *lupi* ("the wolf," not "of the wolf"). Is this grammatical inaccuracy itself a slip of the pen or is it rather intended to call attention to the name of this artwork as an

incantation of sorts, a summons beyond the constraints of grammar and reinforced by repetition of that final, magical-sounding "*us*"? Word play, after all, contains humorous, magical, and cognitive aspects all at once. Word play points to the multiplicity of meanings implicit in language, as well as to its tricks, because it depends on linguistic ambiguity. Word play also relies on the physical surface of language – its sounds – as a place of pleasure independent of meaning: *Lapsus Lupus* is fun to say and to hear and clever to think about – not least because of its grammatical inaccuracy: What exactly does this title mean, we are led to wonder? As one critic noted, the function of Ontani's titles "is to offer a magical key to the true interpretation of his works" because "the word play found in Ontani's titles reveals the hidden passageway to the visionary dreams of his art" (Eccher 61). The "slip" in the phrases *lapsus linguae, lapsus calami*, and *lapsus memoriae* – the first of which is far more common in everyday Italian than in English (contemporary Italian, it is worth noting, retains a fondness for Latin expressions) – refers to words spoken, written, or remembered imprudently, inadvertently, or mistakenly. Thus, Ontani's wolf also is an imprudent one, appearing as a wolf should not, showing up when and where a wolf is not supposed to be.

As for this wolf's slip – the wolf's involuntary blunder, or *lapsus*, psychoanalysis makes much of these blunders, claiming that they verbalize unconscious desires that cannot be consciously uttered because they are not consciously known. What are the most obvious among the wolf's unconscious mistakes? Surely, Romulus and Remus were white. . . . The wolf is mistaken: The furry pelt we see is clearly borrowed. . . . The wolf is mistaken: Is not the beast supposed to be female? However involuntary, *lapsus* are mistakes that ask questions – mistakes that reflect on the reliability of stories and the inevitable choices narratives must make, or make *us* make, as the consumers and producers of those stories. *What if* the twins were not white, the rescuer was not a sexy woman, and the she-wolf was not really a wild animal? *What if* the ethnic origins of Italians are not as white as they like to think? *What if* narrative history is not about objective facts but rather about personal memory; not about an objective message but rather about a subjective reception; not about repetition of well-known facts but rather about remembrance of forgotten ones? Literary and cultural critics, as well as some historians, have wondered whether the process Freud called *repression* might not be applied to their own field of study. A poem, a novel, a historical document or the reconstruction of a historical event, the understanding of a political change, and even the representation of a she-wolf: Could all

of this work in a way analogous to the mental process of repression – with its ostensible oblivion and eventual return of the once forgotten in disguised form? The story of the Trojan woman named Rhome; the cult of the breastfeeding, fig-loving goddess known as Diva Rumina; and the myth of Rome's founding by a man named Romulus – descended of a Trojan, breastfed by a she-wolf under a fig tree – together make us wonder about the role of remembering and forgetting and the return of the seemingly forgotten in the accounts of the birth of Rome.

Rome is like the proverbial home that my maternal grandmother, who lived in Rome all of her long adult life, used to invoke when she needed to reassure us children that our misplaced possessions would soon be recovered: The home hides, she would say, but it does not steal (*La casa nasconde, ma non ruba*). The she-wolf, we might add, covets and protects but she does not rob; in their abundance and contradictions, her stories may well confuse us but they are abundant and contradictory precisely because they refuse to let go of any details. These stories hide but they do not steal; they are palimpsests forever revealing previous layers of writing. In this stratified wealth of details, observers, travelers, writers, and artists have discovered personal narratives, alternate versions. So also the she-wolf's city, the city of Rome – true to my grandmother's homey promises – eventually reveals to seekers (who only thought they had lost something) things and people believed to be forever gone: forgotten crypts, covered-over houses, recycled churches, and abandoned temples, as well as female Trojan immigrants and indigenous maternal goddesses – themselves forgotten, covered over, and recycled. The she-wolf, through her many lapses, does the same. In this multiplicity of versions, Ontani's parody of the she-wolf's tale and image makes no claim to the last word. On the contrary, *Lapsus Lupus* acts as a parable of the variety of interpretation and signification: for parody – and Ontani's parody of the *Lupa Capitolina* is an effective instance of this – "not only rewrites another work, but suggests yet another one within itself, reminding the reader of the relativism of any work of art, and also of the richness of creative possibilities in an allegedly limited single source" (Hannoush 117). As source, neither the she-wolf nor Rome turns out to be signs as limited as some of their political uses might have presented them. In her various incarnations, in the numerous stories and images she has engendered, and in the countless readings and interpretations she has inspired, the she-wolf reveals aspects of the city, history, culture, and – most poignantly – of ourselves, previously set aside, pushed away, and ignored. These are legends that speak more truly than history, they are memories that defy

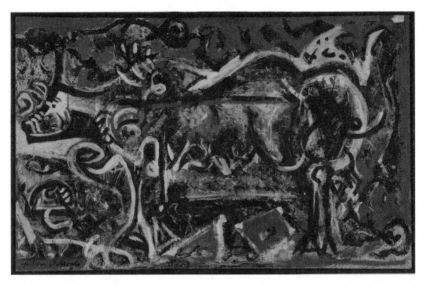

Figure 18. Jackson Pollock, *The She-Wolf*, 1943. Purchase (82.1944). The Museum of Modern Art, New York. Digital image © The Museum of Modern Art / Licensed by SCALA / Art Resource, NY. © 2009 The Pollock-Krasner Foundation / Artists Rights Society (ARS), New York.

oblivion. They speak of all-consuming greed as well as charity beyond even the boundaries set by nature – boundaries of species and maternity, gender and ethnicity; of wild, irrational fury born of instinct and of the drive for self-preservation; but also of fierce protectiveness toward all that need shelter.

JACKSON POLLOCK'S LAYERED *SHE-WOLF*

Lapsus Lupus presents a Roman she-wolf impersonated by a Roman artist and residing in a New York City art museum. In another collection in the same city hangs another Roman she-wolf, this one painted by an American. Jackson Pollock's *The She-Wolf* (1943) was this artist's first painting to be bought by a museum (Fig. 18). Its purchase in 1944 by the Museum of Modern Art in New York indicated an official recognition of the twentieth-century American painter (1912–1956) by the artistic establishment. Although it is an example of abstract expressionism, and thus a shocking departure from the she-wolves one usually meets in Rome – most of these beasts are promptly recognizable for who they are – Pollock's painting titled *The She-Wolf* is deeply influenced by and

relies on the viewer's knowledge of the story of Rome's foundation. The painting's most immediate inspiration has been identified as one of the two bronze she-wolves at the Frick collection in New York City – a museum that Pollock knew well (Herman and Paoletti 140). The Renaissance statue in the Frick is, in turn, a reworking of the bronze *Lupa Capitolina*.

Pollock's *She-Wolf* is not an easy painting to read, and my interpretation is deeply indebted to Herman and Paoletti's article, "Re-Reading Jackson Pollock's *She-Wolf*." Crisscrossed with black and white lines and patches of color, only through prolonged viewing does the figure of a she-wolf begin to emerge from the apparent chaos. The animal, seen in profile, advances to the left – the same direction that the *Capitoline She-Wolf* is heading. The beast takes up most of the canvas, dominating it both vertically and horizontally. This relative absence of surroundings ties Pollock's painted beast to her bronze inspiration: Each stands on her own with no thematic distractions other than the twins. For the Capitoline bronze, the nurslings are clearly an afterthought, stylistically different from a beast oblivious to their presence; in Pollock's painting, they are reduced to one barely identifiable baby. The animal figure on the canvas is far more prominent than the human element: The baby can only just be seen, located as he is at the very left side of the painting.

The most recognizable features of Pollock's animal – the body parts that always mark the she-wolf's gender in art and that allow us to perceive the beast's shape in the tangle of lines and colors that comprise Pollock's expressionism – are her udders. These essential organs are delineated in Pollock's painting by three inverted V's, black and white and strategically placed just below the center of the canvas. Without udders, who would speak of a she-wolf rather than her plain old male mate? (These three visible udders must each be half of a set, so that Pollock's beast seems to have a total of six – the Capitoline bronze, instead, has a more realistic eight.)

Pollock is quoted as having said that "*She-Wolf* came into existence because I had to paint it. Any attempt on my part to say something about it, to attempt explanation of the inexplicable, could only destroy it" (Cernuschi 52). Still, the painter's thematic concerns around the time he produced *She-Wolf* focused on myths and totemic imagery, on the relationship between humans and animals, and on how the intimacy of this bond has been portrayed in ancient and even prehistoric art – like Arturo Martini's *Wounded She-Wolf*, which also processes the influence of ancient styles on a more modern artwork. Pollock's *She-Wolf* includes the

figure of a bison that, although difficult to distinguish, seems to derive from cave paintings of that animal. This resemblance underlines the extent to which Pollock's she-wolf herself is inspired by cave paintings: Her shape follows undulating lines and overlaps with the other figures sharing the canvas. Although it lacks the rough stone surface on which cave paintings appear to us, Pollock's canvas includes patches of applied plaster, the texture of which – along with the mottled quality of the paint used to define the bison – is reminiscent of the surface of cave paintings. In her spare, essential lines, this she-wolf remembers an age far older than 753 BCE. Also evocative of the hunting scenes so frequently depicted in cave paintings, the most visible element of color on Pollock's canvas is a red arrow across the center; this is another connection to Arturo Martini's *Wounded She-Wolf*, who is wounded by an arrow piercing her middle. Pollock's red arrow suggests violence, as does the she-wolf herself: Given the insignificance of the single baby, the beast's evident sexuality in this painting is imaged by her swollen udders; however, sharp and pointy, they appear more as a sign of sexual predation than of a maternal embrace.

There may be other hidden figures on Pollock's canvas: most notably an Etruscan-inspired warrior striding across the animal's front leg and a possibly pregnant woman. Both are reminiscent of the Roman she-wolf: She too is the alleged work of an Etruscan artist (an identity not publicly questioned in Pollock's time), icon of a conquering empire, and sacred to the god of war – but she is also female and mother, sexual being, and possibly a whore. The warrior attacks the bison even as he reflects the colors and lines of the she-wolf's haunches: The figures do not exist independently but rather rely on one another for any sort of identification, however inconclusive. As was the case with the Mirror of Bolsena, meaning in Pollock's picture must arise from each figure's interaction with the other painted shapes. Furthermore, these shapes – bison, warrior, and pregnant woman – can only be perceived and possibly understood by excavating the painting in the manner of an archaeologist: They are layered on the canvas like ruins within an ancient site. We need to look at length and dig deeper in order to find them. Viewers, that is, must engage in an archaeological sort of visual activity retracing the painter's own stratified execution. Characteristically, Pollock used many layers of paint in his work; these he applied in sequenced steps with a process that tends to obscure the forms already painted with the ones most recently delineated. This layered process also makes the retrieval of each sedimented image analogous to the archaeologist's task – as well as to the psychoanalyst's probing. Therefore, interpretation and the

identification of the shapes with any sort of certainty become arduous tasks. The unconscious is like Rome, Freud said, with every layer of its history still available, however stratified. The unconscious is like a she-wolf, we might add, a beast that through the centuries also acquired multiple meanings that became layered on features that used to be more easily recognizable. It has even been advanced that Pollock applied paint in a random manner and only later decided to insist on the figure of the she-wolf, once the marks he had randomly created suggested to him the specific image of the Roman beast. Imagine that.

Pollock's critics claim that more than by Freud, the artist was deeply influenced by Jungian psychology at the time he painted his *She-Wolf*. From this perspective, the American artist's animal may be seen as one of the archetypal symbols through which, according to Carl Jung, human beings connect to psychological issues (Herman and Paoletti 148). From a Jungian perspective, Pollock's *She-Wolf* would be an intentional palimpsest, a representation of the artist's inner worlds. The mythic symbols originally associated with the archetypal figures of the she-wolf become fused in this painting with the artist's personal symbolism, his own internal realities, and perhaps his deepest fears too. "In the *She-Wolf*," Ellen Landau claims, "Pollock has presented an animal with power over life and death. The teats exhibit her life-giving function; the absence of children indicates her more fearful aspects" (302). As Dante insisted on informing his readers, the she-wolf ever was a scary beast.

KRISTIN JONES'S EPHEMERAL SHE-WOLVES

Although Jackson Pollock moved his she-wolf to the waters of the Hudson River, the Roman beast is deeply identified with the Tiber River, the waterway on the banks of which she found the abandoned twins of legend. It is from the dangers of the river that she most immediately rescued them. For centuries, this river continued to instill fear in those who lived by its shores. Plaques all over the city commemorate when the Tiber's waters spilled over the riverbanks and flooded the historical center. In the late nineteenth century, after the devastating flood of 1870, high walls made of travertine stone were finally built to contain the river's exuberance. Although very effective in keeping the destructive river away from a vulnerable city, these walls have also effectively imposed a distance between the city and a waterway that had been so crucial, both practically and mythically, to Rome's foundation and subsequent history. Since the building of the retaining walls, many steps need to be negotiated if one

is to get close to the water flow; most people see the river, these days, only from far above. No longer feared due to its high walls, the river has abandoned its role as protagonist to the city's life. Several initiatives have been undertaken in recent years to bring the Tiber River back into Rome's daily life: In the summer, there is a makeshift beach with a pool on the riverside (it is not recommended to bathe in the river's own murky waters); movies are shown on giant screens at the shores of Tiberine Island; boats ply the river for the low price of a bus ticket; fairs and festivals regularly take place along the paved banks; and a bike path extends the entire length of the right bank, filling up with urban cyclists on weekends.

In June 2005, the public art project *Tevereterno* (Eternal Tiber) designated Piazza Tevere (i.e., the section of the riverbank between Ponte Sisto and Ponte Mazzini in the center of Rome) as a new artistic venue. Art could be the means of bringing the Tiber back into the lives of those who live near it and defy the distancing presence of the restraining walls. At that time, American visual artist Kristin Jones (1956–) and Roman art curator Gaia Cianfanelli, together with a group of international artists produced a large-scale, multimedia installation: *Summer Solstice*. In the course of the performance, Jones unveiled twelve huge figures of she-wolves (all about 8 meters tall and between 12 and 20 meters long) on the restraining wall of the right bank of the Tiber, along the 560 meters separating Ponte Sisto from Ponte Mazzini. Although they look painted, these massive she-wolves were produced with stencils laid on the blackened stone walls: Jets of hot water cleaned the area left open by the stencils and the century-old dirt left behind created the silhouettes of the beasts. Not unlike an archaeologist, Jones removed materials instead of adding them and let the incrustations of the past speak of their own historical presence. The twelve images show the changing iconography of the she-wolf in ancient, medieval, and Renaissance times, entertaining a complicated relationship with memory and history. The she-wolves emerge from the patina of time, thus demanding to be remembered; yet, with time, the beasts will disappear: This is part of the artist's plan and integral to the work's meaning. Soon, the twelve she-wolves will be completely gone, reabsorbed by the dirt that allowed their appearance in the first place. The memory they embody is a fleeting one.

The she-wolves that inspired Jones's "clean" figures were chosen from an archive of more than three hundred collected from museums throughout the world by the director of the Capitoline Museum, Claudio Parisi Presicce. Working with Presicce for more than three years,

Jones drew directly from images in Presicce's collected archive in a classic black-figure style from a wide range of historical sources, including both two- and three-dimensional figures (with the collaboration of Roman illustrator Francesca Fini). Among the beasts discussed in this book, they include the unidentified animal nurse on the stele of Felsina (Jones classes her among her she-wolves); the *Lupa Capitolina* – by far, the most recognizable, even in the two-dimensional version (Fig. 19); the she-wolf on the altar of Ostia in Palazzo Massimo; and the recycled she-wolf on the diptych of Rambona. Other stenciled beasts are inspired by she-wolves appearing on a Saxon amulet, a silver *denarium* and a bronze coin, a Renaissance fresco in Ferrara, a marble sculpture from the same period, and the baroque maps of a German cartographer. What all these she-wolves have in common is the absence of babies; the twelve beasts stand alone. Their udders are swollen but no one is taking advantage of their milky abundance. Jones's choice to eliminate the twins from her stenciled she-wolves may reflect a desire to return to the early *Capitoline She-Wolf*: She originally had no twins. Or it could be a decision to focus on the beast herself rather than the twins – and particularly the one twin, Romulus, the founder – who inevitably upstaged this foster mother in the story. Jones's iconographical choice also underlines that not only maternity determines the importance of the wolf in these twelve stenciled images because her presence and power transcend her maternal skills. In her twelve variations on the retaining walls of the Tiber River, the she-wolf represents more than the milk with which she fed Rome's founder – although her swollen udders, clearly visible in all of Jones's she-wolves, point to her nursing role and to that milk. The number and massive shape of the stenciled wolves testify to the endurance of the she-wolf's artistic and cultural legacy. The sheer abundance and size of these beasts indeed must be significant: There are no fewer than twelve and they are enormous. The range of their geographical and historical provenance is also impressive, as is the variety of materials with which the originals of these stenciled images were made: stone, bronze, silver, ink, paint, and ivory. The Tiber she-wolves are the city's protectors; their maternal role is implicit. With the twins removed, their space becomes available for any viewer to occupy. In incarnating Rome – its antiquity and its modernity as well as the city's natives and its visitors – these twelve she-wolves are large enough and free enough to be mothers to all.

As well as acting as protector, however, the she-wolf needs protection herself; above all else, she needs safety from oblivion. This seems to be one of the messages of Jones's Tiber she-wolves and of her choice

Figure 19. Kristin Jones, *Summer Solstice*, 2005. Piazza Tevere, Rome. Photo credit: Mimmo Capone.

to selectively display the beast's archive in public. Object and subject of collective memory, the she-wolf fits Pierre Nora's most influential phrase: She is a place of memory (*lieu de mémoire*). The truth of places of memory, in this historian's words, is "that without commemorative vigilance, history would soon sweep them away." Such vigilance, in the case of the she-wolf, has been effected through a variety of discourses and diverse political and artistic positions; clearly, it is not from a single source that the she-wolf's survival has been assured, much less has she been reproduced with a single intent or effect. One of the reasons why the she-wolf has been experienced as a necessary cultural presence is because places of memory – the she-wolf in Rome being privileged among them – buttress our identities. At the same time, the very fact that they need to be built indicates the weakness of what they defend: No longer internal, Nora contends, modern memory needs outward signs – a sort of scaffolding. Through archives, museums, monuments, and the like – all places of memory – we attempt "at once the complete conservation of the present as well as the total preservation of the past" (Nora 12–13). Jones's she-wolves illustrate this animal's continuity across ages and cultures and her threatened status as a place of memory: Modern memory is archival and sensory, relying on physical images in order to

survive. Through Jones's selection and magnification, the twelve giant she-wolves on the Tiber's retaining walls thus become a public archive of sorts, a place of memory that, unlike the carefully guarded and difficult-to-access Capitoline Archive, is easily available to all. The twelve giant she-wolves along the Tiber River visibly conserve the past, even as the ephemeral technique through which they were produced – the stenciled dirt will eventually disappear – underscores this past's instability and fundamental impermanence.

CONCLUSION: THE LIVE WOLVES
OF ROME

S HE-WOLVES, IN FIGURATIVE LANGUAGE, ARE USUALLY HUMAN FEMALES.
Whether fictional or historical, powerful women have long been
described with this animal name to suggest their political ambition, sex-
ual insatiability, maternal obsessions, or illicit desires: Marie Antoinette,
Hillary Rodham Clinton, Reynard's Hersent, Masuccio's unnamed lady,
De Sade's Madame Saint Ange, and Verga's Pina (see Chapters 5 and 6)
are some examples of this metaphorical practice. The she-wolf's vora-
cious hunger, in misogynous discourse, can have a variety of objects –
primarily politics, sex, and motherhood. Revenge is one of its motivat-
ing forces. One such human she-wolf, maternal and vengeful, appears in
Victor Hugo's acclaimed 1831 novel, *Notre-Dame de Paris*. This wolfish
woman is a walled-up recluse who rejoices at the news that a gypsy
woman has been executed because gypsies had long ago abducted her
only daughter. Her fierce motherhood mixes with a blind hunger for
revenge, turning the recluse into the caged beast that best embodies such
characteristics: "And she began pacing up and down before the bars of
her window, disheveled, eyes blazing, banging her shoulder against the
wall, with the wild look of a caged she-wolf which has long been hun-
gry and feels feeding time draw near" (360). I describe Victor Hugo's
recluse as a way to introduce Rome's own caged she-wolves: Unlike
their Parisian counterparts, Rome's captives were not only allegorical
animals but also flesh and blood. Attached to their lupine symbol of sec-
ular power, the excited citizens of a newly Italian Rome – in the 1870s
no longer under Vatican rule – desired the she-wolf's physical, breathing
presence in their midst. On August 28, 1872, a committee headed by
the mayor of Rome, Pietro Venturi, resolved to place "in the garden of
the Campidoglio, in an appropriate hut, a live she-wolf as the emblem of
Rome; the future budget will include the expense of twenty-three and

a half liras, monthly, for the financial support of the animal" (Cappozzo 89). For about a century, from two years after Rome's incorporation to the Italian state until the 1970s, live wolves were kept on the Capitoline Hill.

The presence in the middle of Rome's historical center of fierce, live she-wolves must have made quite an impression on Romans and visitors alike. The captive body of a wild animal is a compelling spectacle, its hold on the imagination comparable to that of ruins: Both ruins and caged animals "are clearly shadows of their former selves" (Dekkers 39). Her placement on the Capitoline Hill, inaugurated as the preserve of ruins by the bronze *Lupa*'s move there in 1471, intensified the caged beast's ruined state and the role of this hill as a sanctuary devoted to the protection of an endangered past. Henry James, who "delighted" in Rome's ruins as "sentient" (*Italian Hours* 229), mentioned the incarcerated she-wolf in 1873: "The legendary wolf of Rome has lately been accommodated with a little artificial grotto, among the cacti and the palms, in the fantastic triangular garden squeezed between the steps of the church and the ascent to the Capitol, where she holds a perpetual levee and 'draws' apparently as powerfully as the Pope himself" (*Italian Hours* 198). It is ironic that James should compare the caged wolf to the pope because the beast, among other things, stood for the pontiff's loss of power. In a strange parallel, the pope at this time also vociferously considered himself a "prisoner" to the new Italian state. Both pope and wolf are icons of Rome – one religious, the other secular – and both attract visitors to the Eternal City. It is not difficult to imagine what tourists such as those who commented on the *Lupa Capitolina* in Chapter 6 would have said about the live beast. Byron likely would have lamented the caged wolf's fate. Miller's Mollie Wopsus, conversely, true to her type, sees "the little she-wolf" from the stairs ascending to the Capitoline and demands of her Italian companion: "I want you to buy me that she-wolf." For this American heiress, everything is or ought to be for sale. Signor Murietta manages to talk reason into her, even as he, like Henry James, connects the beast with the pope: "Why, my dear Mollie, that wolf bears the weight of the New Italy on its back. Rome would part rather with the pope than that little she-wolf" (50).

Romans of all ages stroll by the Capitoline Hill today. Only until the 1970s, however, could they pause before the undersized cage to observe the animal that embodied the rediscovered, reinstated values of their secular government. The she-wolf pointed to and confirmed the attachment of Roman citizens to a pre-Vatican past, most of all, and

their sense of civic duty before a lay authority – in contrast with the papal power that had for centuries ruled them. In his 1877 guidebook, *Roma Sacra* (Sacred Rome), Monsignor Luigi Tinti vehemently expounds critical opinions about the she-wolf's live presence:

> In climbing up the Capitoline Hill, and inspired to reflect on such a monument, I was distracted by the loud barking of a she-wolf. The City has had her enclosed in a large cage, visible to passersby, in order to remind them of Rome's legendary origin. The restless she-wolf paced within the hateful prison, howling either out of greedy hunger or else out of instinctive anger against the iron bars. Then I heard, with my own ears, a woman of the populace cry out, "Why do they keep you shut in there, dear she-wolf? Weren't you born free in the woods, and aren't we all, today, free?" What cruel irony resonated in the proud Roman woman's words! For it is true that today, under the false pretense of freedom, of subversive and licentious press, of unbridled immorality, of unpunished and blasphemous heresy, and through many other means of social corruption, the morals of more young people are being ruined, and even more of their bodies killed, than the hungry she-wolf would destroy were she free to roam the public streets.
>
> (Tinti, n.p.)

Tinti's diatribe against a flesh-and-blood she-wolf, in the genealogical line of Dante's and Carducci's against a beast made of words, is morally and politically conservative. The author does not identify in the caged she-wolf what other clerics were condemning as the "liberal she-wolf" – the she-wolf, that is, symbolic of the secular, liberal government that had ousted the pope from central Italy; that she-wolf had been much reviled in the Jesuit journal *La civiltà cattolica* in 1866 as "the filthy liberal she-wolf who devours, always starving" and "hastens to rob what is left to monks, nuns, and priests" ("La lupa liberale" 172–173). Tinti adds instead a twist to this genealogical line of she-wolf invectives: Whereas the Roman beast was inveighed against in the *Divine Comedy* as the hungry destroyer of souls (see Chapter 5) and as an allegory of the Church of Rome in Carducci's tirade against the Vatican (see Chapter 6), Tinti's sympathy, evoked by the beast's caged condition, portrays her insatiable hunger as a lesser evil in this fraudulent world. For the world has been corrupted, Tinti implies, by the secular government that since 1870 has replaced in Rome the pope's political authority. Far more dangerous is contemporary society, with its decadent mores and snares against the young, than a famished beast able to kill only bodies – and not too many at that. (Tinti alludes to Francis of Assisi's wolf of Gubbio: Francis also pronounced the

spiritual destruction by hell's agents to be more fearsome than a wolf able to kill only bodies: "How much more, then, are the jaws of hell to be feared, when we see so many held in terror by the jaws of a little animal!"; *The Little Flowers* 70).

Surely the she-wolf's howls distract the visitor to Rome, in Tinti's view, from the loftier thoughts inspired by ancient, medieval, and Renaissance monuments. Unlike the diptych of Rambona (see Chapter 8), Tinti's text is unable to recycle the she-wolf into a Christian icon; much less was this cleric able, like Lorenzetti's allegorical fresco in Siena (see Chapter 8), to see in the Roman nurse the basis of all good government. In Tinti's excerpt, the she-wolf is a victim of current city politics, like the young people captured and jailed by the secular ideology of Rome's recently installed post-papal administration. Tinti's bitter tirade of the wolf's caged condition mirrors Henry James's more nuanced implication: that the she-wolf calls to her side as many admirers as the pontiff, for both are imprisoned specimens of a long-lost power – ruined metonyms of what once was. The woman from the populace sympathetically mourning the beast's fate – in her pity, she is reminiscent of Wordsworth's Ploughboy: For both of these characters, compassion is the she-wolf's lesson (see Chapter 6) – is an uncomfortable presence for Tinti, albeit an inspiring one. The woman and the she-wolf are both female, both Roman, and both free inside yet regrettably caught within a fate not of their own choosing. Tinti understands this woman's words not literally, as they might have been meant, but rather ironically, like the intellectual cleric that he was: neither female nor Roman nor, likely, free. He heard irony resonate in the woman's appeal to freedom and feels compelled to tell of another irony he detected in the scene before him. For every word related to freedom in 1872 Rome must call back the "liberation" of Rome, the city's military removal from the political power of the pope.

The live she-wolf at the foot of the Capitoline Hill commemorated Rome's liberation from Vatican control and the annexation of the city to the Italian kingdom. Italy was united in 1861, Rome was annexed in 1870 and made the capital of Italy in 1871, and the she-wolf was caged in 1872. Flocks of sheep and goats could still be seen within Rome's walls during the 1800s but less frequently as the century progressed. It was in the late nineteenth century, at the same time as real animals disappeared from daily life, that "animals proliferated in new and newly popular representational and cultural forms. Rather than disappearing, animals multiplied within systems of representation governed by cultural rather than biological reproduction" (Feldman 161). That is, the late nineteenth

century witnessed a shift in how animals affected the existence of many people: No longer a daily presence, animals increasingly served as ways to rethink what is distinctively human about human beings, especially interiority – its nature and its structure. The back-and-forth pacing of the caged she-wolf, for example, could be read in all those who likewise moved, physically or spiritually, back and forth, acting like the live wolf on the Capitoline Hill. Thus, "You look like the she-wolf on the Capitoline" (*Me pari 'a lupa der Campidojo*) was a common vernacular idiom in Rome, inspired by the animal's well-known neurotic habits and used to describe anyone unable to stay still. A human and more internal imprisonment was visibly reflected in the she-wolf's external incarceration. The she-wolf, at this point, embodied the condition of humans in general, not only that of vengeful, ambitious, or oversexed women.

The centuries-old dialectic of human identification with the she-wolf and differentiation from her beastly nature is expressed through the role of the iron bars that enclose her: They kept visitors safe but also announced by their presence the thrilling danger of the one within; they separated animal from human but facilitated an otherwise impossible proximity. The smallness of the cage made the animal seem more violent and aggressive, magnifying her wildness and concentrating her aggression through the cramped space. The she-wolf and her cage constituted each other, in a sense, each defining the other's meaning and the beast's difference from human visitors. It has been said about captive animals in general that the cage "implicitly argued that there was a clear distinction between the human and the animal and that this distinction was not merely spatial but ontological." The cage, that is, allowed the visitor's safety even as it confirmed the danger at hand; "the cage argued for its own necessity" by making the animal "seem still wild, not still" (Feldman 164–167). In her narrow cage, the Capitoline she-wolf could bare her fangs but she could not bite. She could pace – and pacing was what she proverbially had become known for – but she could not hide. Forced to satisfy the voyeurism of those she could not possibly harm, the caged she-wolf had no room of her own. She could capture the imagination of her viewers, but it was the she-wolf herself who had been forever captured: Bars restricted the movements of her body and ideology placed analogous limits on her story.

Although animals have been kept in cages for millennia, the modern zoological garden as we know it, with its abbreviated name *zoo*, was founded in the nineteenth century. This is the same period that witnessed

the unification of Italy, the annexation of Rome, and the caging of the Capitoline she-wolf. In Italian literary history, the late nineteenth century is marked by Giovanni Verga's *verismo*: "The She-Wolf" was published in 1880 (see Chapter 6). Of all the animals that crowd literary texts, particularly naturalist prose, this she-wolf must be one of the most symbolic. She embodies a reflection not only on peasant life in nineteenth-century Sicily and, misogynistically, on unbounded female sexuality but also on the ties that bind us all within and the futility of escape. The protagonist is caged and her defiant attempts to break out result, as we have seen, in her violent death. The literary cage of Verga's she-wolf protagonist makes of her animal self a metaphor for the human spirit. Pina's beastly character, moving restlessly between containment and escape, could be read as a metaphor for every human self, for our vacillation between social dictates and bodily desires – the obligations of our affects and the pull of our most primal drives. Readers may prefer to dissociate themselves from the unsympathetic character of Verga's she-wolf – she has an enduring affair with her own daughter's husband, after all – but the dynamics of containment and escape, transgression and punishment that figure in her story also enter the story of us all. Women may well be she-wolves from this perspective but, more generally, all humans are animals; only an effective cage, however invisible, allows us to create some distance and envision some freedom from the dangers of the beast within.

In 1911, the Rome zoo was inaugurated. It provided spacious enclosures, company for each animal with at least one other specimen of the same species, and dens for time alone. No one visiting the Rome zoo today (euphemistically renamed the Bioparco a few years ago), after experiencing the more famous among the American zoos, would regard it as a striking example of progressive animal keeping. However, when it first opened at the beginning of the twentieth century, Rome's *Giardino zoologico* was considered among the best zoos in Europe, thoughtfully and beautifully arranged with ditches replacing bars in the keeping of many wild beasts. Even with the creation of the Rome zoo, though, and the increased awareness of the needs of captive animals, the she-wolf's life on the Capitoline Hill did not improve. Her lonely cage was still small and cold, her movements impeded, her privacy nonexistent; she could never withdraw from the crowd's excited gaze, from the "perpetual levee" that Henry James had so aptly described.

The link between the fancy new zoo and the she-wolf's deplorable cage appears in a poem by Trilussa, the Roman-dialect poet discussed in Chapter 6. Trilussa had much to say about the pitiable conditions of the

captive she-wolf and the eagle that, for a time, kept her company. His 1911 poem, "L'Aquila romana" (The Roman Eagle), is a dialogue between the two caged beasts placed in Rome's center to remind us of "the victories of a distant age." The Eagle complains about being incapable of flying, and the She-Wolf responds that only foreign animals are respected in modern Rome and able to enjoy the luxury of a villa – a reference to the swanky new zoo. In Trilussa's critique, the Arabian parrot, Brazilian monkey, and American mouse, housed in Rome's recently built zoo, all obtain greater respect than the indigenous eagle and she-wolf, which are regarded as dull "barnyard animals." As in so many literary and political texts about the she-wolf, there is allegory at work in this poem, in which the exotic zoo animals metaphorically stand for the foreign visitors who came to Rome for the Universal Exposition of 1911. The Exposition received greater public attention than the celebration of the fiftieth anniversary of Italy's unification and the fortieth of Rome as Italy's capital. So the Roman She-Wolf concludes the poem with a regret about her most famous action: "What a rotten deal I cut, in breastfeeding Romulus! Darn it! If I get to do it over again, instead of nursing him, I will eat him!" (801).

The Roman She-Wolf, of course, does not get another chance. In 1939, however, twenty-eight years after writing "L'Aquila romana," Trilussa gives the caged she-wolf the opportunity to speak again and express her foreknowledge concerning her own fate. In a four-line poem titled "Lupa romana" (Roman She-Wolf), the poet acknowledges: "The day that the She-Wolf nursed Romulus she thought of neither honors nor glory: she already knew that, once she got out of the Fable, they would cage her in History" (1448). Throughout Trilussa's life, a wolf was caged within iron bars at the Capitoline Hill; this animal's all-too-real imprisonment was metaphorical as well, the figurative bars of both fictional and historical narratives proving no less solid than the physical ones containing the live she-wolf. Nor for Trilussa is history less ideological and biased than the fables it tries to keep at arm's length: Freedom from the snares of legend means for the she-wolf entrapment in the tricks of history – this, Trilussa's animal "already knew." In 1939, when "Lupa romana" was written, the fascist regime was still very popular but Trilussa's satirical pen spared no one: The rhetoric of *romanità*, so dear to Mussolini, is unmasked in these lines as providing "neither honors nor glory." Trilussa's She-Wolf, humbly and presciently, does not expect the honors and glory she deserves, for the Roman beast always knew her state, physical and metaphorical, to be a captive one.

In 1954, when the three-year-old resident of the Capitoline cage unexpectedly died, the presence of a live wolf on the slope of Rome's most significant hill became controversial for the first time since 1872. In their characteristic vernacular, Romans exclaimed "poor beast" (*porabbestia*) in reference to the dead wolf. A British expatriate publicly questioned the wisdom of replacing the deceased animal, asking the *London Times* to intercede in the wolf's favor with Rome's administration (Carvigno). Many Romans supported him, including institutions such as the Rome Zoo and the National Association for the Protection of Animals. The mayor shrugged off these criticisms as left-wing attacks against his own Christian Democratic Party and the more patriotic right-wing members of the Roman political class: Why would anyone who loves Rome's glorious past object to its live reminder in the heart of the city? Another city counselor publicly wondered why there was such indignation for the caged she-wolf and the eagle that in the meantime had joined her, whereas no one complained about zoos and the numerous caged songbirds living in Roman households. There were so many who requested the wolf's return that within the year, the beast came back in an admittedly enlarged and more comfortable cage. It is interesting that it was a male specimen this time, standing in for his more symbolic and traditional female partner. Apparently, no one really cared to see swollen udders under the caged wolf. Whether male or female, the incarcerated beasts all acted the same way: This male wolf too, like the females who preceded him, soon began pacing back and forth, delighting some but infuriating many – although it was not until two decades later that the cage would be emptied once and for all.

In a 2006 autobiographical piece inspired by the caged she-wolf and titled with the vernacular cry of sympathy for her 1954 death, "*Porabbestia*," Giorgio Cappozzo claims to know why the live she-wolf was never moved to the Rome zoo: "The fruit of the governing men's civic passion deserved no destiny other than that of *symbolizing*" (91). The story of this caged she-wolf, Cappozzo insists, needs to be retold every so often because her physical captivity signaled the domestication of Rome's history and its exploitation by the ruling political class: "The she-wolf. We should have killed her before the first winter. Or stolen her, kidnapped her, confiscated her. We should have asked the governing class for a ransom and for the promise never to cage any narration again" (92). The caging of the she-wolf is a caging of history in the service of ideology, as Trilussa humorously forewarned in 1939. The she-wolf's multiple political uses throughout the centuries confirm, at one level, her effective

capture and deployment by the ideology in power. She protected the empire on ancient Roman coins and cuirasses, presided over the pope's justice at the medieval Lateran Palace, oversaw the superiority of ancient Roman culture from the Renaissance onward, and – as gift – she performed a cultural colonization of sorts in both the fifteenth and twentieth centuries. However, for every such dominant use of the she-wolf, for every interpretive cage attempting to enclose her, there is a vulnerable underside, a loose bar – so to speak – through which the beast stealthily escapes. The she-wolf of the legend is a generous beast, but it was a prostitute who was probably the first mother of all Romans (Chapter 1). The bronze *Lupa*, beloved today as the mother of all Romans through her tenure at the Lateran Palace, must remind us of the pope's judicial brutality: Her image guards a set of severed hands (Chapter 2). Mussolini appropriated the she-wolf but, in calling Italian children her sons and daughters, he questioned their legitimacy (Chapter 6). Therefore, some writers and artists decided to play with the she-wolf instead of being played by her. Whereas Arturo Martini unmasks the she-wolf's beautifully human side, translating her ancient shape into a multicultural narrative that could not be assimilated by fascist discourse, Luigi Ontani wears the she-wolf's pelt, impersonates another gender and another species, and adopts both her posture and children of a different ethnicity (see Chapter 9). Amara Lakhous's protagonist, also of non-Roman descent, suckles her avidly after learning how not to be bitten (see Chapter 6). The she-wolf acquires her significance by participating in a pattern of meaning that is never still; she cannot be wholly captured. Small wonder, then, that as Cappozzo allegorically concludes, "The poor beast's cage is still there, under the Capitoline Hill. It is rusty and empty. As it should be. Without wolves, eagles, or flies. Empty" (92).

Today, flesh-and-blood wolves are back in Rome. Since 2005, the Bioparco houses, in a dedicated, 1,600-square-meter enclosure, five Croatian wolves rescued from the notoriously horrible conditions in the Rijeka zoo. These wolves were born in captivity and, healed of the hardships of Rijeka, they seem comfortable in the space known as the "Forest of the Wolves" (*Selva dei Lupi*). *Selva* – etymologically related to the founding twins' biological mother, Rhea Silvia – is an old literary word in Italian: No one would use it today to name a real-life forest. This is the very word that Dante chose to describe the "dark forest" where he met the feared she-wolf, the "*selva oscura*." The name of the wolves' enclosure at the Rome zoo is a literary one, indeed, an allusion to the wolves of literature and their fierce connotations – and especially

to their figurative weight in Italian cultural history. The *Selva dei Lupi* is no dark, Dantesque forest, though: It replicates the wolves' natural habitat, with trees and dens and even a small pond. Early in 2006, a competition among Rome's children assigned names to the five wolves. One was called Francesco, after Francis of Assisi, lover of animals and tamer of wolves. For another, and the least surprising, the chosen name was Romulus. (Incidentally, there is no Remus – for fear perhaps that such a name might promote lupine fratricide.)

The onomastic identification of one of these wolves with Rome's founder is not the only connection between the wolves from Rijeka and the history of the Eternal City. Although the five Croatian wolves were the object – not the subject – of a rescue, the bond of their species with Rome's birth could not be left untold. So, just outside the wolves' enclosure in the Bioparco, visitors can view a massive plastic panel framed by rough-hewn wood. The large title printed on it is "Legend tells . . . ," for the panel illustrates, in seven child-friendly vignettes, the zoo's wolf-enhanced, bowdlerized version of the she-wolf story of old. In the first vignette, a young woman in a blue tunic and high-strapped sandals is running, pursued by a wolf, her long hair in the wind: "The legend of Rome's birth tells that one day, while Rhea Silvia was going into a wood, a wolf made her flee into a cave, where . . . " The caption ends and we turn to the next image, in which the young woman skids to a stop before a strapping, smiling Roman centurion. This hunk of a man, we soon find out, is no regular soldier: " . . . she met Mars, the God of War." What happens between them is discreetly left unsaid, although in the following vignette, Mars has his arm on Rhea Silvia's shoulder: "From their union . . . " In the next image, Rhea Silvia is alone, holding a large, swaddled baby in each arm: " . . . were born the two famous twins, Romulus and Remus." Then, an angry man, holding a spade in one hand, gives a bag containing the twins to a middle-aged, balding servant: "Amulius, Rhea Silvia's uncle, angered because the young woman had broken her chastity vow, buried her alive and ordered the newborns killed." In the next image, the same balding servant places a basket holding the twins in the water: "The servant charged with the task did not have the courage to commit such a crime, and after placing the two brothers in a wicker basket, he abandoned them in the Tiber with the hope that someone would rescue them." All's well that ends well: The last image shows a smiling she-wolf and two happy, diapered babies, one in the act of nursing and the other about to do the same: "Safety came from a she-wolf who, having found the basket under a fig tree at

the foot of the Palatine Hill, instead of feeding on the little ones, decided to adopt them and raise them."

Temporary likenesses of the she-wolf constantly appear on posters and flyers. Those advertising Rome's first film festival in 2006 – described in the preface – are some of the more spectacular and widely circulated in recent years. The plastic panels at the Bioparco may well be the most recent among the she-wolf's permanent palimpsests, the latest addition to the she-wolf's shifting pattern of meanings. The cartoonish story outside the rescued wolves' enclosure spreads the good news of the she-wolf's crucial role for the city. Its position and emphasis on wolves (for there is a wolf at both the beginning and the end of the story) also quite clearly call for a sense of circularity and reciprocity. A wolf pushed Rhea Silvia into the arms of Mars and a wolf saved Romulus and made Rome possible. The least Rome can do, the viewer must surely realize, is to do its part in the saving of wolves in need and to keep them in a "*selva*" whence, instead of hurting poets, pilgrims, or babies, they may remind us all of where our story began.

So the narrative of the she-wolf herself continues to be told in literature, history, art, and popular culture, its frequency, visibility, and signifying power undiminished by the passing of time. Most recently, the she-wolf has made a spectacular appearance on the 2009 calendar of Italy's biggest coffee company, an image also appearing on billboards and posters. In the shapely guise of a scantily clad young woman on all fours, with the Colosseum in the background and two chubby babies below her, this she-wolf holds a tiny espresso cup and gives her viewers a sexy, menacing look that says at once "come hither" and "stay away." The proliferation of she-wolves exemplified by this and other commercial images brings to mind the comment made by Swiss historical anthropologist Johann Bachofen more than a century ago, when he observed the increased recurrence of the nursing she-wolf on late imperial Roman monuments. He concluded: "The more the empire ages, the more frequent the she-wolf becomes as the symbol of a hope-filled future; thus do peoples, in times of decadence, go back to the ancient illusions of their early youth" (200).

The numerous recent versions of the she-wolf's tale may indeed fill Romans with ancient delusions of grandeur conveniently exploited by marketing specialists. Given the she-wolf's slipperiness and her persistence, however, I like to think that the hopes she instills in her viewers are more productive than illusory. Her legend can renew a sense of historical belief by encouraging a desire to discover hidden meanings in

this unbelievable tale and a quest for understanding the bigger picture. Meanwhile, the she-wolf tells our scientific minds to be tolerant of the beliefs of others because through the thoughtful, self-reflective practice of belief, we may learn more than we think. The she-wolf's bronze effigy has roused confidence in the power of art to bring together differences and to resolve historical and stylistic conflict through visual and narrative harmony. Her body, both realistic and stylized, also realizes this impossible encounter of opposites. Like the she-wolf, perhaps, we too can be both private and public: What could be more private than breastfeeding and yet, in the she-wolf's case, what could have been more public? The she-wolf's many deceptions invite us to question appearances, in Rome as elsewhere: Not all that looks ancient actually is and the *Lupa* may be medieval – but then again, you never know: Does age always matter? In her monumental versions, the she-wolf reminds her visitors to notice apparently insignificant details – because sometimes they make all the difference – and that not all that appears to be a she-wolf actually is one. That she is a predator, I can see on my son's face, when the lupus rash gets bad – but Dante knew that already and warned me: There is greed in motherhood and in each mother's desire for her child's perfection – that, too, is a she-wolf's trait. The she-wolf's gifts, however, are worth considering: My gratefulness bounces back to the she-wolf, gift-like, and she too is in my debt; may this book begin to satisfy her greed. She is a ruin, no doubt, a metonym of greatness and history dead and buried multiple times and each time resurrected into a new use – the latest one: my book-length exorcism of a frightening, wolfish illness. As the mate of *lupus*, the *lupa* symbolizes another way of belonging to the Eternal City where I was born; however, she tells me too that symbols are unstable – and who knows what she will mean years from now, to me or anyone else. That her memory will endure, I do not doubt: The she-wolf's ability to change herself – as narrative, as artwork, as symbol – assures her survival in a city such as Rome, founded on recycling of the old and the renewal of what is there already, the city visible on the traces of its palimpsests and on the verbal and visual transformations of a wild she-wolf that, perhaps, has been there always.

BIBLIOGRAPHY

Aikin, Roger Cushing. "Romae de Dacia Triumphantis: Roma and Captives at the Capitoline Hill." *The Art Bulletin* 62.4 (1980): 583–597.

Alföldi, André. "La louve du Capitole: Quelques remarques sur son mythe à Rome et chez les Étrusques." *Hommage à la mémoire de Jérôme Carcopino*. Paris: Les Belles Lettres, 1977. 1–11.

Alinovi, Francesca. "Luigi Ontani." In Weiermair, ed. *Luigi Ontani*. 50–54.

Andreae, Bernard. *The Art of Rome*. Trans. Robert Erich Wolf. New York: Harry N. Abrams, 1977.

Arendt, Hannah. *On Revolution*. London: Penguin, 1990.

Aristotle. *History of Animals*. Trans. D'Arcy Wentworth Thompson. Whitefish, MT: Kessinger, 2004.

Atkinson, David, and Denis Cosgrove. "Urban Rhetoric and Embodied Identities: City, Nation, and Empire at the Vittorio Emanuele II Monument in Rome, 1870–1945." *Annals of the Association of American Geographers* 88.1 (1998): 28–49.

Attino, Tonio. "La lupa capitolina smascherata dal C14: Un'opera medievale." *La Stampa* August 1, 2007.

Auden, W. H. *Collected Poems*. Edward Mendelson, ed. New York: Modern Library, 2007.

Bachofen, Johann Jakob. "La lupa romana sui monumenti sepolcrali dell'Impero." *Annali dell'Istituto di Corrispondenza Archeologica* (1867): 183–200.

Baddeley, Welbore St. Clair. "The Sacred Trees of Rome." *The Nineteenth Century and After* 58.19–20 (1905): 100–115.

Baedeker, Karl. *Italy: A Handbook for Travelers. Second Part: Central Italy and Rome*. Leipsic, Germany: Baedeker, 1890.

Bailey, Cyril. *The Religion of Ancient Rome*. London: Constable, 1907.

Barthes, Roland. "Wine and Milk." *Mythologies*. Trans. Annette Laverse. New York: Hill and Wang, 1972. 58–61.

Bartsch, Shadi. "*Ars* and the Man: The Politics of Art in Virgil's *Aeneid*." *Classical Philology* 93 (1998): 322–342.

Beard, Mary Ritter. "Picturing the Roman Triumph: Putting the Fasti Capitolini in Context." *Apollo* (July 2003). Available at www.apollo-magazine .com. Accessed January 2009.

Beer, Jeanette M. A. *Beasts of Love: Richard de Fournival's Bestiaire d'Amour and a Woman's Response*. Toronto: University of Toronto Press, 2003.

Belli, Giuseppe Gioacchino. *Poesie inedite*. Rome: Salviucci, 1865.

Benjamin, Walter. "The Work of Art in the Age of Mechanical Reproduction." In Charles Harrison and Paul Wood, eds. *Art in Theory, 1900–2000: An Anthology of Changing Ideas*. London: Blackwell, 2007. 520–527.

Berry, Mary. *Extracts from the Journals and Correspondence of Miss Berry from the Years 1783 to 1852*. Theresa Lewis, ed. Vol. 1 of 3. London: Longmans, Green, and Co., 1866.

Blewitt, Octavian. *A Handbook for Travellers in Central Italy*. London: John Murray, 1850.

Bloch, R. Howard. *Medieval Misogyny and the Invention of Western Romantic Love*. Chicago: University of Chicago Press, 1991.

Blondin, Jill. "Power Made Visible: Pope Sixtus IV as *Urbis Restaurator* in Quattrocento Rome." *The Catholic Historical Review* 91.1 (2005): 1–25.

Boholm, Asa. "Reinvented Histories: Medieval Rome as Memorial Landscape." *Ecumene* 4.3 (1997): 247–272.

Boldrini, Sandro. "*Leo timens* e *Lupus Ferox*: animali esemplari o una metafora politica?" In Carlo Santini, ed. *Il linguaggio figurativo della Fontana Maggiore di Perugia*. Perugia: Calzetti-Mariucci, 1996. 199–217.

Bonfante, Larissa. "Nursing Mothers in Classical Art." In *Naked Truths: Women, Sexuality and Gender in Classical Art and Archaeology*. London: Routledge, 2000. 174–196.

Bowen, Elizabeth. *A Time in Rome*. London: Vintage, 2003.

Bramblett, Reid, and Jeffrey Kennedy. *Top 10 Rome*. London: Dorling Kindersley, 2008.

Brattain, Michelle. *The Politics of Whiteness: Race, Workers, and Culture in the Modern South*. Princeton, NJ: Princeton University Press, 2001.

Braun, Emil. *Handbook for the Ruins and Museums of Rome: A Guidebook for Travellers, Artists, and Lovers of Antiquity*. London: Williams and Norgate, 1855.

Brendel, Otto J. *Etruscan Art*. New Haven, CT: Yale University Press, 1995.

Browning, Elizabeth Barrett. *The Letters of Elizabeth Barrett Browning*. Fredric G. Kenyon, ed. London: Smith, Elder & Co., 1898. 2 volumes.

Brownson, Orestes Augustus. "The Church and the Revolution." *Brownson's Quarterly Review*. New York: Dunigan & Brother, 1859. 281–323.

Burckhardt, Jacob. *The Civilisation of the Renaissance in Italy*. Trans. S. G. C. Middlemore. New York: Swan Sonnenschein, 1904.

Buzard, James. *The Beaten Track: European Tourism, Literature, and the Ways to Culture, 1800–1918*. Oxford: Clarendon Press, 1993.

Byron, George Gordon. *Childe Harold's Pilgrimage*. Chicago: W. B. Conkey, 1900.

Camerer, Colin. "Gifts as Economic Signals and Social Symbols." *The American Journal of Sociology* 94 (1988): 180–254.

Canons Regulars of the Order of the Holy Cross: The Basilica of San Giorgio in Velabro. Available at www.oscgeneral.org/basilica/july93.html. Accessed December 2009.

"Capitoline Wolf." Available at www.romegeorgia.com/capwolf.html. Accessed December 2009.

Cappozzo, Giorgio. "Porabbestia." In Maja and Tarantini. 89–92.

Carandini, Andrea. "Sullo specchio con Lupa, Romolo e Remo." *Ostraka* 6.2 (1997): 445–446.

Carandini, Andrea. *Roma: Il primo giorno*. Rome: Laterza, 2007.

Carandini, Andrea, and Rosanna Cappelli, eds. *Roma: Romolo, Remo e la fondazione della città*. Milan: Electa, 2000.

Carcopino, Jérôme. *La louve du Capitole*. Paris: Les Belles Lettres, 1925.

Carducci, Giosuè. "Alla città di Ferrara nel 25 aprile del 1895." *Rime e ritmi*. Bologna: Zanichelli, 1899.

Carrier, David. "Remembering the Past: Art Museums as Memory Theaters." *The Journal of Aesthetics and Art Criticism* 61.1 (Winter 2003): 61–65.

Carroll, Lewis. *Through the Looking Glass, and What Alice Found There*. New York: Rand McNally, 1917.

Carruba, Anna Maria. *La lupa capitolina: Un bronzo medievale*. Rome: De Luca, 2006.

Carvigno, Maurizio. "La lupa capitolina." Available at www.soslupi.bioparco .it/lupacapitolina.htm. Accessed December 2009.

Cernuschi, Claude. *Jackson Pollock: Meaning and Significance*. Boulder, CO: Westview Press, 1992.

Choay, Françoise. *The Invention of the Historic Monument*. Trans. Lauren M. O'Connell. Cambridge: Cambridge University Press, 2001.

Cicero. *The Catiline and Jugurthine Wars of Sallust Together with the Four Orations of Cicero Against Catiline*. Translated into English by a Graduate of the University of Oxford. Oxford: Slatter, 1841.

Cicero. *The Treatises of M. T. Cicero on the Nature of the Gods; On Divination; On Fate; On the Republic; On the Laws; and On Standing for the Consulship*. Trans. and ed. C. D. Yonge. London: Bohn, 1853.

Cole, Spencer. "Cicero, Ennius, and the Concept of Apotheosis in Rome." *Arethusa* 39 (2006): 531–548.

Compagni, Dino. *Cronaca fiorentina*. Milan: Guigoui, 1860.

D'Annunzio Gabriele. *Laudi del cielo, del mare, della terra e degli eroi*. Milan: Treves, 1903/1907.

Dante Alighieri. *The Divine Comedy*. Trans. by Henry Wadsworth Longfellow. London: Routledge, 1867. 3 vols.

Dekker, Midas. *The Way of All Flesh: The Romance of Ruins*. Trans. Sherry Marx-Macdonald. New York: Farrar, Straus and Giroux, 2000.

Della Porta, Giambattista. *L'Olimpia*. In *Comedie del S. Gio. Battista Della Porta Napoletano*. Venice: Sessa, 1597.

Demaray, John. "The Pilgrims' Texts and Dante's Three Beasts: *Inferno*, I." *Italica* 46.3 (1969): 233–241.

De Rosa, Alessandra, and Bruce Murphy. *Rome for Dummies*. Hoboken, NJ: Wiley Publishing, 2008.

Derrida, Jacques. *Given Time: I. Counterfeit Money*. Trans. Peggy Kamuf. Chicago: University of Chicago Press, 1994.

Dionysus of Halicarnassus. *The Roman Antiquities of Dionysius Halicarnassensis*. Trans. Edward Spelman. London: The Booksellers of London and Westminster, 1758.

Du Bellay, Joachim. *"The Regrets," with "The Antiquities of Rome," Three Latin Elegies, and "The Defense and Enrichment of the French Language." A Bilingual Edition*. Ed. and trans. Richard Helgerson. Philadelphia: University of Pennsylvania Press, 2006.

Duhn, Friedrich von. "Dante e la Lupa Capitolina." *Studi etruschi* 2 (1928): 9–14.

Dulière, Cécile. *Lupa Romana: Recherches d'iconographie et essai d'interprétation*. Bruxelles and Rome: Institut Historique Belge de Rome, 1979.

Dunford, Martin. *The Rough Guide to Rome*. New York: Rough Guide, 2007.

Du Perac, Étienne. *Urbis Romae Sciographia ex Antiquis Monumentis Accuratiss Delineata*. Rome: Francisco Villamoena, 1574/1595.

Dupont, Florence. "La matrone, la louve et le soldat: Pourquoi des prostitué(e)s 'ingénu(e)s' à Rome?" *CLIO: Histoires, Femmes et Sociétés* 17 (2003): 21–44.

Eccher, Danilo. "Sogni l'Ontani: Distant Dreams." In Weiermair, ed. *Luigi Ontani*. 61–62.

Eden, P. T. *A Commentary on Virgil: Aeneid VIII*. Leiden: Brill, 1975.

Edsall, Thomas. "Palin: Wolf in Sheep's Clothing." Available at www.huffingtonpost.com, October 6, 2008. Accessed November 2008.

Edwards, Catharine. *Writing Rome: Textual Approaches to the City*. Cambridge: Cambridge University Press, 1996.

Elfenbein, Andrew. *Byron and the Victorians*. Cambridge: Cambridge University Press, 1995.

Eliade, Mircea. "Les Daces et les loups." *Numen* 6.1 (1959): 15–31.

Evans, Jane De Rose. *The Art of Persuasion: Political Propaganda from Aeneas to Brutus*. Ann Arbor: University of Michigan Press, 1992.

Falasca–Zamponi, Simonetta. *Fascist Spectacle: The Aesthetics of Power in Mussolini's Italy*. Berkeley: University of California Press, 1997.

Feldman, Mark. "The Physics and Metaphysics of Caging: The Animal in Late Nineteenth-Century American Culture." *Mosaic* 39.4 (2006): 161–181.

Fellini, Federico, director. *Fellini's Roma*. Ultra Film, Les Productions Artistes Associés, 1972.

Fergonzi, Fabio. "Arturo Martini." In Penelope Curtis, ed. *Scultura lingua morta: Scultura nell'Italia fascista*. Leeds, UK: Henry Moore Institute, 2003. 60–74.

Fergusson, James. *An Historical Inquiry into the True Principles of Beauty in Art*. London: Longman, Brown, Green, and Longmans, 1849.

Ferrari, Claudia Gian. "Arturo Martini ed Edoardo Persico." Available at www.claudiagianferrari.it/d_Documenti/d_Contributi/testo26.pdf. Accessed October 2008.

Fisher, Robert I. C., ed. *Fodor's Rome 7th Edition*. New York: Random House, 2009.

Flemming, Rebecca. "*Quae Corpore Quaestum Facit*: The Sexual Economy of Female Prostitution in the Roman Empire." *The Journal of Roman Studies* 89 (1999): 38–61.

Fochessati, Matteo. "È firmata dall'architetto Piacentini la nuova sede Carige." Available at www.gruppocarige.it/grp/carige/html/ita/banca/arte_cultura/2004_5/pdf/64_69.pdf. Accessed December 2009. 64–69.

Fodor's Rome. New York: Fodor's Travel Publications, 2006.

Folkard, Richard. *Plant Lore, Legends and Lyrics: Embracing the Myths, Traditions, Superstitions and Folk-Lore of the Plant Kingdom*. London: Low, Marston, Searle, and Rivington, 1884.

Formont, Maxime de. *The She-Wolf: A Romance of the Borgias*. New York: Brentano, 1922.

Fortis, Alberto. "A voi romani." *Alberto Fortis*. LP. Prod. C. Fabi and A. Salerno. Philips Records, 1979.

Freccero, John. "Dante's Firm Foot and the Journey without a Guide." *The Harvard Theological Review* 52.4 (1959): 245–281.

Freedberg, David, et al. "The Object of Art History." *The Art Bulletin* 76.3 (1994): 394–410.

Freud, Sigmund. *Civilization and Its Discontents*. Trans. James Strachey. New York: Norton, 2005.

Fuller, Margaret. "Dispatches from Europe to the New York Tribune, 1846–1850." In Susan Cahill, ed. *Desiring Italy*. New York: Fawcett Books, 1997. 187–197.

Garwood, Duncan, and Abigail Hole. *Lonely Planet: Rome City Guide*. Lonely Planet, 2008.

Gergel, Richard A. "Agora S166 and Related Works: The Iconography, Typology, and Interpretation of the Eastern Hadrianic Breastplate Type." In Anne P. Chapin, ed. *Caris: Essays in Honor of Sarah A. Immerwahr*. Athens: American School of Classical Studies at Athens, 2004. 371–410.

Giustiniani, Vito R. "Dante's 'Lupa': A Problem in Translation." *Italica* 46.2 (1969): 109–119.

Gould, Sabine Baring. *The Lives of the Saints*. Charleston, SC: BiblioBazaar, 2008.

Grandazzi, Alexandre. *The Foundation of Rome: Myth and History*. Trans. Jane Marie Todd. Ithaca, NY: Cornell University Press, 1997.

Guerrazzi, Francesco Domenico. *Lo assedio di Roma*. Milan: Dante Alighieri, 1870.

Guerrini, Paola. "L'epigrafia sistina come momento della 'Restauratio Urbis.'" In Massimo Maglio, ed. *Un pontificato e una città: Sisto IV (1471–1484)*. Vatican City: Scuola Vaticana di Paleografia, Diplomatica e Archivistica, 1986. 453–468.

Hall, Newman. *The Land of the Forum and the Vatican or Thoughts and Sketches During an Easter Pilgrimage to Rome*. London: Nisbet, 1854.

Hall, Stuart. "Introduction." In Stuart Hall, ed. *Representation. Cultural Representations and Signifying Practices*. Thousand Oaks, CA: Sage Publications, 1997. 1–12.

Hannoush, Michele. "The Reflexive Function of Parody." *Comparative Literature* 41.2 (1989): 113–127.

Hare, Augustus J. C. *Walks in Rome (Including Tivoli, Frascati, and Albano)*. London: Kegan Paul, 1905.

Harrison, Robert Pogue. *Forests: The Shadow of Civilization*. Chicago: University of Chicago Press, 1993.

Harrison, S. J. "The Survival and Supremacy of Rome: The Unity of the Shield of Aeneas." *The Journal of Roman Studies* 87 (1997): 70–76.

Harrison, Simon. "Four Types of Symbolic Conflict." *The Journal of the Royal Anthropological Institute* 1.2 (1995): 255–272.

Haskell, Francis, and Nicholas Penny. *Taste and the Antique*. New Haven, CT: Yale University Press, 1982.

Hays, Steve. "*Lactea Ubertas*: What's Milky about Livy?" *The Classical Journal* 82.2 (1986–1987): 107–116.

Head, George. *Rome: A Tour of Many Days*. Vol. 2 of 3. London: Longman, 1849.

Headlam, C. E. S. "The Art of Virgil's Poetry." *The Classical Review* 34.1–2 (1920): 23–26.

Heffernan, James A. W. *Museum of Words: The Poetics of Ekphrasis from Homer to Ashbery*. Chicago: University of Chicago Press, 2004.

Helbig, Wolfgang. *Guide to the Public Collections of Classical Antiquities in Rome*. Trans. James F. and Findlay Muirhead. Leipsic, Germany: Karl Baedeker, 1895. 2 vols.

Herman, Alexander B., and John Paoletti. "Re-reading Jackson Pollock's *She-Wolf*." *Artibus et historiae* 50.25 (2004): 139–156.

Herrnstein Smith, Barbara. "Animal Relatives, Difficult Relations." *Differences* 15.1 (2004): 1–23.

Hetzler, Florence M. "Ruin Time and Ruins." *Leonardo* 1.1 (1988): 51–55.

Higonnet, Anne. "On the Object." In Freedberg et al. 399–401.

Hitt, Jack. "Harpy Hero Heretic Hillary." January–February 2007. Available at www.motherjones.com. Accessed November 2008.

Holleman, A. W. J. "The Ogulnii Monument at Rome." *Mnemosyne* 40.3/4 (1987): 427–429.

Honour, Hugh, and John Fleming. *A World History of Art.* London: Laurence King, 2005.

Horner, Stanley. *The Subject of Art in Process: Undressing the Emperor's Nude Close.* Bloomington, IN: Trafford, 2000.

Hugo, Victor. *Notre-Dame de Paris.* Trans. Alban Krailsheimer. Oxford: Oxford University Press, 1999.

Hult, David F. "The Allegoresis of Everyday Life." *Yale French Studies* 95 (1999): 212–233.

"I nuovi figli della lupa." Available at epokal.blogspot.com/2008/10/i-nuovi-figli-della-lupa.html, October 20, 2008. Accessed December 2009.

Infessura, Stefano. *Diario della città di Roma di Stefano Infessura Scribasenato.* Oreste Tommasini, ed. Rome: Forzani e C. Tipografi del Senato, 1890.

Isidore of Seville. *The Etymologies of Isidore of Seville.* Trans. Stephen A. Barney et al. Cambridge: Cambridge University Press, 2006.

James, Henry. *William Wetmore Story and His Friends. From Letters, Diaries, and Recollections.* 2 Vols. Boston: Houghton Mifflin, 1903.

James, Henry. *Italian Hours.* Boston: Houghton Mifflin, 1909.

Jones, Peter. "Museums and the Meaning of Their Contents." *New Literary History* 23.4 (1992): 911–921.

Justin. *Epitome of the Philippic History of Pompeius Trogus.* Available at www.tertullian.org/fathers/. Accessed November 2008.

Kampen, Natalie Boymel. "The Muted Other." *Art Journal* (Spring 1988): 15–19.

Kennedy, Dan. "The Two Faces of Hillary Rodham Clinton." Available at www.bostonphoenix.com, June 1999. Accessed November 2008.

Knopf Guides: Rome. New York: Random House, 2007.

Komunyakaa, Yusef. *Talking Dirty to the Gods.* New York: Farrar, Straus and Giroux, 2001.

Koshar, Rudy. "'What Ought to Be Seen': Tourists' Guidebooks and National Identities in Modern Germany and Europe." *Journal of Contemporary History* 33.3 (1998): 323–340.

Krautheimer, Richard. "The Carolingian Revival of Early Christian Architecture." *The Art Bulletin* 24.1 (1942): 1–38.

Kristeva, Julia. "Motherhood According to Giovanni Bellini." In James Matheson Thompson, ed. *Twentieth-Century Theories of Art.* Montreal: McGill-Queen's Press, 1990. 441–466.

"La lupa liberale." *La civiltà cattolica* 17 (1866): 172–256.

La Regina, Adriano. "Presentazione." In Carruba 9–10.

La Regina, Adriano. "Roma, L'inganno della lupa è 'nata' nel medioevo." *Repubblica* November 17, 2006.

Lactantius. *The Works of Lactantius.* Trans. William Fletcher. Edinburgh: Clark, 1871. Vol. 1 of 2.

Lakhous, Amara. *Clash of Civilizations over an Elevator in Piazza Vittorio.* Trans. Ann Goldstein. New York: Europa, 2008.

Lanciani, Rodolfo. *Ancient Rome in the Light of Recent Discoveries.* Boston: Houghton Mifflin, 1888.

Landau, Ellen G. *Reading Abstract Expressionism: Context and Critique.* New Haven, CT: Yale University Press, 2005.

Lansing, Richard, and Teodolinda Barolini. *The Dante Encyclopedia.* London: Taylor & Francis, 2000.

Laqueur, Thomas. *Making Sex: Body and Gender from the Greeks to Freud.* Cambridge, MA: Harvard University Press, 1990.

Lee, Egmont. *Sixtus IV and Men of Letters.* Rome: Edizioni di Storia e Letteratura, 1978.

Lello Petrone, Paolo di. *La mesticanza.* Città di Castello: Lapi, 1912.

Lever, Evelyne. *Marie Antoinette: The Last Queen of France.* Trans. Catherine Temerson. New York: Macmillan, 2001.

Levi, Mario Attilio. *Ercole e Roma.* Rome: L'Erma di Bretschneider, 1997.

Lévi-Strauss, Claude. *Totemism.* Trans. Rodney Needham. Boston: Beacon Press, 1963.

Lippi, Lorenzo (Perlone Zipoli). *Il Malmantile Racquistato.* Notes by Paolo Minucci et al. Luigi Portirelli, ed. Milan: Società Tipografica de' Classici Italiani, 1807.

Livy. *The History of Rome by Titus Livius.* Vol. 1, Books I–X. Trans. D. Spillan. New York: Harper and Brothers, 1879.

Lombardi, G. "A Petrographic Study of the Casting Core of the *Lupa Capitolina* Bronze Sculpture (Rome, Italy) and Identification of Its Provenance." *Archaeometry* 44.4 (2002): 601–612.

Lorenzi, Rossella. "Rome's She-Wolf Younger than Its City." November 22, 2006. Available at dsc.discovery.com/news/2006/11/22/shewolf_arc_print .html. Accessed December 2009.

Löwy, E. "Quesiti intorno alla lupa capitolina." *Studi etruschi* 8.12 (1934): 78–105.

Macadam, Alta. *Blue Guide Rome.* New York: Norton, 2006.

Macaulay, Thomas Babington. *The Lays of Ancient Rome.* Moses Grant Daniel, ed. Boston: Ginn, 1899.

MacCannell, Dean. *The Tourist: A New Theory of the Leisure Class.* Berkeley: University of California Press, 1999.

MacCormac, Earl R. "Metaphor Revisited." *The Journal of Aesthetics and Art Criticism* 30.2 (1971): 239–250.

Magister Gregorius. "De Mirabilibus Urbis Romae." In Rushforth, G. McN. "Magister Gregorius de Mirabilibus Urbis Romae: A New Description of

Rome in the Twelfth Century." *The Journal of Roman Studies* 9 (1919): 45–58.

Maja, Silvana, and Nadia Tarantini, eds. *Allupa allupa: Stupore e allarme di venticinque scrittori e venticinque artisti visivi*. Rome: DeriveApprodi, 2006.

Malvasia, Carlo Cesare. *Malvasia's Life of the Carracci*. Trans. Anne Summerscale. University Park: Pennsylvania State University Press, 2000.

Mansuelli, G. A. *The Art of Etruria and Early Rome*. Trans. C. E. Ellis. New York: Crown, 1965.

Marengo, Kimon (Kem). *Lupa Capitolina*. In David Williamson, ed. *The Age of Dictators*. Cover image.

Masson, Georgina. *The Companion Guide to Rome*. Revised by John Fort. Woodbridge, UK: Boydell and Brewer, 2003.

Mastro, Paolo di Benedetto di Cola dello. *Il Memoriale di Paolo di Benedetto di Cola dello Mastro del Rione di Ponte*. In *Archivio della R. Società Romana di Storia Patria*. Vol. XVI. Achille De Antonis, ed. Rome: Biblioteca Vallicelliana, 1893. 41–130.

Masuccio, Salernitano. *The Novellino of Masuccio*. Trans. W. G. Waters. London: Lawrence and Bullen, 1895. 2 Vols.

Mazzio, Carla. "Sins of the Tongue in Early Modern England." *Modern Language Notes* 28.3–4 (1998): 93–124.

Mazzotta, Giuseppe. *The Worlds of Petrarch*. Durham, NC: Duke University Press, 1993.

Miglio, Massimo. "Il leone e la lupa: Dal simbolo al pasticcio alla francese." *Studi Romani* 30.2 (1982): 177–186.

Miller, Joaquin. *The One Fair Woman*. Vol. 1 of 3. London: Chapman and Hall, 1876.

Murphy, Bruce, and Alessandra de Rosa. *Italy for Dummies*. Hoboken, NJ: Riley, 2007.

Muscardini, Giuseppe. "La lupa capitolina e la continuità dacoromana." *Chroniques italiennes* 10.4 (2006): 1–16.

Musto, Ronald. *Apocalypse in Rome: Cola di Rienzo and the Politics of the New Age*. Berkeley, CA: University of California Press, 2003.

Neustadt, Kathy. "The Folkloristics of Licking." *Journal of American Folklore* 107.423 (1994): 181–196.

Nevola, Fabrizio. *Siena: Constructing the Renaissance City*. New Haven, CT: Yale University Press, 2008.

Newton, Michael. *Savage Girls and Wild Boys: A History of Feral Children*. New York: St. Martin's Press, 2002.

Nievo, Ippolito. *Le confessioni d'un italiano*. Available at www.liberliber .it/biblioteca/n/nievo/. Accessed December 2009.

Nock, Arthur Darby, and J. D. Beazley. "Sarcophagi and Symbolism." *American Journal of Archaeology* 50.1 (1946): 140–170.

Nora, Pierre. "Between Memory and History: *Les Lieux de Mémoire.*" *Representations* 26 (1989): 7–24.

Olson, Roberta J. M. "An Album of Drawings by Bartolomeo Pinelli." *Master Drawings* 39.1 (2001): 12–44.

Ovid. *Fasti.* Trans. A. J. Boyle and R. D. Woodard. London: Penguin, 2000.

Pais, Ettore. *Ancient Legends of Roman History.* Trans. Mario E. Cosenza. Manchester, NH: Ayer, 1974.

Parsons, Nicholas T. *Worth the Detour: A History of the Guidebook.* Stroud Gloucester, UK: Sutton, 2007.

Pascarella, Cesare. *I sonetti – Storia nostra – Le prose.* Accademia dei Lincei, ed. Milan: Mondadori, 1978.

Petrarca, Francesco. *Rerum Familiarium Libri.* Trans. Aldo Bernardo. Albany, NY: SUNY Press, 1985.

Petronius Arbiter. *The Satyricon of Petronius Arbiter.* Trans. W. C. Firebaugh. Charleston, SC: Forgotten Books, 1962.

Picard, Gilbert-Charles. "La louve romaine, du mythe au symbole." *Revue archéologique* 2 (1987): 251–263.

Pinelli, Bartolomeo. *Istoria Romana.* Rome: Scudellari, 1818–1819.

Piozzi, Hester Lynch. *Observations and Reflections Made in the Course of a Journey through France, Italy, and Germany.* London: Strahall and Cadell, 1789. Vol. 1 of 2.

Plautus. *Asinaria. The Comedies of Plautus.* Trans. H. T. Riley. Vol. II. London: Bell, 1889. 477–524.

Pliny. *The Natural History of Pliny.* Trans. John Bostock and H. T. Riley. Vol. II. London: Bell, 1890.

Plutarch. *Plutarch's Lives: With Notes, Critical and Historical, and a Life of Plutarch.* Trans. John Langhorne and William Langhorne. N.P.: Applegate, 1860.

Plutarch. "Roman Questions." Trans. Isaac Chauncy. In William Goodwin, ed. *Plutarch's Morals.* 5 vols. Boston: Little, Brown, 1874. Vol. II: 204–264.

Polzer, Joseph. "Ambrogio Lorenzetti's 'War and Peace' Murals Revisited: Contributions to the Meaning of the 'Good Government Allegory.'" *Artibus et Historiae* 23.45 (2002): 63–105.

Pope, Alexander. *The Dunciad.* London: Lawton Gilliver, 1727.

Porter, Darwin, and Danforth Prince. *Frommer's Rome.* Hoboken, NJ: John Wiley, 2006.

Prescott, Anne Lake. "*Translatio Lupae*: Du Bellay's Roman Whore Goes North." *Renaissance Quarterly* 42.3 (1989): 397–419.

Presicce, Claudio Parisi. "I grandi bronzi di Sisto IV dal Laterano al Campidoglio." In Fabio Benzi et al., eds. *Sisto IV: Le arti a Roma nel primo Rinascimento.* Rome: Associazione Culturale Shakespeare and Co., 2000. 189–200.

Presicce, Claudio Parisi. *La lupa capitolina.* Milan: Electa, 2000.

Propertius, Sextus. *Propertius.* Trans. J. S. Phillimore. Oxford: Clarendon, 1906.

Quilligan, Maureen. *The Language of Allegory: Defining the Genre.* Ithaca, NY: Cornell University Press, 1992.

Raaflaub, Kurt A. "Between Myth and History: Rome's Rise from Village to Empire." In Nathan Rosenstein and Robert Morstein-Marx, eds. *A Companion to the Roman Republic.* Malden, MA: Blackwell, 2006. 125–146.

Raybould, Robin. *An Introduction to the Symbolic Poetry of the Renaissance.* Victoria, BC: Trafford, 2005.

Rehak, Paul. *Imperium and Cosmos: Augustus and the Northern Campus Martius.* Ed. John G. Younger. Madison: University of Wisconsin Press, 2006.

Rolland, Romain. *Jean-Christophe: Journey's End.* Trans. Gilbert Cannan. New York: Holt, 1913.

"Roman She-Wolf Come Down from Pedestal." May 2007. Available at www .italymag.co.uk/italy/lazio/roman-she-wolf-come-down-pedestal. Accessed December 2009.

Roscher, W. H., ed. *Ausführliches Lexicon der Griechischen un Römischen Mythologie.* Leipzig, Germany: Teubner, 1886–1890.

Sade, Marquis de. *Justine, Philosophy in the Bedroom, and Other Writings.* Trans. Richard Seaver and Austryn Wainhouse. New York: Grove Press, 1990.

Saito, Yuriko. "Why Restore Works of Art?" *The Journal of Aesthetics and Art Criticism* 44.3 (1985): 141–151.

Sanga, Glauco. "Passioni animali e vegetali. Per un'etnolinguistica delle sensazioni." *La ricerca folklorica* 35 (1997): 29–38.

Saylor, Steve. *Roma: The Novel of Ancient Rome.* New York: Macmillan, 2007.

Scalia, Christopher J. *Romantic Antiquarianism: Representations of Antiquaries, 1776–1832.* Dissertation, University of Wisconsin–Madison. Ann Arbor: University of Michigan Press, 2007.

Schiebinger, Londa. "Why Mammals Are Called Mammals: Gender Politics in Eighteenth-Century Natural History." *The American Historical Review* 98.2 (1983): 382–411.

Schneider, Wolf. *Babylon Is Everywhere: The City as Man's Fate.* Trans. Ingeborg Sammet and John Oldenburg. New York: McGraw-Hill, 1975.

Schoch, Richard. "'We Do Nothing but Enact History': Thomas Carlyle Stages the Past." *Nineteenth-Century Literature* 54.1 (1999): 27–52.

Schwabsky, Barry. "Luigi Ontani." *Artforum International* 33.4 (1994): 81.

Sedgwick, Catharine Maria. *Letters from Abroad to Kindred at Home.* New York: Harper & Brothers, 1841. 2 vols.

Shakespeare, William. *Henry VI. Part 3.* Randall Martin, ed. Oxford: Oxford University Press, 2001.

Shelley, Mary Wollstonecraft. *The Last Man.* Morton D. Paley, ed. Oxford: Oxford University Press, 1998.

"She-Wolves: From Tiber to Hudson." Available at www.tevereterno.it. Accessed December 2009.

Sienkiewicz, Henryk. *Quo Vadis: A Narrative of the Time of Nero*. Trans. Jeremiah Curtin. London: Little, Brown, 1898.

Simon, Kate. *Rome: Places and Pleasures*. New York: Knopf, 1972.

Simpson, J. R. *Animal Body, Literary Corpus: The Old French* Roman de Renart. Amsterdam: Rodopi, 1996.

Slane, Andrea. *A Not So Foreign Affair: Fascism, Sexuality, and the Cultural Rhetoric of American Democracy*. Durham, NC: Duke University Press, 2001.

Smith, Goldwin. "The Greatness of the Romans." *The Eclectic Magazine of Foreign Literature, Science, and Art* 28 (1878): 108–119.

Spenser, Edmund. *The Shorter Poems*. Richard A. McCabe, ed. London: Penguin Classics, 1999.

Springer, Carolyn. *The Marble Wilderness: Ruins and Representation in Italian Romanticism 1775–1850*. Cambridge: Cambridge University Press, 1987.

Stallybrass, Peter. "The World Turned Upside Down: Inversion, Gender, and the State." In Valerie Wayne, ed. *The Matter of Difference: Materialist Feminist Criticism of Shakespeare*. Ithaca, NY: Cornell University Press, 1991. 201–220.

Staples, Ariadne. *From Good Goddess to Vestal Virgins: Sex and Category in Roman Religion*. London: Routledge, 1998.

Steves, Rick, and Gene Openshaw. *Rick Steves' Rome 2007*. Emeryville, CA: Avalon Travel, 2007.

Stinger, Charles. "The Campidoglio as the Locus of *Renovatio Imperii* in Renaissance Rome." In Charles Rosenberg, ed. *Art and Politics in Late Medieval and Renaissance Italy, 1250–1500*. Notre Dame, IN: University of Notre Dame Press, 1990. 135–156.

Stone, Marla. "A Flexible Rome: Fascism and the Cult of *Romanità*." In Catharine Edwards, ed. *Roman Presences: Receptions of Rome in European Culture 1789–1945*. Cambridge: Cambridge University Press, 1999. 205–220.

Story, William Wetmore. *Roba di Roma*. New York: Houghton Mifflin, 1894.

Strinati, Claudio. *Annibale Carracci*. Florence: Giunti, 2001.

Strong, Eugenia. "Sulle tracce della lupa romana. (Progetto di studio)." *Scritti in onore di Bartolomeo Nogara, raccolti in occasione del suo LXX anno*. Rome: Tipografia del Senato, 1937. 476–501.

Subrenat, Jean. "Rape and Adultery: Reflected Facets of Feudal Justice in the *Roman de Renart*." *Reynard the Fox: Social Engagement and Cultural Metamorphoses in the Beast Epic from the Middle Ages to the Present*. Oxford: Berhahn Books, 2000. 17–36.

Summit, Jennifer. "Topography as Historiography: Petrarch, Chaucer, and the Making of Medieval Rome." *Journal of Medieval and Early Modern Studies* 30.2 (2000): 211–246.

Sutton, Tiffany. "How Museums Do Things without Words." *The Journal of Aesthetics and Art Criticism* 61.1 (2003): 47–52.

Tertullian. *The Writings of Tertullian.* James Roberts and Alexander Donaldson, eds. Vol. 1. *Ante-Nicene Christian Library: Translations of the Writings of the Fathers Down to A.D. 325.* Edinburgh: Clark, 1869. 11 vols.

The Green Guide: Rome-Vatican City. Clermont Ferrand: Michelin Travel Publications, 2001.

The Little Flowers of Saint Francis of Assisi. Trans. Franciscan Fathers at Upton. Revised Thomas Okey. London: Kegan Paul, 1905.

Tickner, Lisa. "The Impossible Object?" In Freedberg et al. 404–407.

Time Out Rome. London: Ebur Publishing/Random House, 2007.

Tinti, Luigi. *Roma sacra: I suoi monumenti e altri celebri santuari d'Italia.* Available at avirel.unitus.it/bd/autori/tinti/. Accessed December 2009.

Trilussa. *Tutte le poesie.* Claudio Costa and Lucio Felici, eds. Milan: Mondadori, 2004.

Twain, Mark. *The Innocents Abroad, or The New Pilgrim's Progress.* Hartford, CT: American Publishing Company, 1884.

Varro. *De Rerum Rusticarum.* In *Roman Farm Management: The Treatises of Cato and Varro.* Trans. and ed. F. H. Belvoir. Whitefish, MT: Kessinger, 2004. 24–153.

Verga, Giovanni. "The She-Wolf." In *Cavalleria Rusticana and Other Stories.* Trans. G. H. McWilliam. London: Penguin, 1999. 34–38.

Villani, Giovanni. *Cronica di Giovanni Villani.* Francesco Gherardi Dragomanni, ed. Vol. IV. Florence: Sansone Coen, 1845.

Virgil. *The Aeneid of Virgil.* Trans. Allen Mandelbaum. Berkeley: University of California Press, 1982.

Wallis, Brian. "A Forum, Not a Temple: Notes on the Return of Iconography to the Museum." *American Literary History* 9.3 (1997): 617–623.

Weiermair, Peter. "The Self-Presenter of Myths: The Unity of Art and Life in the Work of Luigi Ontani." In Weiermair, ed. *Luigi Ontani.* 9–13.

Weiermair, Peter, ed. *Luigi Ontani.* Zürich: Stemmle, 1996.

Williamson, David G. *The Age of the Dictators: A Study of the European Dictatorships, 1918–1953.* Harlow, UK: Pearson Education, 2007.

Williamson, Paul. *Gothic Sculpture, 1140–1300.* New Haven, CT: Yale University Press, 1998.

Wilsmore, S. J. "What Justifies Restoration?" *The Philosophical Quarterly* 38.150 (1988): 56–67.

Wind, Edgar. "The Eloquence of Symbols." *The Burlington Magazine* 92.573 (1950): 349–350.

Wiseman, T. P. *Remus: A Roman Myth.* New York: Cambridge University Press, 1995.

Wiseman, T. P. "Reading Carandini." *The Journal of Roman Studies* 91 (2001): 182–193.

Wordsworth, William. *Yarrow Revisited and Other Poems*. London: Longman, 1835.

Wright, Alison. *The Pollaiuolo Brothers: The Arts of Florence and Rome*. New Haven, CT: Yale University Press, 2005.

Zanker, Paul. *The Power of Images in the Age of Augustus*. Trans. Alan Shapiro. Ann Arbor: University of Michigan Press, 1988.

INDEX

INDEX